'And I saw quite certainly that we must needs be in a state of longing and suffering until the time when we are led so deeply into God that we really and truly know our own soul.'

Julian of Norwich

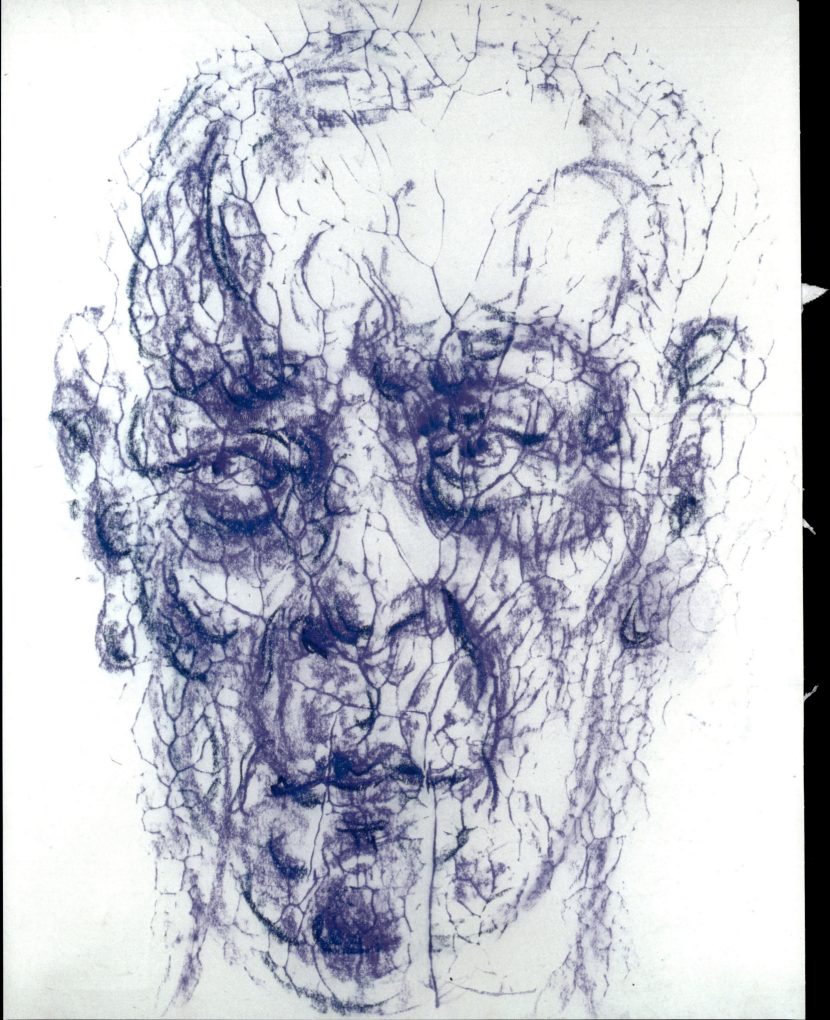

DIVINING The HUMAN

Alexander Newley

Acknowledgements

My thanks to Alexander DeCadenet for pointing me towards Lord Ian Strathcarron and his wonderful team at Unicorn Books; especially Ocky Murray, who created such a great book design. And my deepest gratitude to Ljubisa Tesic and Tomas Karadzic at Grafoprint who worked their magic in the printing phase to give the book such a beautiful finish.

And for their generous support in realising this project, huge thank yous to my patrons Dan and Linda Kiely and Tara and Giovanni Incisa Della Rochetta. Also to all my students and collectors who gave so generously to the process: Bruce and Sue Campbell, Martin and Isabella Millard, Daniel Pichney, Haneen Lehane, Beth Rudin Dewoody, Lihong Zuo, Judi and Tom Randall, Tanya Hamilton and Sue Lewis.

And to Lila Hammond, for her sage advice and unfailing help choosing images and editing text: you gave so much to this book with your brilliance. And a special thank you to Andria Zafirakou, who volunteered her time amidst a crazy workload to give me such a beautiful introduction.

And finally, my greatest love and thanks to my wife, Sheela, for her support in the making of this book-and for all she has given me.

This book is dedicated to the memory of

Anthony Newley and Leslie Bricusse

whose creative partnership inspired me and helped me to follow my own creative path.

There is no life I know to compare with pure imagination...

Published in 2022 by Unicorn,
an imprint of Unicorn Publishing Group LLP
5 Newburgh Street, London, W1F 7RG

www.unicornpublishing.org

All rights reserved. No part of this book may be reprinted or reproduced or utilised in any form or by any electronic, mechanical or other means, now known or hereafter invented, including photocopying and recording, or in any information storage or retrieval system, without permission in writing from the publishers or a licence from the Copyright Licensing Agency Ltd, www.cla.co.uk

A catalogue record for this book is available from the British Library

Text and images © Alexander Newley

Designed by Ocky Murray
Proofread by Ramona Lamport
Supervisor Studio Tesic
Printed by Grafoprint

Every effort has been made to trace copyright holders and to obtain their permission for the use of copyrighted material. The publisher apologises for any errors or omissions and would be grateful to be notified of any corrections that should be incorporated in future reprints or editions of this book.

ISBN 9781913491444

(front cover)
Talbott Spirit Flower
2021, oil and acrylic on canvas, 18x30"

(back cover)
photo © Sir David Suchet CBE

(front endpaper)
BuddhaChrist
1999, acrylic and oil on canvas, 24x30"

(previous page)
Blue Fractal Head
1999, pastel on paper, 9x11"

(back endpaper)
Self-portraits
Various years and materials

Contents

6	**Introduction**
9	**Beginnings**
35	**Theatre**
57	**Inner Landscape**
71	**Hollywood Portraits**
93	**Abstraction**
113	**Nerves Upon a Screen**
127	**St George and the Dragon**
161	**The City**
203	**The Cardplayers**
213	**Outcasts and Travellers**
233	**On Commission**
269	**New York Portraits**
303	**London**
319	**Witnesses**
331	**Ascension**

Introduction

Andria Zafirakou

This book revitalised and inspired me; I can't stop looking at it. It is a powerful example of the truth I impress on my students about the power of art and how it can give shape and meaning to a life.

Alexander Newley is so many artists, so many personalities in one – the richness of his work captivated me. In these pages you will find surrealism, futurism, mind bending abstraction and a truly seductive descent into the human shadow. I loved every twist and turn of his beguiling story. What brought it all together for me was the honesty and purity of his intent.

I love working with children for the same reason: they have no barrier. I feel I am connecting with a real human being. It is the same with this glorious book, so multifaceted and yet so down to earth. Alexander is an artist passionate about communicating directly, with no barrier of critical theory, no psychobabble – he just wants to touch your heart.

And so naturally he employs the simple tools of painting that have been used for millennia – no video, no clunky installations or smoke and mirrors, just the honest tools of his trade.

When I mention my love for the cave paintings of Lascaux, with their charging herds recorded over 17,000 years ago, he talks reverently of the earth pigments in his paints, loving this connection to source: 'Those first paintings were made with earth mixed with water, the same medium I use now. I find that thrilling, that continuity with the deep past, and our first human desire to record what we experience...'

He is an artist who has returned to first principles and stayed there. But, my God, his brush is his Harry Potter wand: he can do almost anything with it, conjure any world, take us deep into the whizzing realm of Pollock ... and back out again to create portraits of a classical richness. It is no wonder the American director, Oliver Stone, has called him 'the Isaac Newton of British Art'.

Considering his mastery of painting, it is astonishing to me that Alexander is self-taught. This was a conscious decision. He makes no secret of his concern for how art is being taught in art schools today, how the 'sacred calling' is being dulled and diverted into careerism. By contrast, he gives himself permission to operate out of bounds and embrace the role of a maverick. It is why his art is so fresh and personal. He is the definition of a risk-taker, dazzling us with a capacity to explore in so many different directions.

Trust is central to his process. Trust in himself, and trust in art. From the start, he wanted to get lost in painting. There is a beautiful description of his first 'fateful' encounter, aged eighteen, with his grandmother's paintbox: the smell of turps, the oily ooze of paint – it is like he has found his oxygen, his divine tools. And from then on he just flew...

The butterfly image is apt because all through his work we see this technique, his child-like delight in folding and opening the canvas to create complex patterns. *Ascension* (p. 122) is my favourite example. I love this heavenly painting. It really takes you by the heart and lifts you.

It reminds me of that great tradition of visionary British artists – Samuel Palmer,

William Blake, Stanley Spencer – who can move us between real and imaginary worlds, the sacred and profane, giving us a visceral sense of how the divine inhabits nature.

In fact, Alexander extends this tradition by evolving into an abstract painter. It happened in his mid-thirties: a courageous leap away from the representational to explore colour, paint and structure.

At first I thought these pictures were bonkers. But the more I looked, the more I was drawn into their marvellous complexity – and the contest between play and rationality has never been better expressed.

Alexander worked exclusively in this abstract mode for two years, discovering many novel techniques that he imported back into representational painting. A piece like *Veiled* (p. 324) makes me very uncomfortable with its alien quality – but I am enthralled by its vein-like textures and creases: they transform the face underneath into something haunting. It made me wonder what sort of morphine he was on!

His work is so dark in places, but I love it. The *St George and the Dragon* pictures (from p. 126) pulse with danger and mystery. 'The shadow is where we find our missing pieces,' he says. 'We have to descend into it to complete ourselves. Wholeness is the goal of art.'

At the summit of his work stands portraiture. I had an actual cry over the painting of *Rukmini Venkatraman* (p. 256). It is a portrait of his wife's grandmother; but this is *my* grandmother, too, the woman who taught me so much about life and goodness and realness: her beautiful spirit, her womanliness and wisdom shine through. I could swear the painting is breathing.

I have experienced nothing like it on my many visits to the National Portrait Gallery. Alexander's portraits are like hymns to his subjects. He captures their universality and the key detail that gives us their individuality, like the tip-toe feet of *Hunt Slonem* as he reaches for his canvas (p. 283). And his double portraits are similarly probing, showing the connection *and* the chafe of marriage.

Throughout the book his subjects confess how 'enjoyable' and 'restful' it was to sit for him, probably because, as Alexander confesses, 'I tend to fall in love with my subjects as I paint them.'

In other words, they do not feel judged, only deeply seen and appreciated. It is why they show so much of themselves.

In the Studio (p. 190) is one of my favourite parts of the book. It gives us such a visceral sense of the painter's studio. I can smell the paints and varnishes – and the blood, sweat and tears – in his two still lives, *Painter's Table 1 and 2* (p. 193). And he looks so cool in his self-portraits, cap on backwards, paint-encrusted shorts and shoes. I can imagine my GCSE kids looking at these pictures and thinking: 'Movie star? Ninja Warrior? I'd rather be a painter!'

It is this ability to communicate a passion for creativity that makes Alexander such a torchbearer for his growing legion of students. He is an art evangelist, leading his students away from doubt to faithfully embrace themselves and their own process. As a teacher myself, I often see children oppressed by the dos and don'ts of the adult world – cut-off from their journeys by over-protection or, worse, by neglect. Programmed like this, they will never get lost in their enchanted kingdom, never meet and slay their dragons, never find the Holy Grail in themselves. The solution is to startle them awake, and the best voltage for this is the creative spirit.

Alexander Newley is an artist who gives us deep permission to be ourselves. His portraits and his fearless exploration of many media and styles celebrate the human in all its strangeness and glory. His book presents us with the story of his becoming, but it is also a blueprint for how we, too, can become the hero of our own story. That is where the artist's energy is, and the courage to be divinely human.

Chapter 1

Beginnings

In the spring of 1983 I was eighteen and staying with my grandmother at her cottage in Pacific Palisades, California. I had recently survived the shipwreck of my university hopes – my bid to read English at Oxford having failed – and Grandma's was the perfect place to retreat and lick my wounds. I ate to bursting her delicious food and worked away at my poetry. The walls of her comfy home were adorned with the charming paintings of her house and garden that she'd made. One fateful day I opened her paintbox and inhaled the sour-sweet smell of oil paint and turpentine. I was intrigued enough to decide that I wanted to try my hand. I had been an inveterate doodler at school, always drawing the same, deeply etched faces with heavy shading, so when I foraged through Grandma's garage in search of something to paint on, it was a portrait of one of these creatures that I was planning to make. I eventually found an old piece of cardboard, approximately 2x3ft, propped it on a chair in the garden and settled down to work. I experienced no frustration or hesitation, just a smooth channelling of my emotions into the forms that spontaneously arose before me on the painting surface. I felt I was dancing to a private music, speaking my long-lost tongue. Painting had found me, and I was smitten.

The work I produced was lost in a move, but recently I was astonished to see it turn up on Twitter; the owner happily contacted me to say that he'd picked it up at an auction in downtown Los Angeles.

Looking at **Trapped Man (p. 13)** now, I see clear signs of my future preoccupations as an artist: a sense of the figure trapped in the frame, an arduous need to get out of two dimensions into three, and breathe free.

Only a few other works survive from this time. **Mother (p. 13)**, drawn on yellow legal pad, still startles me with its violent crenelations and orifices. **Early Poet (p. 13)**, a large head sketch rendered in felt-tip, is the first instance in my work of an expression I've sought in my subjects ever since: an acceptance of life's pain mixed with an amused spirit of defiance. The bag under the left eye that seems to droop into a teat – as if misery was a form of nourishment – delights me still.

Then came **Zeus (p. 13)**, a wake-up call to the expressionistic effects of colour and handling. This was followed in a similar mythological vein by **Icarus (p. 14)**, in which the half-man/half-bird rears back in fear from his vision of a hollow sun – a premonition of disaster.

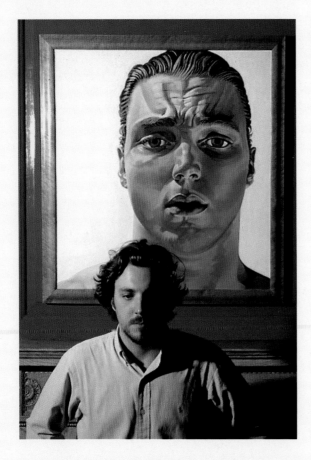

The artist, aged 20, with self-portrait

When I embarked on my first self-portrait I knew it had to be big... On seeing the finished 3x3ft panel, my father said it felt like 'being punched in the face'.

When I returned to England I was on the hunt for a countryside retreat where I could lock myself away and continue painting. Eventually, I settled on the seaside town of Lyme Regis, with its ancient stone promontory, the Cobb, whiplashing out to sea. Here I could roam through lush woodland and hear the waves rolling in through the trees. And I'd found a beautiful Georgian mansion overlooking the bay, whose top floor had recently been converted into a flat with stunning sea views. Here I set up my studio, and rarely left it, except to buy provisions in town. I knew the butcher and the man who sold me my brushes and paints, but otherwise lived as a recluse. This rigorous life suited me, but I was clueless when it came to matters of housekeeping. I soon descended into squalor; not washing or cleaning house, obsessively puffing on an old pipe that looked like an eyeball and keeping strange hours. I only had time for my painting. The studio walls were papered over with reproductions of favourite works by Picasso, Schiele and Munch, and there were images from deep space of galactic swirls, pulsars and black holes. I marinated in music, choosing from a sprawling pile of cassettes by my paint-spattered stereo.

Figure at a Cliff's Edge (p. 15) started life as a large pencil study of three suicides edging to the verge of a cliff. Two of these craven figures were understandably reluctant and afraid, but one – the central figure – seemed content to push to the edge and heroically let go. I lost interest in the other two and cut down my canvas to concentrate on this inspired nihilist. As with **Mother**, my imagination deconstructed the forms of his body to a surreal degree and he morphed into a musical instrument or puppet, poised on the brink of an immortal 'What if?' However, so he wouldn't fall, I drove a rivet into

the iron counterweight of his foot; now he'd stay there forever, resonating like a pitchfork – a monument to life lived 'on the edge'.

Mahler (p. 16), my homage to a favourite composer, came about because of an accidental likeness to the great man which I then developed into a celebration of musical form.

Job 1 (p. 17), after the biblical hero who remains faithful to God under test, was the first in a series I would make of this exemplar of unbending will and devotion. He inspired me to follow my star, even as everything went to hell around me.

Id (p. 19), based on Freud's idea of a core to human appetites that is volcanic and uncontrollable, was suggested by the darting and zig-zagging flightpath of a fly. I was so irritated by this invader of the site-line between me and my work, that I decided to turn around the painting I was working on and start another based on its chaotic flightpath. The pesky insect is still visible as the ultimate end of a downward-curling left eye. As with **Figure at a Cliff's Edge**, there is a sense of torqued and twisted steel in the modelling, but here it gives the appearance of facial structure, and the expression of an angry child, sulky, vindictive and intent on causing mischief. The cloak of numbers is a logical counterpoint to the chaos turned, by artistic alchemy, into complexity.

The Nest (p. 18) opens out the tangle of **Id** into a more naturalistic scene, but the violence of its angles and points is still there. The raw hunger and appetite of the chicks is represented as a leaping fire that the mother bird must extinguish and satisfy.

In my seaside retreat I was constantly at work, eight to ten hours a day. Weekends came and went. Weeks ran into months and I lost all track of time. I had no phone, no central heating. In winter I purchased an old gas heater that leaked butane and made me repeatably ill. Friends came to visit but didn't stay long. I worked through Christmas and saw no family. Once every fortnight I made a call from the payphone in a local parking lot to let them know I was still alive. My conversation was full of superlatives about the things I was seeing and discovering. My father was encouraging, but must have been concerned.

When I embarked on my first self-portrait, **Self-Portrait at 20 (p. 20)**, I knew it had to be big. How was I going to get everything I was going through into one painting? I rigged two light sources – one from above, one below – to mimic the divine and demonic light. A round shaving mirror did duty as my reflective surface, and I covered all the windows with blankets to subsume the studio in darkness. It stayed that way for six months. I worked on the self-portrait exclusively, rolling endless cigarettes, admiring and despairing of the face that evolved before me. Initially, the frown was there to add interest, but it soon became the signifier of the anvil in my brain driving the painting on. Eventually I settled on an all-white background to push the face forward from a timeless space. On seeing the finished 3x3ft panel, my father said it felt like 'being punched in the face'.

Maintaining such intensity over long periods was taking its toll. Living alone, I had no one to advise me to take it easy or to pace myself. A breakdown was inevitable, and it came at the end of my first year. I returned to London and rested. I would go back to Lyme Regis throughout my twenties for the concentration I needed to finish demanding work, but I never again lost myself like I did in that first year, when the themes and styles I would explore for the rest of my career came thrillingly to life.

Early portraits

Self-Portrait at 20 was my first portrait, and it opened the door to more. When I came to paint my sister, **Katy (p. 22)**, I felt like I was at the foot of a mountain in terms of naturalistic portrait technique. I knew nothing about it, and was filled with excitement to explore this fascinating new challenge on my own. The learning curve was steep, and painting the head-and-shoulders of Katy took almost a year.

It was made in my first London studio, off the Fulham Road, about 6x10 sq ft, large enough to swing the proverbial cat.

When it came to painting Katy's hair, I let my imagination wander and it intuitively returned to the interlocking forms and trellises of **Figure at a Cliff's Edge** and **Id**. Here the effect is Medusa-like and magical. The face, too, is made of facets that lock and shift to imply the movement of thought and feeling. In its more naturalistic palette and softer treatment, the painting is a far cry from **Self-Portrait at 20** – and it soon opened the door to my first portrait commission, **Jeffrey Curtiss (p. 24)**.

The success of the Jeffrey Curtiss painting led to a commission for a triple portrait. In **The Morstedt Sisters (p. 25)** I separated the three subjects into a triptych, with each sister representative of a spirit or 'grace'. Charlotta, on the left, is Emotion, the sensitive soul halved by shadow. Bookending her on the right is Anna, the Spirit, voguing in a spotlight like Raphael's Madonna. Emma, in the centre, confronts us with the strong, unflinching gaze of the Intellect. The high-wattage lamps I used enabled me to achieve exact, surgical detail, and the project is the culmination of my interest in photographic realism.

From then on, I released myself to a more painterly and intuitive approach.

These early commissions gave me an anchor in the real world and a respectable craft. Portraiture has been the organising principle of my life as an artist ever since.

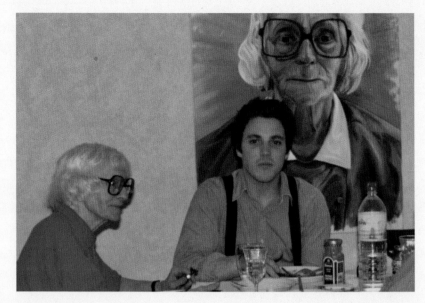

With my paternal grandmother, whose paintbox inspired me. She was an unwavering presence of love and support.

(top left)
Trapped Man
circa 1983, acrylic on board, 24x36"

(top right)
Mother
1986, pencil on legal pad, 8x11"

(bottom left)
Early Poet
1984, ink on paper, 16x20"

(bottom right)
Zeus
1986, acrylic on black board, 24x36"

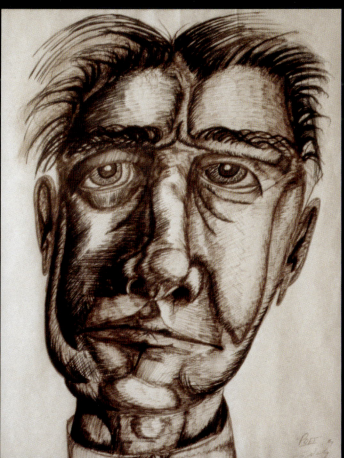
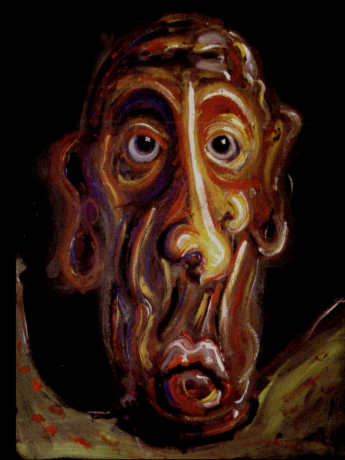

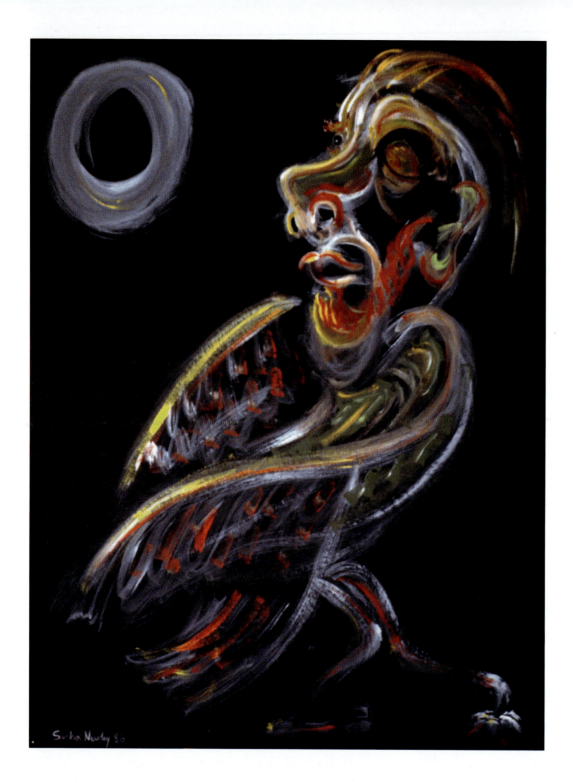

Icarus
1986, acrylic on black board, 24x36"

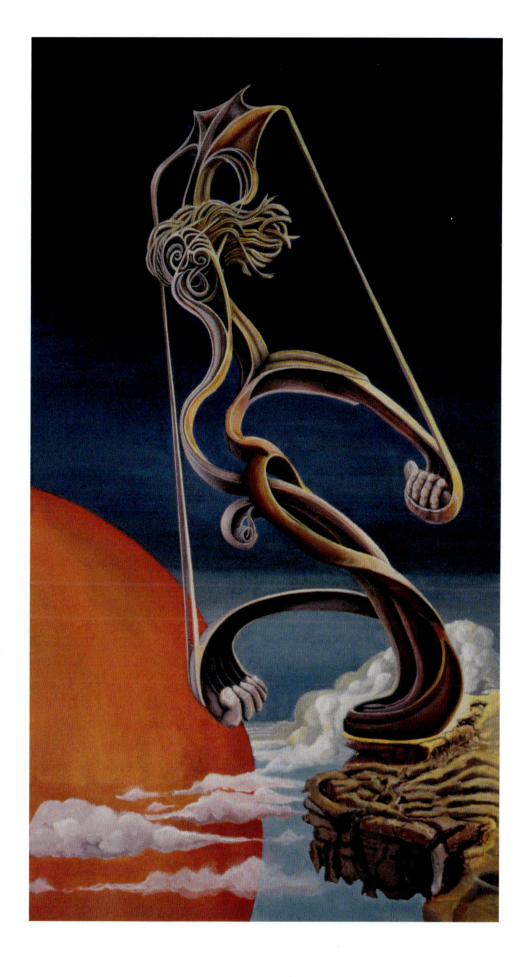

Figure at a Cliff's Edge
1986, acrylic on paper mounted, 30x60"

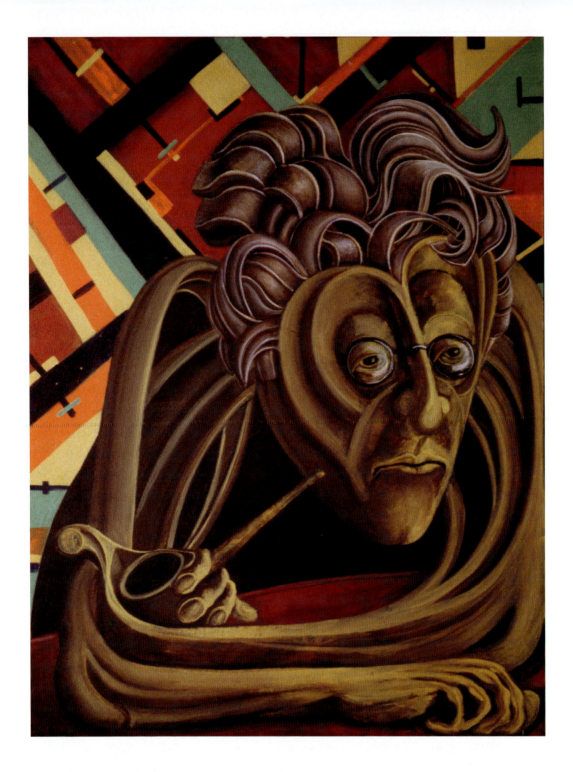

(above)
Mahler
1987, acrylic on board, 24x36"

(opposite)
Job 1
1987, acrylic on board, 30x40"

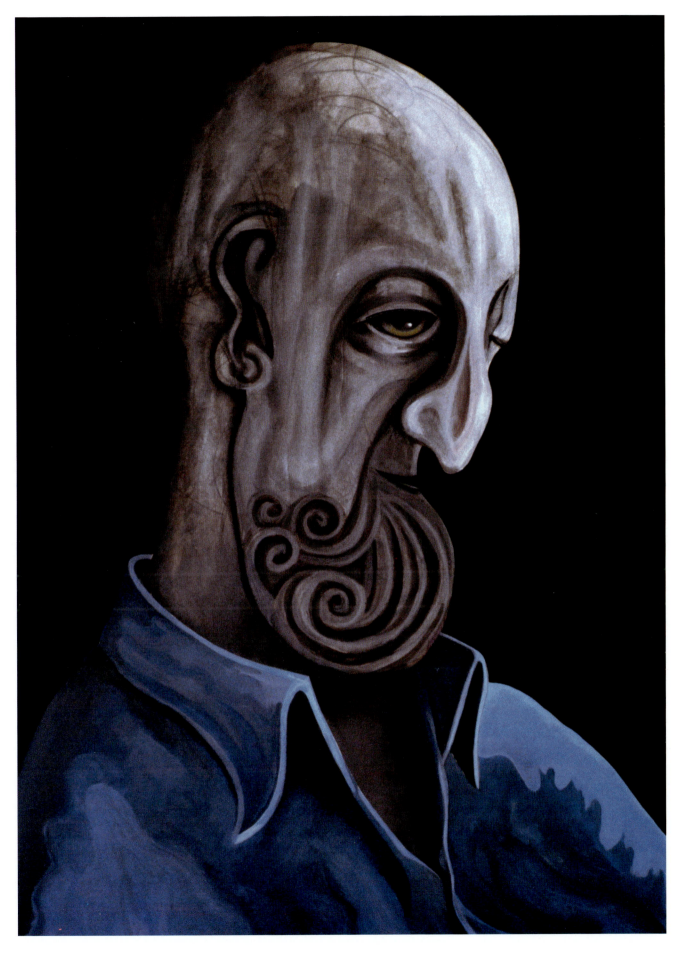

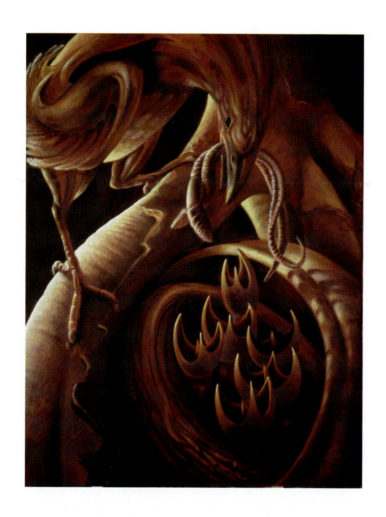

(above)
The Nest
1989, acrylic on canvas, 24x36"

(opposite)
Id
1988, acrylic on board, 24x36"

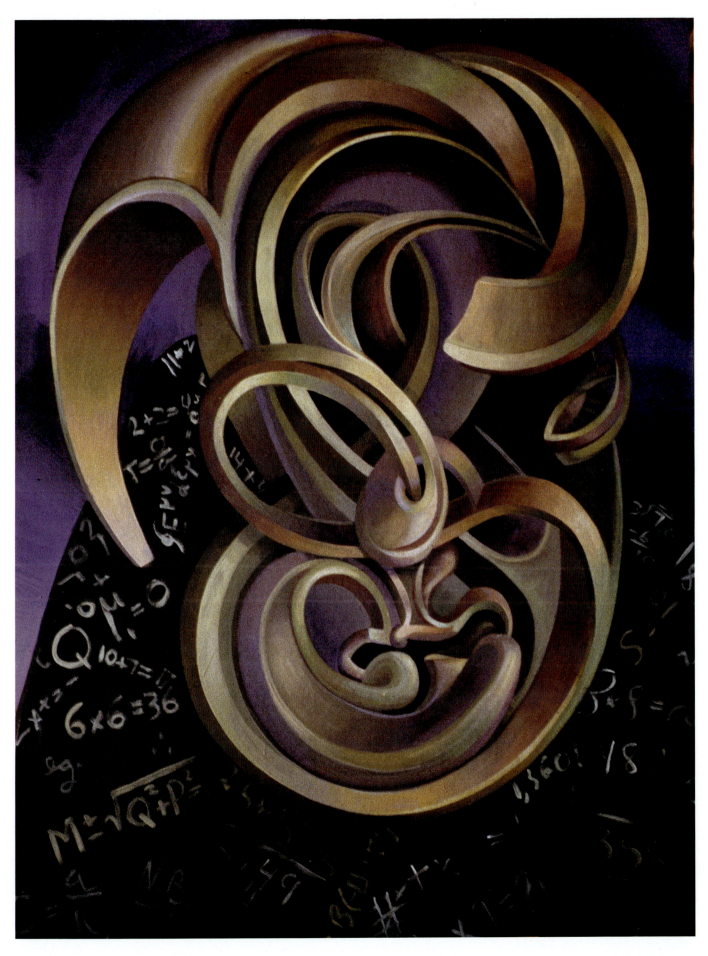

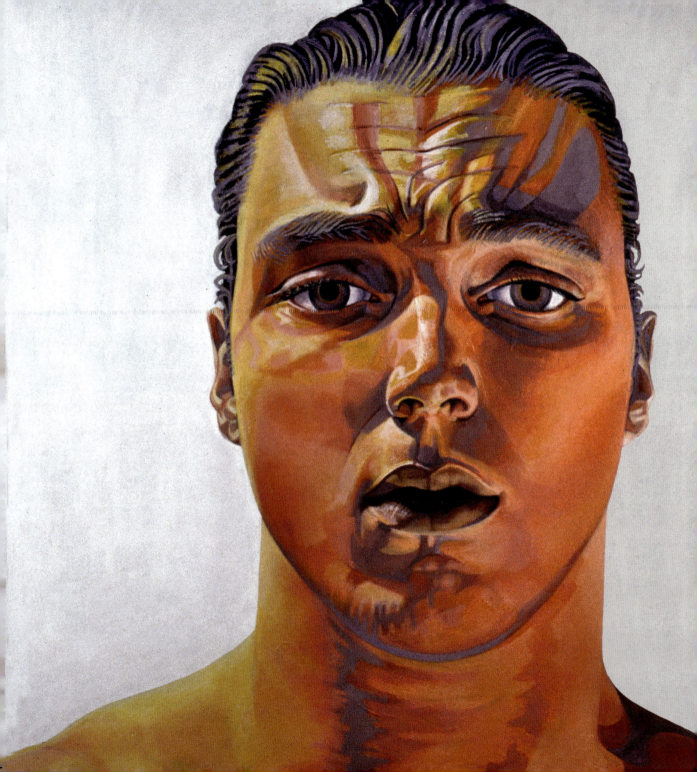

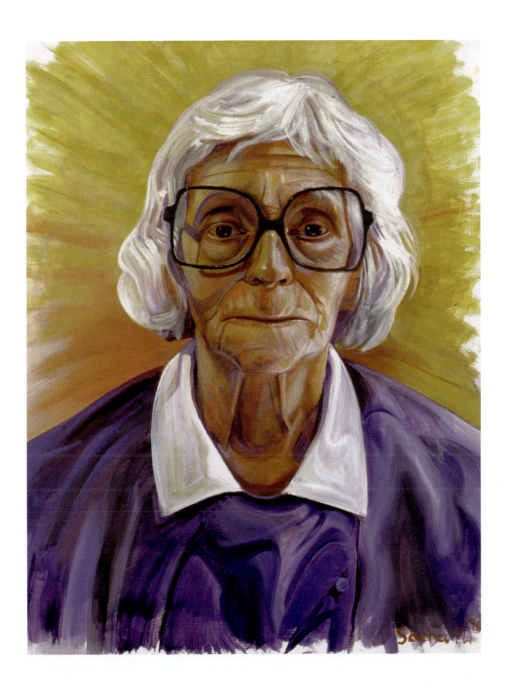

(above)
Grandma
1990, acrylic on canvas, 30x40"

(opposite)
Self-Portrait at 20
1986, acrylic on board, 30x30"

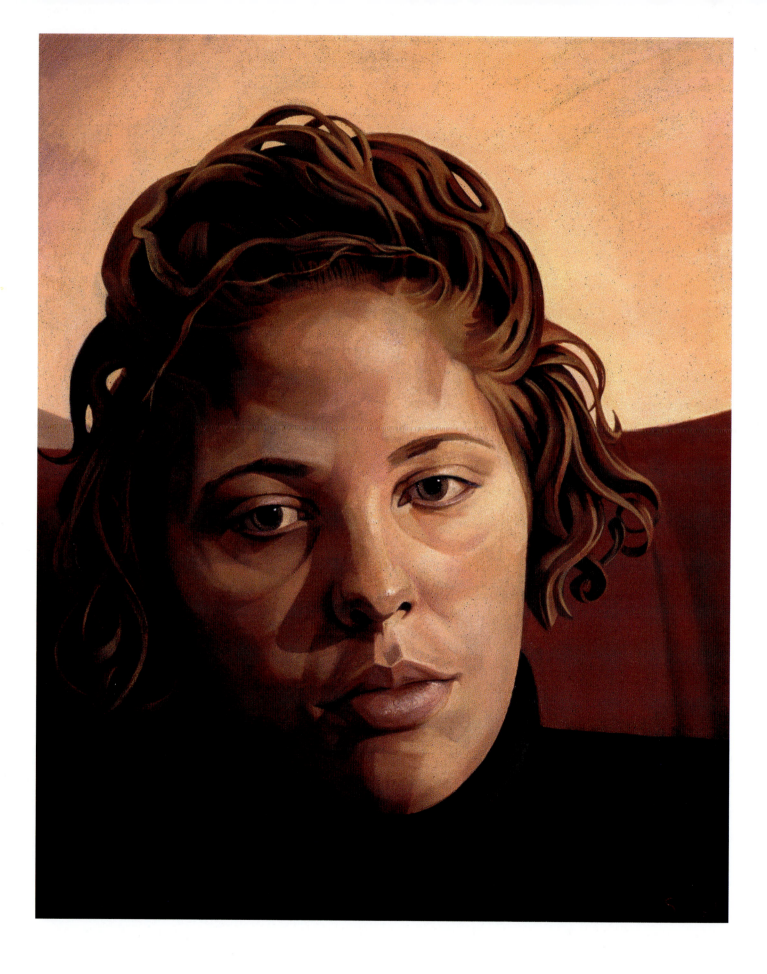

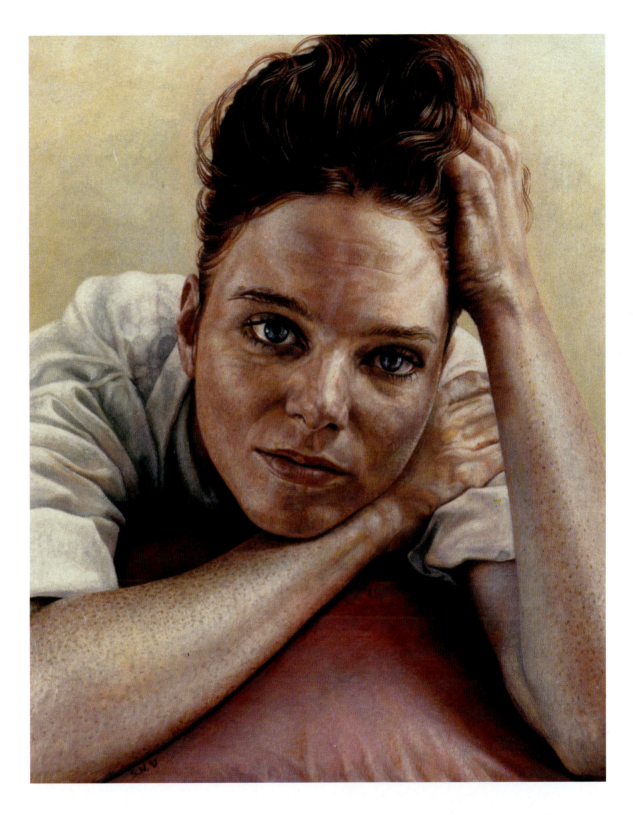

(above)
Tara
1992, acrylic on canvas, 20x24"

(opposite)
Katy
1989, acrylic on wood, 18x24"

'The artist shows his mastery of the person portrayed when he persuades us of the inseparability of the person's external appearance and internal reality.'

Donald Kuspit INTERFACES
Alexander Newley's Portraits

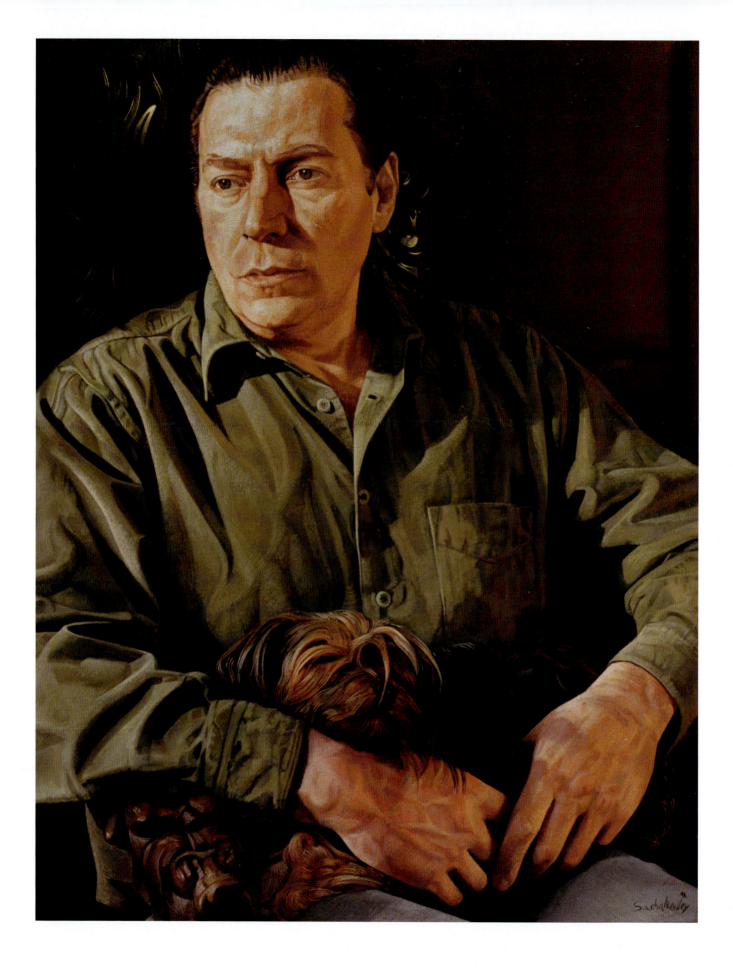

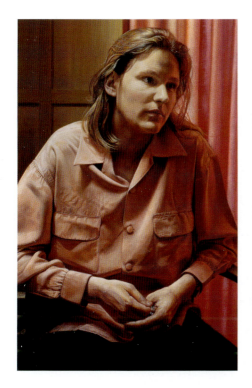 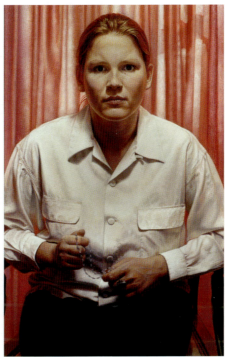 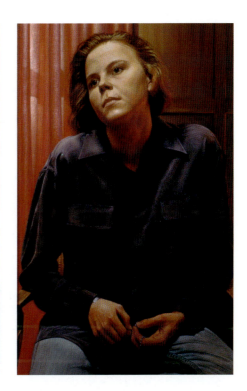

(above)
The Morstedt Sisters Triptych
1991, acrylic on canvas, 3x24x36"

(opposite)
Jeffrey Curtiss
1991, acrylic on canvas, 24x38"

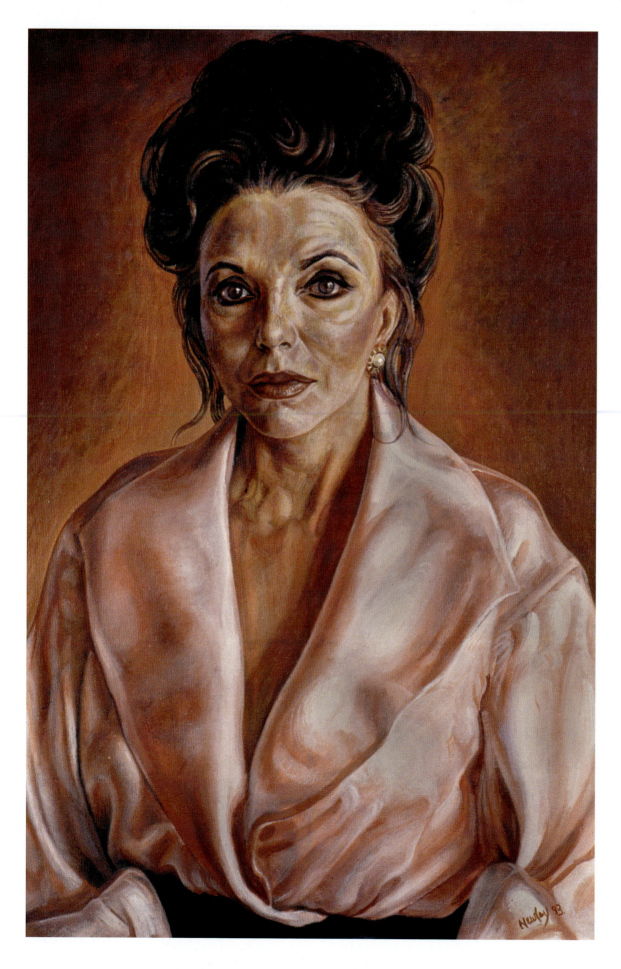

'When my son asked if he could paint a portrait of me in 1992, I jokingly said, "Don't make me look like one of Lucian Freud's models!" However, the result was a nod to Lucian and, good as it was, I wasn't terribly happy with it. When I asked him why he had made me look so tired, he replied, "You had a lot of problems at the time, and although it didn't show in your face, I could feel the tension, and that's what I painted." A few years later we made another painting, of me relaxing in my Los Angeles apartment. This time the result was a realistic depiction of me, which I love so much that it has a prime spot in my Los Angeles apartment. He keeps promising to do a new one, but hasn't yet!'

Dame Joan Collins OBE

The Artist's Mother
1992, acrylic on canvas, 24x36"

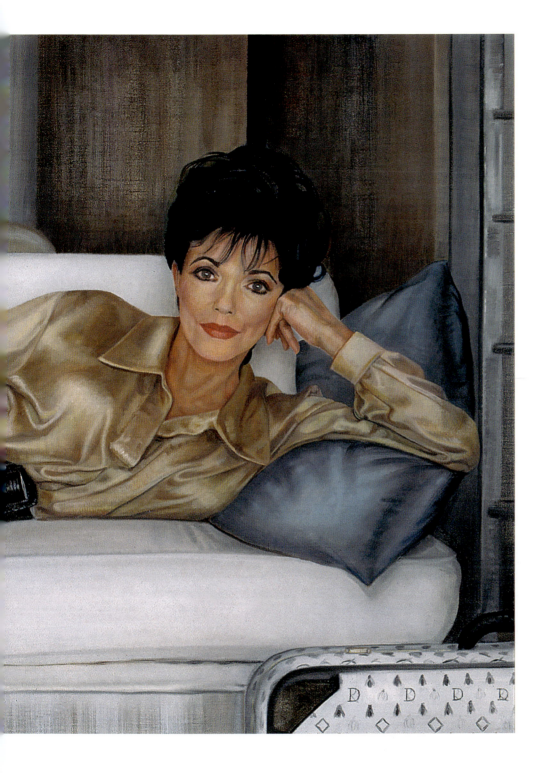

Joan Collins
1996, oil on canvas, 30x60"

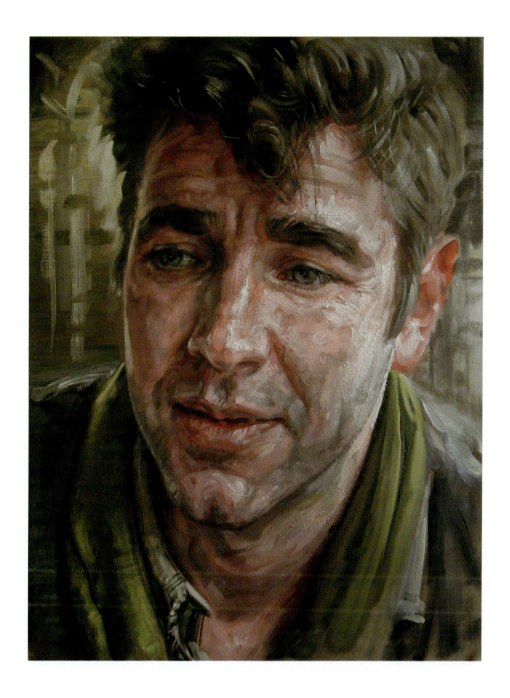

(opposite)
Ivan Massow
1993, oil on canvas, 24x36"

The youthful entrepreneur became a committed collector of my work. I was to paint him again, fifteen years later.

(above)
Ivan 2
2008, oil on canvas, 30x40"

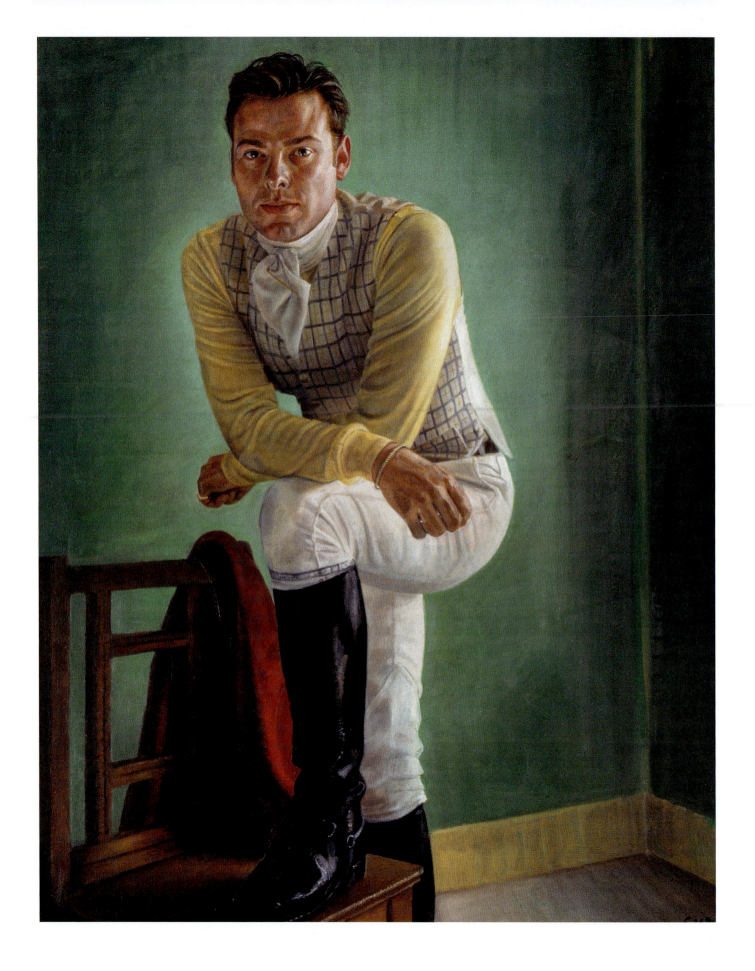

Henry Thornhill
1994, oil on canvas, 26x36"

A young art dealer in his hunting regalia. This was my first use of green in a substantial way – a difficult colour to get right in a picture. The pattern on the waistcoat was an infuriating pleasure. When painting the footwear I was inspired by the beautiful shiny boots in Sargent's portrait of *Lord Ribblesdale*.

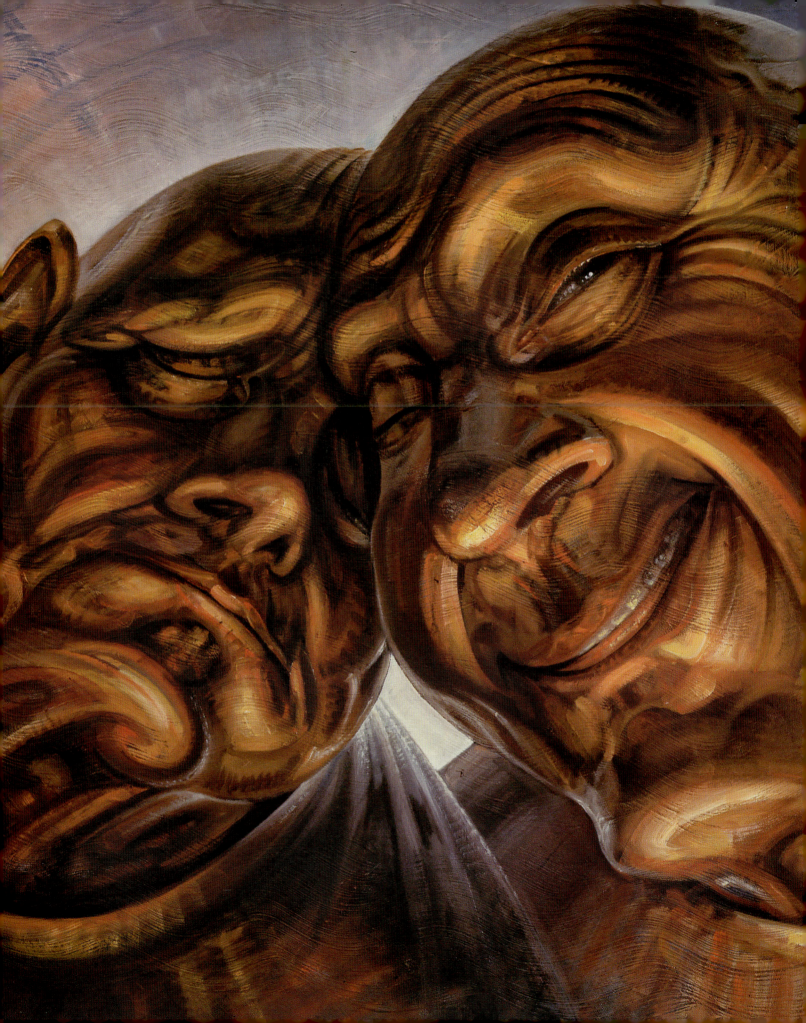

Chapter 2

Theatre

The must-see play of 1991 was *Shadowlands*, with Nigel Hawthorne in a stand-out performance as C.S. Lewis, for which he won a Tony Award. After a long and respectable career in television, Nigel was making his mark as a 'serious' actor. I had met him and his partner, Trevor Bentham, and they paid me the enormous compliment – then only an unknown artist of twenty-six – of agreeing to sit to me for a double portrait, **Nigel Hawthorne and Trevor Bentham (p. 41)**

I went down to see them in Hertfordshire and we set up to paint in the attic of their farmhouse, which was strongly lit by skylights.

This was the first portrait in which I was to tackle the phenomenon of relationship. How would I capture the ineffable energy between two people? I settled on a composition that created a contrast and tension between the two faces: the one looking dramatically at me, the other serenely in profile. This was my sense of their dynamic: the mercurial actor anchored by his more down-to-earth companion, a writer. On seeing the finished picture, Nigel remarked, 'I look like I've just been the recipient of some very bad news.' The picture hung in their country home thereafter.

It wasn't long afterwards that Nigel's growing reputation landed him the part of George III in Alan Bennett's play, *The Madness of George III*. I was well placed to suggest a portrait in character, and the picture that resulted was to be an important step forward for me: **Sir Nigel Hawthorne as George III (seated) (p. 42)**

I was invited to rehearsals to watch Nigel work under the direction of a young Nicholas Hytner. I had the added pleasure of seeing Alan Bennett himself, in trademark tweeds and raincoat, scribbling last minute re-writes.

Nigel was a revelation; a great English actor in full cry, aware that this was the role of a lifetime. I sat mesmerised as he flailed and howled in his ripped nightshirt, the doctors scuffling about him for control. This was my chance to sketch, photograph and observe him up close. At break time, we sat on the edge of the stage together, the afterglow of performance still upon him, and I captured that look of disorganised, inward reflection that was to be the touchstone for the portrait.

The painting came together during the run of the play at the National Theatre. I set up my easel backstage in a clearing between massive scenery flats so that Nigel could nip back between his

scenes, assume the portrait pose and then sprint back for his next cue. It was an odd way to create a portrait but thrilling to be so close to his live performance. I felt I couldn't waste such an opportunity, and suggested we start on a full-length portrait to complement the head-and-shoulders version. He liked the idea and urged me to really 'push the drama' by having the king restrained in some way. I came up with the gothic belt that straightjackets him, and Nigel responded with a wonderful knock-kneed, twisting pose. For the background I imagined the long, vertiginous staircase of his descent into madness. The steps crumble into ash as he lets out a silent, nightmarish scream, **Sir Nigel Hawthorne as George III (full-length) (p. 43)**.

Word of mouth soon had the top brass at the National Theatre appraising my two efforts and deciding that the head-and-shoulders should be used to promote the play during its US tour. A copy of it was given to all the cast; the original painting still hangs in Nigel's home. The full-length standing version was subsequently acquired by the V&A for its collection celebrating theatre.

Scrooge

Painting an actor in character is a double challenge: to capture the drama of the actor's imagined state as well as their likeness.

My father was playing Scrooge in a musical version of *A Christmas Carol*, and I wanted to commemorate his portrayal with a painting, **Portrait of Anthony Newley as Ebenezer Scrooge (p. 44)**. We met for our portrait session at the Lyric Theatre in London, where the show was enjoying a sold-out run after an exhaustive national tour. Onstage before curtain-up, my father, in full make-up and costume, spontaneously struck a series of wonderful poses for me, lent further dramatic effect by the intense stage lights.

Back in the studio, I mixed sawdust and sand into the underpainting to mimic the crusty nature of Scrooge's temperament. As I painted over this dried ground, the texture fought back and the tension between what the paint wanted to do and what *I* wanted it to do was exciting.

On seeing the finished picture, my father remarked, 'This just makes all those awful months touring the show worthwhile'.

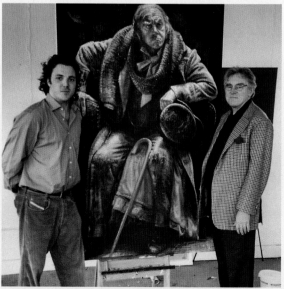

(left) With my Father and the Scrooge portrait
(far left) With Nigel at my 1994 exhibition

> With butterflies in my belly and a sketchpad under my arm, I knocked on the dressing-room door of Dame Judi Dench.

There were places where actual representation was difficult, so thick and broken was the surface. However, I relished the challenge of impacting Dickens's most intractable character on to this intractable surface.

The harsh light had given me no fill in the shadows, so I rectified this by implying the warm light of a fireplace, which cupped the shadowed forms and gave a sense of Scrooge's wintry hovel. On seeing the finished picture, my father remarked, 'This just makes all those awful months touring the show worthwhile.'

Such was the power of the photographic source material I had, that I decided to make a few additional studies on paper. **Scrooge Drawing 1**, **Scrooge Drawing 2**, **Scrooge Drawing 3 (all p. 45)**, show the effect of pastel used over textured paper. The fractal lines alternately suggest a venal character before enlightenment, and a loving, open-minded man after.

My father died in 1999, and shortly after his funeral I was given a series of photographs he had wanted taken and for which he had posed, showing the ravaging effects of cancer on his body. I was deeply moved and disturbed by these images and filed them away. Some years later, I was ready to work from them. As my main inspiration, I used an image that showed him with his arms raised to show the effects of abdominal scarring, and of a belly bloated with tumorous growth. This seemed to me an image of leave-taking, the open hand waving goodbye. I set the painting in a twilight zone between life and death. He sinks away from us, his face half immersed in an astral realm beyond. The expression is ambivalent, admonishing, austerely magical. I called it **Farewell to Prospero (p. 46)**, a fitting epitaph to a great entertainer.

Garrick pictures

In 2016, Kenneth Branagh invited me to portray the leading actors in his season of plays at the Garrick Theatre, giving me exclusive backstage access.

With butterflies in my belly and a sketchpad under my arm, I knocked on the dressing room

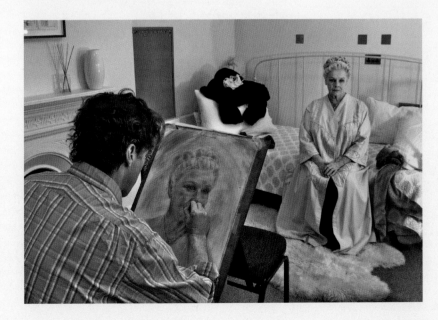

Drawing Dame Judi

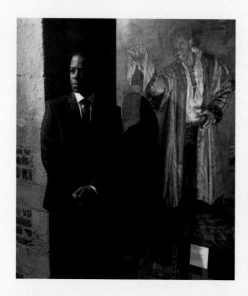

The St Martins Gala. (left) Sir Derek Jacobi and Dame Judi Dench with my portrait of Sir Derek as Malvolio; (far left) Adrian Lester with his full-length portrait.

door of Dame Judi Dench. She immediately put me at ease with her graciousness, impish wit and willingness to accommodate. I made a drawing of her in conté and pencil, **Drawing of Dame Judi Dench (p. 48)**, and then returned the following night to start a full-length painting. Judi was playing Paulina in Shakespeare's *A Winter's Tale*, the no-nonsense truth-teller who calls out Leontes on his delusional jealousy. Halfway through the play, the Bard has the Figure of Time walk on to relate the incidences of the past seventeen years. Traditionally a male role, Branagh had the inspired idea to cast Judi in the part.

She was in a druid's costume when I returned, which inspired my vision of her as Old Mother Time emerging from the primordial mists. I asked her to recreate the emotional state of her portrayal, and she let fall upon me an epic gaze and towering demeanour that was transfixing. She had doubled in size; I was beholding Eternity itself. **Portrait of Dame Judi Dench as The Figure of Time (p. 49)**

My next portrait subject was **Sir Derek Jacobi as Mercutio (p. 50)**, the dapper rogue and best friend of Romeo. 'Come in,' came the gently sonorous reply to my knock. I entered his dressing room and found him reading the *Evening Standard* in his undershorts. He duly folded the paper, put on pin-striped trousers and presented himself for work. I asked him to recite his lines and go through a fluid succession of poses as I sketched and snapped photos. I switched off the lights and used an intense, hand-held Halogen to light him from below and above. He dreamily recited his lines, abandoned to the shadow.

The first portrait gives us the quizzical Mercutio, all dandyish hauteur and wild surmise. In the second, more experimental

> 'I just remember how wonderfully restful it was sitting for Alexander and how remarkably quick he was! I think of him every day because I have a wonderful portrait he painted of Ken Branagh in my house, so I am reminded of his incredible work daily.'
>
> **Dame Judi Dench**

work, I pushed the palette and modelling to capture a complex man undone by his relentless need to take liberties, spouting witticisms even as he dies by the sword: 'Ask for me tomorrow, and you shall find me a grave man.' **Portrait of Sir Derek Jacobi as Mercutio (p. 51)**

The third play in Branagh's season was *Red Velvet*, starring Adrian Lester as real-life actor Ira Alridge, the first black actor to play Othello – a novel event that caused uproar in the bigoted milieu of nineteenth-century London. The play includes a dramatisation of the famous handkerchief scene in which Othello produces Desdemona's lost kerchief and accuses her of infidelity. Watching Lester's performance, I was electrified by his prowling, tigerish jealousy that spun Desdemona in a vicious ballet of desire and disgust. He wore a golden silk robe that flashed in the footlights as he whirled. I knew I had to use it in the portrait.

I was given access to him after this scene and waited in the dressing room while his onstage voice boomed over the Tannoy. The applause sounded and I braced for his entrance. He arrived in a whirlwind of unspent emotion. I asked him to raise the handkerchief and recite his lines. Then he retraced the physical moments of the scene: crouching, ready to spring, accusatory. It was overwhelming to be so close to a living Othello. Then he struck a wonderful full-length pose, legs rooted, the robe flared open as his arm travels forth with the offending article. I knew this was the painting. **Adrian Lester as Ira Aldridge as Othello (p. 52)**

More contemporary in feeling is the full frontal, **Adrian Lester as Ira Aldridge as Othello (close-up) (p. 53)**, with an overlay of Ira's justified anger at an audience hostile to his art.

As the character of Leontes, **Kenneth Branagh (p. 54)** goes through a major arc in *A Winter's Tale*: from a jealous blowhard of a king to a guilty, frozen soul. Act 2 opens with him as the older king, wracked by despair at the deaths of his wife and son, which he has caused. This is the Leontes I found backstage – a total contrast to the hot state in which I encountered Adrian a few days before. It required me to use a softer and more tender approach in the painting, with sable brushes and a palette of blues, blacks and purplish greys. In the finished work it's as if we've met in a dream and he's pushed past me – a granite figure, dusted with frost, sleepwalking through his despair.

When finished, all the Garrick Theatre portraits were auctioned by Lord Jeffrey Archer at a gala benefiting The Connection, the homeless charity of St Martin-in-the-Fields.

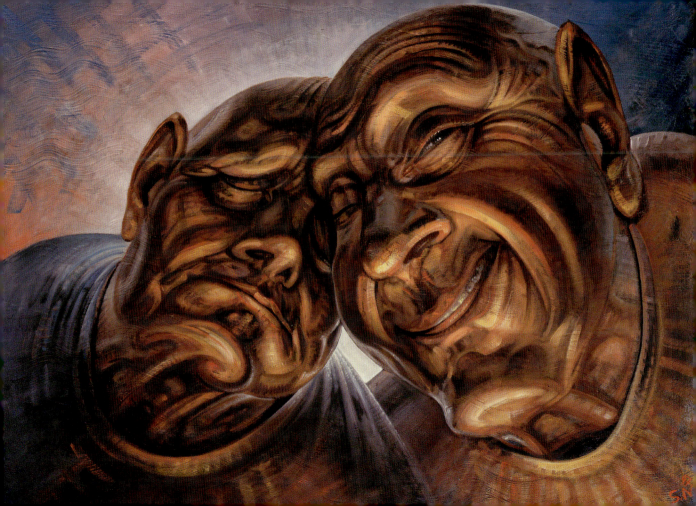

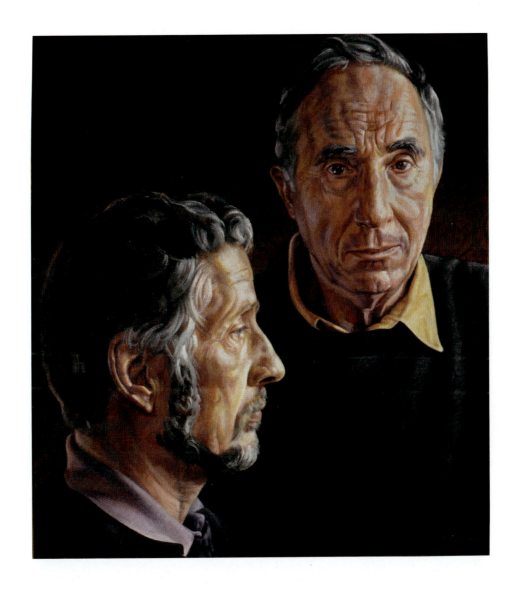

(opposite)
Tragedy and Comedy
1997, oil on canvas, 30x40"

The two faces of drama imagined as conjoined twins attached at the head.

(above)
Nigel Hawthorne and Trevor Bentham
1993, acrylic on canvas, 24x24"

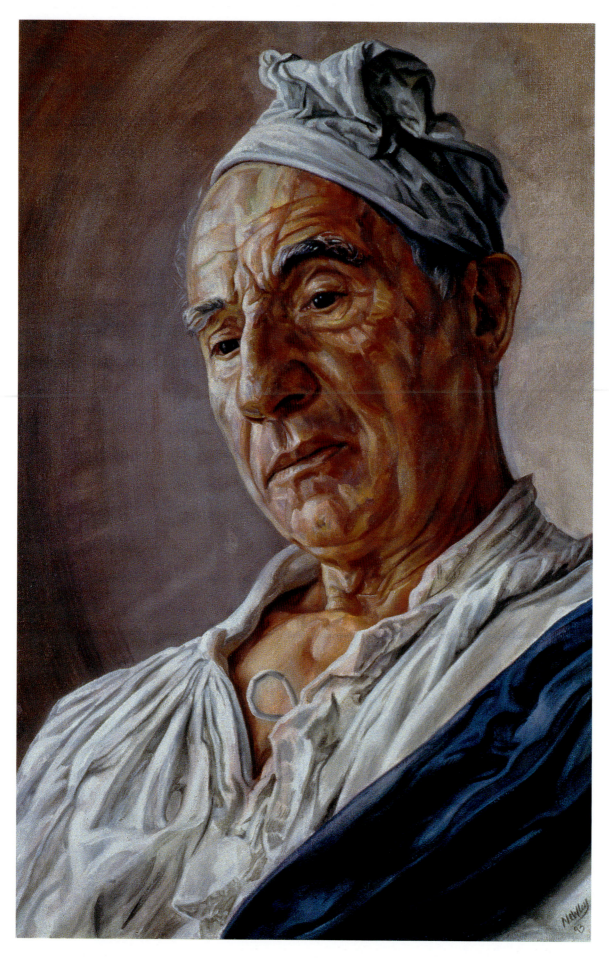

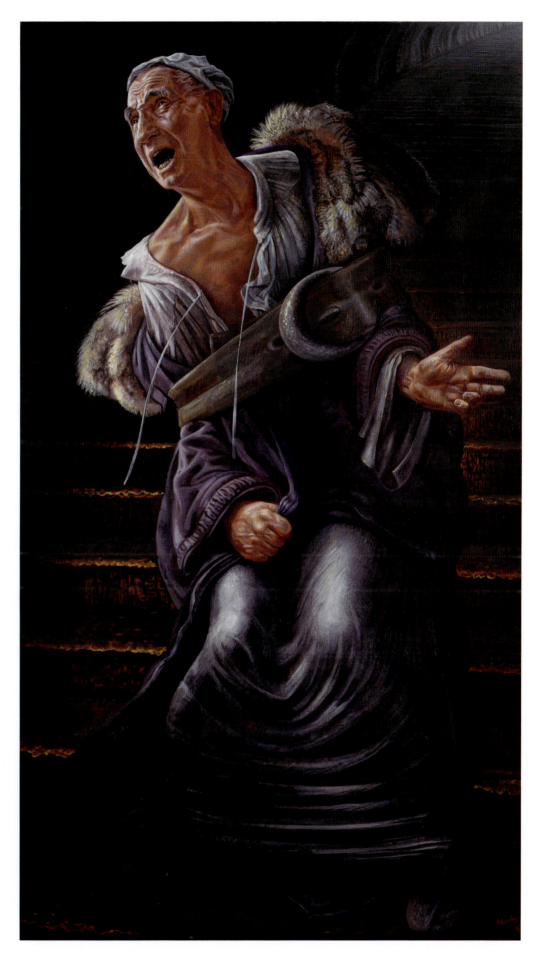

(opposite)
Sir Nigel Hawthorne as George III (seated)
1993, oil on canvas, 24x36"

(right)
Sir Nigel Hawthorne as George III (standing)
1993, acrylic on canvas, 30x60"

Permanent collection, Victoria and Albert Museum

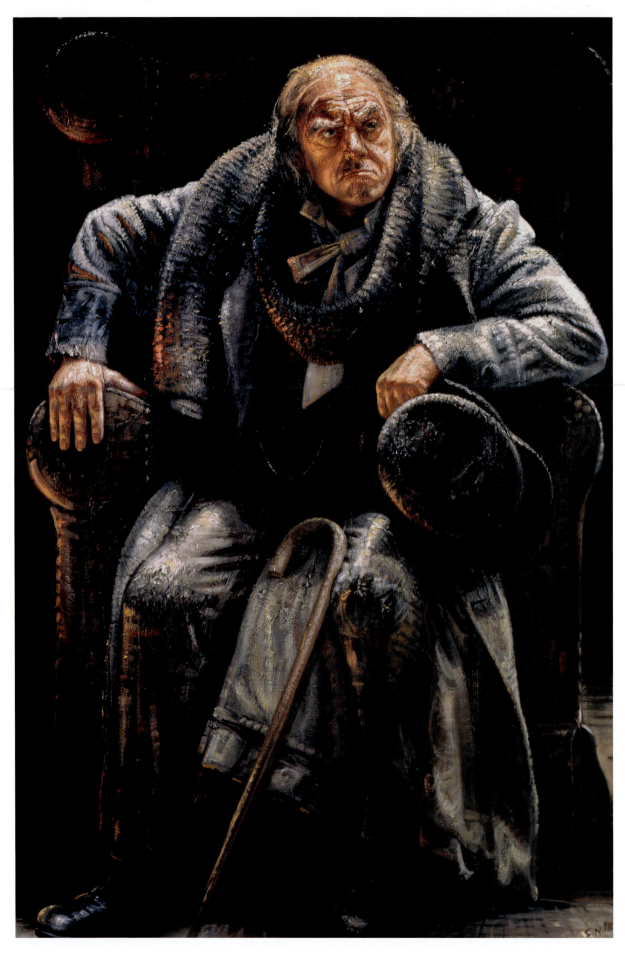

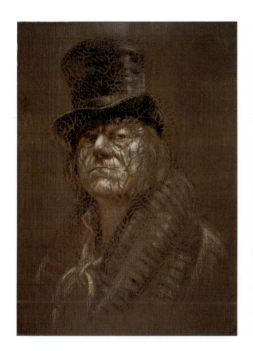 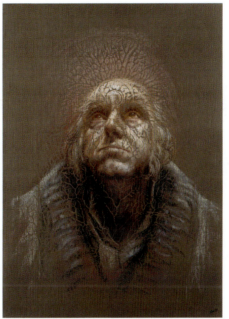 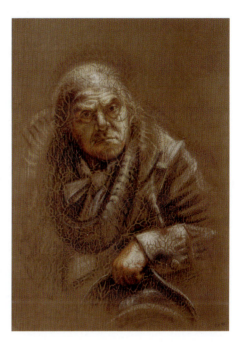

(opposite)
Portrait of Anthony Newley as Ebenezer Scrooge
1998, oil on canvas, 48x72"

(above left)
Scrooge Drawing 1
1999, pastel on paper, 16x20"

(above centre)
Scrooge Drawing 2
1999, pastel on paper, 16x20"

(above right)
Scrooge Drawing 3
1999, pastel on paper, 16x20"

'Newley is a master of "facial affect display", which suggests that he is a good impersonator – a first-rate actor.'

Donald Kuspit

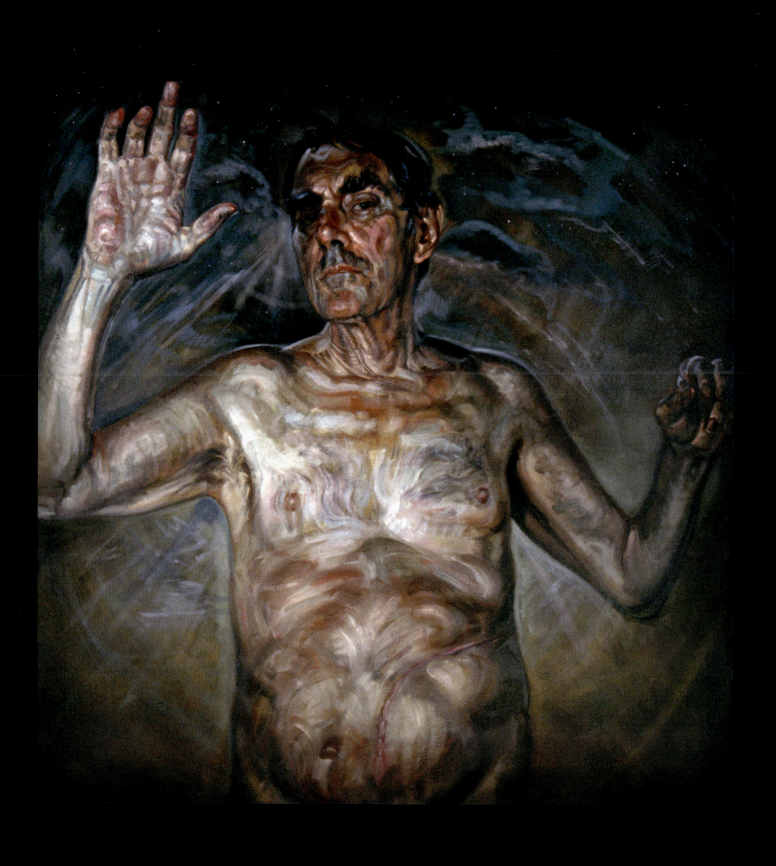

I set the painting in a twilight zone between life and death. He sinks away from us, his face half immersed in an astral realm beyond. The expression is ambivalent, admonishing, austerely magical. I called it *Farewell to Prospero*, a fitting epitaph to a great entertainer.

Farewell To Prospero
2005, oil on canvas, 60x60"

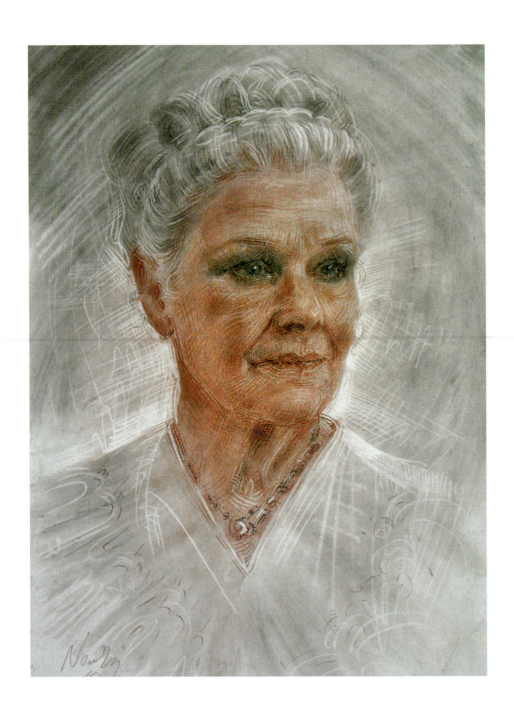

(above)
Drawing of Dame Judi Dench
2016, conté and pastel on paper, 16x20"

(opposite)
Dame Judi Dench as the Figure of Time
2017, oil on canvas, 30x40"

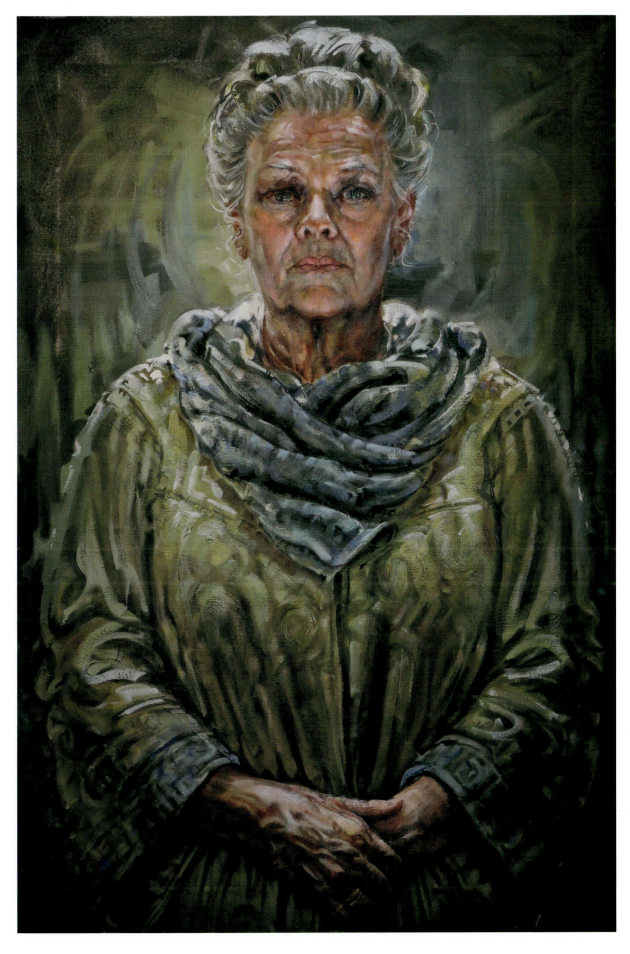

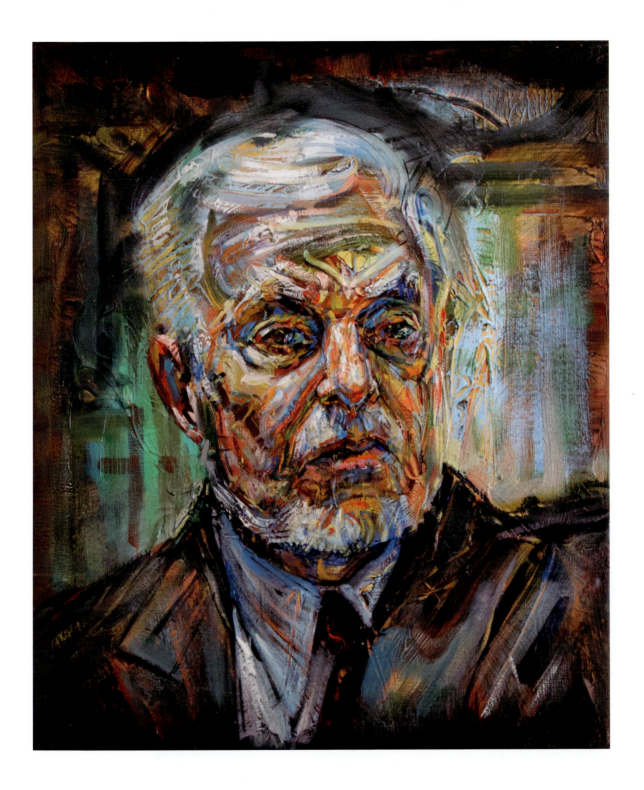

(above)
Portrait of Sir Derek Jacobi as Mercutio
2019, oil and acrylic on canvas, 20x20"

(opposite)
Pastel portrait of Sir Derek Jacobi as Mercutio
2017, pastel on paper, 20x24"

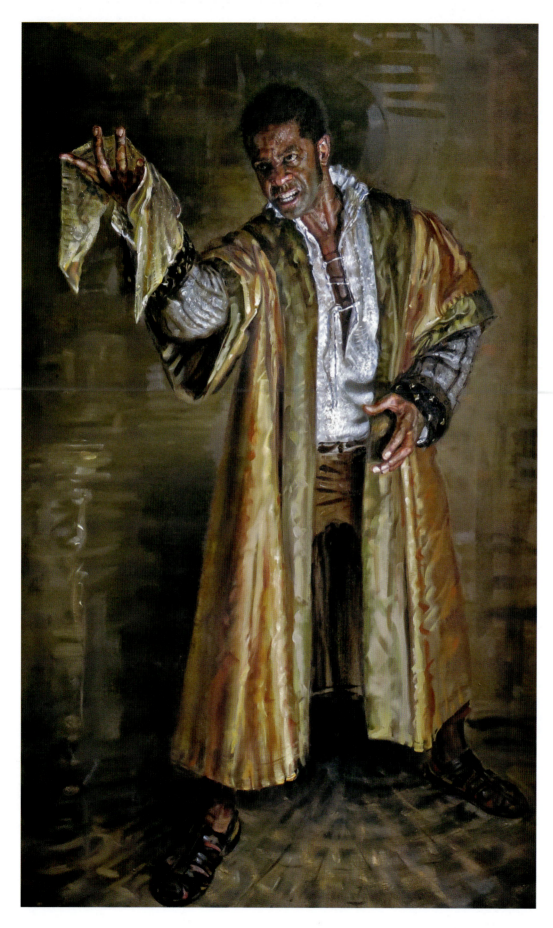

(left)
Adrian Lester as Ira Aldrige as Othello (full-length)
2017, oil on canvas, 36x56"

(opposite)
Adrian Lester as Ira Aldridge as Othello (close-up)
2017, oil on canvas, 16x24"

'I can remember Alex coming to the dressing room to make studies for the portrait. I had just come off stage after one of Othello's pivotal scenes, I was breathless, sweating, my adrenaline was pumping. I look at the painting now and can see he caught all of those colours and emotions in the body of the picture. So much so that when I look at it, the moment comes back to me with startling clarity. I hardly recognise myself.'
Adrian Lester

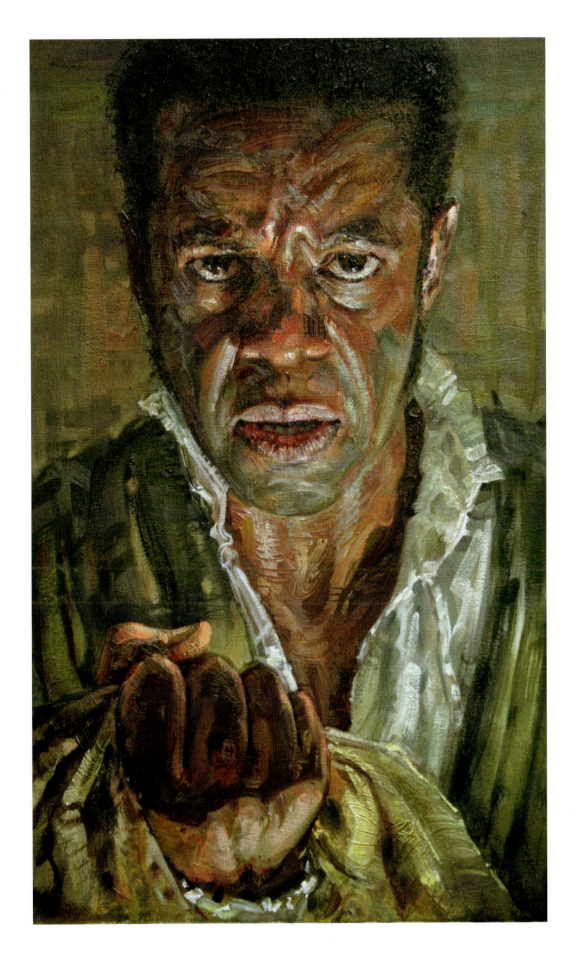

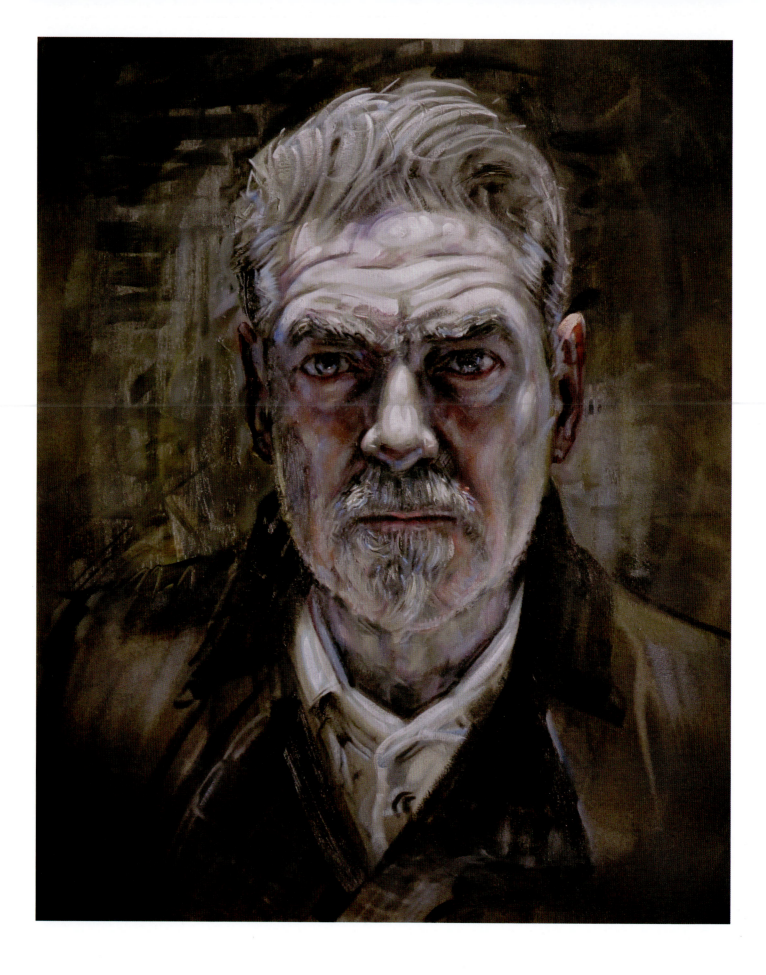

(opposite)
Sir Kenneth Branagh as Old Leontes
2017, oil on canvas, 20x26"

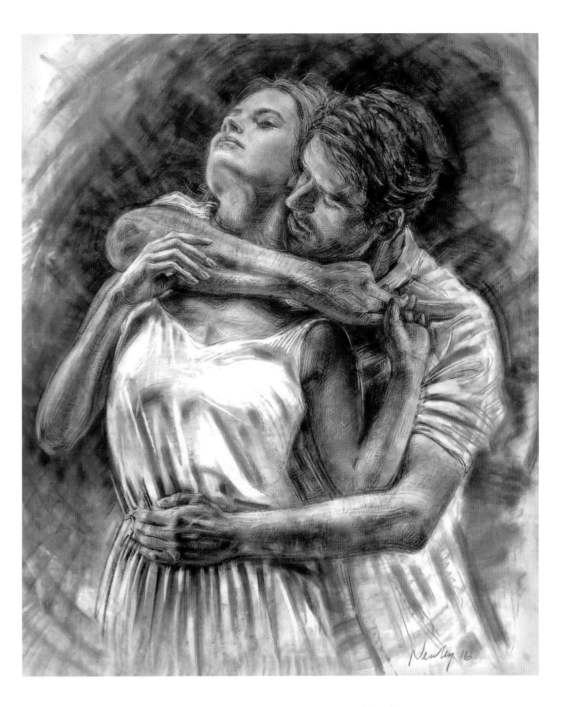

(above)
Lily James and Richard Madden as Romeo and Juliet
2017, conté and pastel on paper, 40x40"

An ardent embrace from *Romeo and Juliet*, as enacted by Lily James and Richard Madden. The whole spectrum of love is here: from lust and clinging desire to a transcendental yearning for divine union. I treated it simply, with charcoal and conté crayon on paper, rubbing down to the whiteness to create my highlights. I wanted to achieve a large-scale drawing with the impact of a painting.

THEATRE 55

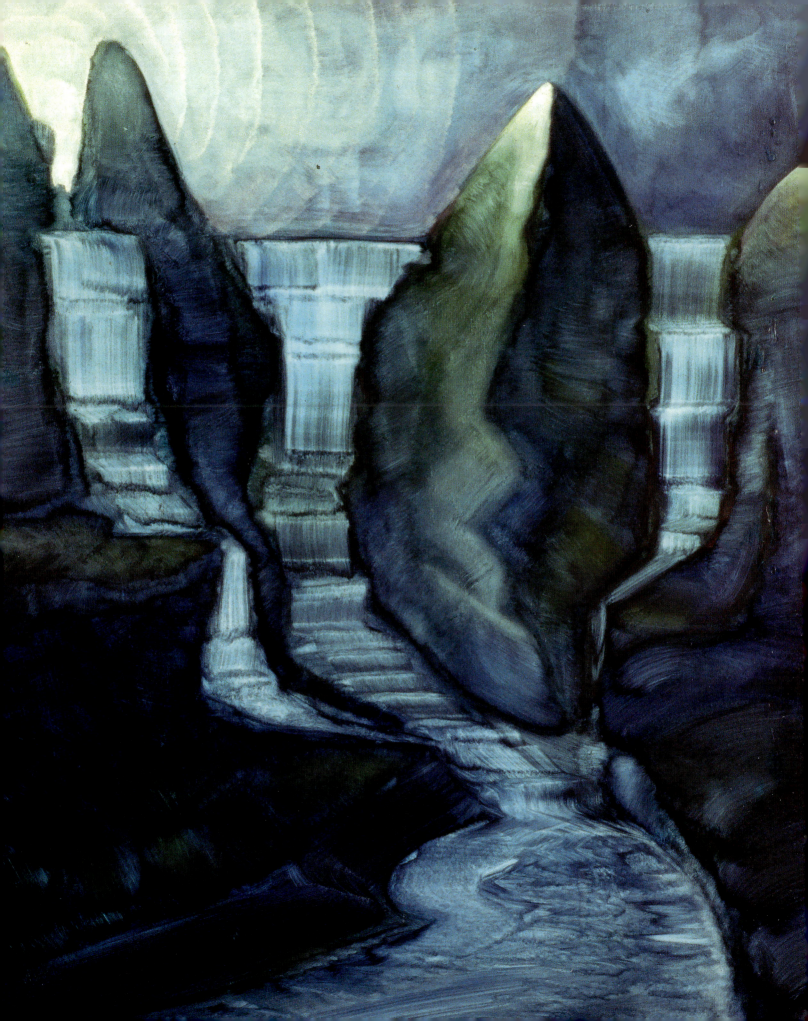

Chapter 3

Inner Landscape

One of the last pictures I painted whilst living in Lyme Regis in the late '80s was **Seascape (p. 59)**. With its beckoning clouds and oil-black sea gridded with light, it tempts the viewer to descend and travel a surreal coastline. It's a dream, lit by an inner sun; a similar realm to which Dante descends when, in the middle of Life's journey, he finds that the path through the upper world goes nowhere.

My inner sun has always been there, irresistibly calling. The landscape beneath it is the difficulty, the obstacle course through which I struggle to reach the light, and transcend.

Often, when the light gets no closer but only sinks tantalisingly below the curving earth, I am apt to lose hope and conclude that my spiritual aspirations are delusional. Then I turn my attention to another kind of painting, focusing on the near-at-hand and material things. Inevitably, I always return to the inner terrain and the distant, calling star. It's how I reorientate myself in a frustrating world.

But I have a strange dilemma: I am drawn to the light but know it will annihilate me. I am only human, more Icarus than risen Christ. If only I could lose my phoney, egoic wings and my false self. But I fear that without them, I am nothing. This is the pivotal fear in the creative process, whereby losing yourself is finding yourself again.

Picasso said: 'I do not seek, I find.' Which is another way of saying that he is always lost and always finding himself anew. Instead of fearing this state of unknowing, he embraces it as an invitation to limitlessness. In knowing nothing, we can know all. This is the nihilism of creativity, leading many artists to despair and some to divine union.

Over time, my inner landscapes have made a map of my progress. **Carnal Landscape (p. 60)** is the next 'postcard' from my inner journey after **Seascape**. The distant light is blocked by a globe-like edifice evocative of a microbe or space capsule. This is a subconscious world of forms that hearkens to sexuality and desire. On the left, soaring and descending landforms terminate as phalluses, and the jarring vision in the foreground is of a tree, threading its root into the ground like a junkie seeking a vein. The broken bridge to the abandoned town that clings like a fossil to the far escarpment is a comment about my own brokenness. Realising this, I strip away the bark from the foreground tree to show a flayed interior. A tortuous landscape certainly; and there is the dialogue

between hot and cold light that I would use repeatedly in my paintings to represent the contrary call of higher and lower powers.

Checking in with myself two years later, I found a very different landscape. **Melting Sea (p. 62)** takes the viewer into the freezer: an arctic waste, with only a distant horizon tinged with warmth and verdure. The promise of salvation seems to have receded. The extra-long, rectangular canvas gives a panoramic feeling of stretched space. The foreground began as a field of stones. I didn't want to create the upheaval and drama of mountain and valleys, but it came anyway: the rocks unaccountably began to enlarge and show themselves as transparent. I immediately realised this was an icefield.

On a second canvas of the same size and dimension I tried again to create an unwavering horizon, but three rock formations arose in the foreground, middle ground and background. **Landscape with Three Stone Heads (p. 62)** references the monumental heads of Easter Island. It's also alive with the wonder I felt as a boy when I visited the Grand Canyon. The masculine presence in the rocks gives courage and confidence for the crossing ahead.

Waterfall (p. 61) is the third piece in the series and breaks the rigid letterbox format by going almost square. When I stroked a wide brush from top to bottom, the striations it created suggested falling water. I went with it, carefully plying the brush to extend the watercourse. The paint is very thinly applied and no white has been used, except in the top left-hand corner. The illusion of frothy, falling water is achieved by the white of the blank canvas showing through the glaze. I echoed the watery effect in the sky, as if the sun were tapping out a metered current in space. All is water and mossy coolness.

These landscapes featured in my first solo exhibition in 1994, along with a number of watercolours. Perhaps the prevalence of water in the landscapes prompted my use of this medium – and the cool blue – in many of these figurative works **(pp. 66–69)**.

Seascape
1988, acrylic on canvas, 20x26"

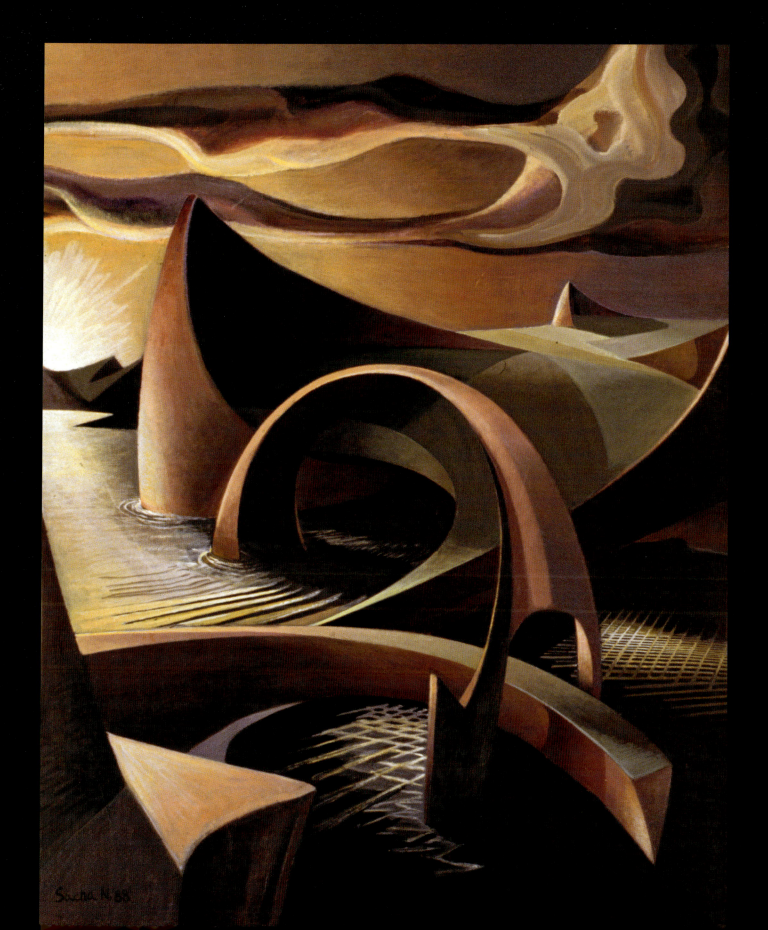

The jarring vision in the foreground is of a tree, threading its root into the ground like a junky seeking a vein.

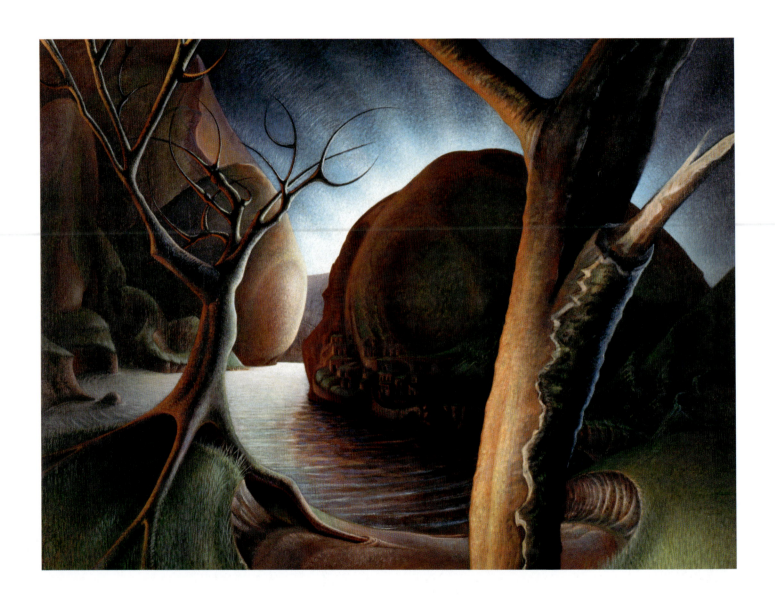

Carnal Landscape
1992, acrylic on canvas, 36x48"

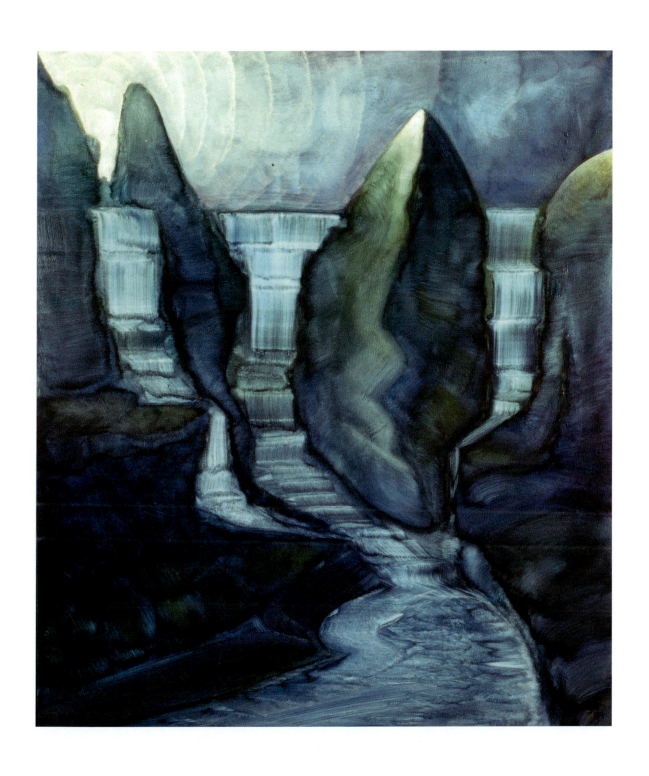

Waterfall
1994, oil on canvas, 40x42"

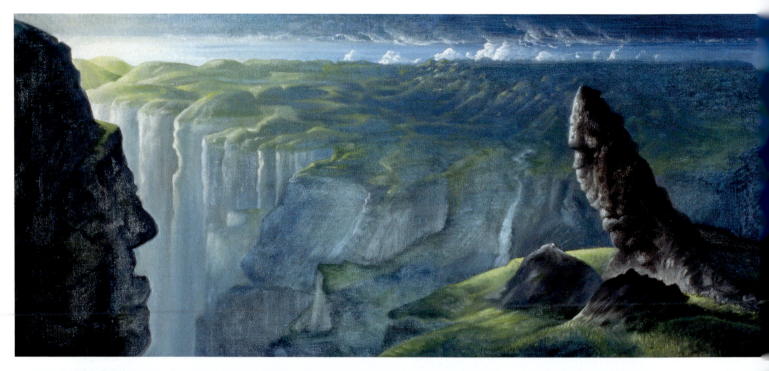
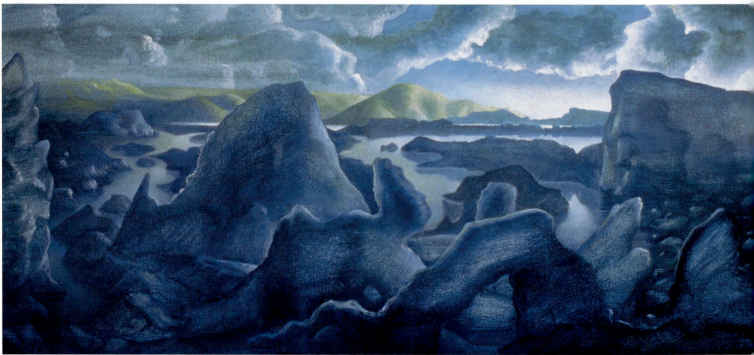

(above)
Landscape with Three Stone Heads
1994, oil on canvas, 20x60"

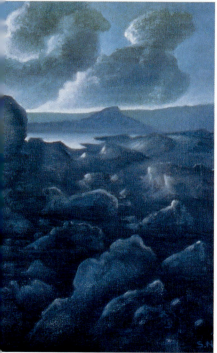

(below)
Melting Sea
1994, oil on canvas, 20x60"

INNER LANDSCAPE

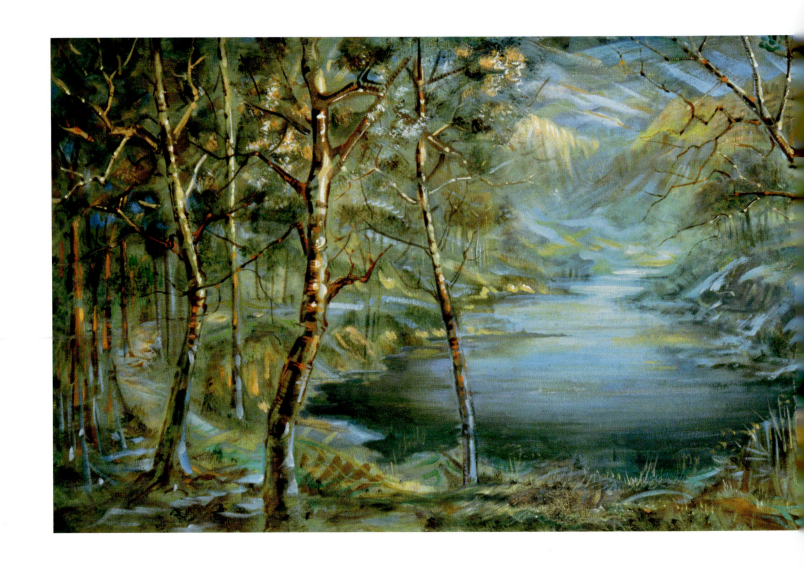

The Lake
2005, oil on canvas, 22x48"

A vision of serenity and sustenance before a mountainous journey.

Tree
1994, ink on paper, 12x16"

INNER LANDSCAPE

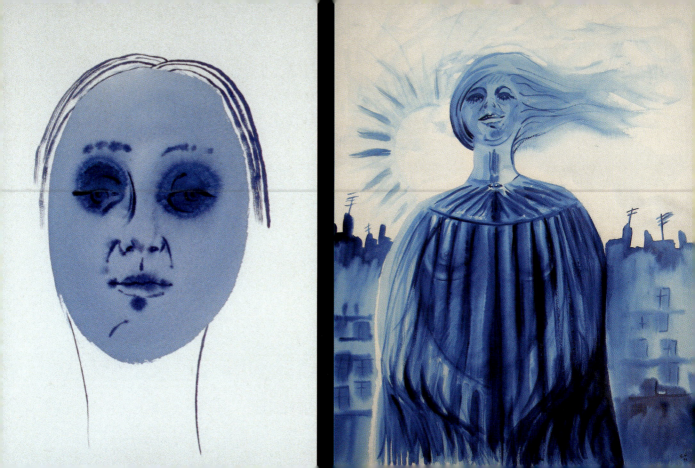

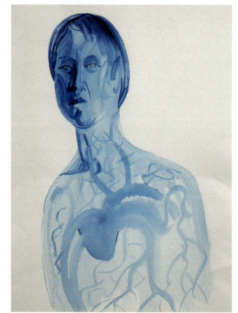

(top left)
Blue Rage
1994, watercolour on paper, 8.5x11"

(top right)
Strong Man
1994, watercolour, 8.5x11"

(bottom left)
Blue Weeping Woman
1994, watercolour, 8.5x11"

(bottom right)
Transparent Man
1994, watercolour, 16x20"

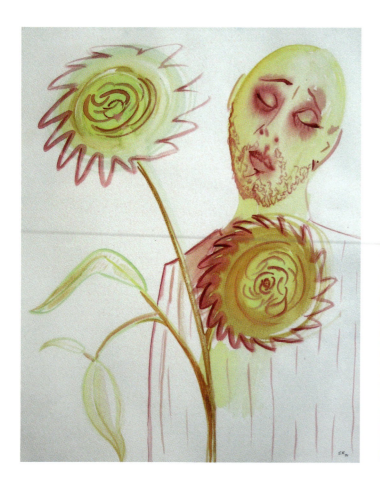 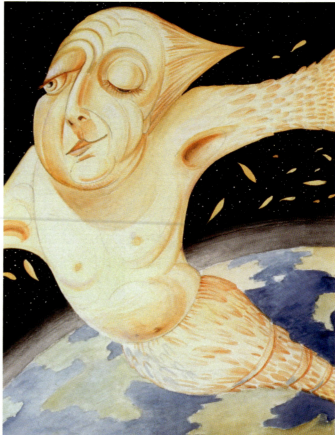

(above left)
Poet With Flowers
1994, watercolour, 16x20"

(above right)
Icarus watercolour
1994, watercolour, 12x16"

(opposite)
Man in a White Suit
1994, pencil on paper, 16x20"

The armchair with horns and a joker's bells; the dapper wardrobe and cigarette; the weary, yet amused look of superiority – all these give us a portrait of the Devil in repose.

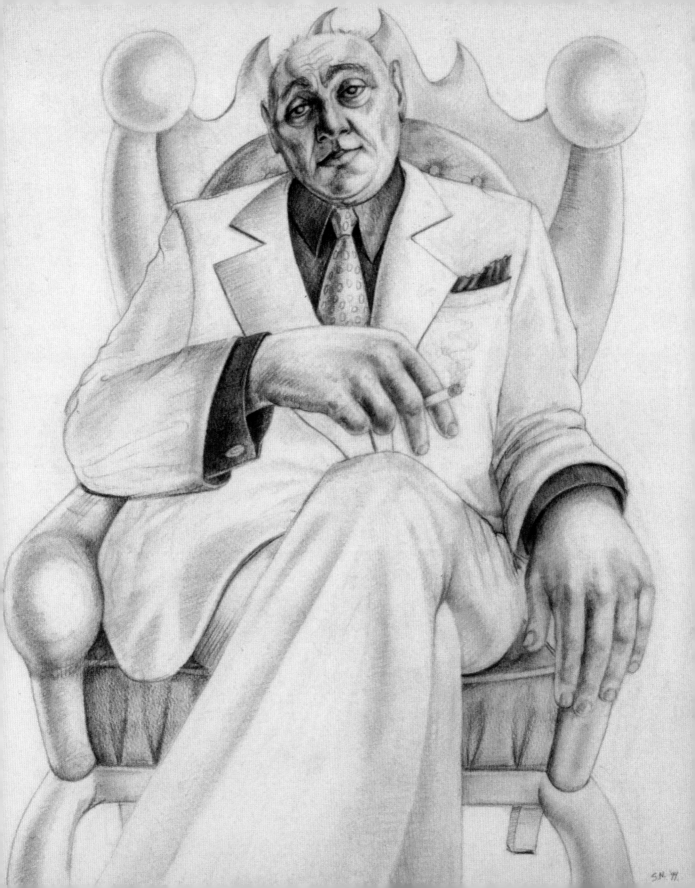

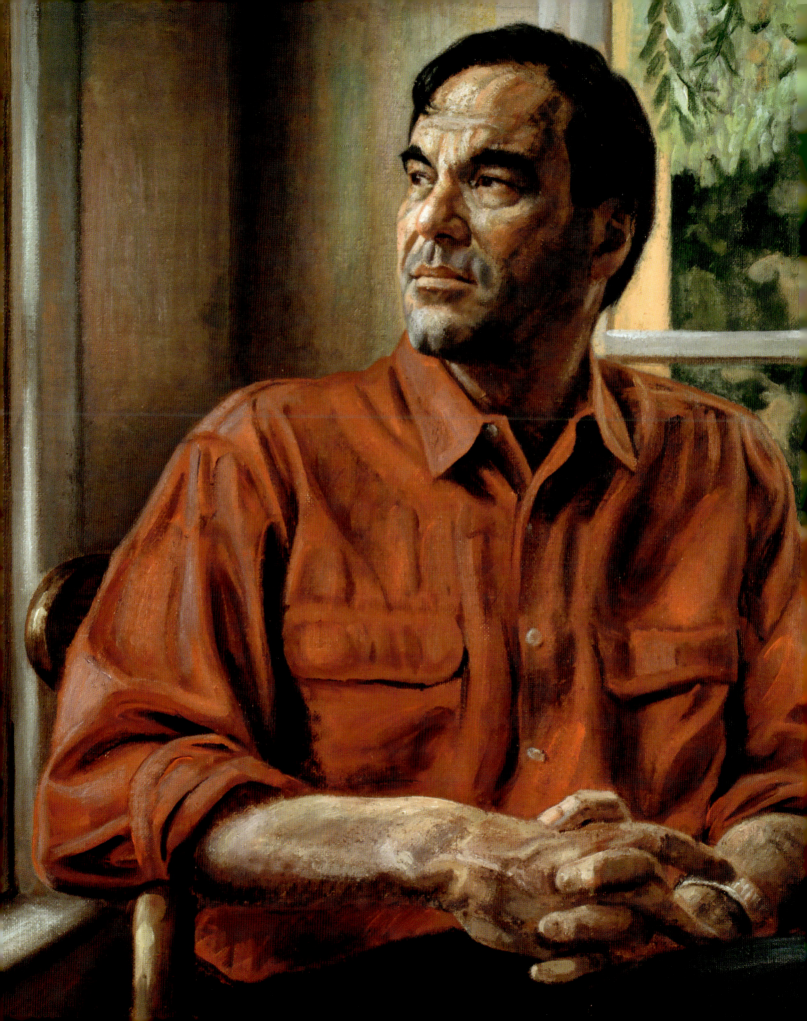

Chapter 4

Hollywood Portraits

My desire to paint **Gore Vidal (p. 80)** was prompted not by an awareness of his work but by a sort of seismic charisma signal that he sent across space. Oscar Wilde, Noël Coward and Truman Capote were all gone, but in Gore I could have access to a living example of their kind.

I sent an introductory letter with some slides, and was astonished by a prompt, handwritten reply. He agreed to sit, but I must come to his villa in Italy – for which he gave me a ten-day window in July.

I landed in Naples and took a long taxi ride, passing Pompeii, to Ravello, an ancient mountain town on the Amalfi Coast. At the hotel, a message from Gore: come to the villa for drinks at 7.00. I struck out through the labyrinthine streets and promptly got lost. Asking various natives – shopgirls, priests, a man nailing shoes – I was assured that 'Maestro Vidale' was just around the next corner. It was almost dark when I hurried through a lemon orchard and found the door of the villa ajar.

I went inside and called out hello. 'In here,' came the reply. I went through into a vaulted library and saw him reaching up to replace a book in the shelves. He turned and regarded me for a moment. When he spoke, I was reminded of Queen Victoria, and when he moved of a magnificent, barnacled fish, slowly drifting through the coral reef of his library.

He told me he had just completed his second book of memoirs, *Palimpsest* – the slab of manuscript lay neatly next to the Olivetti – and that he was in a mood to celebrate. Hence the glass of whiskey in his hand, that never left it, except for a refill. On closer inspection, I saw that the crystal had several tide marks of scum around it; he had no doubt been transfusing from this glass for days. He confessed that he was in the middle of a binge, had put on weight and that this was not the ideal time for a portrait. At which point we were joined by his long-standing companion, Howard Austen, whose leery grin and alcohol-scorched face slightly startled me.

We went on to the balcony to watch the sun sinking over the Bay of Salerno and I did my best to keep up with the flow of their conversation. I realised that I had wandered back in time to the hard-drinking days of the '50s and had better pace myself; or with my boyish face and brushes at the ready, I would be the young, strait-laced lamb to slaughter. Howard was aggressively entertaining, his wit spiked with bile and bitterness after a life

shadowing the Great Man. Drunken invective blasted between them worthy of *Who's Afraid of Virginia Woolf?* I was soon drawn into the spirit of their exchanges, feeling the thrilling demise of my innocence.

Howard mercifully said he was hungry, and we made our way to their favourite taverna. The owner greeted us with due pomp and ceremony, and we took their usual table. The place was empty, but for a huddle of English tourists in the corner, drinking their soup. 'I know they're English because they're quiet and fucking boring,' said Howard, a little too loudly. And for the next ninety minutes this self-effacing table was our captive audience. Howard clearly relished being outrageous and littering his arias with obscenity. Gore leaned in and said that the local mafia boss had just entered. The fat, baby-faced man tipped his hat our way and sat down with two thugs. 'Son of a bitch,' whispered Gore. 'He wants my house and is probably willing to kill me for it.'

The confession added to the sense of danger I was enjoying. Howard ordered another vodka tonic, but the bartender refused. His insistent, foul barking brought the lady from the corner table. Flushed to her English cheeks with indignation, she delivered a perfectly admirable, well-phrased rebuke to 'our disgusting display'. And there was silence. Howard and Gore looked penitent; I imagined an apology would be forthcoming. Then Howard threw his napkin to the floor and rose, trembling. Poor lady ...

We stumbled out an hour later, the English having left long before, sullen and defeated, as Gore called after them: 'Why don't you go back to fucking Sidcup?!' He wasn't to know that one of them was a journalist and that the following day he would feature 'drunk and disorderly' in the pages of the *Telegraph*.

We stood in the dark, deserted square. I was desperate for my bed but Gore clapped his hands and several lithesome youths materialised out of the darkness. He sat down on the steps of an old church and one of them dutifully leapt into his lap, to be stroked and fawned over. Howard was confessing his admiration for my father's songs and launched into a toe-curling rendition of *What Kind of Fool Am I?*, his neck pulsing like a bullfrog. Gore smiled indulgently as Howard's eyes filled with stars ...

I woke the next morning with a head full of rocks and recalled the evening in montage. My last image of the two men, weaving and stumbling home in Chaplinesque fashion was a fitting endplate. I had to paint that day, which was a terrifying prospect, given my state. I washed, held down breakfast and made my way back to *The Swallows Nest* (or *La Rondinaia*, as it was known in Italian). It made sense that baby face was willing to kill for it. The villa clung magnificently to a cliff, its great balustrades breasting out over the Tyrrhenian Sea. I found Gore floating naked in his swimming pool. 'I shall be with you shortly,' he said, fanning his arms.

The first sitting was a disaster, as was the second and third. My initial composition had Gore slumped on his side, like Jabba the Hutt or some Turkish pasha taking hashish, a pose he found comfortable. So comfortable, in fact, that he would routinely doze off during our sessions, especially after large lunches of pasta and Frascati. The heat and the droning cicadas had a soporific effect on me, too, and I had to whistle to keep us both awake. By the fourth sitting I felt myself drowning, and Gore was equally unimpressed by the apparition that was appearing on canvas. 'I look like two hundred pounds of condemned veal,' he drawled; and then, by way of a cure for my failure of vision, he offered me his comic novel, *Duluth*, to read. The aim was to convince me of the swirling and energetic power of his mind, but I didn't warm

> 'He wants my house,' whispered Gore, 'and is probably willing to kill me for it.'

> My initial composition had Gore slumped on his side, like Jabba the Hutt or some Turkish pasha taking hashish ...

to the book – it was frankly over my head – and the portrait plodded on, lacking vitality.

Outside the dimly lit library where we worked, the Bay of Salerno glittered to a curving horizon, while Howard bustled about in the background, waiting for cocktail hour when the fun could begin. There were nightly viewings of Bette Davis movies – Gore spellbound and weepy at the denouements – starry reminiscences of 'Jack and Jackie', and trademark candour about recent visitors: Hilary and Chelsea Clinton came 'to kiss the ring', Robin Williams 'was a genius', and Alec Baldwin and Kim Basinger 'never stopped humping'. On one occasion he confided that *Palimpsest* was dedicated to his boyhood love, Jimmy Trimble – or 'JT', as initialled on the dedicatee page. Gore smouldered as he remembered their 'powerful' boyhood sex and sobbed to tell how 'beautiful Jimmy' had died in the hot breath of a flame-thrower at Iwo Jima.

During one of our boozy lunches, I was bold enough to ask him the hackneyed question: 'If you had it to do all over again...'

'I would invent a religion,' he replied, without missing a beat. 'And this painting lark,' he added, 'you'll have to give it up in ten years and move on to something else. Keep them guessing, or you'll become irrelevant.'

Approaching the end of my ten-day stay I realised I didn't have a painting and went into a tailspin. Then desperation gave me a masterstroke. I realised I could transpose **Man in a White Suit (p. 69)** on to Gore—he exemplified the sort of charisma and seductive genius that verges on evil.

I returned to *La Rondinaia* and totally recomposed the portrait. Time was short, so I made numerous sketches and photographs from a low angle, looking up at Gore imperiously seated like the figure in the drawing.

Back in my London studio, the second version quickly took shape. I lovingly polished all the details: books, globe, the prized plaster-cast of Lincoln's hand to his right and sent off a photo of it to Italy.

'I look like God on the seventh day,' came the reply, 'having decided it was all a terrible mistake.'

So, I kept the painting. Eventually it was acquired by the National Portrait Gallery at the Smithsonian.

Bearing this positive news, I went to see Gore again, in Los Angeles. Howard had died by this time and Gore was wintering in California to receive medical treatment. A Mexican houseboy greeted me and showed me into a palatial living room that transported me back to Ravello: the same paintings, the grand furniture. At first, I didn't even notice Gore sitting in a corner under a blanket. He was frail, but not in mind. Barack Obama was running for president, and I asked his opinion. 'Well, he's very pretty, but so was Harry Belafonte, and he never ran for president.'

I produced an 8x10 of the portrait and told him about the Smithsonian honour. 'It's not that bad after all ...' he mused, looking at it.

After my time with Gore and Howard in Ravello, I couldn't settle back into my London life. It seemed small. Exposure to such characters living messily out loud and without apology gave me a taste of lost grandeur, and I wanted more.

Gore had a love-hate relationship with America. 'The United States of Amnesia,' he famously called it. But I could tell that, even in Bacchic exile, he was pining for that 'Shining City Upon A Hill'. The US was still the place to prove oneself and make one's mark; and I took his fatherly advice to strike out, live more dangerously and believe in myself more, as a divine injunction to 'Go West, young man.'

America, or more particularly Los Angeles, was also calling to me because I had recently completed a course of study at the London Film School and was drawn to express myself further through the creative outlet of Cinema.

The overreach of this ambition soon became clear after several months spent writing scripts in a dingy Hollywood bungalow. It was hard to concentrate on dreams of the Big Screen when a blank canvas – and all the marvellous journeys it offered – was so near at hand.

Little Girl Waiting (p. 89) seems to express the sense of powerlessness and ennui I was feeling about filmmaking, in which the creative artist is beholden to others – producers, actors, etc – and must wait on their patronage before he can express himself. She is also my disgruntled muse, miffed that I have diverted my attention away from Painting – knowing that I must come back to her.

Autumn Sunrise (p. 88), although part of my inner landscape series, was inspired by daily walks up to the Hollywood Reservoir, a beautiful gift of water amidst scrubby hills, where I would meditate and revitalise. The painting expresses the power of nature to reset our mood and refocus attention on the source, where it belongs. As I had done in **Melting Sea (p. 62)** and **Landscape with Three Stone Heads (p. 62)**, I compressed the skyline and deepened the space, but the cold blues of those paintings are replaced by tones of opulent fruitfulness. I was feeling better about life, even though the foreground shadows are never out of the picture.

Inevitably, I gave up on movie-making and went back to painting full-time. But I was now in Los Angeles, not exactly the best place for an oil-on-canvas painter. How could I take advantage of the situation?

I remembered meeting **Billy Wilder (p. 82)** at a party in London. We'd had a wonderful conversation about his classic film, *The Apartment*, and how best to place the camera in a scene for story-telling effect. Since I was in Hollywood, I decided to contact him, fully expecting to run afoul of various secretaries and assistants, but to my great surprise Billy picked up the phone himself. 'Mr Wilder,' I stammered, 'I don't know if you remember me, we met at a party in London ...' I was astonished by his quick recall – and even more that he agreed to sit for a portrait. 'Can you come to my office Thursday at four?' he enquired in his thick Viennese accent, 'I'm on Burton Way.'

I knew the street. It ran through the heart of Beverly Hills. I wasn't prepared for the unprepossessing façade of the building and walked back-and-forth before taking the dingy stairwell by a postcard shop. The chilly landing was lit by blinking strip lights. I knocked on his door. A shuffling tread, and then that owlish face, peeping over his glasses: 'Ah good, come in...' The room was close with papers and scripts, its walls hung with posters of *Stalag 17*, *Some Like it Hot* and others of his pantheon. 'I still write every day,' he said, 'but those sons of bitches at the studio, they're all twelve now, and none of them know my work.' I followed him into an adjoining room, small and dark with one window high in the wall. Beneath this, he wrote. 'Can we do it here?'

I started setting up in the available space, which was small and decidedly dim. 'Would you like a coffee?' he asked. I took a beat: Billy Wilder, giant of Hollywood's golden age was offering *me* a Latte.

'Thank you,' I managed, fully expecting him to go to the old coffee machine in the corner. But he put on his coat and left the office. I went to the window and saw him waiting at the curb. 'You can't be serious ...' I said to myself as he shuffled across, waving to stopped cars, and disappeared into a Starbucks opposite.

Unlike Gore, a complex man beset by insecurities and disappointments, Billy was humble and down-to-earth; altogether too great for the posturing of eminence. He had arrived

> **I was now in Los Angeles, not exactly the best place for an oil-on-canvas painter. How could I take advantage of the situation?**

With Billy, toasting the completion of the portrait

> 'Billy loves the portrait,' she said, 'he just doesn't like himself very much.'

at the source of himself and was complete. This is what I wanted to paint. I felt it when he sat down in position and stared at me in three-quarter profile, the famous 'brain full of razor blades' sizing me up. It was time for *me* to be the Director and take Action. But I'd made my task very difficult in agreeing to the smaller room; not only was I barricaded into a corner with no light on my canvas or room to ply my brush, palette and mahlstick, but the window-light was hitting my subject from above and behind, a real challenge – unless you happened to be Rembrandt. I had this master in mind as I started scratching away. The coffee didn't help the trembling of my hand, and I could barely see what I was accomplishing, but at the end of an hour I turned the canvas to him and he seemed pleased.

After we fixed a time for the next sitting, he asked if I could drive him home. I was mortified to escort the maestro into my dilapidated old Ford, its front end carpet-bombed with bird-poop. He seemed not to notice, or at least didn't want to embarrass me with his distaste. To make matters worse, we were forced to sit in traffic on Sunset Boulevard for forty-five minutes, hemmed in on all sides by the gleaming Hollywood elite. Did they recognise the director of *Sunset Boulevard* in their midst – the confidante of Bogart, Monroe and Cooper? Billy didn't care. He probably enjoyed the irony. Hollywood was good at these surreal moments, I rationalised, white-knuckled with shame at the wheel.

We had three more life sittings, Billy the total professional, stoic and perfectly still; he knew exactly what his director wanted. After the last session, he took me to his favourite Italian restaurant around the corner. On the way he stopped briefly at a residential address and asked me to wait. As he went in, I saw through the door a wall of screens and racing animals. He was placing a bet. Lunch was pasta with white truffles, at which he spoke lovingly of Audrey Hepburn. 'When she got cancer,' he shook his head, 'that's when I knew there was no God.'

When I showed him the finished portrait, he was silent, and I thought displeased. I drove home in a black mood and was relieved to find a waiting message from Audrey, Billy's charismatic and indomitable wife: 'Billy loves the portrait,' she said, 'he just doesn't like himself very much.'

Nevertheless, the portrait he liked of the man he didn't like went up on his wall next to his beloved Klimts and Schieles, and I was gratified to hear him speak reverentially of its painted shirt folds, suspenders, and most of all, 'the light on my face.'

My painting of Billy gave me the confidence to approach another director I admired, **Oliver Stone (p. 83)**. I had brought a portfolio of my paintings to a cocktail party at Ray Stark's house (producer of *West Side Story*,

With my Beethoven painting

Lolita, *The Night of The Iguana*) because I knew Oliver was a friend and might be there. Sure enough, he arrived late after an all-day session in the editing suite. Ray introduced us and I showed him my book. His eyes lit up when he saw Billy's portrait and exclaimed, 'You painted Wilder?!' I smiled, and we agreed he should be next.

Our sittings started several weeks later at his house in Santa Monica. He was an avid collector, mostly of contemporary Chinese art, and proudly showed me his collection. There was also a shrine to his Vietnam experience, containing pictures of his lost comrades and Buddhist relics – but this was a closed sanctuary, a place for private meditation, and nobody but he was allowed.

When it came time to paint, he had a glass of wine to get in the mood, and asked if he could read a script while I worked. I consented, knowing that he was a highly sensitive and emotional man who probably didn't like being scrutinised too closely. After a few false starts, I asked him to put down the script, lace his fingers and gaze out the window. This worked as a composition; and then I imagined that the contemplative pose, combined with the tropical fronds at the window, had cast his mind back to Vietnam. I remembered a TV interview in which he'd responded to a question about his war experience: 'I could tell you about it in words… but you can't smell it, and you have to smell it,' he had added, with a smile of distaste.

This portrait was to be the first of three. I delivered it finished and Oliver seemed pleased. Then he called me the next morning and said his girlfriend felt the skin was too coarse, and could I change it? I explained that I'd put sand in the paint to build it up and make it gritty. I wanted to create a dynamic surface to mimic the edge in his films and make a definitely 'masculine' painting. I preferred not to change it, I said, but I *could* create another.

Oliver 2 (p. 85) shows a decidedly smoother Oliver. It was also the one that ended up on the wall of his office. To complete the series

When I first arrived in Los Angeles in 1996, it seemed that the only thing on people's minds was the O.J. Simpson Trial.

and make a triptych, I added a third, very warm painting, created under artificial light: **Oliver 3 (p. 84)**.

Working with Oliver over time forged a friendship and he became a committed collector, acquiring not only the portraits but also some of my abstract paintings. When I completed my portrait of **Beethoven (p. 90)** with its heavy textures and dramatic lighting, I knew that Oliver must have first refusal. He promptly bought it and hung it over his mantelpiece. His support meant a lot to me at a critical juncture in my career and gave me the confidence to continue in Hollywood as a painter.

When I first arrived in Los Angeles in 1996, it seemed that the only thing on people's minds was the O.J. Simpson trial. It had been grinding on in an LA courthouse for many months and was an entertainment phenomenon in itself, splitting people along racial and political lines and creating fierce debate.

Into this firestorm stepped the doyen of Hollywood writer-journalists, **Dominick Dunne (p. 87)**, with his fearless and penetrating reportage for *Vanity Fair*. His insider exposes from the courtroom were avidly anticipated and devoured for their insight into the

> When it came time to paint, he had a glass of wine to get in the mood and asked if he could read a script while I worked.

mysteries of the case and its colourful and reprehensible characters.

Dunne had himself witnessed the dark chicanery of the American legal system when the killer of his daughter, Dominique, had walked free after a paltry three-and-a-half year sentence. He was inevitably putting demons to rest with his obsessive scrutiny of the Simpson case, and it wasn't surprising that he developed a clear bias against the famous defendant. I liked his fearless approach, and had been wanting to paint him for some time.

I tried to contact him through reception at the Chateau Marmont, the famous old hotel on Sunset Boulevard where he had been living and journaling for a year, but he was constantly evasive, citing his impossible workload and the ever-impending verdict. It was true: in addition to his long days in the courtroom, every host of a stellar late-night party or a studio lunch wanted Nick Dunne at their table, dishing and gossiping.

Feeling it was hopeless to pursue, I dropped the whole thing, only to run across him by chance a few weeks later in a near-deserted restaurant in Venice Beach. This portrait must be fated to happen, I told myself encouragingly as I strode over to his corner table and offered my hand. He stared daggers at me, and his officious-looking companion shrank between his shoulder blades. I wasn't to know that I had just blundered into one of Dunne's private meetings with a source, possibly blowing the man's cover and upsetting his prize scoop.

I took his curt reply and promise to be in touch as a good sign and went back to my table for a stiff drink. I waited three weeks before

Painting Dominick at the Chateau Marmont

calling the Chateau again. He took my call and said he was totally jammed but might have an hour or two. The appointed day was to prove one of the most fraught for him. Following Simpson's acquittal, Dunne went on CNN and brazenly accused O.J. of guilt: 'if he'd come up to me at a restaurant and offered his hand, I wouldn't shake it, because it's covered in blood'.

This passionate admission cost him four death threats, all dutifully received by hotel reception at the Chateau, and turned his demeanour, on the day I finalised gained access to him, into a man under siege, a general in his bunker contemplating suicide or blind flight.

His hotel room was a sight: collapsing book piles, snowdrifts of paper, fax machines beeping and belching paper – while the phone rang incessantly. He damned the intrusions, fearing another death threat; so we agreed that he should tell reception to hold all calls, or our two hours together would be a washout. He welcomed the excuse to cut off, and noticeably relaxed. I found that the only area for painting was in the kitchenette, where I could have enough space and light. I moved the breakfast table to the wall, and he asked if he could sit at it and work on his jury notes while I continued to set up. I agreed, and immediately saw the pose I was looking for: a man at boiling point, chasing a fugitive sense of justice with his pen.

Our first sitting was a dream. Dominick forgot that I was there, and his intensity drew me into a shared focus. During our second and third sittings he was more resigned to the verdict and quieter. I had caught the emotion from the first sitting and now concentrated on the position of the limbs, the hands and the slant of the body.

He had returned to New York by the time I finished the painting. I flew out and presented it to him at his apartment on Fifth Avenue. 'How much?' he asked, looking at it propped on a chair. I told him the fee, which seemed princely at the time. 'I'll take it,' he shot back, and we were soon walking up Fifth Avenue to his framers, the portrait under my arm.

The picture went on to play a prominent role in the novel that he was to write about the O.J. case: *Another City, Not my Own*. It adorned the back cover and spine of the first hardback edition and achieved exposure all over America. I regularly saw it on bus stop advertisements

> 'I was in LA covering the O.J. case and this guy just kept calling me asking for a portrait. I put him off, but he wouldn't take no. Then I was in some out-of-the way place with a source and he just walks up. I thought my contact would leave and I'd lose my story. I was furious. But then the portrait turned out to be so wonderful I used it on my book ...'
>
> **Dominick Dunne**

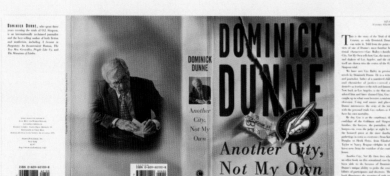
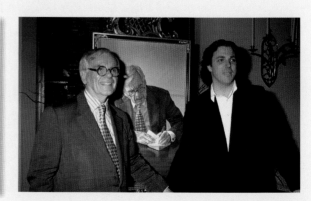

Dominick's book jacket, and with Dominick by his portrait

With my mother by her portrait

and billboards but it played a deeper and more disturbing role in the book itself. Gus Bailey, Dominick's alter ego, is murdered under the painting in his Connecticut study – the very same place where it hung in real life – and remained, until Nick's real-life death in 2009, whereupon it was moved to the house of his son, Griffin Dunne.

Like Oliver and Billy before him, Dominick was something of an angel in my life, and it was through his influence that I secured my exhibition of portraits at the Chateau Marmont in 1997. The show contained all the recent Hollywood portraits, as well as some from London. Gore Vidal and Nigel as George III were featured, along with the three Olivers, the recent reclining portrait of my mother and, of course, Dominick and Billy, both of whom attended along with a crush of celebrities. I couldn't believe the turnout. As the huge lobby reached capacity and drowned out the pianist singing Cole Porter, my PR lady breathlessly collared me: 'There's a queue on Sunset Boulevard because of the show,' she exclaimed, 'the cars can't get in; they're calling out the police to direct traffic!'

At a particularly dizzy moment, I was summoned downstairs to personally welcome Sharon Stone to the party, which meant leaving Oliver alone with a scrum of paparazzi. He was concerned because I'd decided to show *all three* of his pictures. 'They already think I'm an egomaniac,' he murmured. I later read that he had said to an interviewer, praising me in his inimitable fashion: 'He brings light to darkness and darkness to light, resolving the ying and yang of nature. I see him as the Isaac Newton of British Art.'

'He brings light to darkness and darkness to light, resolving the ying and yang of nature. I see him as the Isaac Newton of British Art.'

Oliver Stone

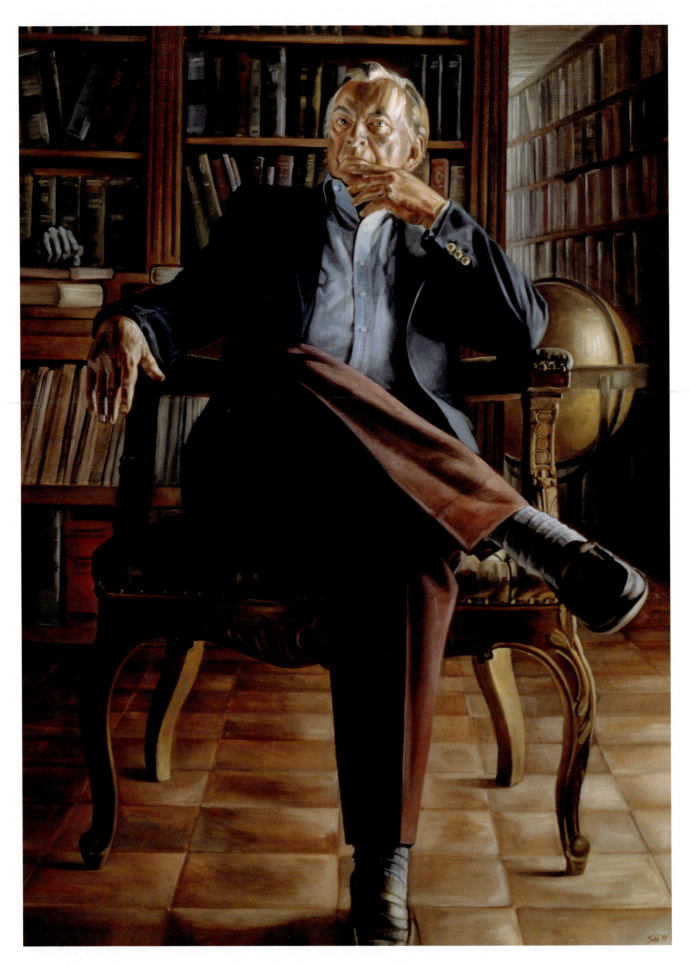

'I look like God on the seventh day, having decided it was all a terrible mistake.'

Gore Vidal

Gore Vidal
1994, oil on canvas, 36x54"

Permanent collection, The National Portrait Gallery at The Smithsonian

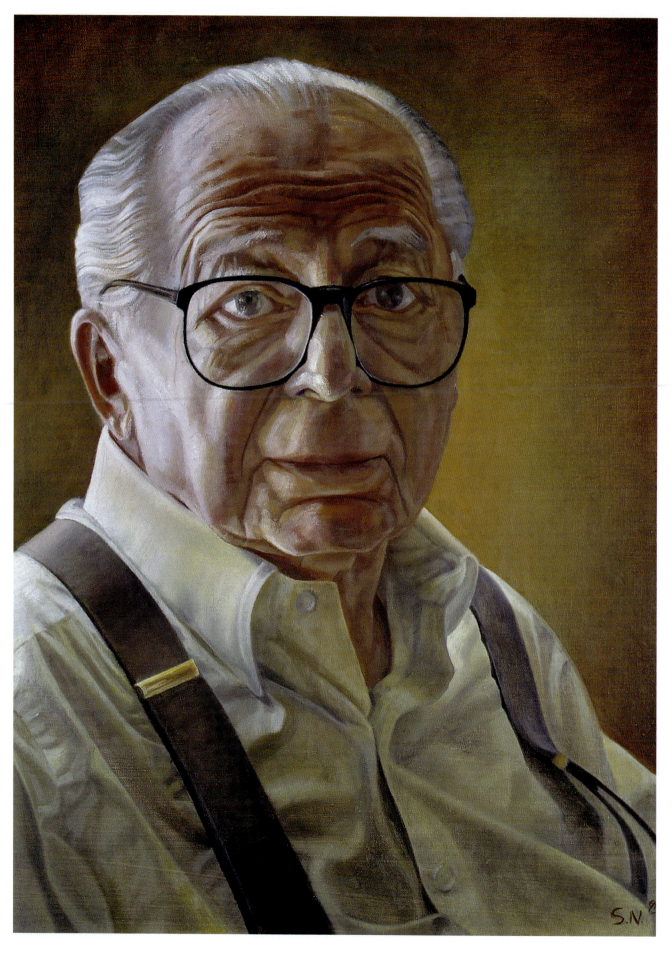

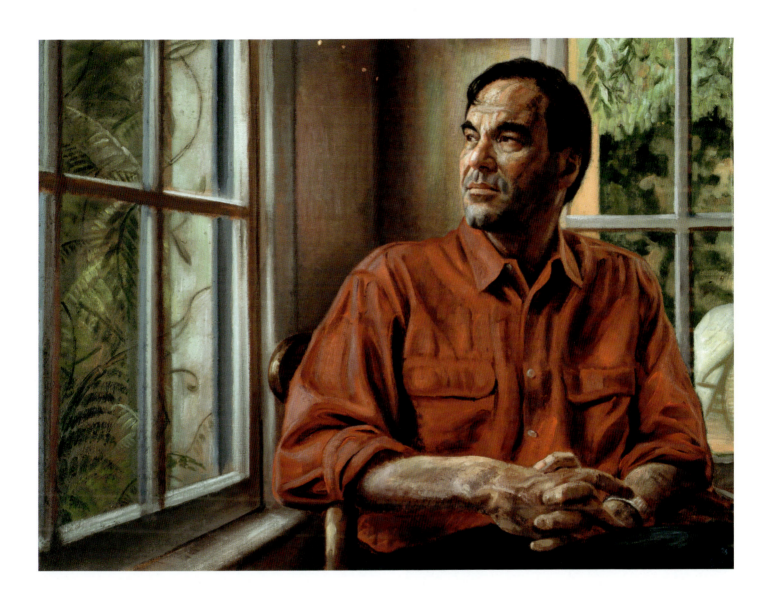

(above)
Oliver Stone
1996, acrylic on canvas, 26x36"

(opposite)
Billy Wilder
1995, oil on canvas, 20x26"

He stared at me in three-quarter profile, his famous 'brain full of razor blades' sizing me up. It was time for *me* to be the Director and take Action

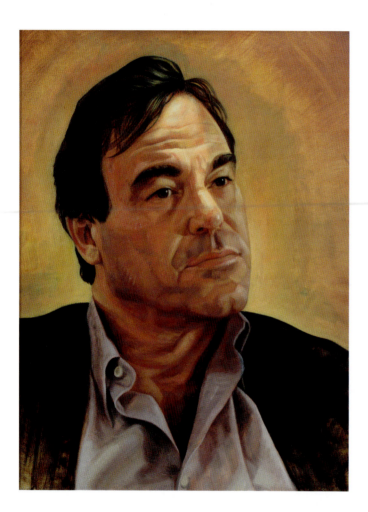 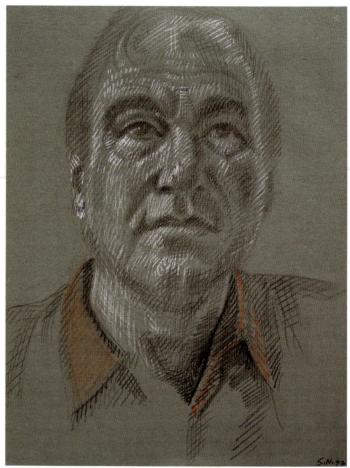

(above left)
Oliver 3
1996, oil on canvas, 18x24"

(above right)
Sketch of Oliver
1997, conté on paper, 8.5x11

(opposite)
Oliver 2
1996, oil on canvas, 20x20"

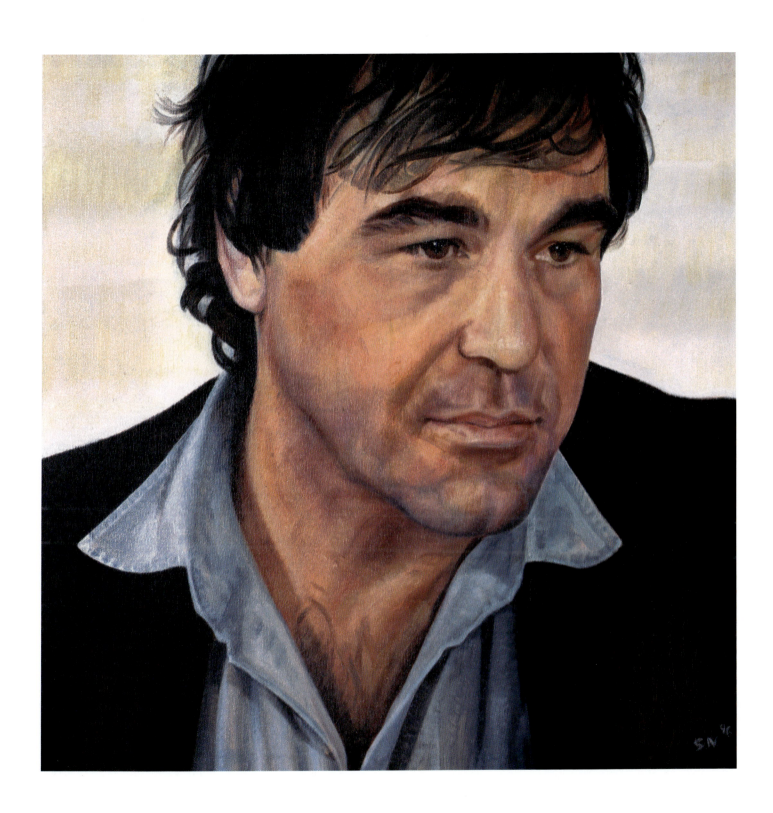

(above)
Drawing of Dominick
1997, conté and pencil on paper, 11x16"

(opposite)
Dominick Dunne
1996, oil on canvas, 24x36"

HOLLYWOOD PORTRAITS 87

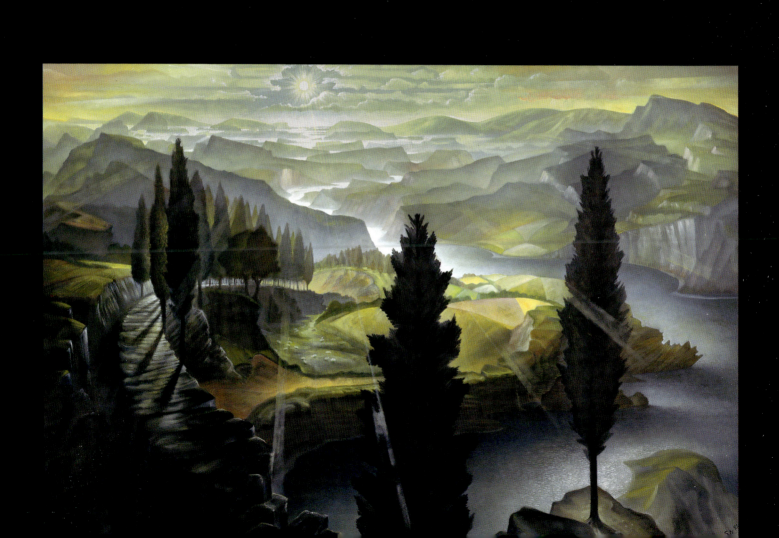

Little Girl Waiting
1995, oil on canvas, 24x36"

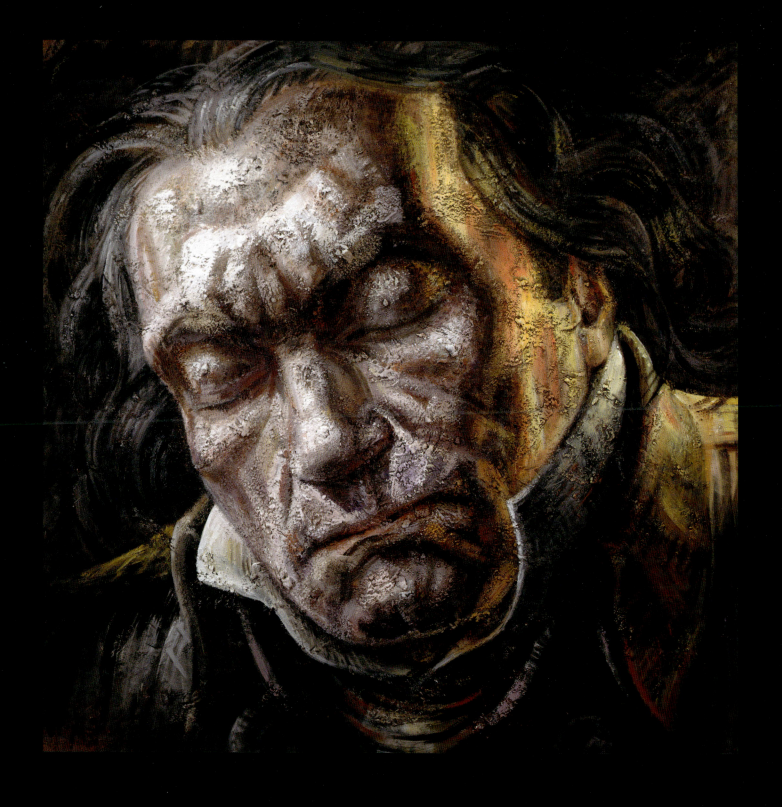

Beethoven
1996, acrylic on canvas, 36x36"

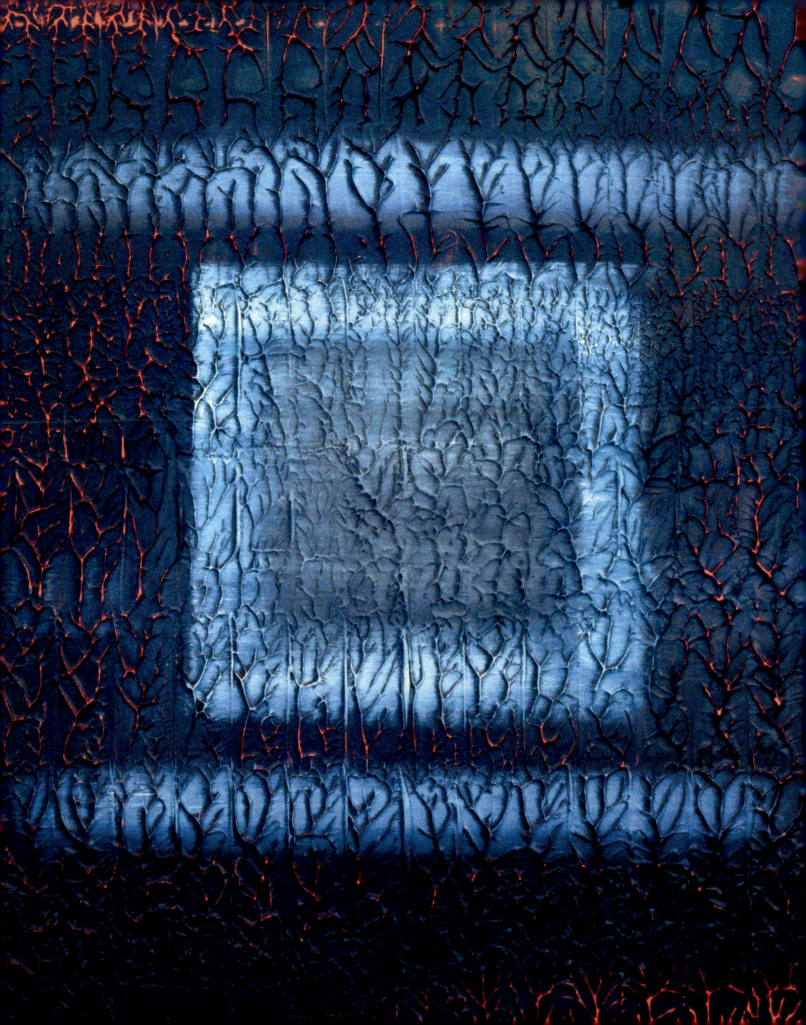

Chapter 5

Abstraction

My exhibition at the Chateau Marmont was the culmination of my first two years in Los Angeles. My celebrated subjects were big game trophies, and I felt that by capturing them in paint I was somehow absorbing their power. But the alchemy was only partly successful. Even though the show was a huge success, it didn't lead to an avalanche of commissions. After all the froth and bubble, I was still a jobbing portraitist looking for my next picture. And I had to put myself about, flatter and coerce; it was hard work and I felt my commitment wavering. There was something in me that chafed against the inherent power-play of portraiture, in which the portrait artist submits to another, celebrating their essence and specialness, whilst his own self remains unrealised.

I was working on my latest commission, patiently painting-in the silk and beaded design on the hem of a sari worn by an Indian lady, when my concentration failed and I knew I had to open up new avenues of expression or slowly suffocate.

By this time I had moved to Venice Beach, and was paying the steep rent on my first big white studio. Hunching over a portrait and fussing with its details in this cavernous space seemed ridiculous. I had been eyeing the large blank canvasses stacked against my wall and finally just snatched one up. I squeezed out some colours and immediately started painting, enjoying the freedom of mark-making. I wanted to steer clear of representation, but what soon emerged was a new kind of pictorial logic: grid-like structures marched across the canvas and organised themselves around a central square. This focal point was the subject of the painting, but not in the normal way. It was more like I was making a portrait of my perceptual apparatus itself; a rational brain, obsessed to zero-in on the details.

There was another energy at work, too, an impulsive, serpentine desire that was continually running circles around the grid or dancing through it in perfect counterpoint. This was the other side of my psyche: the drunken

This was the other side of my psyche: the drunken Dionysius to my stately Apollo – and both were wrestling for control of the painting.

On seeing my empty, workaday studio, Oliver exclaimed: 'Where are the women?! An artist's studio should be full of nudes!'

Dionysius to my stately Apollo – and both were wrestling for control of the painting.

I tried to stand back and referee the struggle, but it raged in my body as a buried pain I had to dig out. I was afraid of this turmoil, and in some sense I was trying to make its confinement appear or seem beautiful. Perhaps this would grant it rest. But that never came, only a ceaseless search for better prison bars to contain the raw energy. If the paintings appear beautiful, the viewer is deceived; they are contemptuous of our longing for a sense of peace and beauty that will always elude us.

Requiem (p. 99) was my breakthrough, the first abstract I made that seemed to express a strong, unnameable emotion. The title was suggested by its apparent similarity to an open grave of bones, some of which have a cruciform shape. The heavy, gridded frame arrests the troubling vision and holds it open for our inspection – just as it protects it from desecration.

Deeper (p. 102) uses the discoveries I made with texture to suggest a sunken energy reactor or sacred source, while **Prussian Window (p. 101)** shows these energies come violently to life, threatening to explode the painting.

It was appropriate that my studio was on the top floor of an old police station, and that downstairs the landlord had cannily preserved the old holding cells, painting them white and using them as exhibition rooms. The themes of freedom and confinement in my abstracts were ready-made for this space; and in 1998, I had a show there.

Oliver came and picked out **Fresh (p. 106)** and **Smitten (p. 107)**. On seeing my empty, workaday studio, he exclaimed: "Where are the women?! An artist's studio should be full of nudes!"

Blue Seeds
1998, oil on canvas, 32x42"

The background was made by a roller brush, which gave the impression of tyre-marks. I was moved to redeem this wasteland by floating electric blue seeds over it.

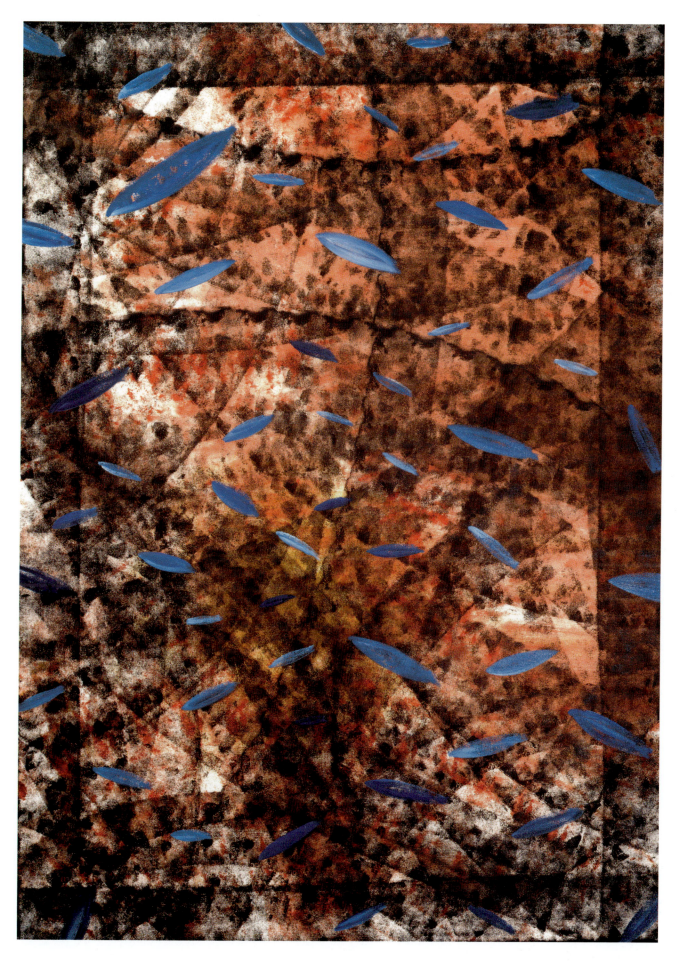

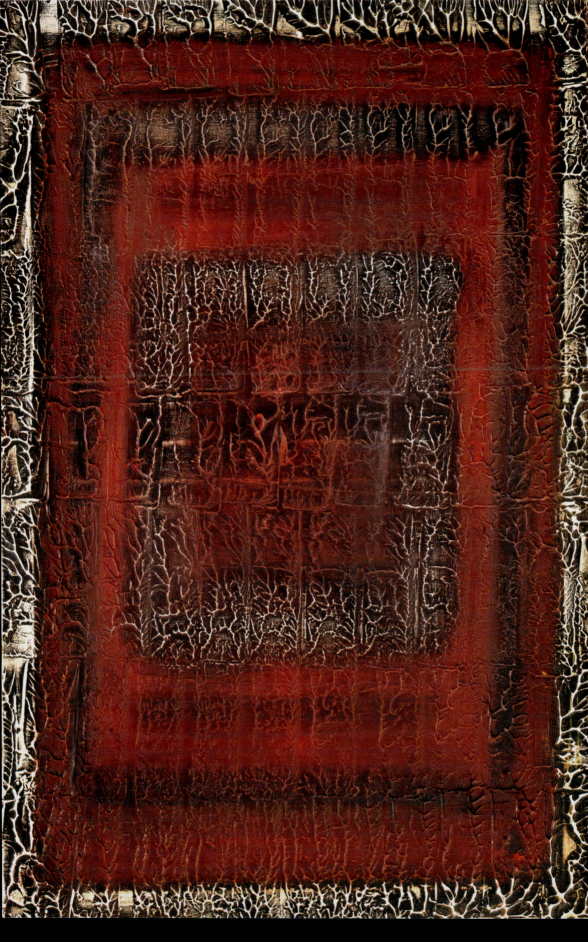

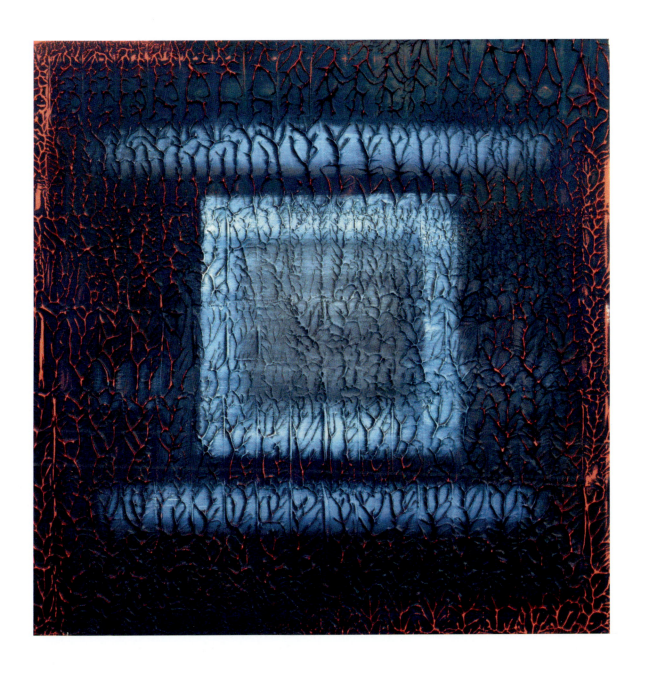

(opposite)
1st Glyph
1997, oil and acrylic on canvas,
24x36"

I like the appearance of chiselled ivory, and of an unearthed monolith.

(above)
Blue and Red Glyph
1997, oil and acrylic on canvas,
36x36"

There's a powerful hum here, dangerous and numinous.

(above)
Red Static
1998, oil on canvas, 16x20"

(opposite)
Requiem
1998, oil on canvas, 48x72"

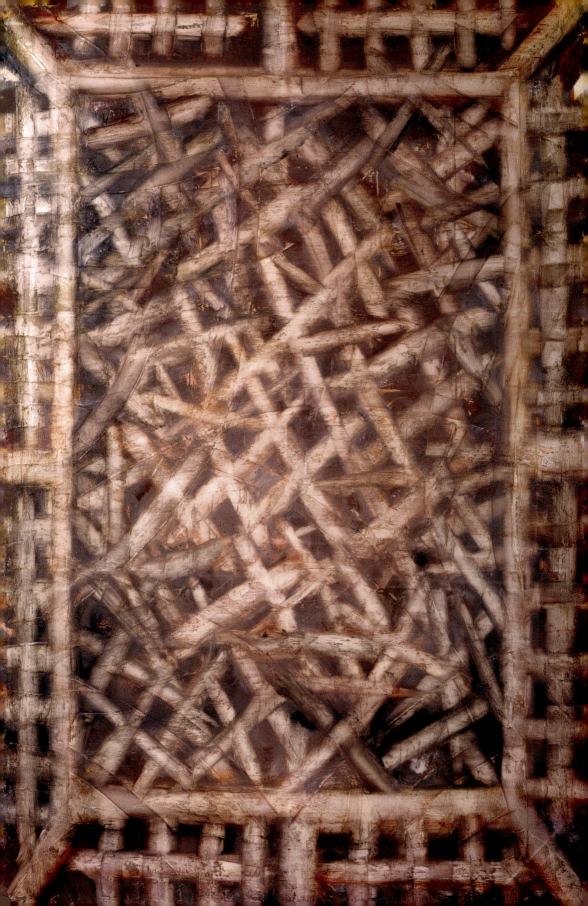

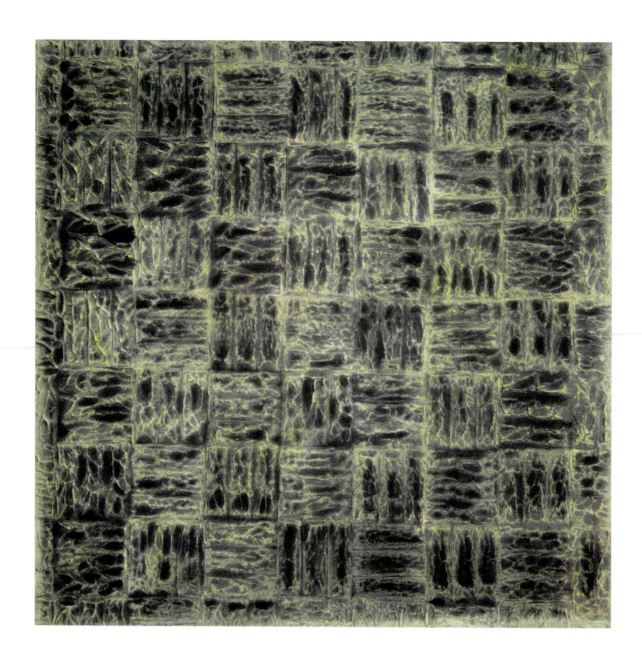

Large White Glyph
1997, oil and acrylic on canvas, 48x48"

The cubic/fractal effect projected large, achieving the look of a tapestry.

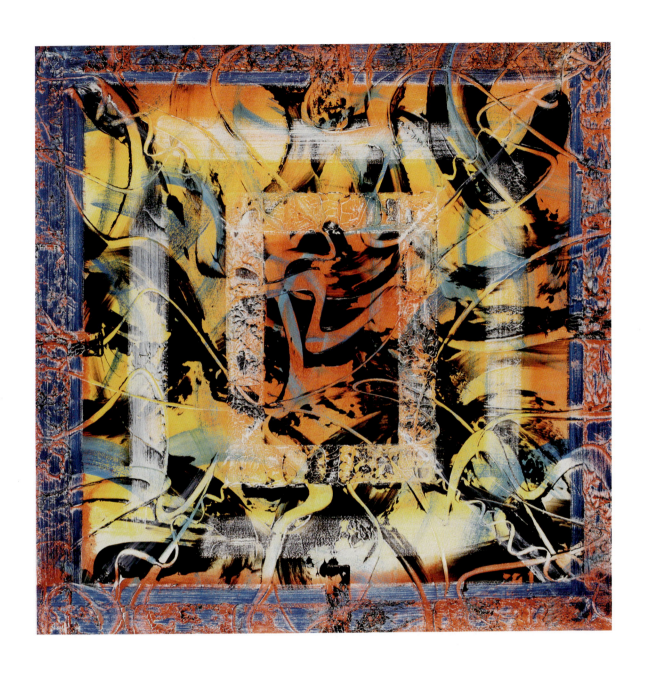

Prussian Window
1999, oil and acrylic on canvas, 48x48"

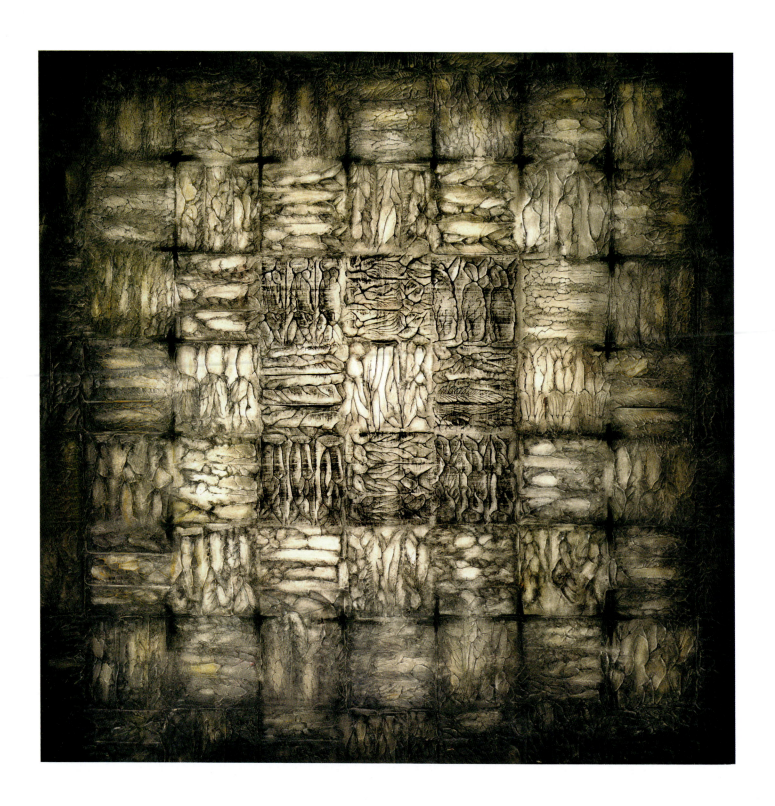

Deeper
1997, oil and acrylic on canvas,
48x48"

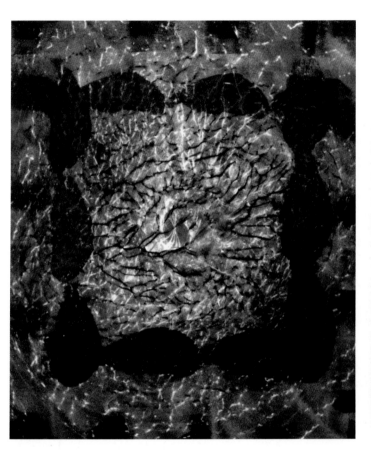

Deeper Study 1
1998, mixed media on paper,
11x16"

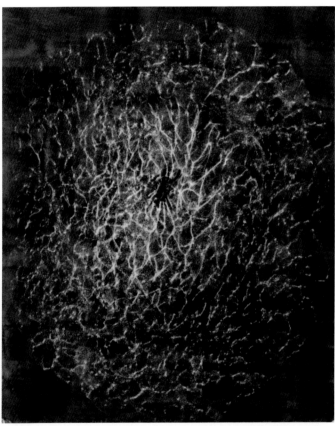

Deeper Study 2
1998, mixed media on paper,
11x16"

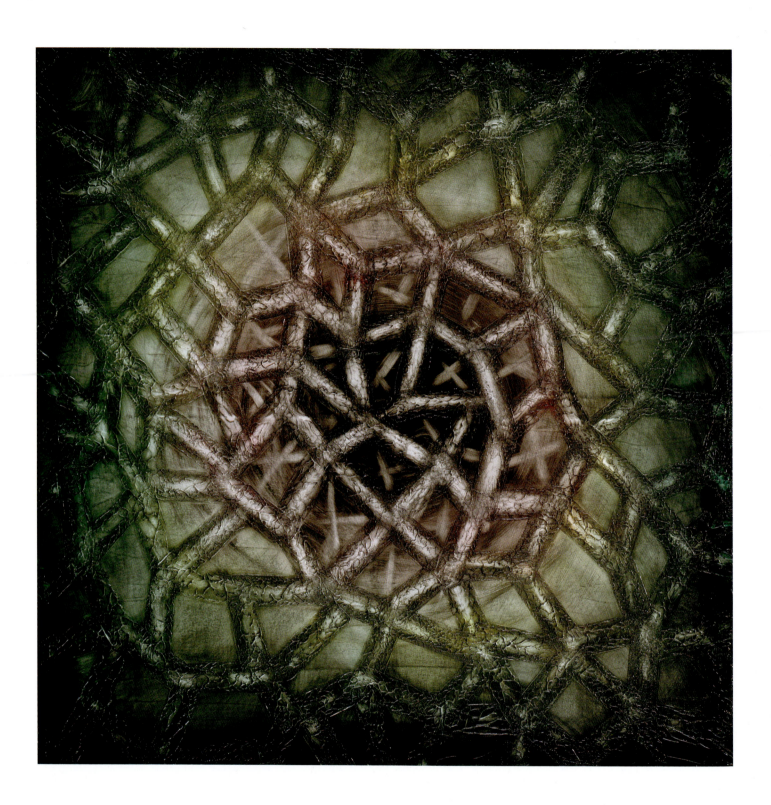

Black Spring
1998, oil and acrylic on canvas, 48x48"

The exuberance of spring involuted, disappearing back into itself.

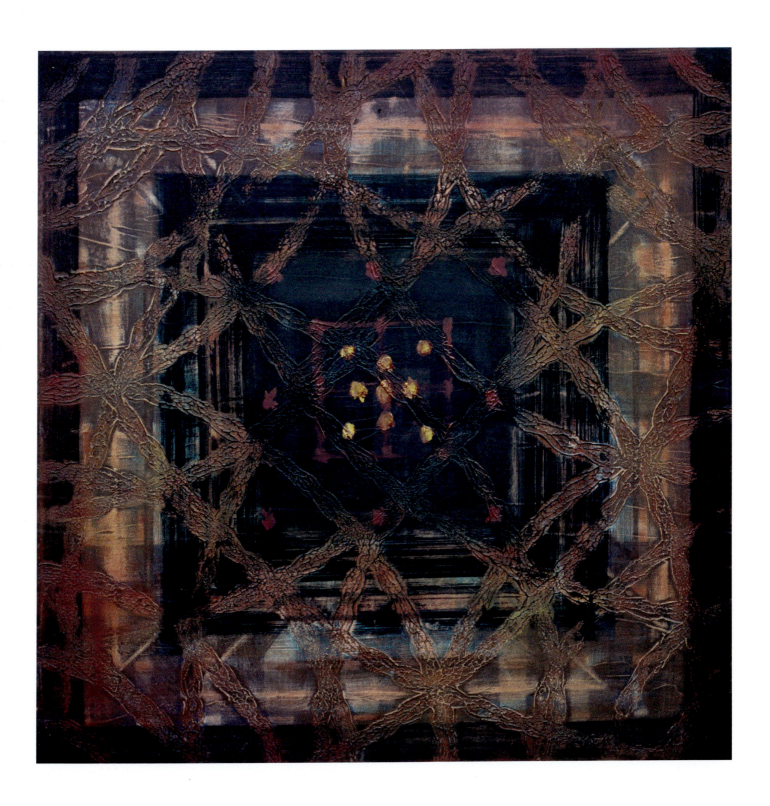

The Persistence of Painting
1999, oil and acrylic on canvas, 48x48"

Embers smoulder at the centre of a dead reactor, traced and retraced by fossilised remnants of life.

ABSTRACTION

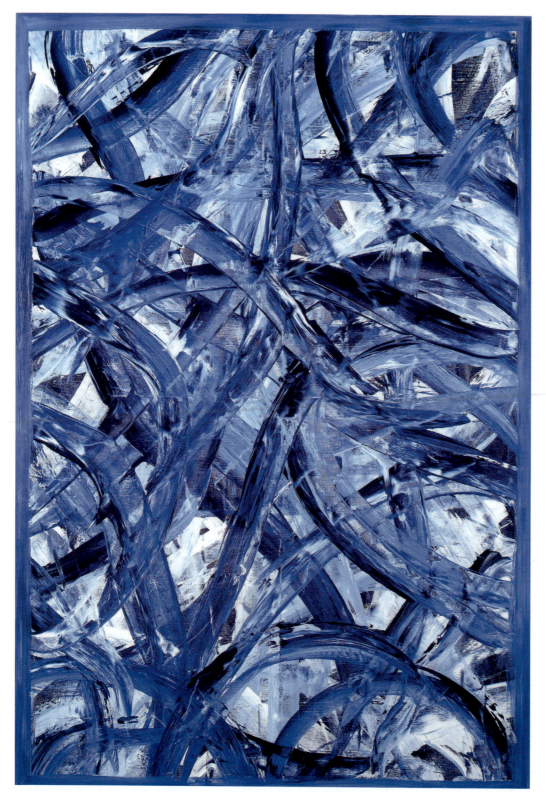

(left)
Fresh
1998, acrylic on canvas, 32x42"

Fresh is pure, serpentine energy, suggestive of interweaving jets of water. I made it in a happy frenzy, with a heavily paint-loaded palette knife. It's easy to see why Oliver, with his abundant energy, resonated with this one; and its companion piece, *Smitten*, with its nervous brocade made by etching into wet paint with a trowel.

(opposite)
Smitten
1998, oil on canvas, 32x42"

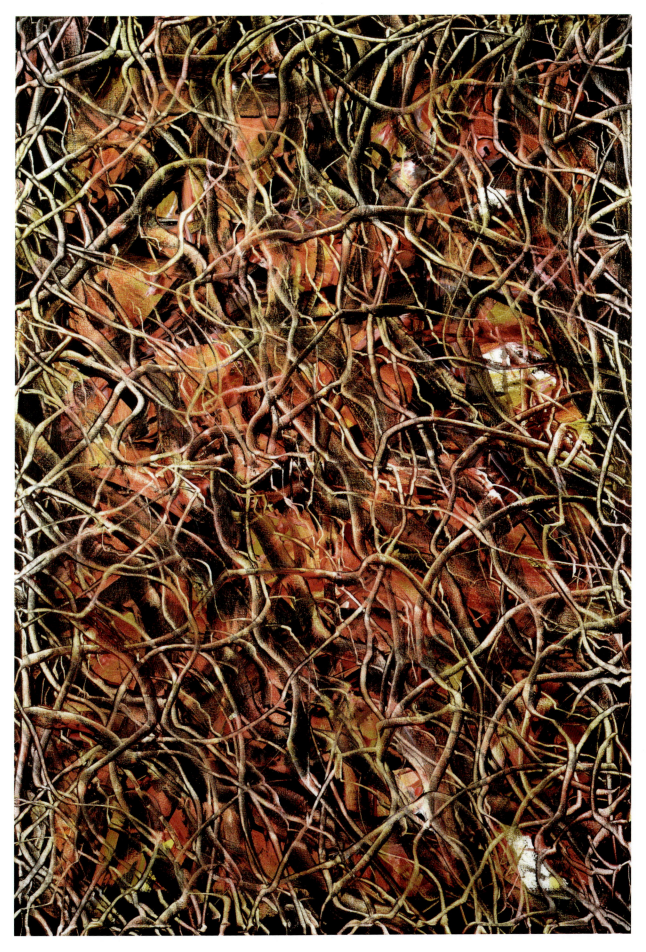

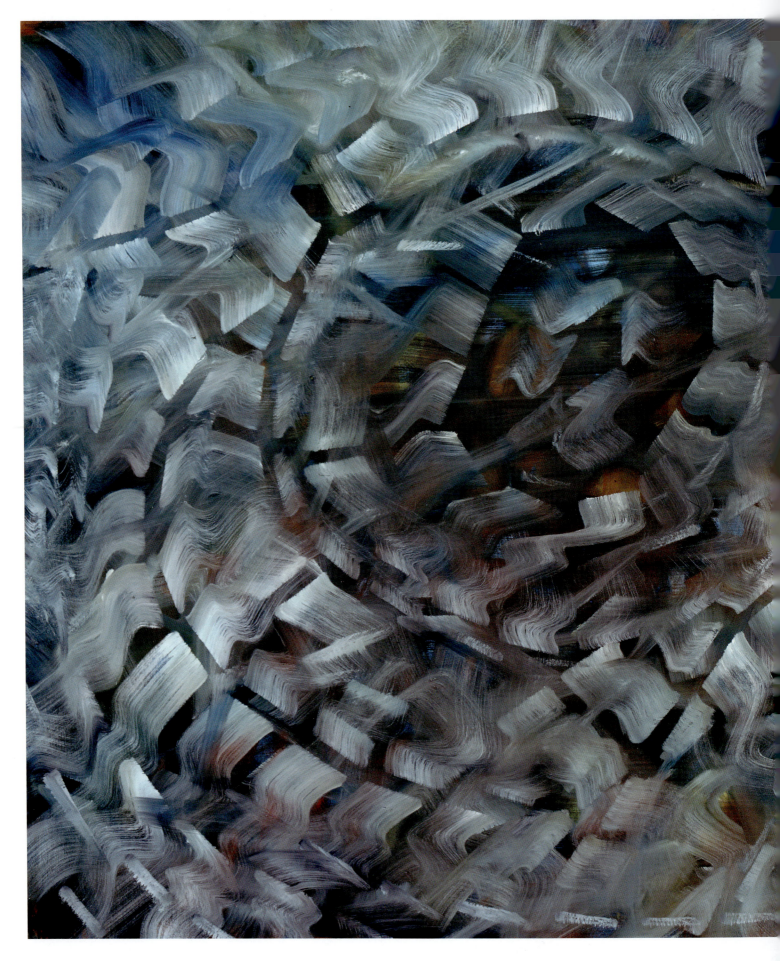

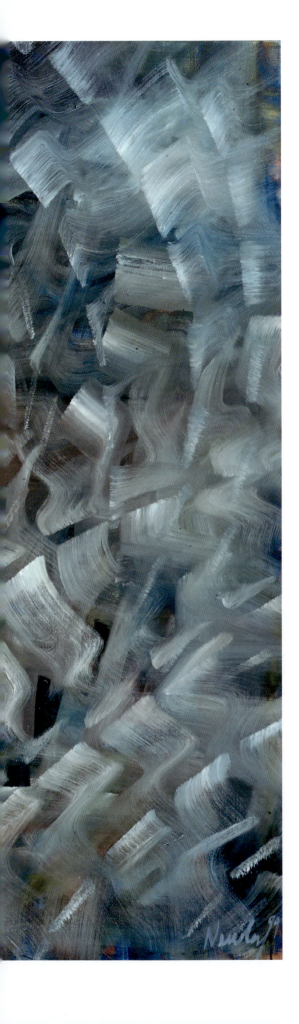

Large White Brush Painting
2000, oil on canvas, 48x60"

First Crush

2002, acrylic on paper, 30x40"

My experiments with crushed paper and acrylic spray yielded some interesting results. Here is a meditation on the strange beauty of damage.

Topographical Drawing
2002, mixed media on paper, 36x36"
The skull of a lost and forlorn planet,

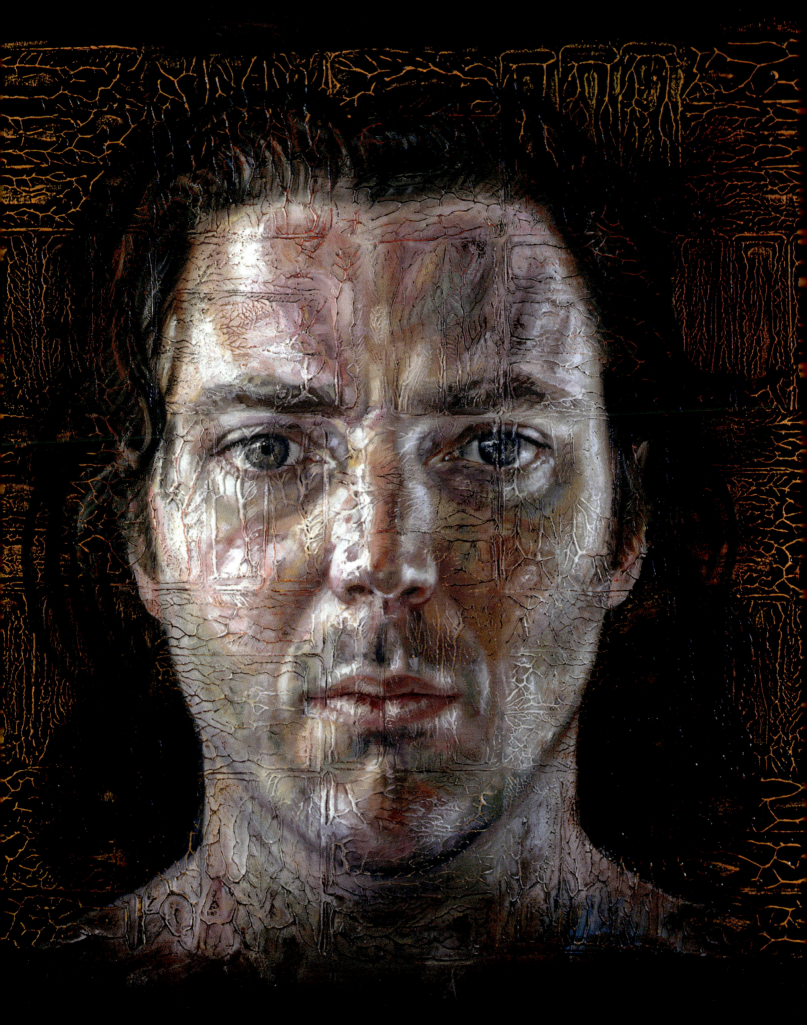

Chapter 6

Nerves Upon a Screen

When I returned to representational painting after two years as an abstract painter, I brought with me all the new techniques and strategies that I'd discovered. I found that I could use them to visualise the unseen world of energies that interpenetrates the human body, as well as to represent the complexity and beauty of nature.

In **Self-Portrait at 33 (p. 121)** my face is gridded with fractal cells. They're a fusion of natural and man-made circuitry, suggesting a troubling future in which the human self is invaded by technology. **Man Meditating (p. 116)** shows the absolute centeredness of enlightenment: energy courses up through the body and fans out to reveal the nervous system and astral web, knitting together self and other, form and space.

The piece put me in mind of T.S. Eliot's lines in *The Love Song of J. Alfred Prufrock*: 'It is impossible to say just what I mean! / But as if a magic lantern threw the nerves in patterns on a screen.' I found this poetic image so powerful and appropriate that I used it as the title of my next show, 'Nerves Upon a Screen', at Proud Galleries, London, in 1999.

Many of the works in this show were created in Florida, during an intense, two-month sojourn. I had gone there to be with my father in the final stages of his illness from cancer. I set up a makeshift studio nearby and visited with him daily, sketching and talking for as long as he could manage.

With its blotchy mosaic of inks and disintegrating textures, **The Artist's Father (p. 117)** sees through to my father's vanishing life force. I also turned this X-ray vision on myself and produced a series in mixed media. **Self-Portrait Looking Down (p. 118)** seems to follow my father into the unravelling void, whereas **Self-Portrait Looking Up (p. 119)** goes against entropy by affirming hope and rebirth. **Blue Fractal Self-Portrait (p. 120)** is riddled with fault lines, suggesting that the human self is forever poised between integration and decay.

Many of my textures were created by folding and then peeling open the paper or canvas. This resulted in symmetrical Rorschach patterns that suggested to me images from Eastern and Western religion. The eruption of energy in **Ascension (p. 122)** lifts Christ from the Cross, a natural torrent that might fuel the growth of trees and flowers. With its suggestion of butterfly wings, the piece tellingly relates religion to the process of incubation and rebirth in nature.

I found that these fractal patterns could also be imprinted on acetate by pressing and rubbing clear sheets of plastic over textured boards. Once dry, these acetate works were mounted in Perspex and exhibited against a window. They're a variation on stained glass, transfusing the pure, white light of divinity into biological forms **(pp. 124–125)**.

'It is impossible to say just what I mean!
But as if a magic lantern threw the nerves in patterns on a screen.'

T.S. Eliot, *The Love Song of J. Alfred Prufrock*

Bug
1999, oil and acrylic on folded paper, 16x20"

The technique of multiple folding used to create a comic anatomy.

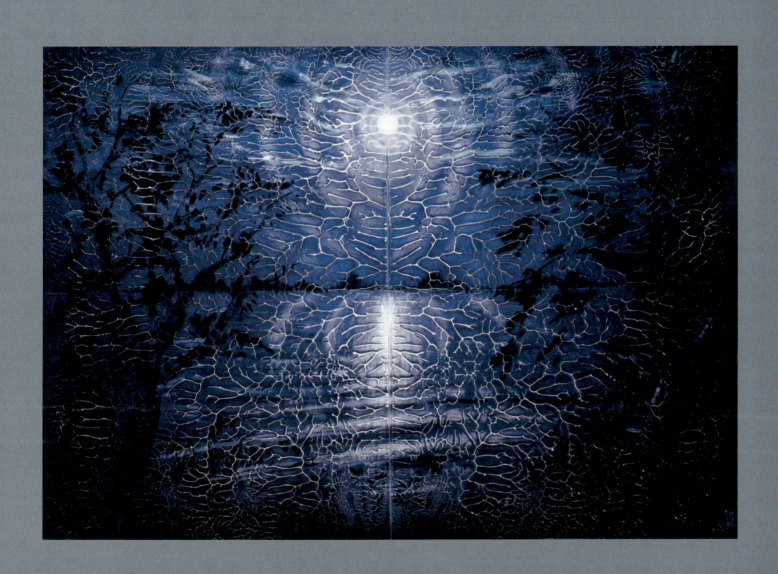

Moonlight
1999, acrylic and oil on canvas,
36x48"

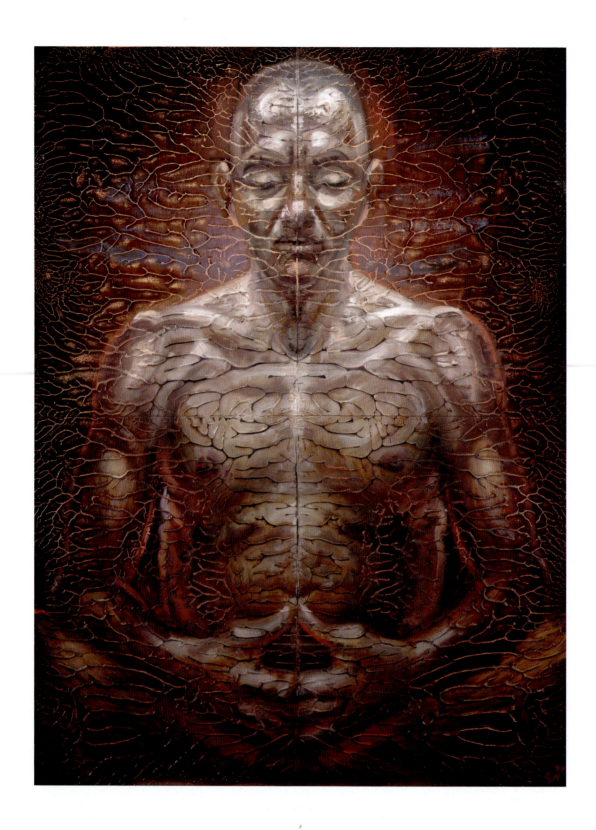

Man Meditating
1999, oil and acrylic on canvas, 40x50"

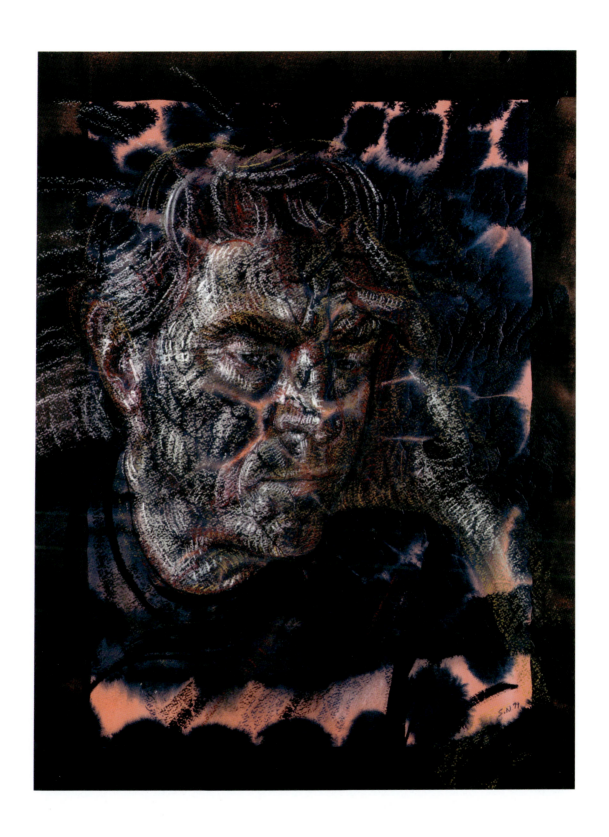

The Artist's Father
1999, mixed media on paper, 16x20"

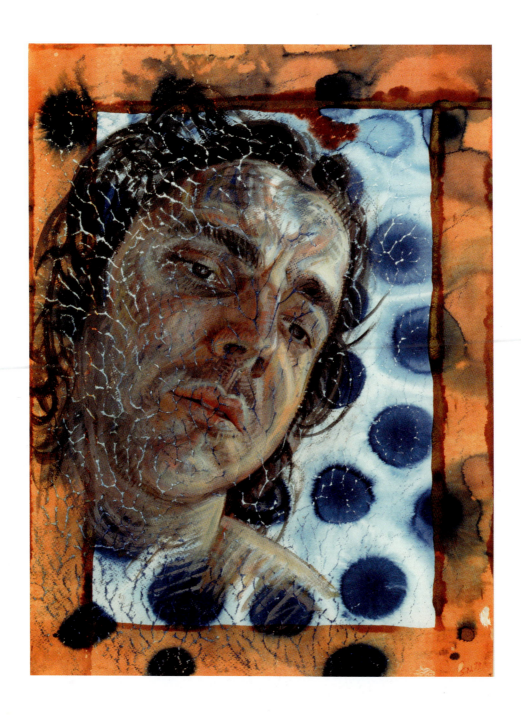

Self-Portrait Looking Down
1999, mixed media on paper, 16x20"

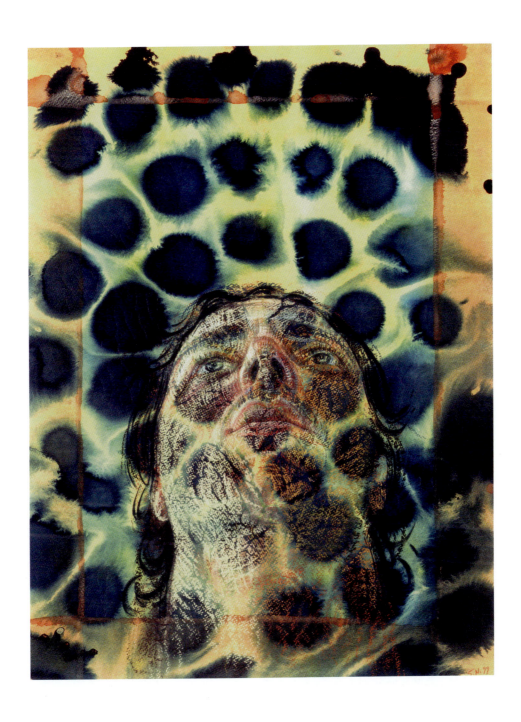

Self-Portrait Looking Up
1999, mixed media on paper, 16x20"

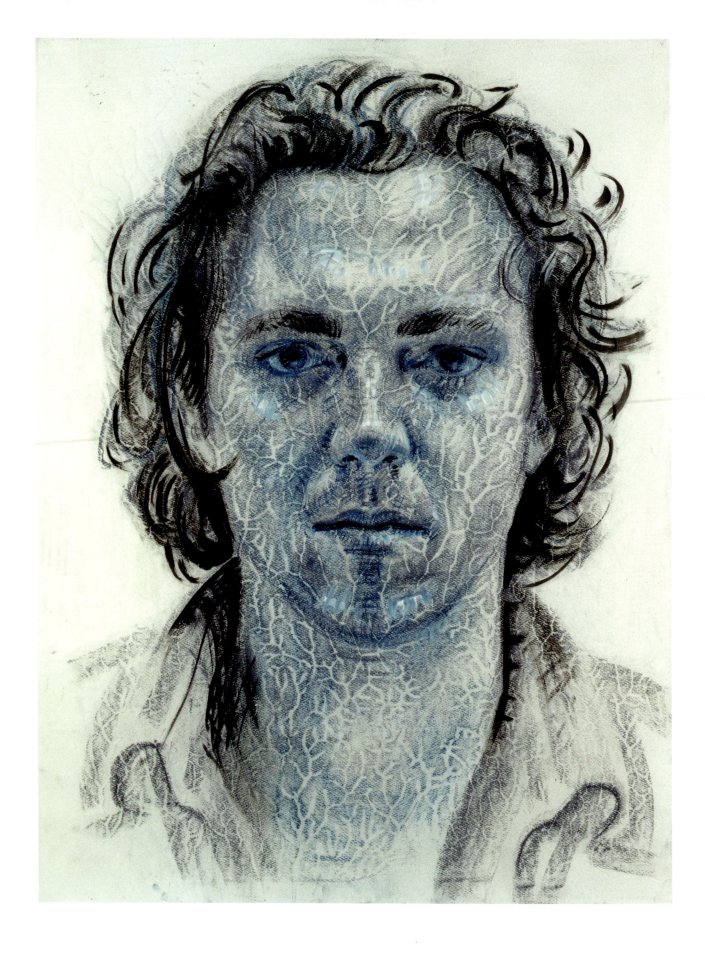

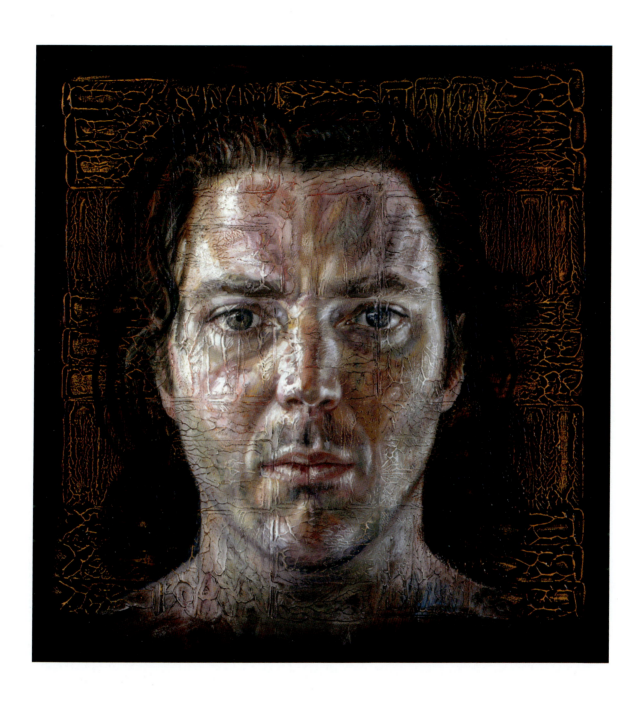

(opposite)
Blue Fractal Self-Portrait
1999, mixed media on paper, 16x20"

(above)
Self-Portrait at 33
1999, acrylic and oil on canvas, 36x36"

Ascension
1999, oil and acrylic on canvas, 36x72"

With its suggestion of butterfly wings, the piece tellingly relates religion to the process of incubation and rebirth in nature.

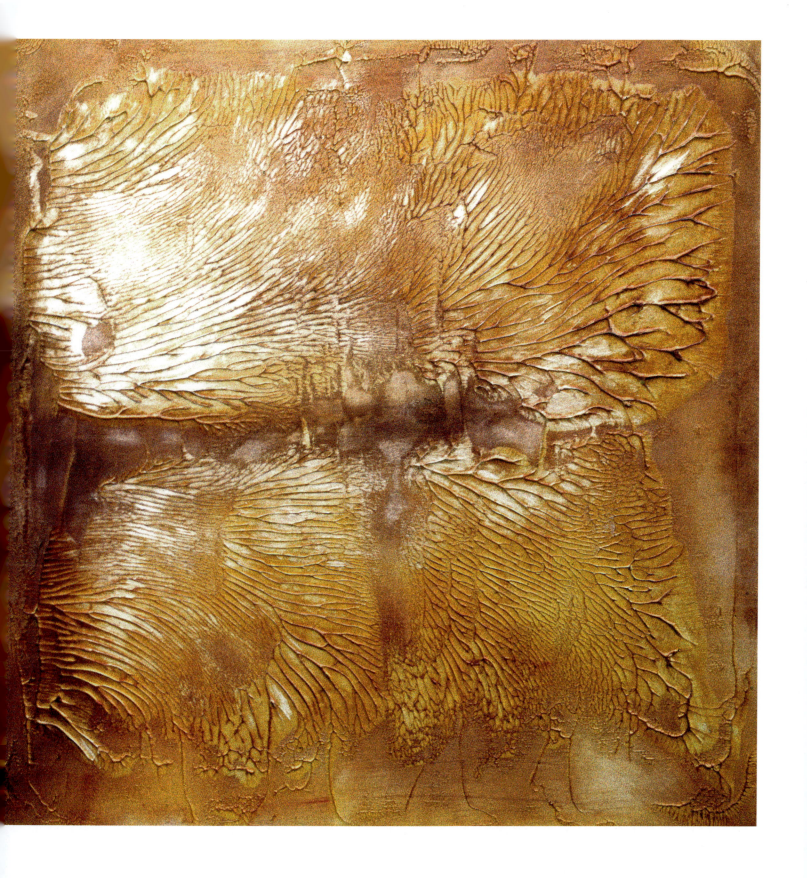

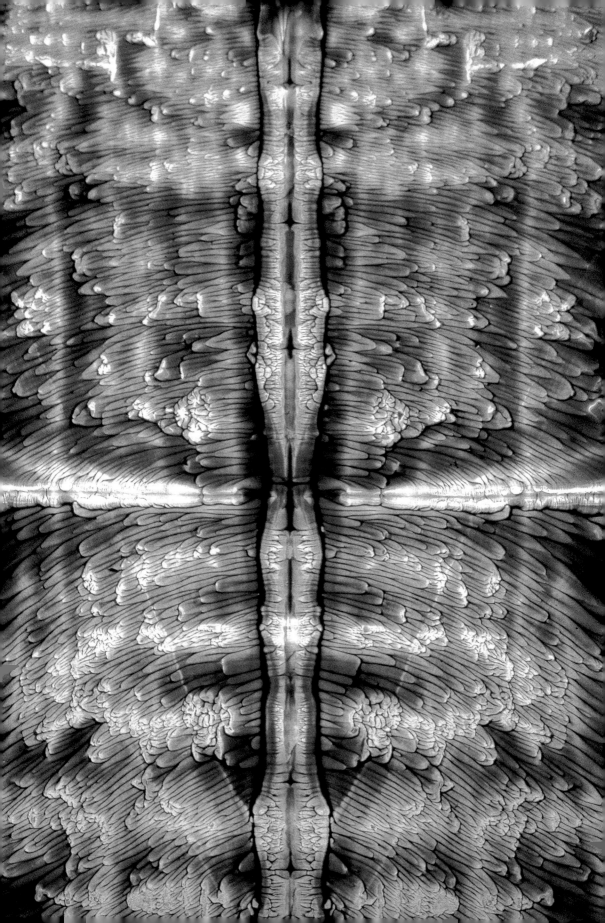

(left)
Blue Fractal Cross
1999, acrylic on acetate 8x12"

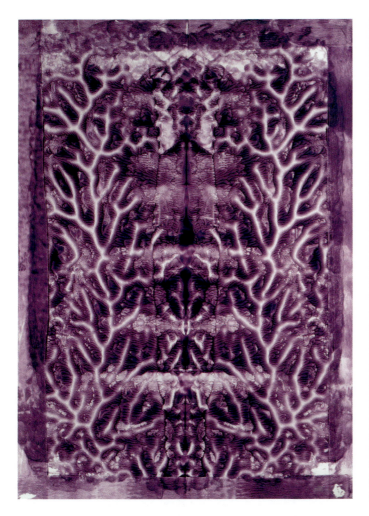

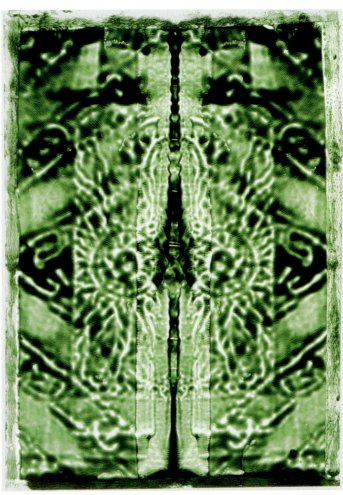

Purple Fractal
1999, acrylic on acetate,
8.5x11"

Fertility
1999, acrylic on acetate,
16x20"

The evergreen lingam
and life-giver.

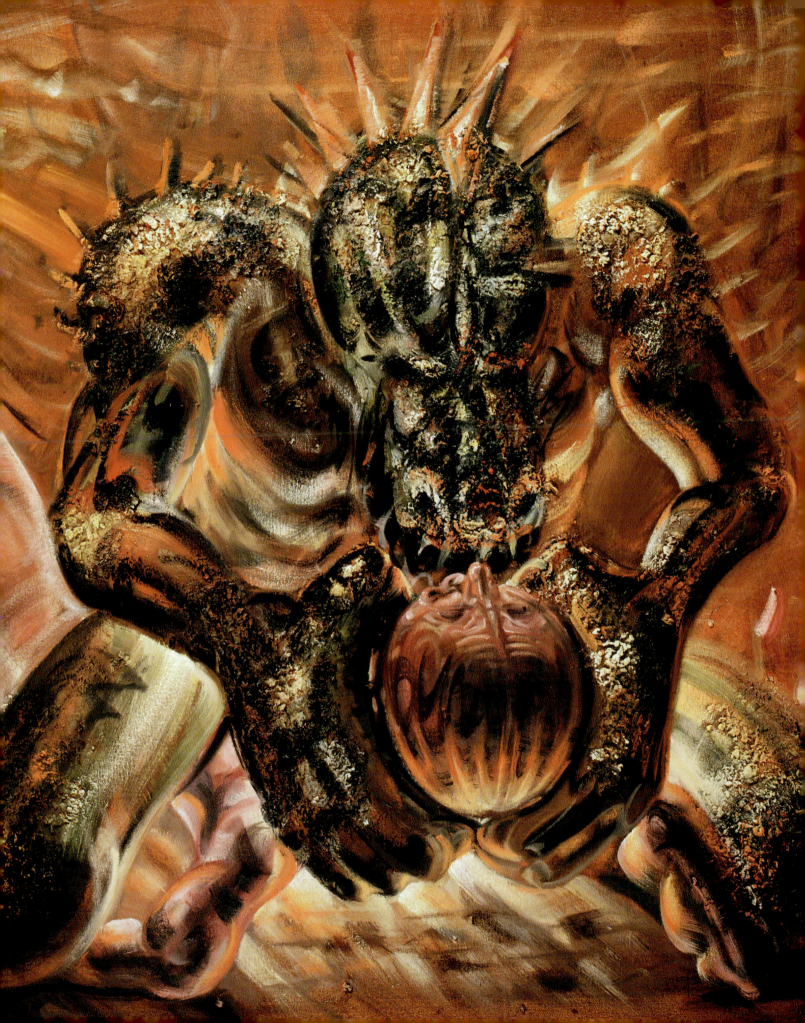

Chapter 7

St George and the Dragon

The loss of my father and the show at Proud Galleries following in quick succession left me depleted and without a clear way forward in my work. I entered a fallow period and lost focus. I needed to; resisting these winters in the creative process is dangerous and can lead to total exhaustion and depression. The artist rarely knows what the new direction will be, but must trust the process of downtime and allow the psyche to completely unravel and renew.

When the time came for the next body of work, I felt it like a strong wave that propelled me back to Los Angeles. I had lost my sunlit studio on the top floor of the police station and had to relocate to a basement space with no natural light. This move downwards was appropriate: like Orpheus, I was descending.

Braintree (p. 142) announces the change. After the bright hope of **Autumn Sunrise (p. 88)**, this next 'postcard' from my inner journey puts dawn on hold. The sci-fi surrealism of **Carnal Landscape (p. 60)** has evolved into a more naturalistic setting, but the mood of anxiety prevails. The tree blitzed by light on the left recalls a cerebellum perched on its brainstem, hence the title. This is not a consoling light; it is harsh, mental and clinically exposing.

As if in response to this psychic shift, came a commission from the art collector, Duncan McLaren, to paint my version of St George and the Dragon – that timeless tableaux involving a knight, a fire-breathing dragon and a captive maiden. The subject has fascinated artists from Uccello and Tintoretto to Rubens and Gustave Moreau, and I was greatly inspired to make my contribution to the pantheon.

But first I had to understand how the subject spoke to me, and how modern psychology had clarified and expanded its meaning.

At the core of the knight's quest is the maiden. In **She (p. 132)**, this feminine siren is imagined in a submarine world where she smoulders with light and magnetic attraction. She represents the soul trapped far below the surface of everyday awareness, and she calls to the conscious self (the knight) to rescue and heal her. But standing in the way is the ego. This monster must be defeated for the true, soul-filled self to emerge.

I had always been fascinated by **Da Vinci's profile drawing, A Warrior in a Helmet (p. 135)**, and now it came forward as the template for my own self-reinvention as the knight. In **Self-Portrait as Leonardo's Warrior (p. 135)**, I 'suit up' in readiness to answer the

'Whenever you see images of St George and the Dragon, you always see the fearless rider having slain a very small dragon. In my mind the dragon is much bigger than the man and horse. So, I commissioned Alexander to reverse the whole event and have the Dragon and St George grappling for survival. I always felt marginally sorry for the Dragon. Alexander's interpretation of this moment of struggle I love. Who will win? The doubt is there.'

Duncan McLaren

maiden's call. The other accoutrements of my warrior-self come to hand: a shield, various war helmets and armours, and a powerful horse (pp. 136–141).

On this proud steed I make my way deep into the unconscious realm, until a dark, forbidding wood challenges my progress. **Dragonwoods (p. 144)**.

It seems natural at this juncture that I should continue on foot – **Entering Dragonlands (p. 145)** – seeking direct contact with the beast and fighting him in hand-to-hand combat. This is a story about a man in conflict with himself; and the horse – with all its traditional associations of valour and domination – is therefore superfluous.

'Out of arguments with others we make rhetoric, out of arguments with ourselves we make poetry.' Yeats's saying was on my mind as I worked. I was sensing that my whole project was futile and misdirected, and that the dragon was in fact my ally. He represented that portion of my life force that had been split off from me in childhood during my indoctrination into 'civilised' life. The Whole Man is threatening to the status quo and therefore it is best to start breaking him early through the false trials of education and institutionalised control. Herein lay the true villain of the piece, teaching me to demonise myself and fear my own power.

The paintings are therefore full of a tension between my traditional allegiance to the Jekyll/Hyde myth and my growing suspicion that I deeply needed the dragon's wildness and inspiration far more than his obedience.

I began to conceive of a series of paintings that would explore each phase of the encounter between man and beast: from violent engagement, through death and mourning, to eventual enlightenment. As St George saves his soul, he also brings light into the shadow, so that its power can be turned to deliberate and compassionate use in the world.

My battle with the dragon took a year and challenged me on every level: technically, emotionally, intellectually and physically. Many of the works were created in a state of frenzy in which I lost myself and emerged in a daze when the image had somehow resolved itself.

Possessed (p. 150), a thickly painted 4x4ft canvas came together in a flash. It describes the crucible of the Jekyll and Hyde conflict that can only be resolved by integrity.

Mastery (p. 152) is the main picture in the sequence, and the largest. St George gains the upper hand and dominates his flailing foe. The outcome is still in doubt, but St George's face, twisted by effort, almost seems to smile.

In **Hesitation Before the Kill (p. 154)**, the maiden stands on a distant cliff, arms raised to

heaven in anticipation of her saviour. Perhaps our hero confuses her soulful cry with the dragon's last gasp, because for a fatal moment he hesitates and goes limp. Is he killing himself?

Kill (p. 155) decidedly banishes the moment of doubt and the thing is done with orgiastic, blood-lusting finality.

Mourning the Dragon (p. 156) explores the immediate aftermath of victory, when St George collapses over his opponent and is suddenly and accountably overwhelmed by grief. In the heat of conflict some of the dragon's spiky features have transferred to him, and for the first time he feels the truth that in defeating the dragon he has defeated himself.

Theseus and the Minotaur

Many years later, in 2017, it was Duncan McLaren who again inspired me to return to the underworld, this time to paint my rendition of the myth of Theseus and the Minotaur. What began in conception as a more tender and inwardly reflective work, ended again in violence. It's clear that the process of understanding, loving and enlightening the shadow takes a lifetime.

In the painting **(p. 158)**, the man without a face is in fact the aggressor. The dragon throws back his head and in his death throes we suddenly recognise the victim who compels our sympathy. We realise that he has never been heard. He is wild and beautiful life in its essence. There is no happy ending here.

> 'Out of arguments with others we make rhetoric, out of arguments with ourselves we make poetry.'
>
> **W.B. Yeats**

Study for St George Triumphant
2000, charcoal on paper, 16x20"

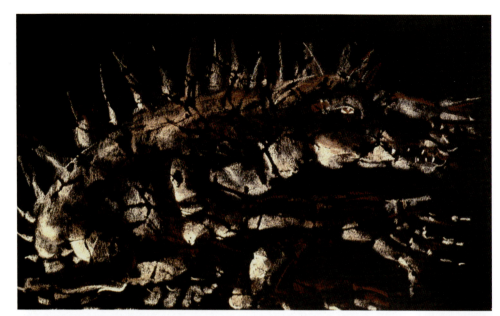

St George and the Dragon black drawings
2000, eleven pastel studies on black paper, 8x12" each

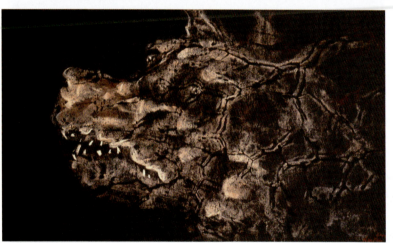
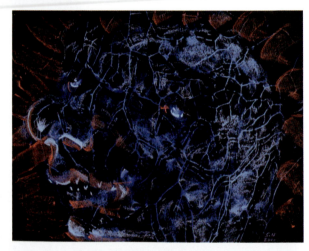
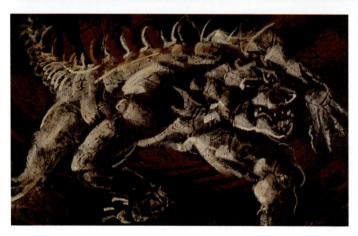
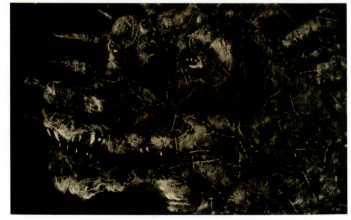

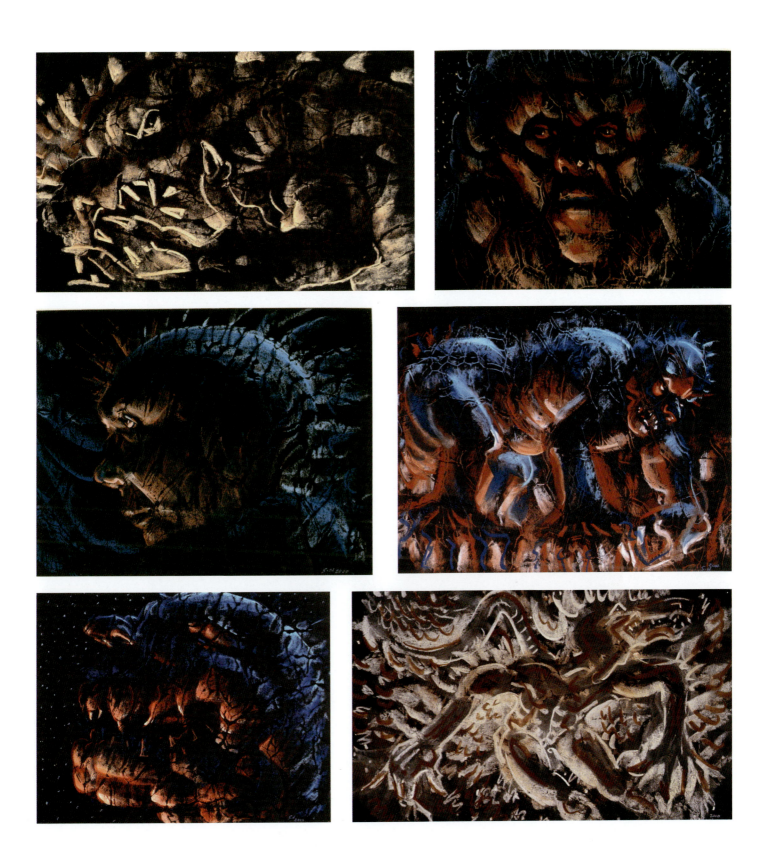

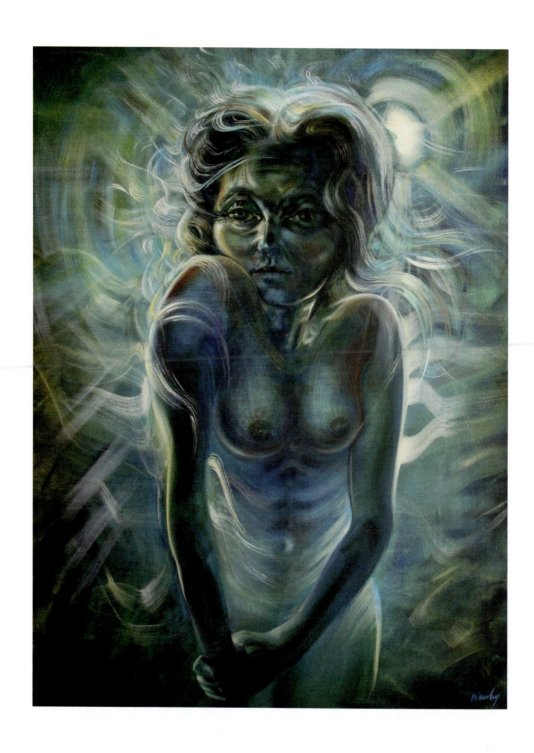

She
2000, oil on canvas, 32x42"

She Devil
2000, mixed media on paper, 20x20"

The maiden also has a demonic aspect, possibly as a result of her woundedness and victimisation by the dragon's ignorance and wrath. The violation of her sacred innocence and the pain, and feelings of rejection associated with that, have turned to anger and a desire for revenge – provoking fear and hostility in the viewer.

Armoured Man
2009, oil and acrylic on canvas, 30x32"

Armour is the dragon's thick skin covering the man, making him insensitive, just as it makes him invulnerable. Eventually, if the maiden's call goes unanswered, it swallows and deadens him completely.

I had always been fascinated by Da Vinci's profile drawing, *A Warrior in a Helmet*, and now it came forward as the template for my own self-reinvention as the knight ...

Leonardo da Vinci's profile drawing, A Warrior in a Helmet

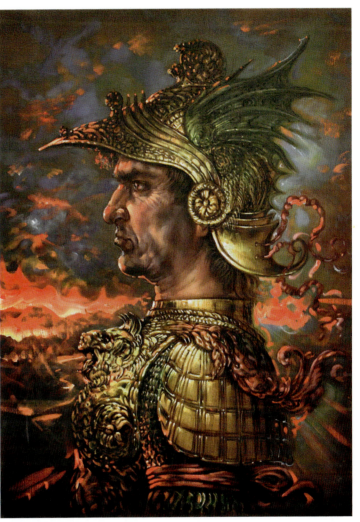

Self-Portrait as Leonardo's Warrior
2009, oil on canvas, 30x40"

Armour Study 1
2008, oil and acrylic on board,
18x24"

Armour Study 2
2008, oil and acrylic on board,
18x24"

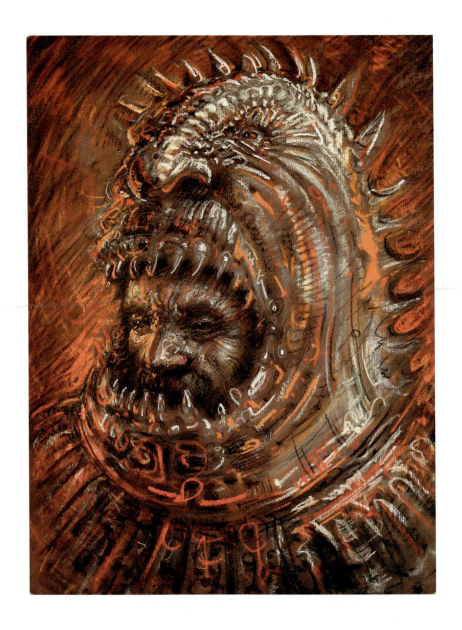

Man in a War Helmet
2009, pastel and conté on paper, 18x27"

Although the man inside the armour is still alive, his belief in the war is dead.

Shield Study
2009, oil and acrylic on canvas,
24x24"

War Horse
2009, pastel and conté on paper,
18x18"

Riding to the Dragon
2009, pastel on paper, 18x27"

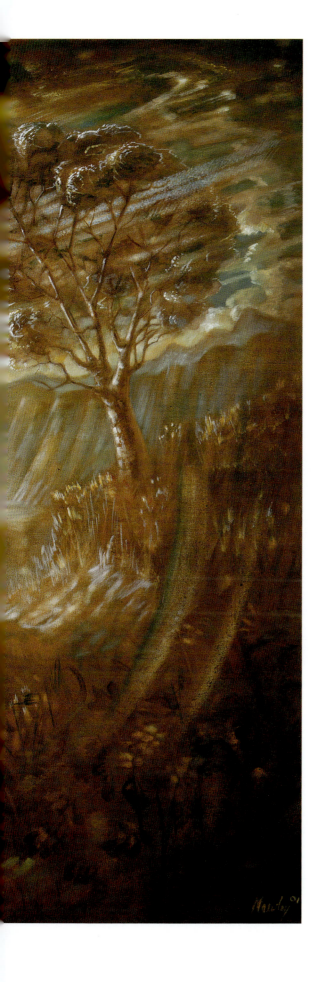

Braintree
2001, oil on canvas, 36x52"

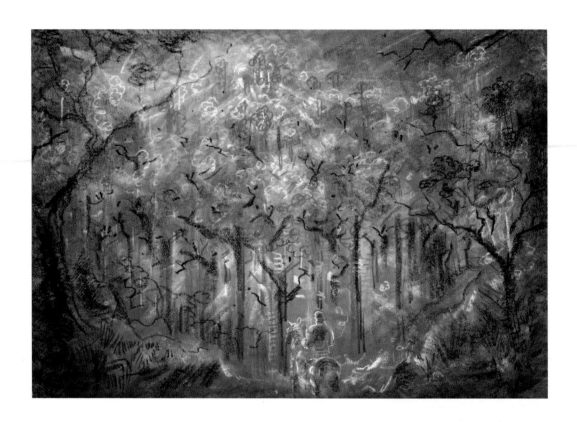

(above)
Dragonwoods
2009, pastel on paper,
18x27"

(opposite)
Entering Dragonlands
1999, oil and acrylic on canvas,
48x62"

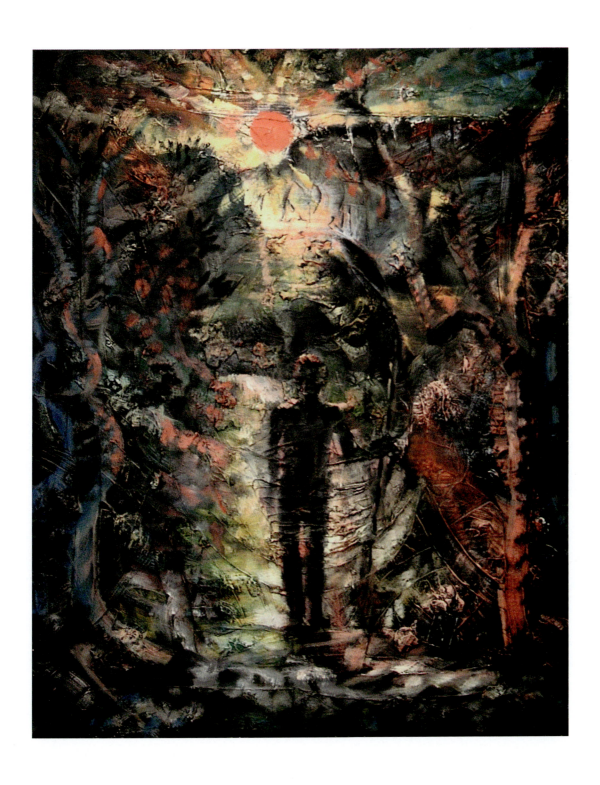

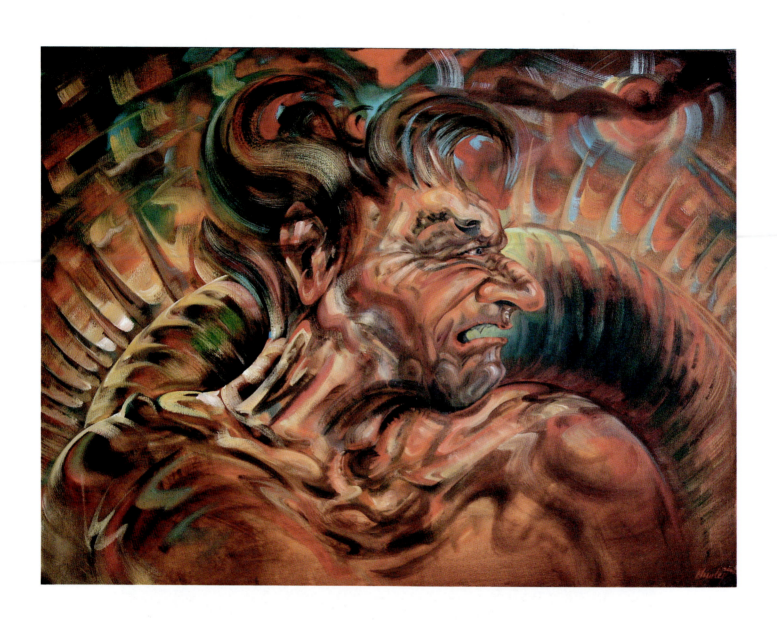

Head of St George
2000, oil on canvas, 32x42"

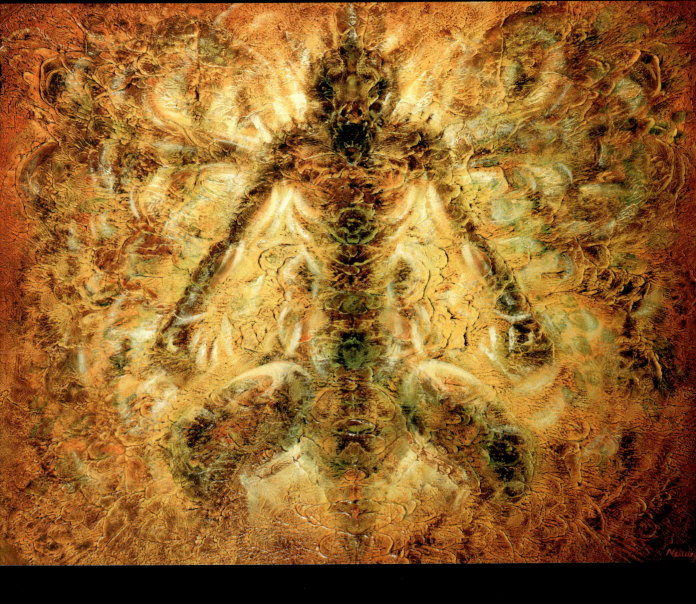

Dragonfire
2000, oil and acrylic on canvas, 48x60"

The dragon perceived through a torrent of flame, blowing a hot ball of gas that encloses him like a sun. We are at the source of that inner radiance that has led the knight to his doom, and eventual salvation.

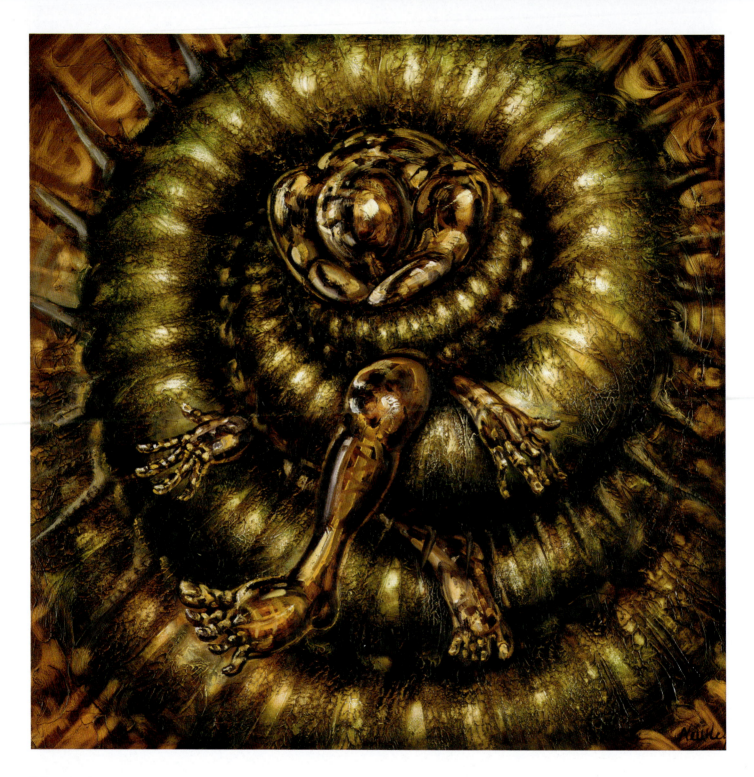

Tail-wrapped
2000, oil and acrylic on canvas,
36x36"

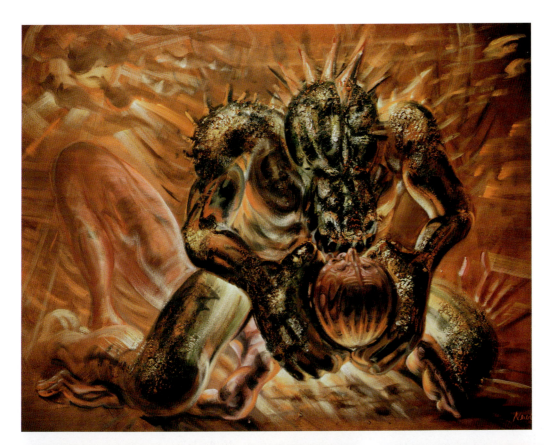

Strangler
2000, oil on canvas, 18x18"

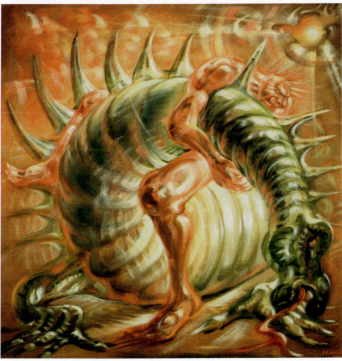

Strangler, small study
2000, oil and acrylic on canvas, 32x42"

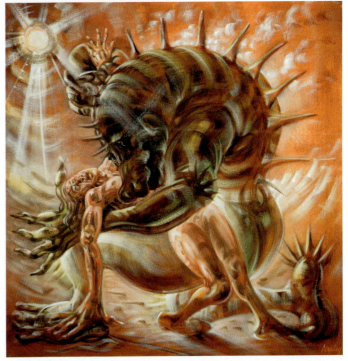

Dragon Tango
2000, oil on canvas, 36x36"

I sense the dragon's playfulness here: he's making a fool of me, casting me as the passive partner in his dance of death – but not out of spite; he just wants to shake me out of my morbid silliness so that I can live a fuller life.

ST GEORGE AND THE DRAGON

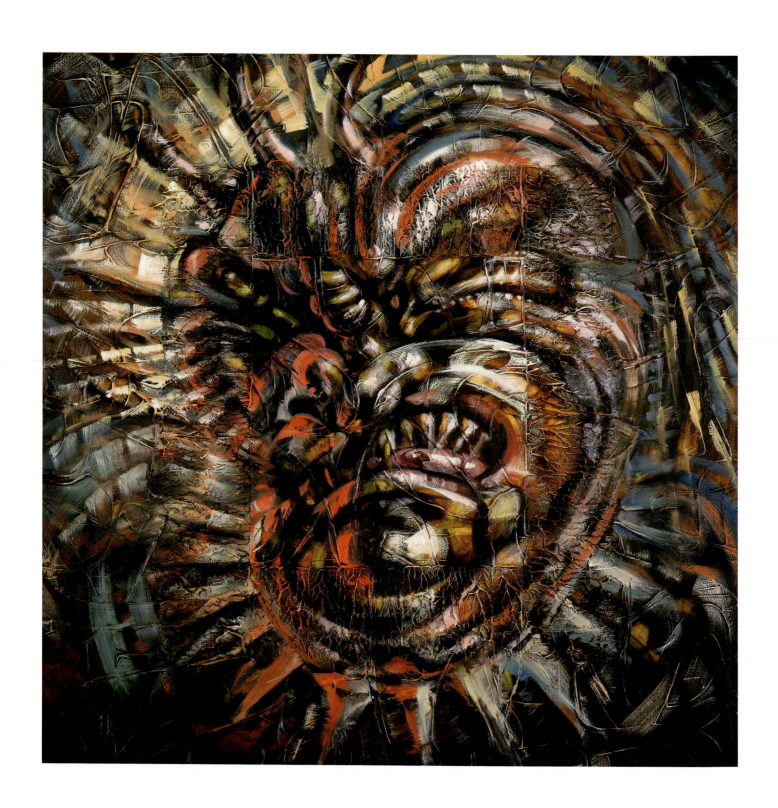

Possessed
2000, oil on canvas, 48x48"

Study for Mastery
2000, charcoal and ink wash on paper, 18x26"

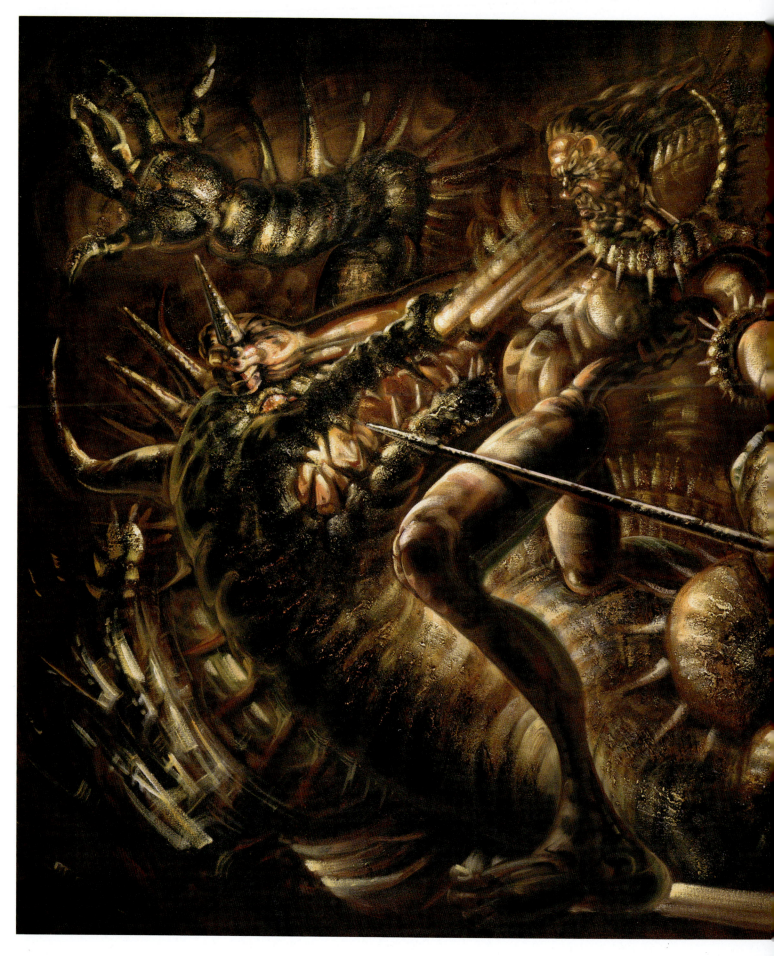

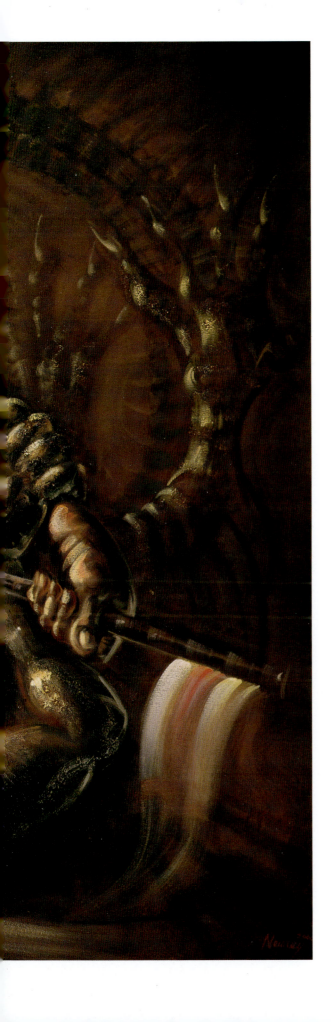

Mastery
2000, oil on canvas, 48x60"

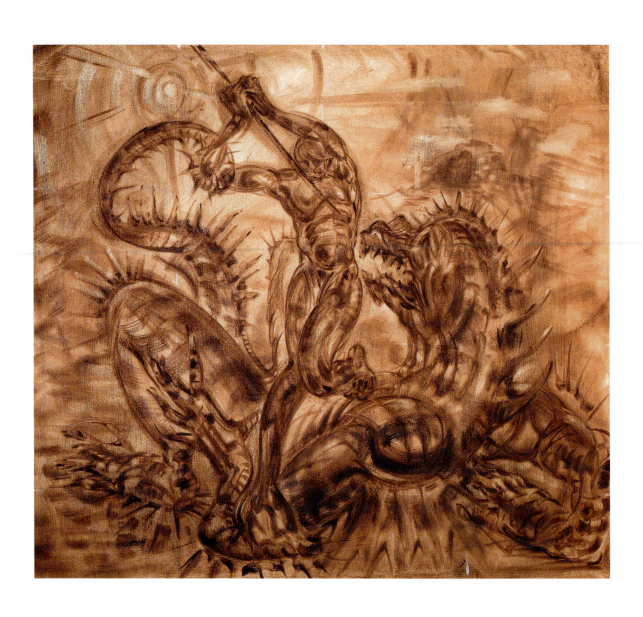

Hesitation before the Kill
2000, oil on canvas, 36x36"

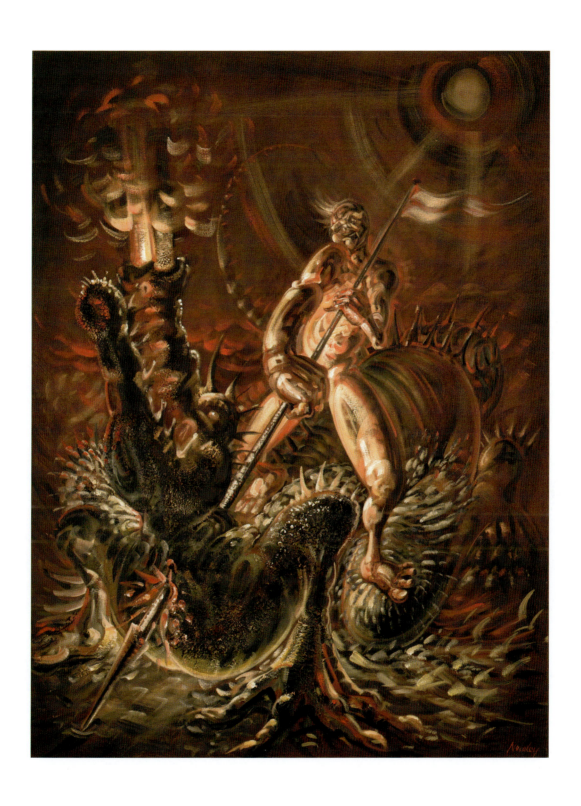

Kill
2000, oil on canvas, 34x48"

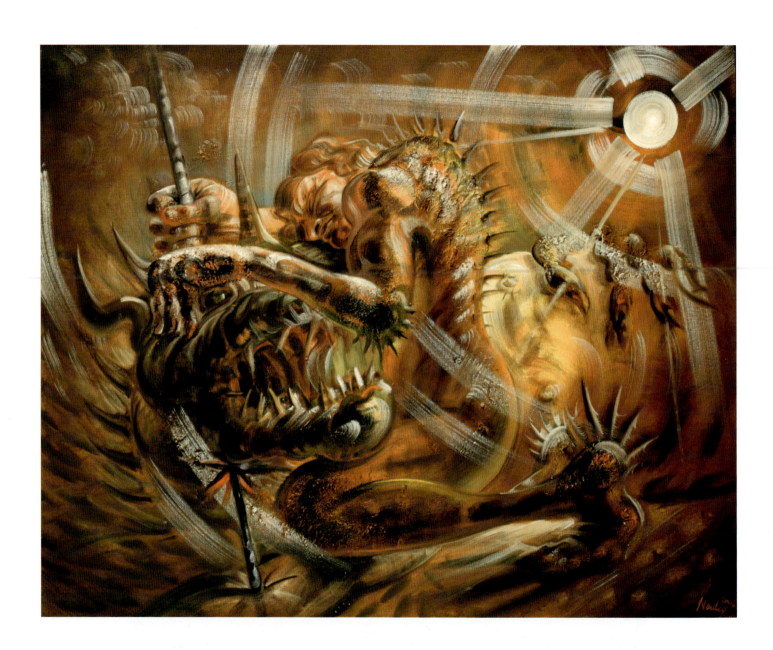

(above)
Mourning the Dragon
2000, oil on canvas, 34x48"

(opposite)
St George Triumphant
2000, oil on canvas, 50x60"

Our hero stands on the mountain top, flying the flag of his integration: half-man, half-beast, but greater than both. He has transcended duality and has the wings to show for it.

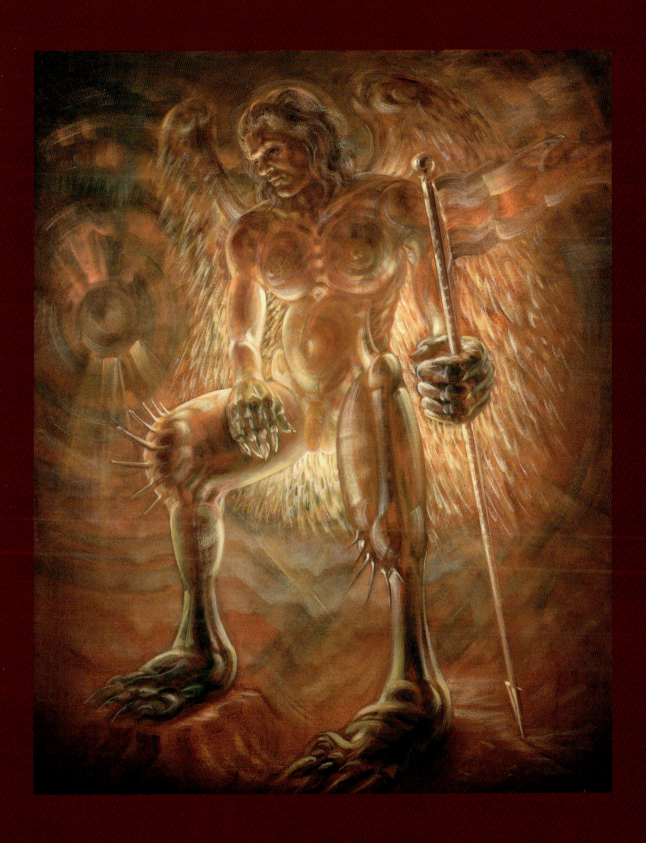

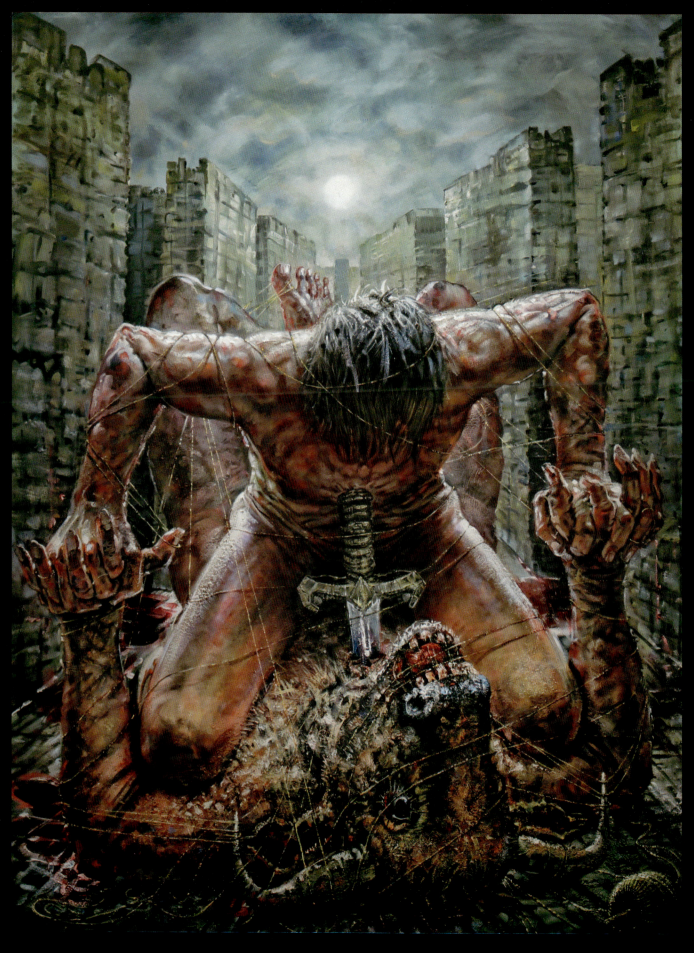

(opposite)
Theseus and the Minotaur
2017, oil on canvas, 40x56"

The golden thread Theseus uses to navigate the labyrinth entangles man and beast in a fatal embrace. At heart, they are ever-connected in a cycle of death and rebirth.

(above)
Theseus and the Minotaur Pietà
2016, pencil on paper, 12x18"

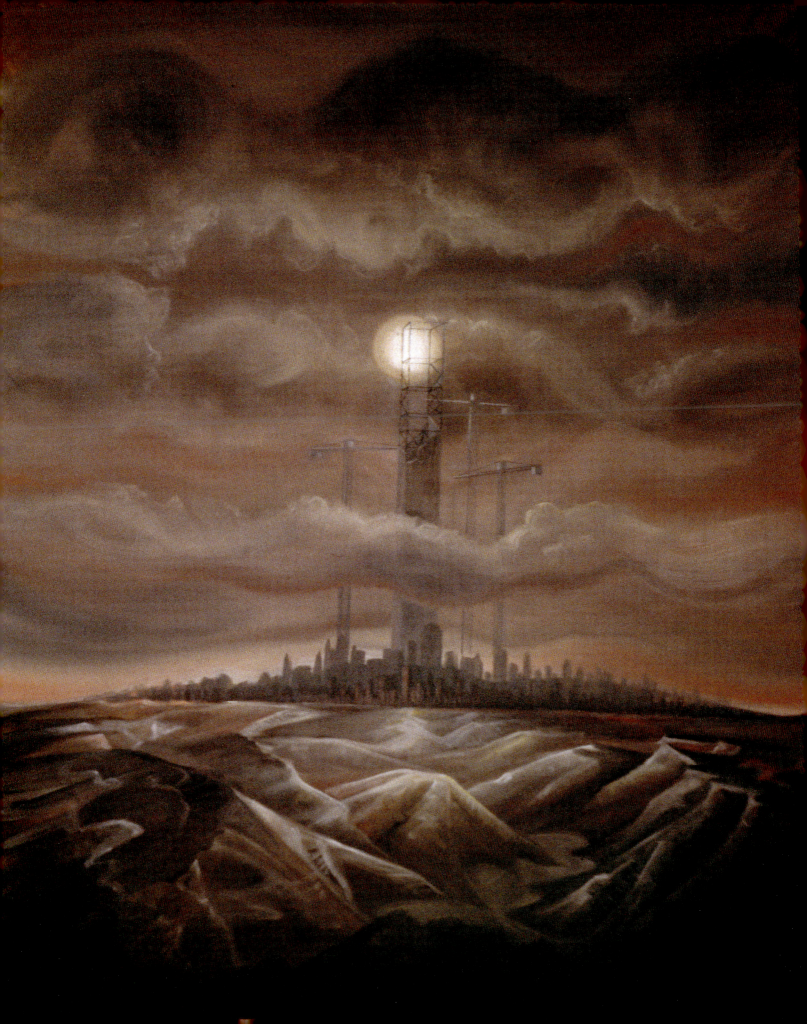

Chapter 8

The City

The city, as a symbol, has featured in my work since the beginning. In **The Wall (p. 164)** it takes up the entire background and casts its spell of division and mistrust over the waifs and strays that parade through the foreground. These figures were made by tracing the grain in the wood panel on which I was working. The spirit of the piece recalls the neurotic and paranoid works of the Weimar artists, George Grosz and Ludwig Meidner, and shares their dark view of the city as a distraction, a temptation to depravity and frivolity where energy is frittered away and the human being wears a mask, or the 'face to meet the faces that you meet' as T.S. Eliot describes it in *The Love Song of J. Alfred Prufrock*.

This pessimistic view is taken to the extreme in **The Tower (p. 166)**, a brooding and dystopian vision of a metropolis in a graveyard of its own making. The relentless growth of the city has literally sucked nature dry, to the point that we seem to be on the moon or a planet hostile to life, such as Mars. The sky is a noxious brew of gases, and the unfinished tower – my contemporary take on the Tower of Babel – appears as an empty, skeletal boast against the suffocated sun.

In **Lunar City (p. 172)**, the fallen world has literally relocated to the moon and enjoys a retrospective view of Mother Earth through a protective, atmospheric dome. This sci-fi vision is a critique of the fantasy that would have us transfer the earthly spore of nature and paradise to extra-terrestrial planets. What results is a further disengagement from nature and an increasing dehumanisation. The 'park' that nestles under the dome can only ever be an artificial copy of Nature herself.

If I dealt exclusively with the shadow aspect of the city in my early works, my move to New York City in 2000 changed all that. In a stroke, my negativity disappeared and my vision of the metropolis was transformed. More than any other city, New York seems to exist on two levels at once: the visionary Oz, which promises fame and fortune, and the grinding reality of the day-to-day concrete jungle, which eats human energy and spits out failure. The friction between these two 'cities' was to prove the driver of my New York pictures.

Sheep Meadow (p. 174) and **303 Central Park West (p. 175)** come from my first period of ecstatic engagement when I was painting the city en plein air. With their combination

of linear and natural form, these works recall the world of my abstracts. I also crossed the East River to paint the famous view of **Brooklyn Bridge (p. 163)** with the soaring World Trade Centre behind it. I had no idea that the unspeakable events of 11 September were only weeks away.

I was so inspired by the city that my imagination soon took over and I no longer had to leave the studio. **Dawn, Manhattan Island (p. 176)** is a rhapsodic anthem to the ideal city. The Big Apple's seductive powers have convinced me that fortune lies here. The city is no longer a trap but an accelerator of our dreams and potencies. I'm feeling, in other words, what everybody feels when they first move to New York.

But the more I worked, the more the pictures opened to a dynamic energy verging on the apocalyptic. Looking at these pre-9/11 pictures now, I see a clear prophetic strain. In **Manhattan Office (p. 178)**, the powerful executive gazes through his floor-to-ceiling windows at what appears to be a mayhem of exploding and collapsing buildings. In **Times Square (p. 170)**, the eerily quiet heart of capitalism's carnival seems to forebode emptiness.

It wasn't surprising that when I sent this body of work to London for my coming exhibition at the Catto Gallery there was a question about my making mileage out of the tragedy. I assured them that all the pictures had been painted *before* 9/11, and that any sense of impending disaster in them was due to artistic clairvoyance.

Man Protecting Child (p. 188) and **Carrying Out the Dead (p. 188)** were created after the tragedy. They reference its horror, and express the hope of a salvation through human kindness and love.

Several years later I experienced my own personal Ground Zero when I lost everything I had worked for and believed in – a degree of devastation that can either kill or provoke a powerful, defiant response. **Self-Portrait At Ground Zero (p. 189)** celebrates the latter. I stand naked in a blasted crater and look up through a ghostly crust of the city's foundations. There's a wild, sky-blue optimism in my eyes and a defiant desire in my body; even from the pits of tragedy life springs eternal.

I had no idea that the unspeakable events of 11 September were only weeks away.

Brooklyn Bridge
2001, oil on canvas, 16x24"

The Wall
1987, acrylic on wood, 30x40"

(left)
Man Sparing Change
1987, acrylic on board, 30x40"

A passer-by digs for change, even though he knows the ugliness of poverty is never going away. The simple, hard lines show the divisiveness and indifference of a city where natural compassion dies.

(opposite)
Graffiti Man
2000, oil on canvas, 20x30"

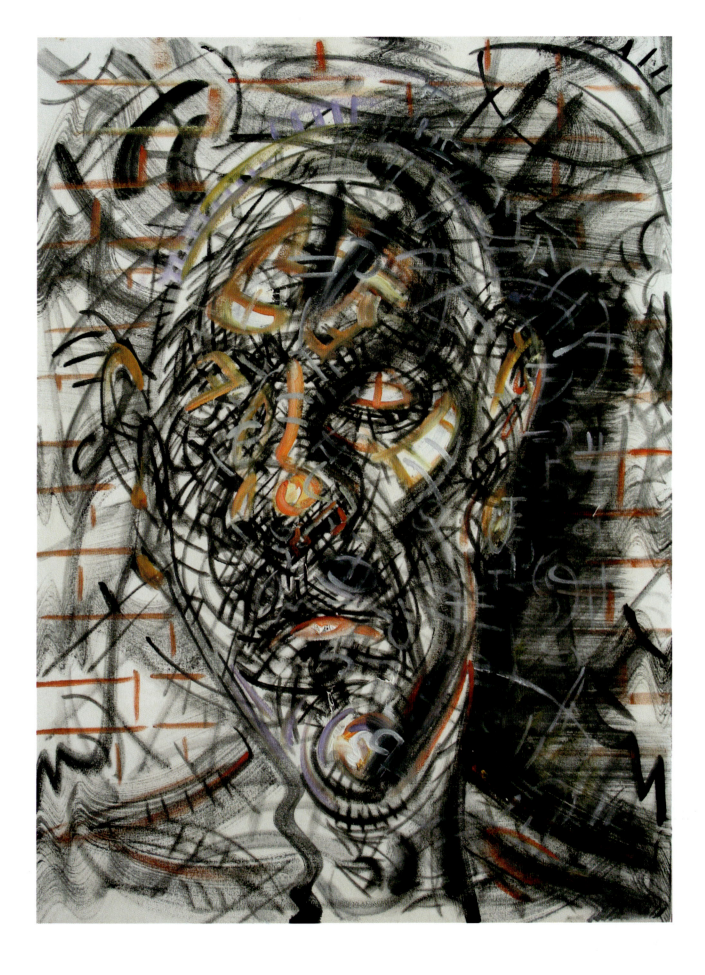

(left)
The Tower
1994, oil on canvas, 42x56"

(opposite)
Sin
2003, oil on canvas, 18x24"

This fellow arrived late one night and almost scared me out of the studio. I left him without colour because his power needs no elaboration. He sits enthroned at the city's centre and absorbs human power – turning it into fear, obedience and lifeless concrete.

The relentless growth of the city has literally sucked nature dry, to the point that we seem to be on the moon or a planet hostile to life, such as Mars.

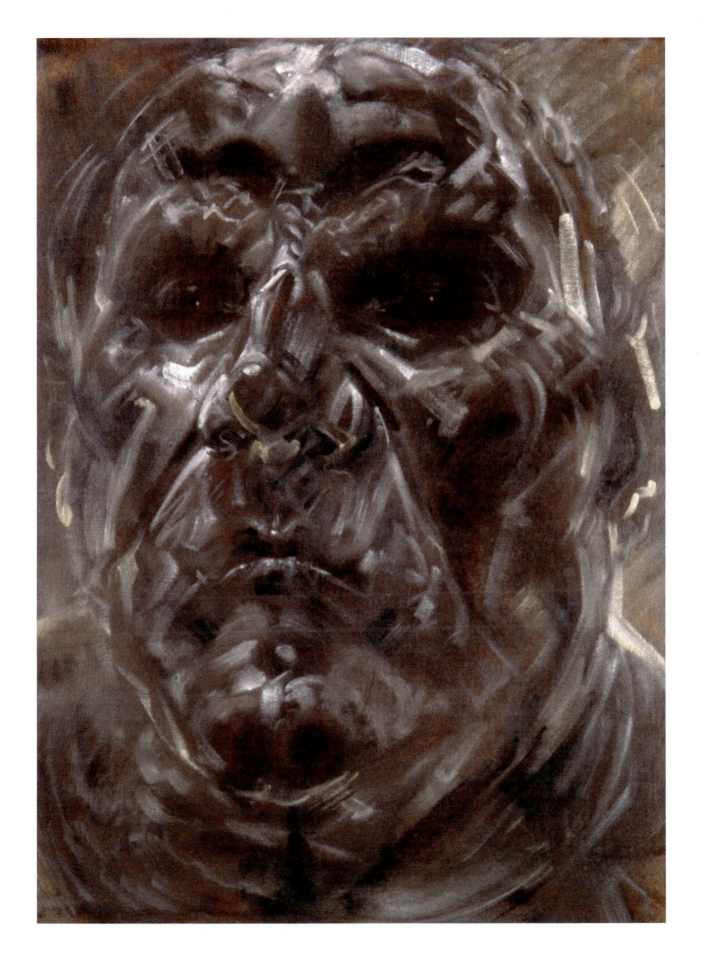

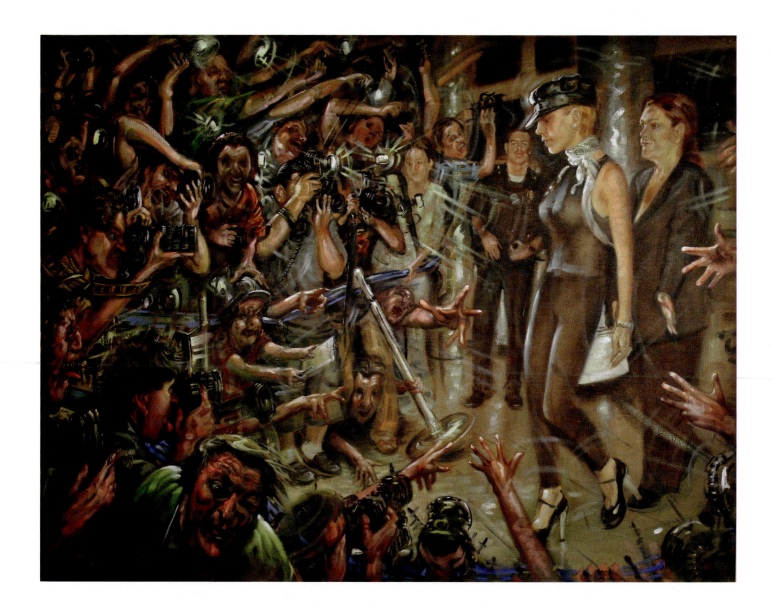

Paparazzi
2008, oil on canvas, 32x42"

The grotesque scrum of photographers are a contemporary equivalent of the ghouls and goblins of medieval fable. Severed from the divine source, they are lost souls who must feed off the false idols of celebrity culture.

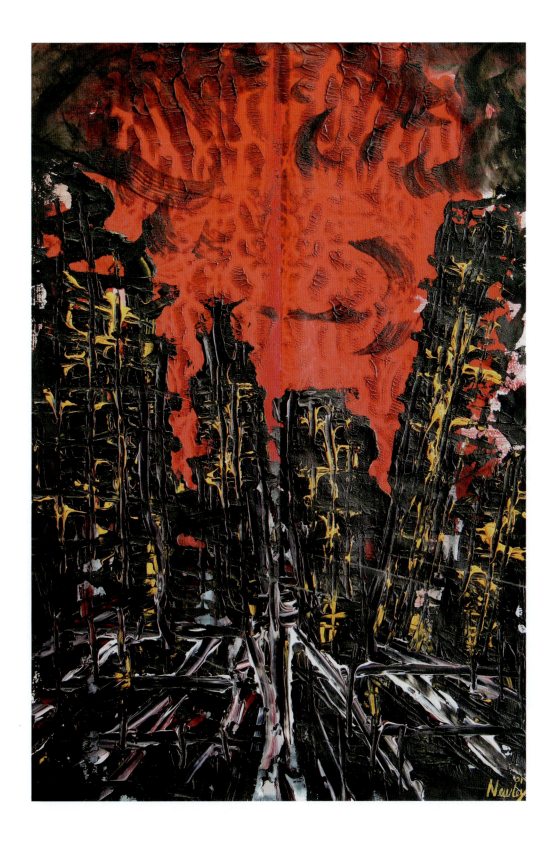

Hell City
2001, acrylic on canvas, 12x18"

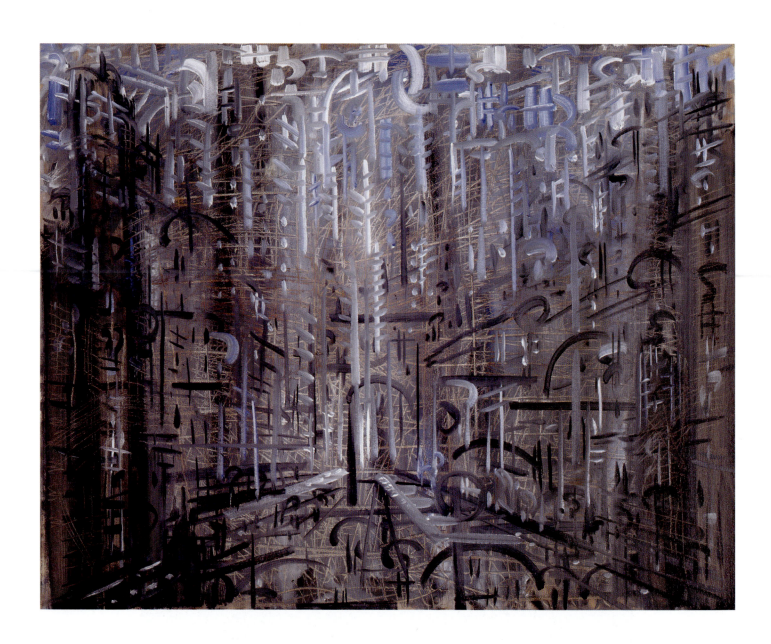

(above)
Times Square
2001, oil on canvas, 20x26"

(opposite)
Programmed
1998, acrylic on canvas, paper, 16x20"

His open mind receives a sinister, hypnotising frequency. He is programmed to obey without question.

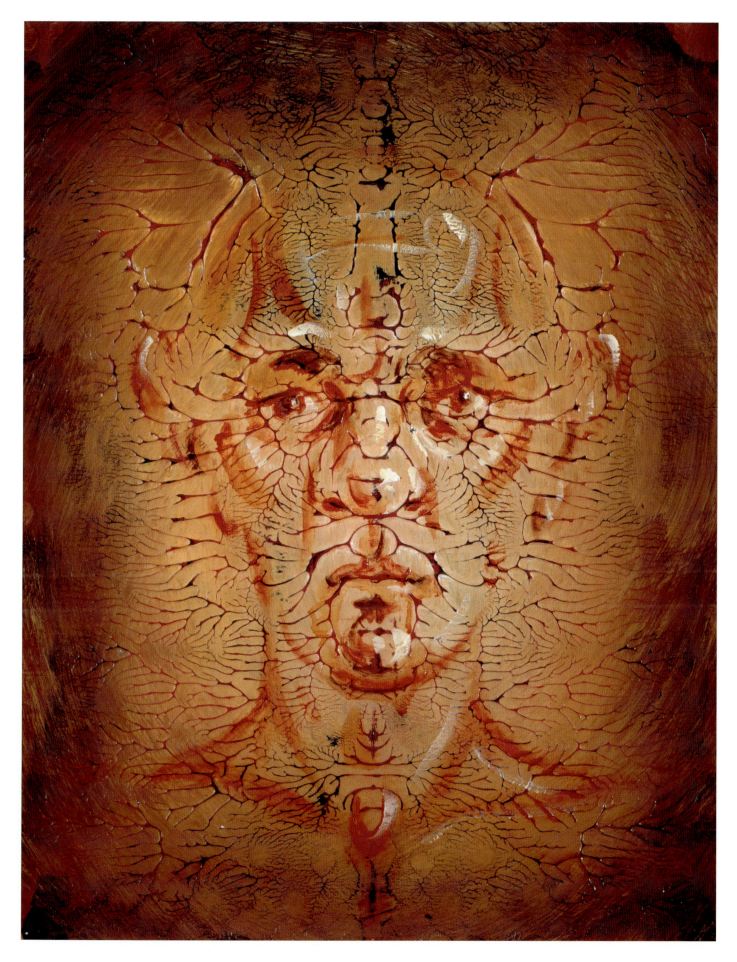

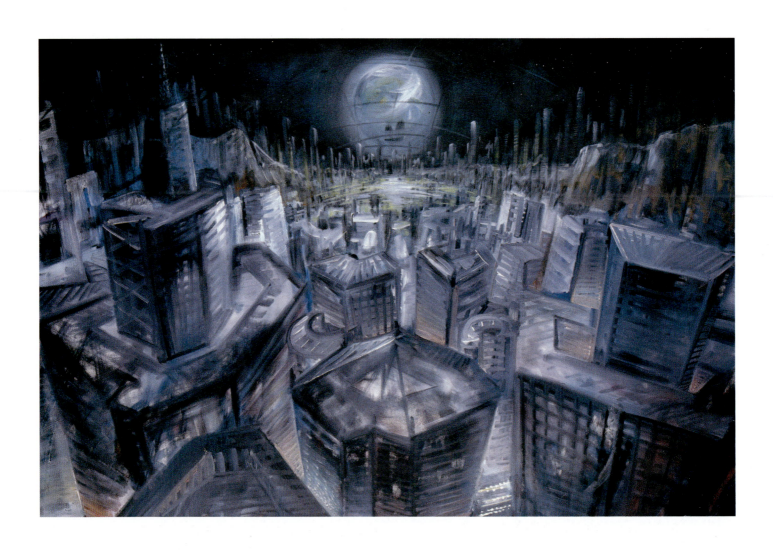

(above)
Lunar City
2005, oil on canvas, 48x72"

(opposite)
New York City Waking
2001, pastel on paper, 18x27"

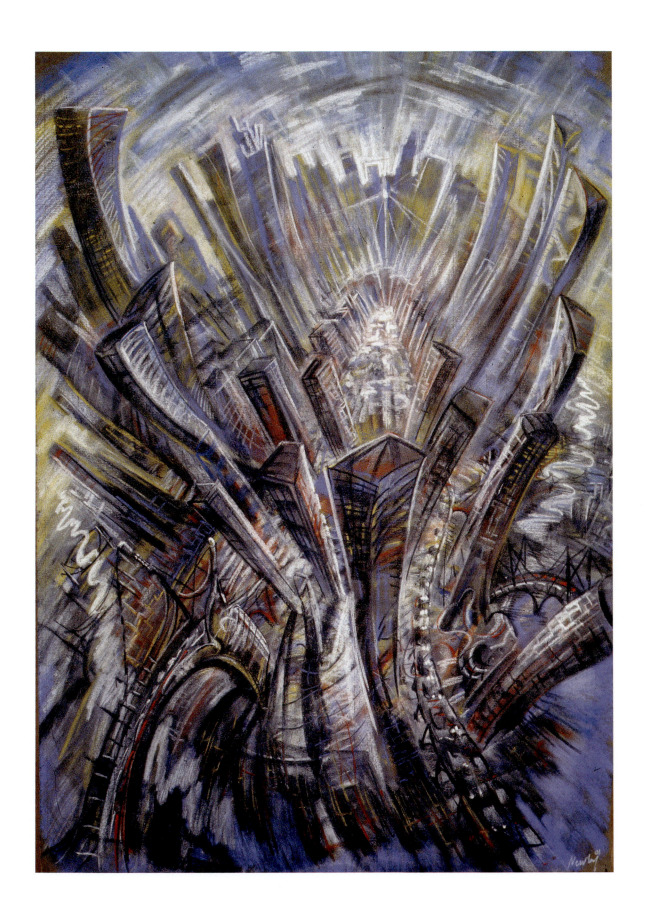

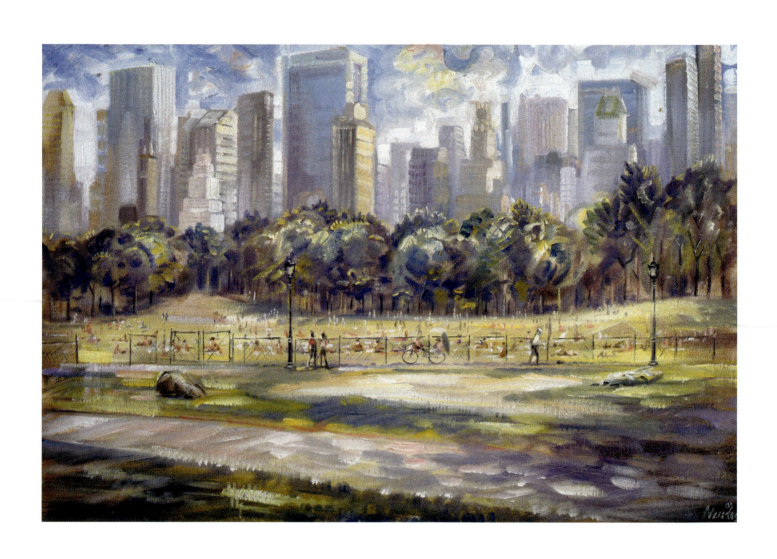

Sheep Meadow
2001, oil on canvas, 16x26"

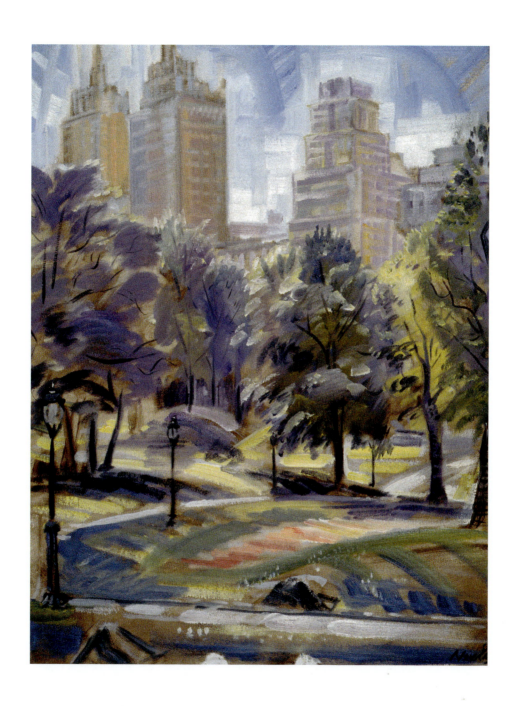

303 Central Park West
2001, oil on canvas, 14x18"

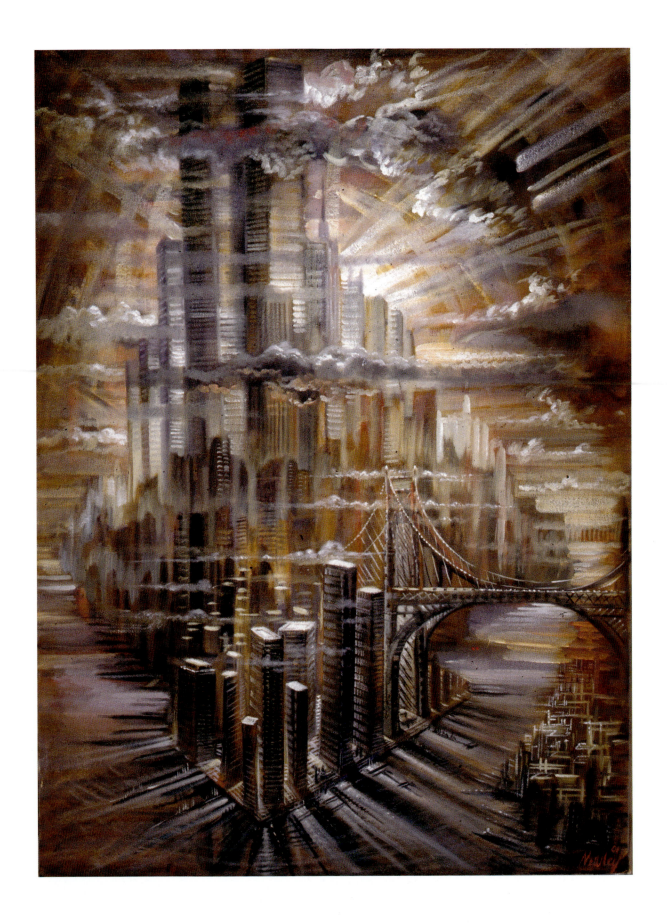

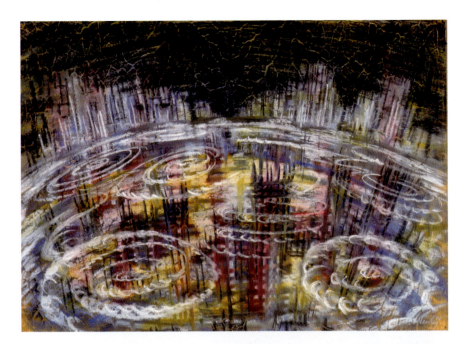

NYC from the Atmosphere
2001, pastel on paper, 18x27"

Red City from the Air
2001, mixed media on paper, 18x26"

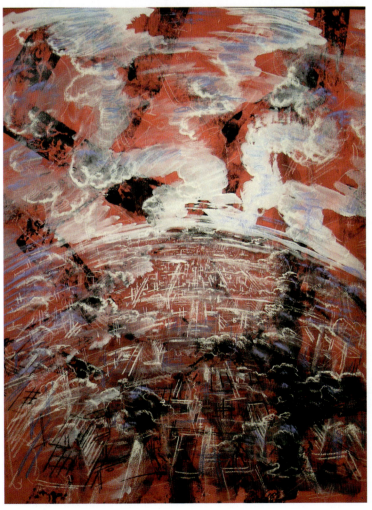

(opposite)
Dawn, Manhattan Island
2001, oil on canvas, 18x27"

My negativity disappeared and my vision of the metropolis was transformed... I was feeling, in other words, what everybody feels when they first move to New York.

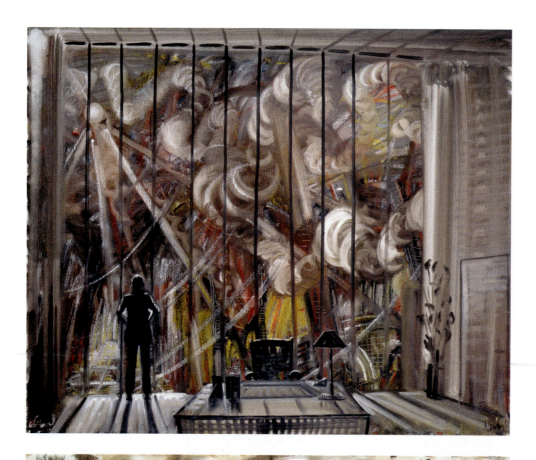

Manhattan Office
2001, oil on canvas, 20x26"

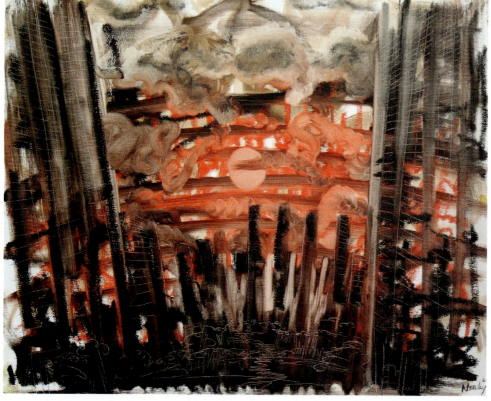

Red Sunset, Central Park
2001, oil on canvas, 16x20"

(opposite)
Storm, Lower Broadway
2001, pastel on paper, 12x20"

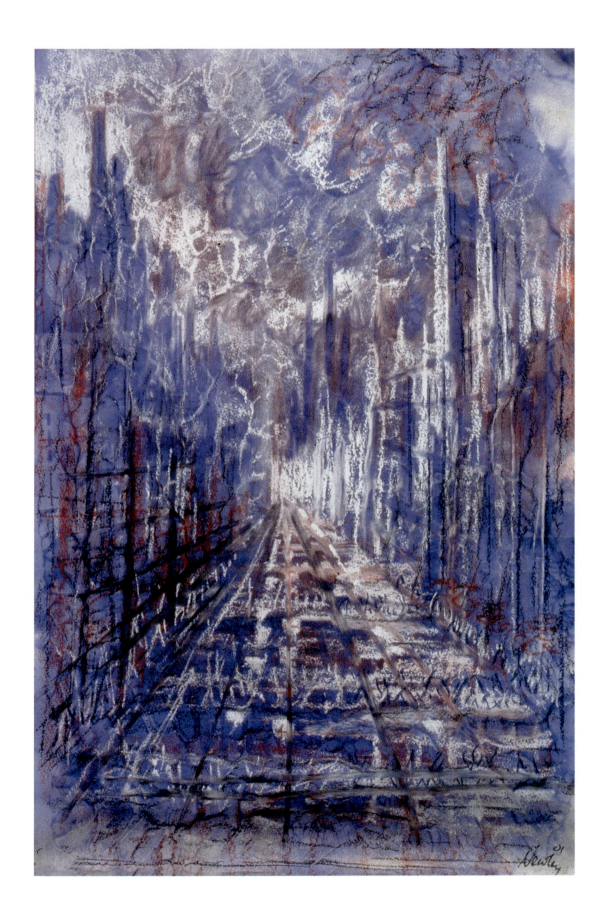

(above)
Ghost of the Park
2001, mixed media on paper,
18x26"

(opposite above)
Central Park, Winter
2001, mixed media on paper,
18x30"

(opposite below)
Central Park Dawn
2001, pastel on paper, 20x26"

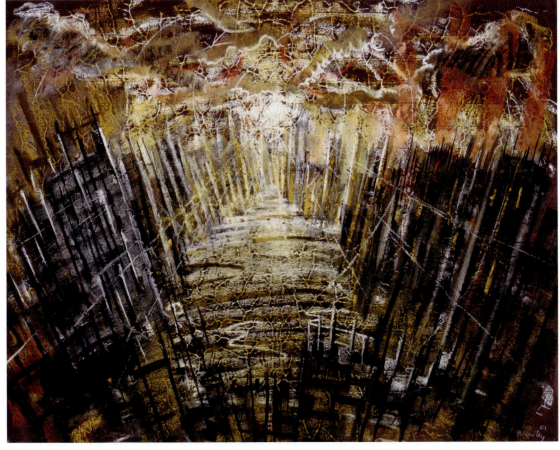

THE CITY 181

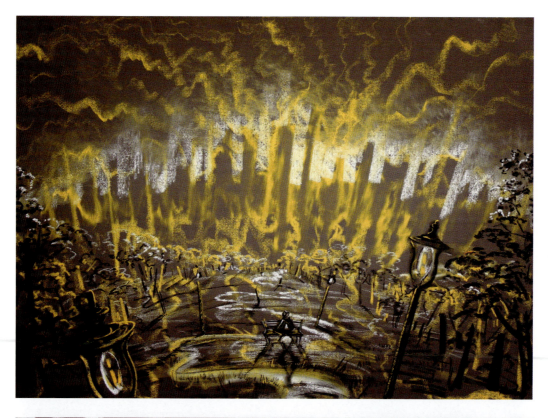
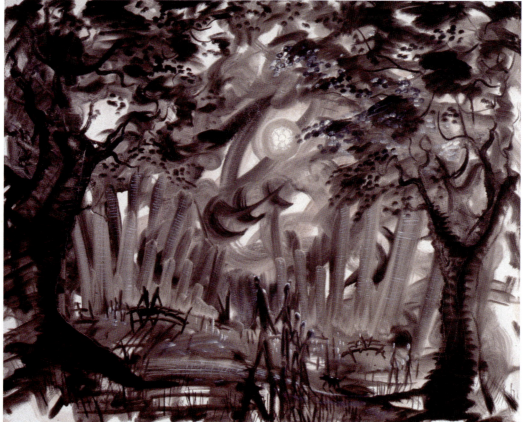

(opposite above)
Kiss in the Park
2001, pastel on paper, 18x26"

(opposite below)
A Walk in the Park
2001, oil on canvas, 16x20"

(above left)
Windy City
2001, pastel on paper, 18x26"

(above right)
Winter Rush Hour
2001, pastel and conté on paper, 10x16"

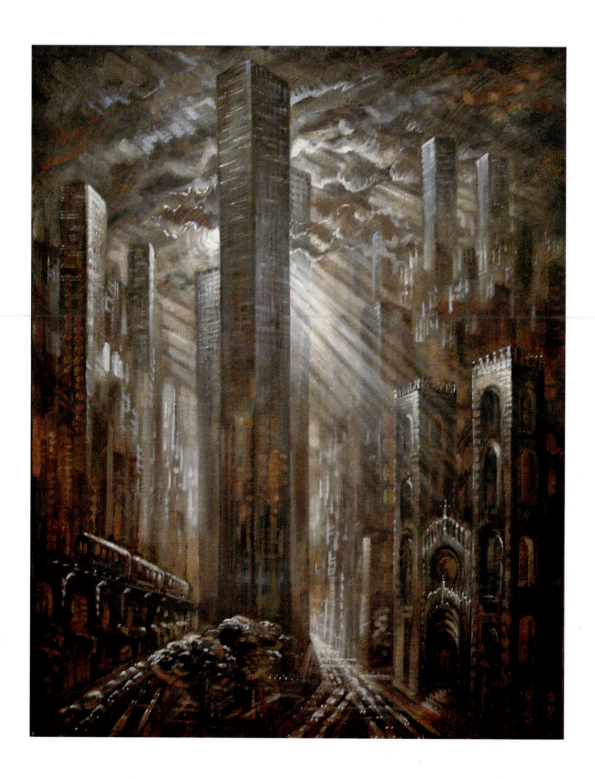

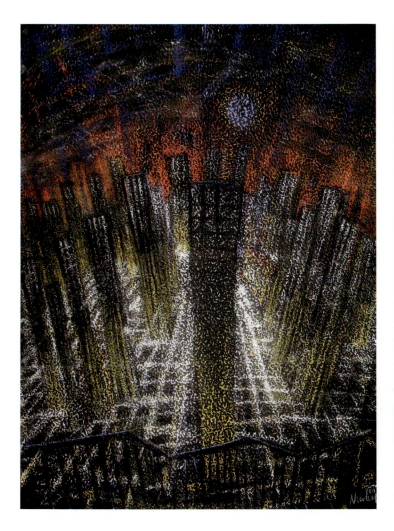 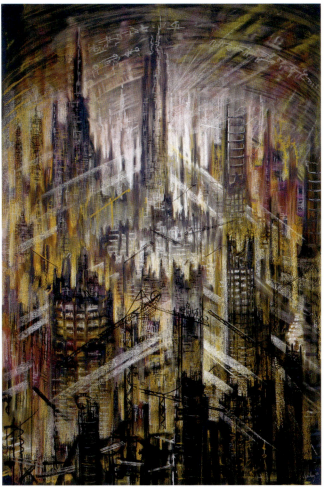

(opposite)
Church and City
2001, oil on canvas, 20x26"

(above left)
Bright Lights, Big City
2001, pastel on paper, 20x26"

(above right)
Building City
2001, pastel on paper, 20x26"

THE CITY 185

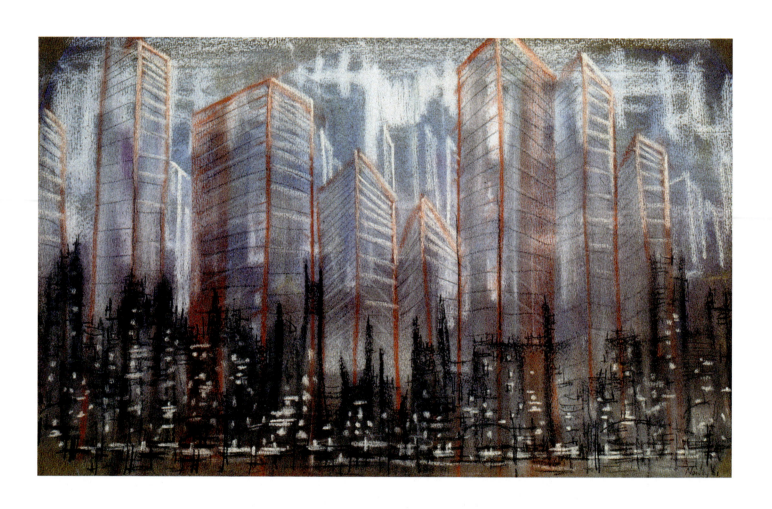

Old City/New City
2001, pastel on paper, 10x14"

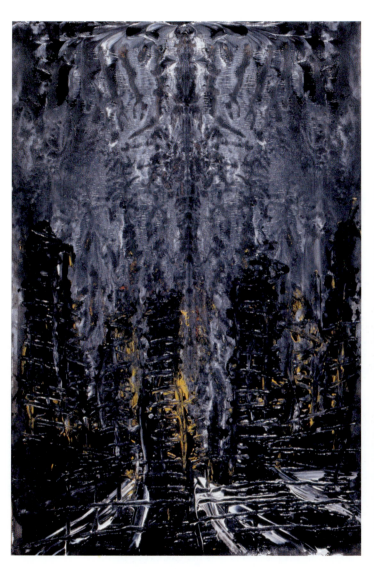

Black City
2001, acrylic on canvas, 12x18"

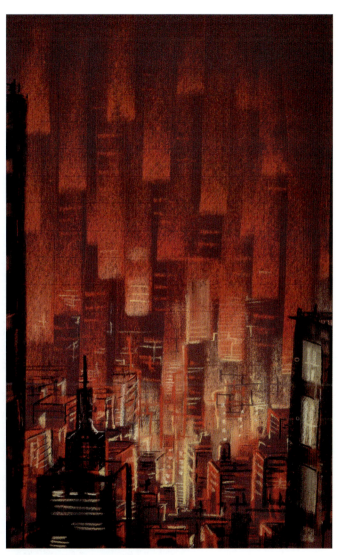

Hot City
2001, pastel on paper, 14x18"

Man Protecting Child
2002, pastel on paper, 30x40"

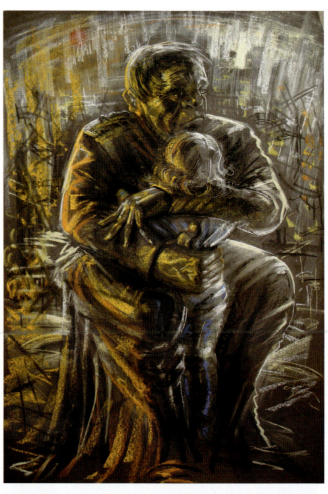

Carrying Out the Dead
2002, mixed media on paper, 18x24"

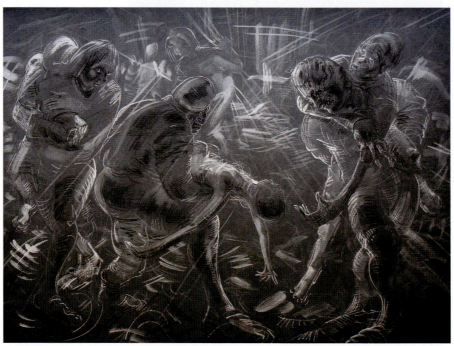

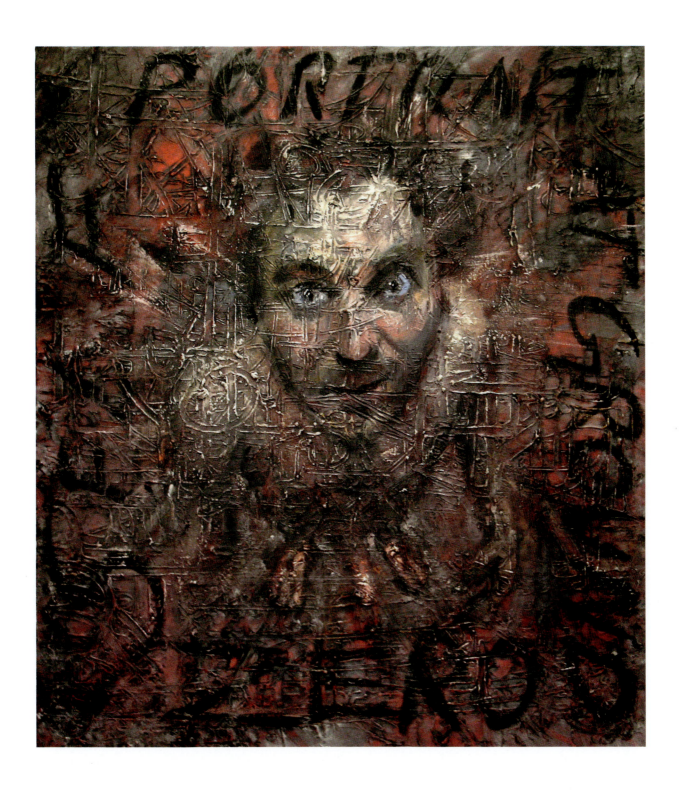

Self-Portrait At Ground Zero
2008, oil and acrylic on canvas, 36x36"

There's a wild, sky-blue optimism in my eyes and a defiant desire in my body; even from the pits of tragedy life springs eternal.

In the studio

Self-Portrait With Feet On The Ground (p. 192) shows me in my Harlem studio working through the challenge of a self-portrait. It introduces a series of pictures that take the studio, and the nude, as their subject.

Painter's Table 1 and **Painter's Table 2** (both p. 193) memorialise the blood, sweat and tears of painting with a fetishistic take on the artist's tools. For me these instruments have magic, and the spirit of toil that informs them a kind of virtue. Working with such exclusive focus to finish a work of art takes belief in the world and all it means. Otherwise, why bother? The creative act is therefore the opposite of nihilism.

Girl in a Red Chair (p. 194) owes a big debt to Lucian Freud and I was gratified to learn that the master himself, after seeing the painting reproduced in a magazine, confided to a friend: 'I was very attracted to the *Girl in a Red Chair* ...'

Self-Portrait In Kangol Cap (p. 201) was painted just before I left my Harlem studio for a larger space downtown. I wanted to take advantage of the skylight I had there, and posed myself for the painting in extreme toplight with my eyes cast in shadow. The picture sums up the impact of 9/11, and everything that I was going through at the time.

Painter in Studio
2000, mixed media on canvas, 14x18"

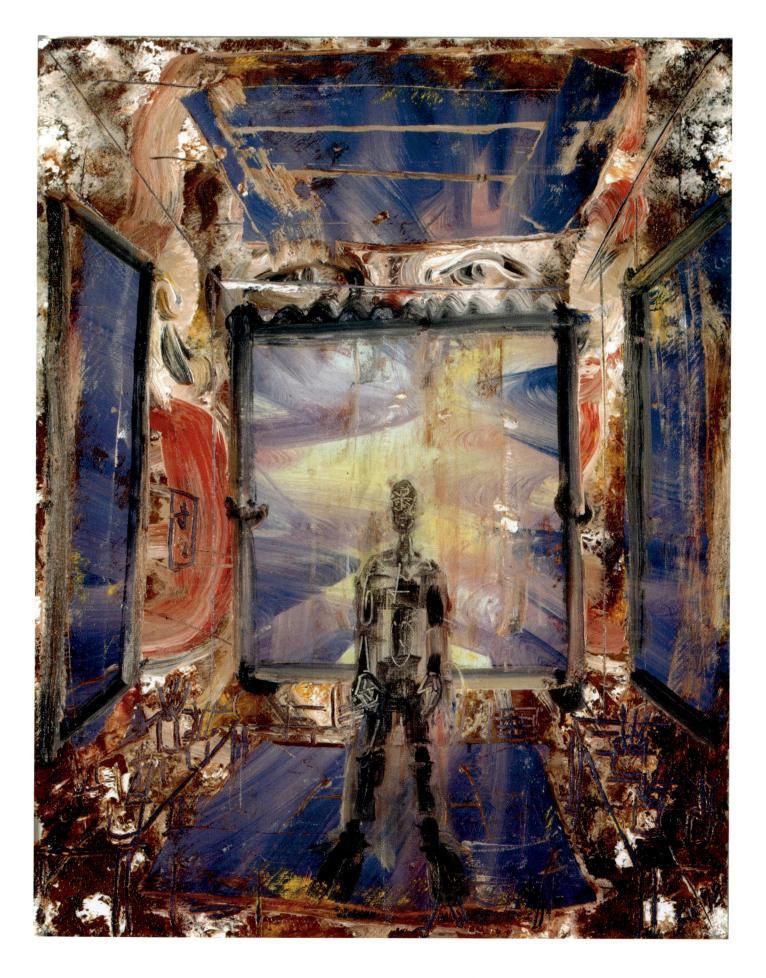

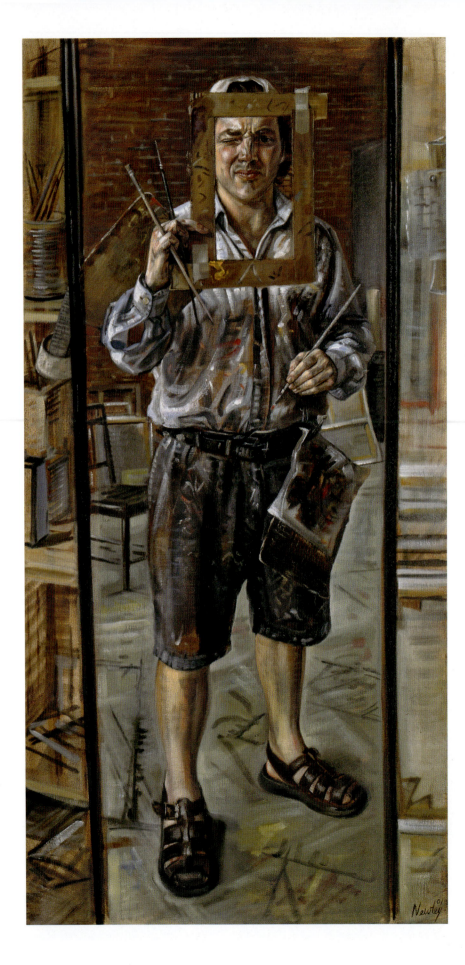

Self-Portrait With Feet On The Ground
2001, oil on canvas, 16x32"

(opposite above)
Painter's Table 1
2000, oil on canvas, 16x20"

(opposite below)
Painter's Table 2
2001, oil on canvas, 16x20"

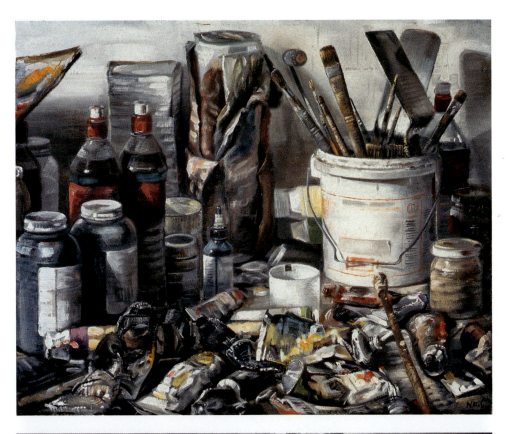

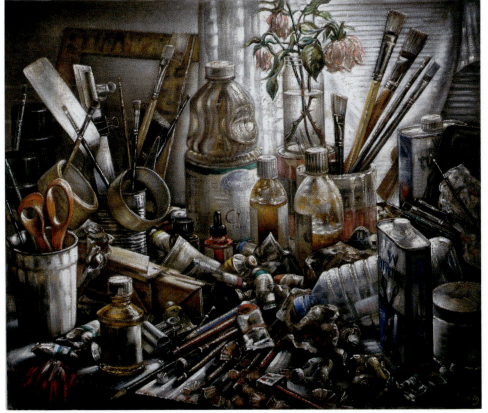

'I was very attracted to the *Girl in a Red Chair* ...'

Lucian Freud

Girl in a Red Chair
2001, oil on canvas, 18x26"

Hamptons Interior
2001, oil on canvas, 12x16"

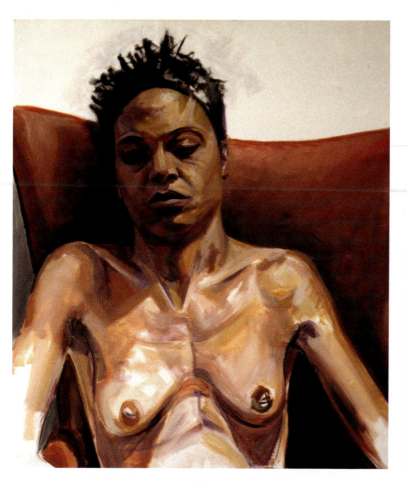

Pilar
1992, acrylic on canvas, 36x40"

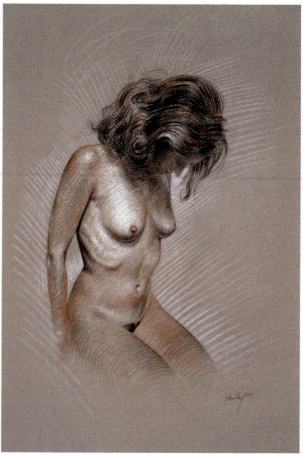

Nude, Head Bowed
2000, conté on paper, 8.5x11"

Blue Nude, Harlem
2001, pastel on paper, 14x22"

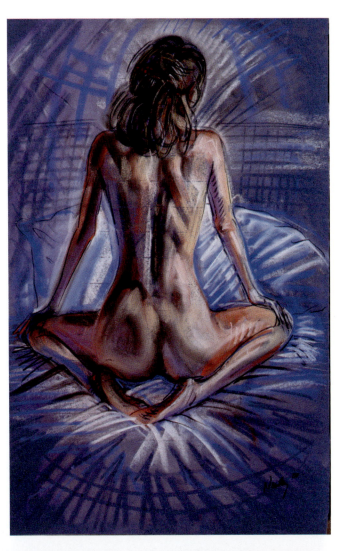

Red Nude, Harlem
2001, pastel on paper, 14x22"

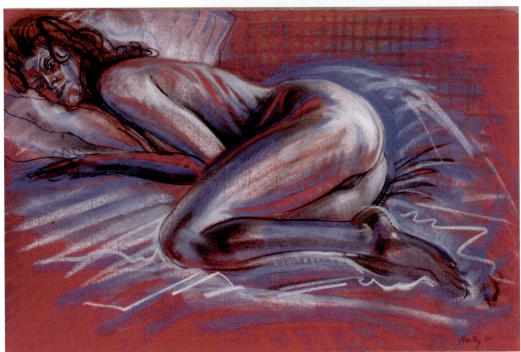

THE CITY 197

Grief
1999, pastel on paper, 18x27"

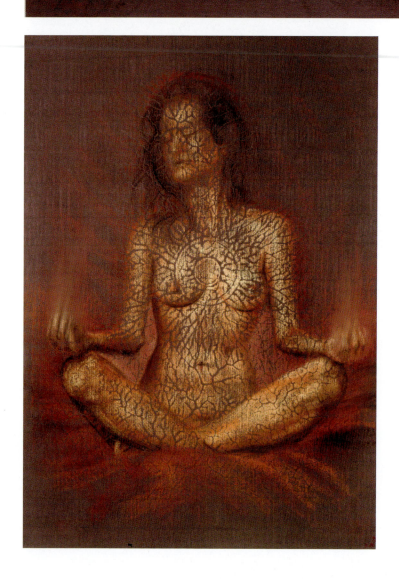

Samadhi
1999, pastel on paper, 18x27"

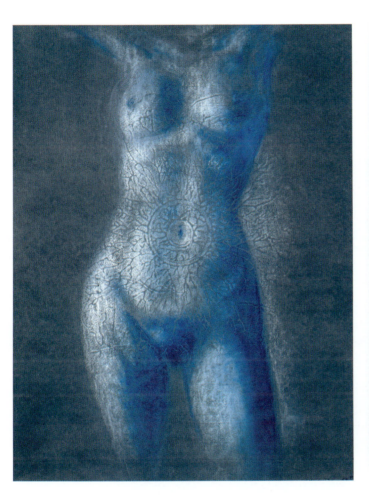
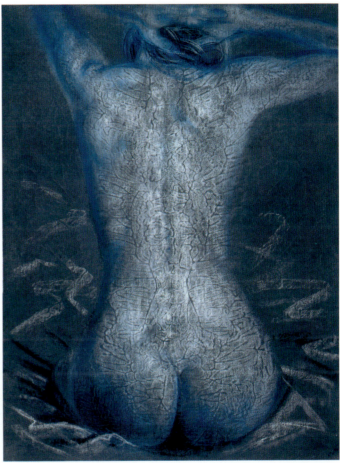

Blue Fractal Nude, Arms Lifted
1999, pastel on paper, 18x24"

Blue Fractal Nude, Back View
1999, pastel on paper, 18x24"

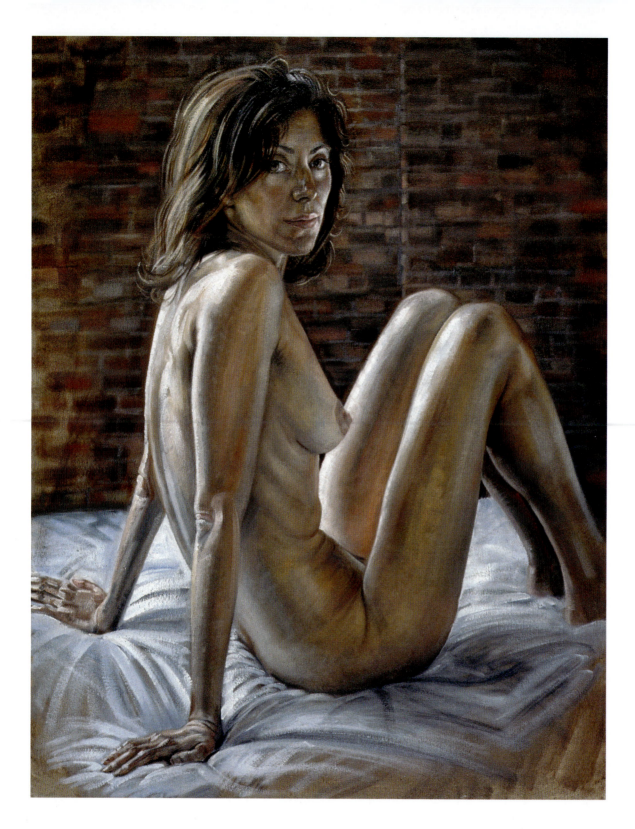

Nude Against the Bricks
2001, oil on canvas, 20x26"

Self-Portrait In Kangol Cap
2002, oil on canvas, 16x26"

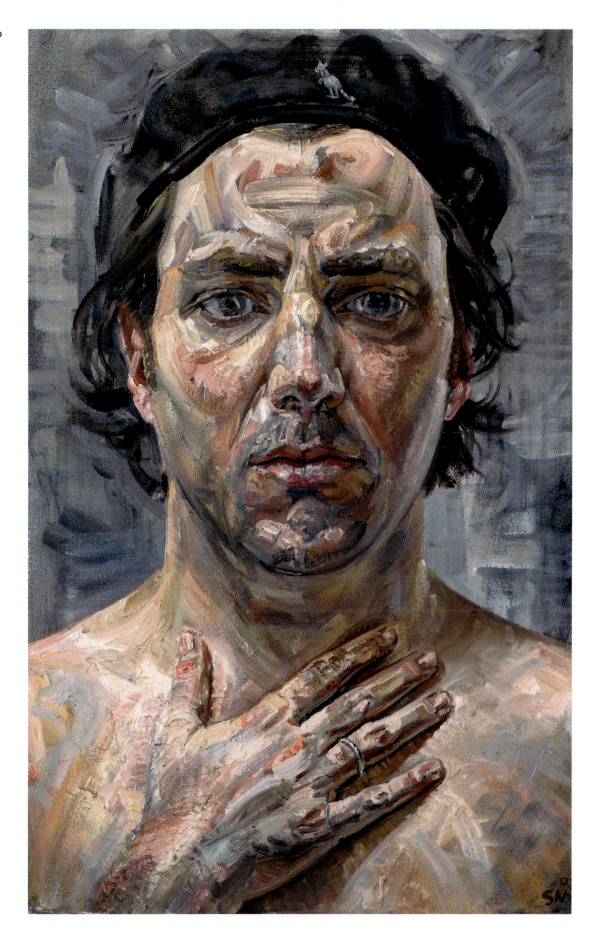

THE CITY 201

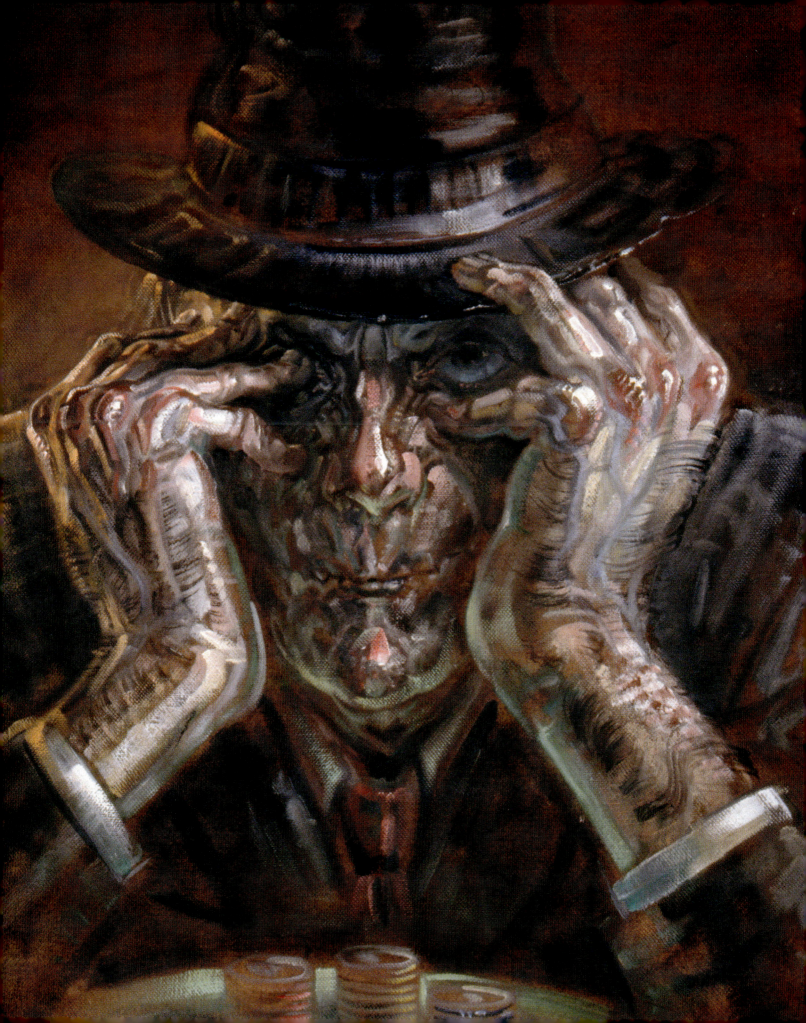

Chapter 9

The Cardplayers

My experience of living and painting in Harlem influenced my work. Something of the danger and vivid life of those streets soaked in and influenced my technique and decisions about subject-matter.

The Cardplayers (p. 204) are spirits from my own ghetto. I love them dearly, and spent hour after hour perfecting their every feature, immersed in a grotesquery that was beautiful to me. I felt my face morphing and changing as I painted and mirrored back their ugliness.

The picture channels my love for German Expressionism and artists such as Otto Dix and Max Beckmann. There's a strong affinity with Beckmann's nightmare vision in *Night*, and the twisted limbs recall Egon Schiele, whom I had loved since my teens.

In the painting the humid backroom stinks in its urinary light. There's a theatrical delight in the characterisations and a desire to push the audience to disgust and laughter. It's a low painting with high intentions – the ideal of popular art as espoused by Kurt Weill and the Berlin subculture of the 1930s.

The composition is designed to revolve our attention around the table like a whirlpool, sucking us into the company of this ribald crew. We realise they are human after all; and their nature, deformed by neglect and avarice, is redeemed by our regard.

Painting it was empowering and I held nothing back, no shadow or supposed perversity. Imagination was given full permission; and I loved rendering the twisted musculature and pushing the highlights and vivid reds and greens.

While working on the group I decided that I wanted to come in close and make individual portraits of each player. I was interested in repeating my depictions of these imaginary beings, thereby giving them extra life and legitimacy. I was also having too much fun to stop, and wanted to ride this wild horse of free expression all the way.

Art is beyond good and evil: it sees beauty in ugliness and vice versa.

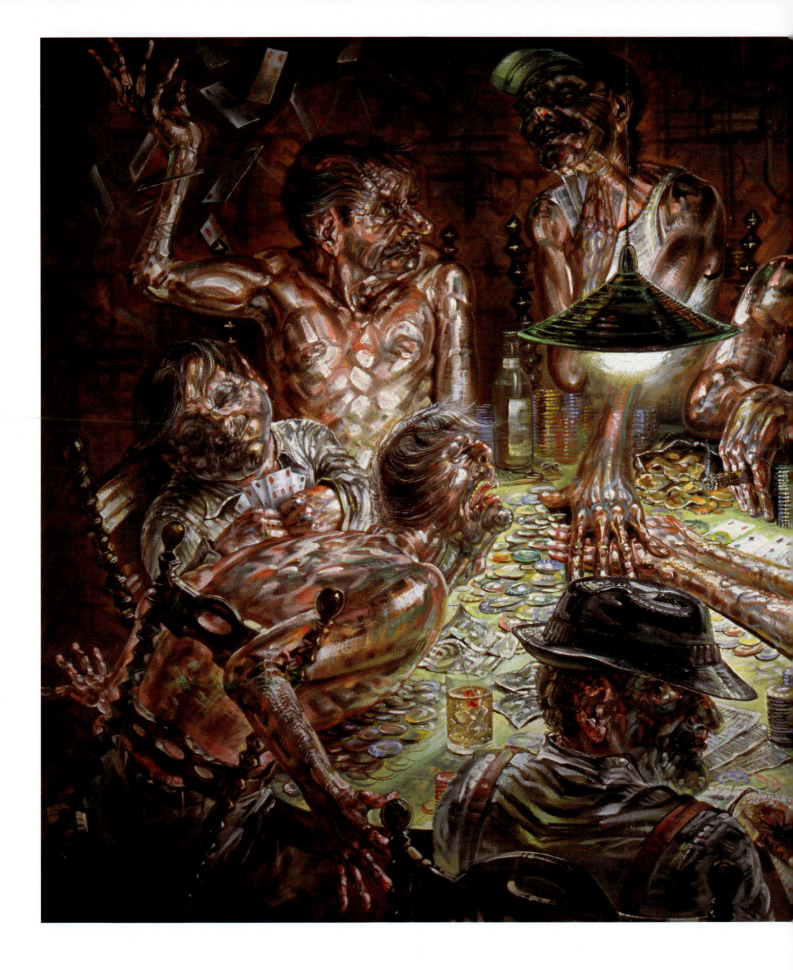

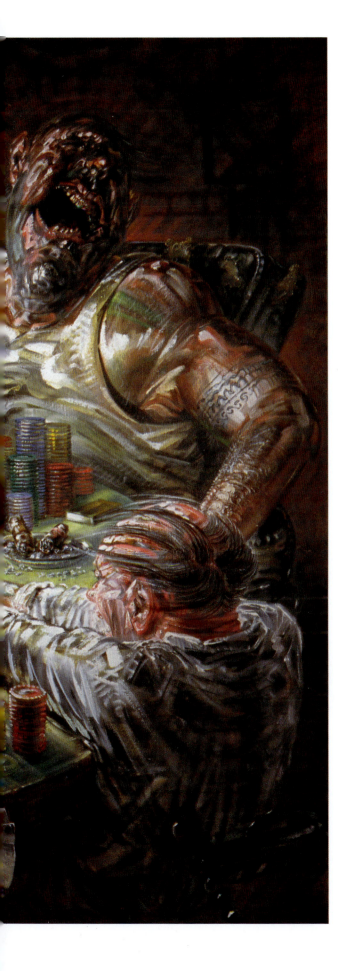

The Cardplayers
2003, oil on canvas, 36x54"

The composition is designed to revolve our attention around the table like a whirlpool, sucking us into the company of this ribald crew.

'Newley's figures act with their bodies as well as faces – the most expressive part of the body. They dramatise their emotions, theatricalising their creativity in the process, with their whole being. Their creative achievement is to show that body and self are not only inseparable but in some way the same.'

Donald Kuspit

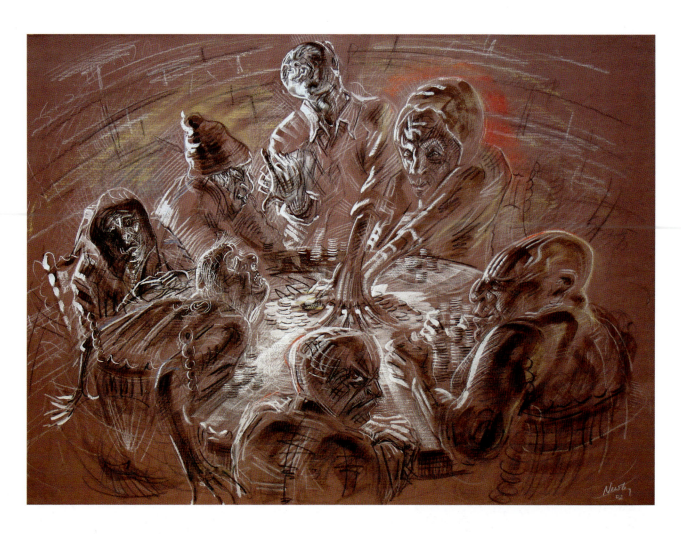

Study for The Cardplayers
2002, mixed media on paper, 18x27"

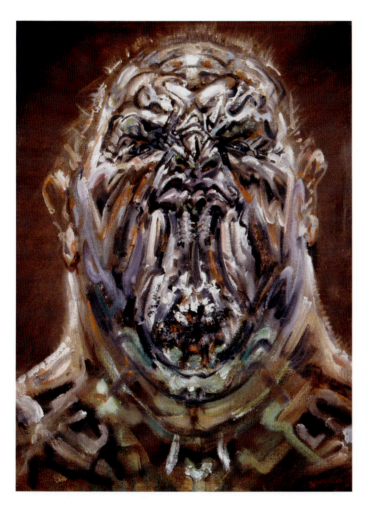

Player 1
2003, oil on canvas, 18x24"

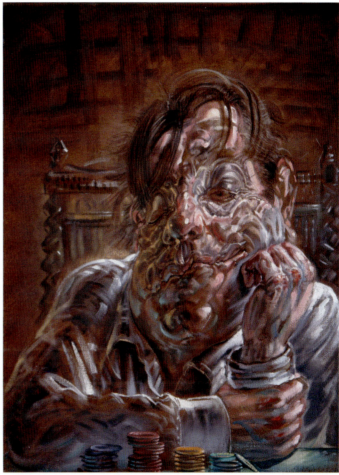

Player 2
2003, oil on canvas, 18x24"

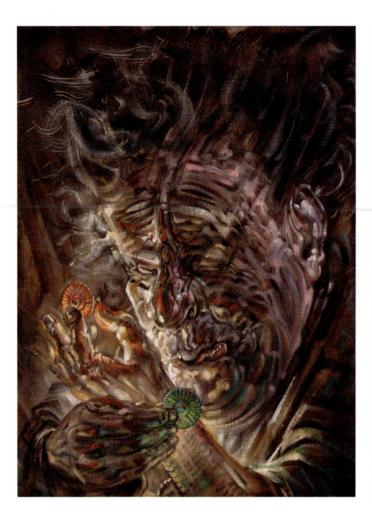

Player 3
2003, oil on canvas, 18x24"

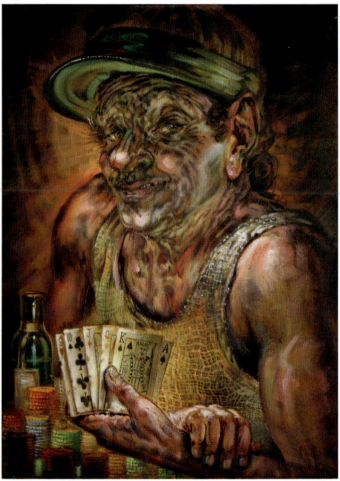

Player 4
2004, oil on canvas, 18x24"

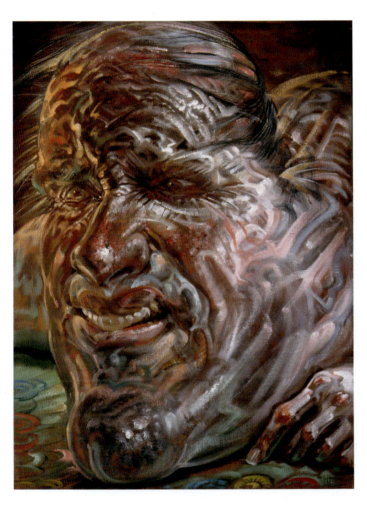

Player 5
2003, oil on canvas, 18x24"

Player 6
2003, oil on canvas, 18x24"

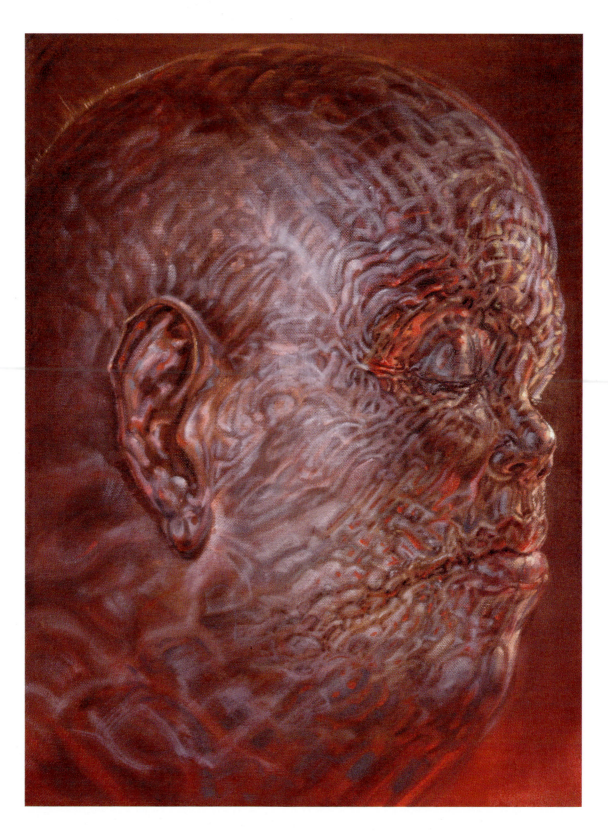

Player 7
2003, oil on canvas, 18x24"

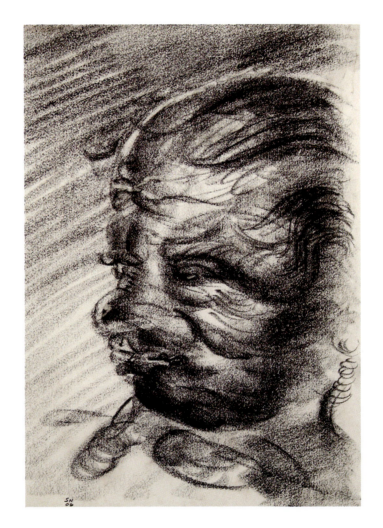

Study for Player 7
2003, pastel on paper, 8.5x11"

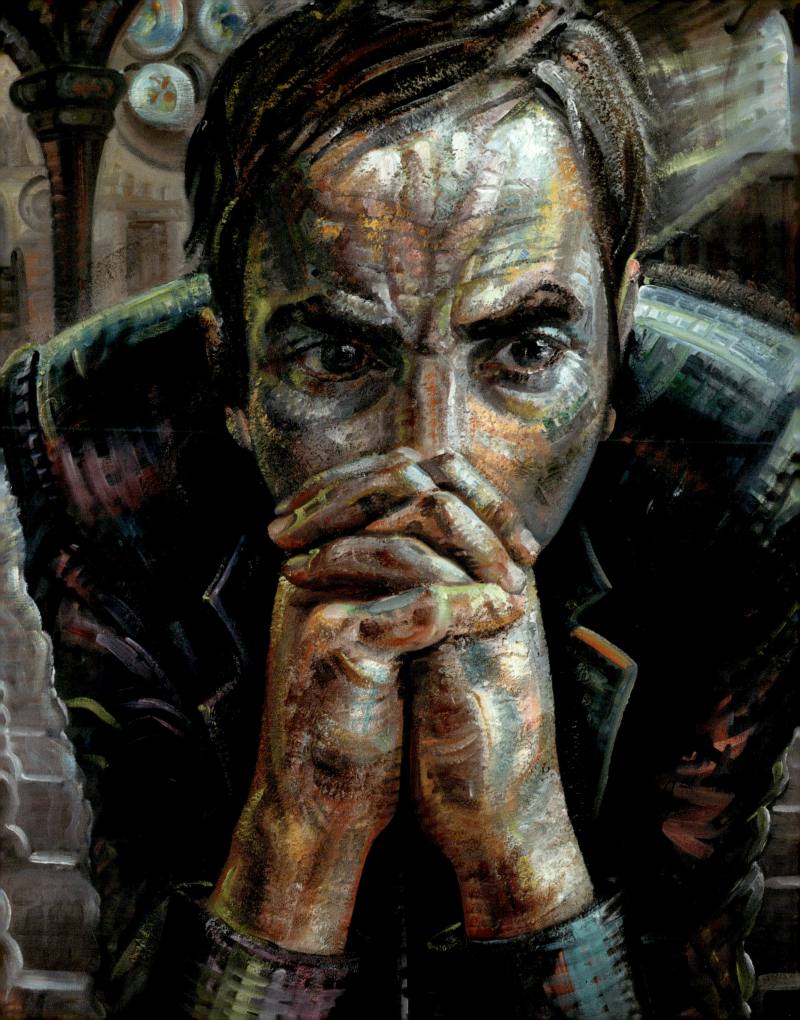

Chapter 10

Outcasts and Travellers

As I was finishing the Cardplayers, a new cast of characters appeared in my work. These beings were usually hooded, and appeared to be in the middle of an enchanted wood or forest. I realised that the inner landscapes I had been periodically painting were the scenes and locations these 'Travellers' had been moving through – but, unlike the Cardplayers, they generally had a natural and playful aura about them. They were holy men, Merlins of the wood; it made sense that in my dragon quest, I should come across them.

They were also far from the city, consciously moving away from the labyrinth of the false self towards something real. As always, that reality was symbolised by light, a rising and setting sun or even the moon, as in **Pilgrims (p. 215)**. There's also a distant mountain in that painting: the second, spiritual mountain we come to late in life, when the vanity of worldly climbing is behind us.

Taken as a whole, the 'Outcasts and Travellers' series explores the process of self-forgetting and letting go that readies the soul for divine union. As part of that process we must get lost, we must die to all we know and shed the mortal coil.

Lost (p. 220) dramatises that moment when the traveller feels truly alone, panics and crashes through the woods without direction until he falls down exhausted. In that state he is like **Job 2 (p. 221)**, enduring a moment of total doubt, searching a godless sky for meaning.

In **Sleeping (p. 220)**, the traveller renews himself. A new day dawns and life-giving sap oozes from the tree that supports his weary head.

In **Traveller (p. 222)**, clearly a self-portrait, our wandering hero is ready to continue on his quest. At length he encounters an adept of the forest, who sits him down and educates him on its mysterious ways. This encounter is celebrated in **Fellow Travellers (p. 225)**, a double portrait that shows the two faces of

> As I was finishing the Cardplayers, a new cast of characters appeared in my work... They were holy men, Merlins of the wood; it made sense that in my dragon quest I should come across them.

The 'Outcasts and Travellers' series explores the process of self-forgetting and letting go that readies the soul for divine union.

humanness: earthly and spiritual. The man of clay grins, but only because he has secured the guidance of a friend, protector and genius. The latter holds a staff, proof of his mastery and knowledge of the Way. He is the fabled wizard of the woods. In finding him, our vagabond is ready for initiation.

But first, purification. And our man of clay must face it alone.

In the sequence that follows, the traveller's quest is absorbed into the legend of St Anthony's temptation. Here, too, a holy man lost in a wood remains faithful to God under extreme duress. Like St George, the subject has a long and illustrious provenance in art, from Bosch and Grunewald to Dalí and Max Ernst, and I felt it was ripe for a revival.

In **Study For The Temptation of St Anthony 1 (p. 223)**, our hero lies prone on a bed of snarling and mutating forms that lasciviously explore him and render him incapable of the moral willpower to break free. Like a junkie gripped by addiction he vainly holds out a Cross, but its light is too weak to unsnare him.

Study for The Temptation of St Anthony 2 (p. 223) takes the bold step of turning the saint away and forcing him onto the ground. It's a winning pictorial strategy and central conceit: battling temptation and reaching for a transcendent light, St Anthony clings to a tree for anchorage, only to find its canopy alive with a shameful expose of the images and temptations that haunt him. The dragon has broken up into troubling pieces – a threat more dangerous and difficult to pin down. The hero's deluded struggle with himself has become an infuriating kaleidoscope that will surely drive him mad – or force him into a deathlike state of denial.

By the time I started the full-size painting **The Temptation of St Anthony (p. 226)**, I was in my new studio downtown and had the space to attack my panoramic scheme. The process ended up taking three years. The work was an ever-shifting puzzle and I was often lost for a way to respond to its technical challenges.

I remember vividly the penultimate day when I finally broke through the tree's confused canopy with a strong black representative of deep space and was able to drink in the cool light of the moon. There, below me, was the curve of the earth. Gravity had been defeated, and the saint had integrated imagination into his moral life and gained the upper hand over his fear.

In **The Mask Seller (p. 230)**, we see an allegory of the artist himself – the seller of masks and faces. He carries a representative bundle of all the ruses and disguises that he has worked through and conquered – the faces and masks that shield us from our own and others' reality. He can offer them now as props and aids to other fellow seekers on the road. All the world's a stage; and he, as a shaman and wise old puppeteer, has earned the right to drop his mask and see beyond. His exhausted human face is beautiful.

Pilgrims
2005, oil on canvas, 36x36"

Seeker
1998, oil on canvas, 30x40"

He witnesses the yawning chasm in himself between what he is and what he wants to be. Perhaps a crime has been committed and he seeks the courage to testify? Or is he himself the criminal? There's a shocking sense of guilt and remorse, as if he has defiled life with his actions, or cowardice.

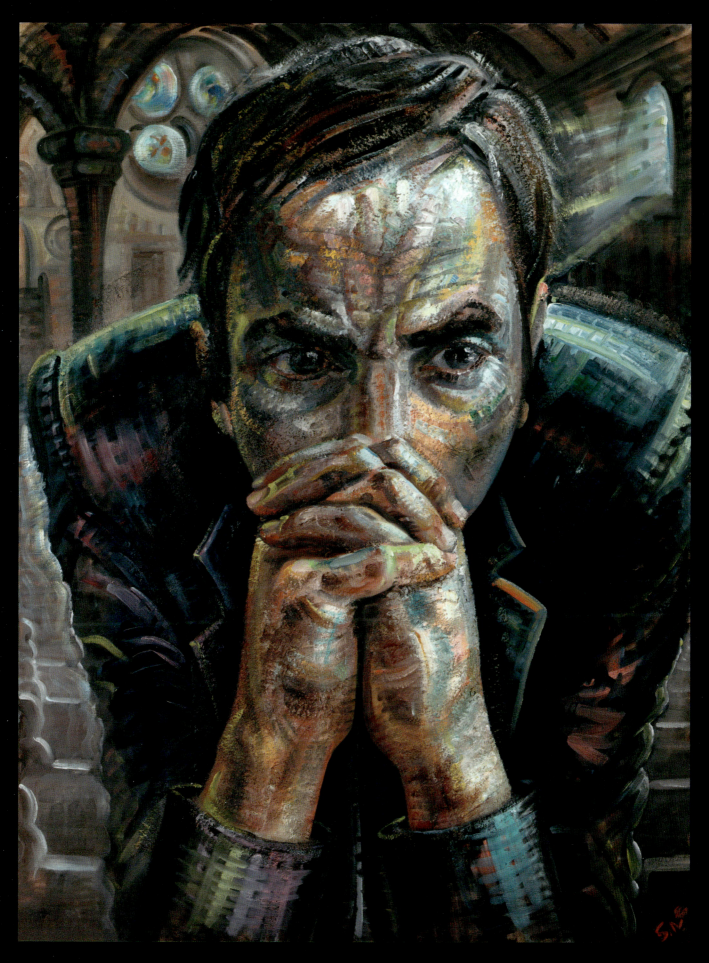

OUTCASTS AND TRAVELLERS 217

Lost, charcoal study
1986, charcoal on paper, 8.5x11"

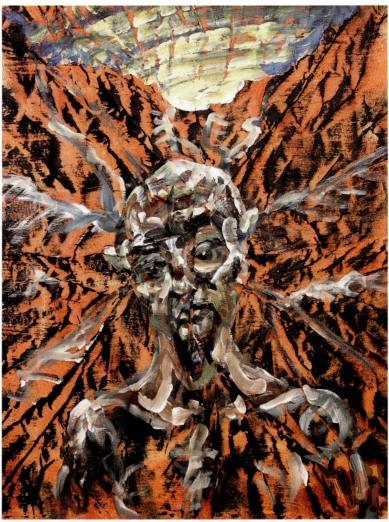

Lost In The Mountains
1999, mixed media on paper, 14x20"

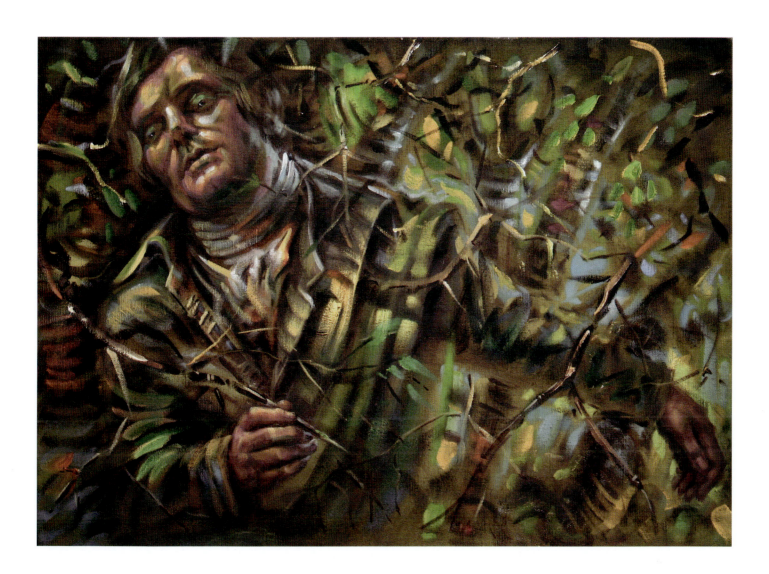

The Poet, Robert Burns
2007, oil on canvas, 18x26"

The disorientation that results from being lost can feed the poet's imagination and open him up to random associations and insights.

OUTCASTS AND TRAVELLERS

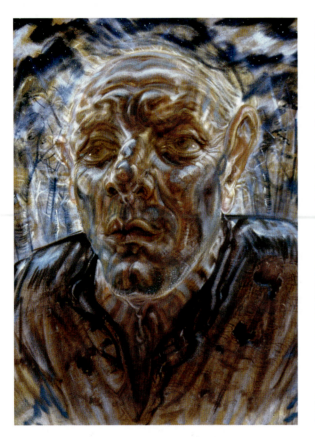

Lost
2002, oil on linen, 20x26"

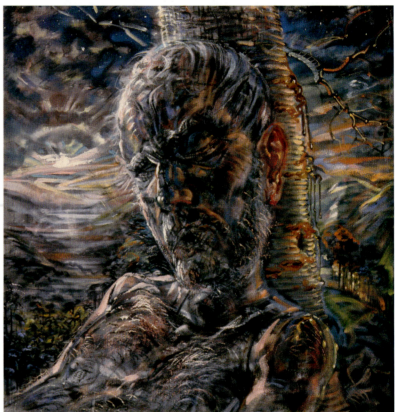

Sleeping
2002, oil on canvas, 24x24"

(opposite)
Job 2
2007, oil on canvas, 32x42"

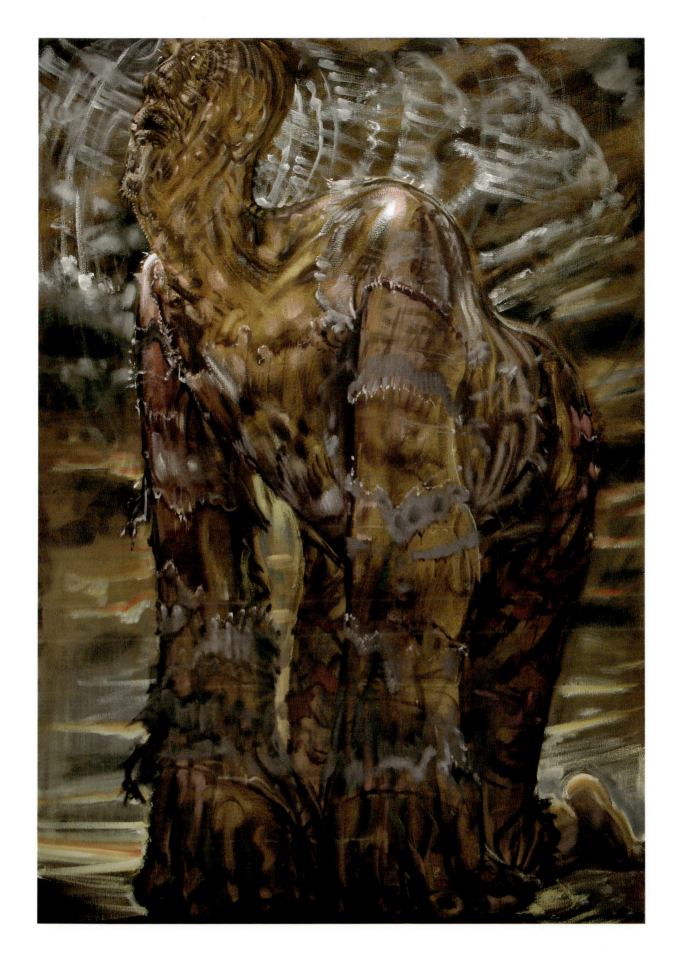

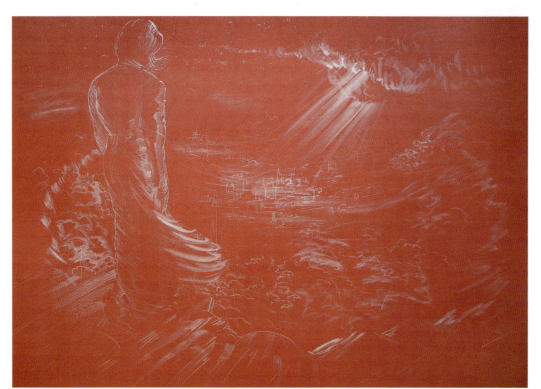

Female Traveller
2001, gouache on red paper, 18x26"

She gazes down at a small town, nestled in a crater. Her robes gust and seem to compel her on to that destination.

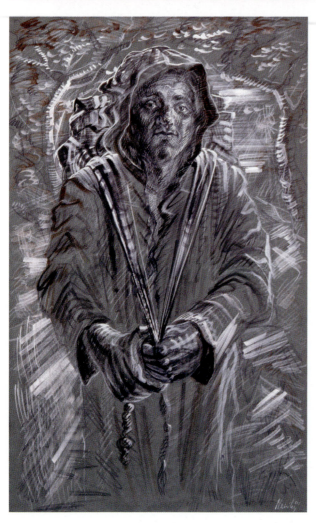

Traveller
2001, conté and acrylic on paper, 20x32"

Study for The Temptation of St Anthony 1
2008, conté and gouache on paper, 20x22"

Study for The Temptation of St Anthony 2
2003, white chalk and gouache on paper, 18x24"

(above)
Study for Fellow Travellers
2002, conté and gouache on paper, 12x18"

(opposite)
Fellow Travellers
2002, oil on linen, 36x48"

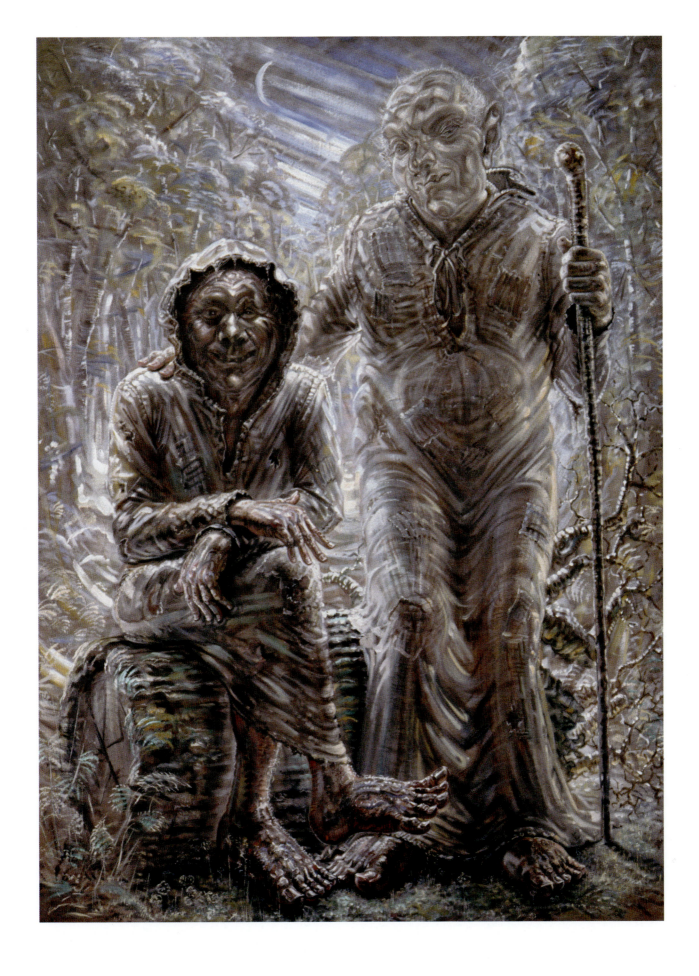

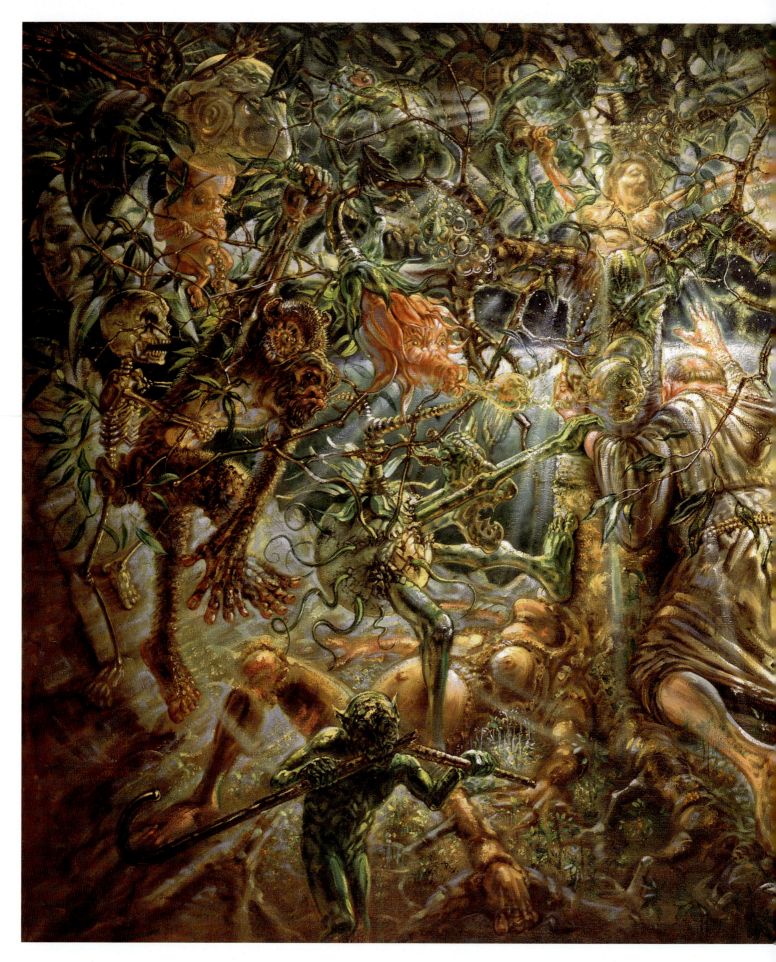

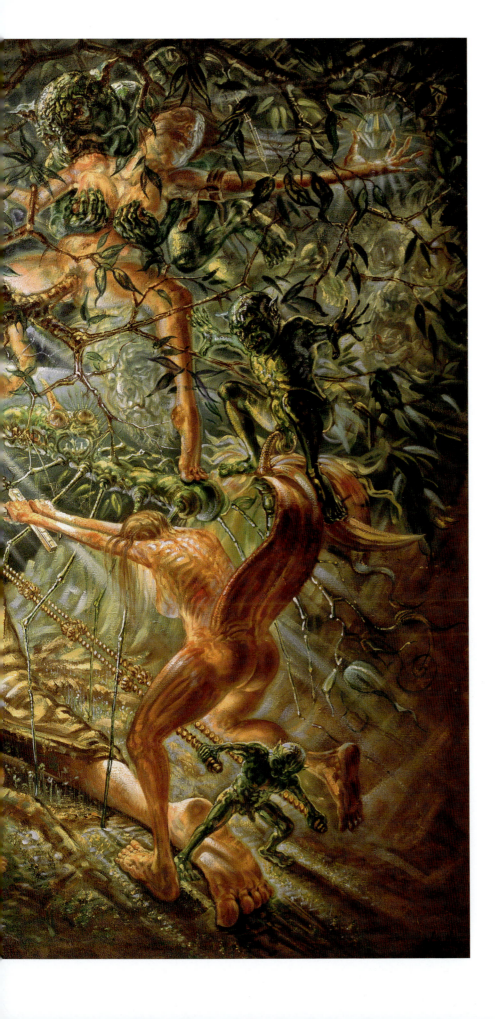

The Temptation of St Anthony
2005, oil on canvas, 48x66"

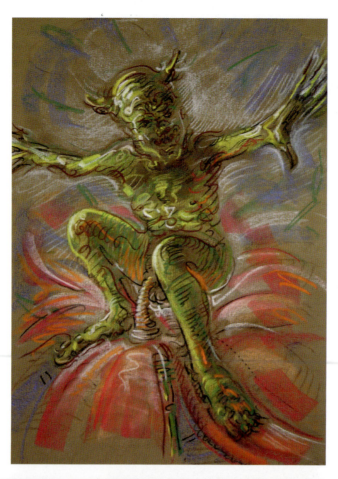

Goblin Study 1
2005, pastel and conté on paper, 8.5x11"

Goblin Study 2
2005, pastel and conte on paper, 18x24"

Head of St Anthony
2005, white chalk on paper, 14x20"

The purified man, ravaged by the spiritual burn of his labours. He turns away from the light because he no longer seeks it but has it inside.

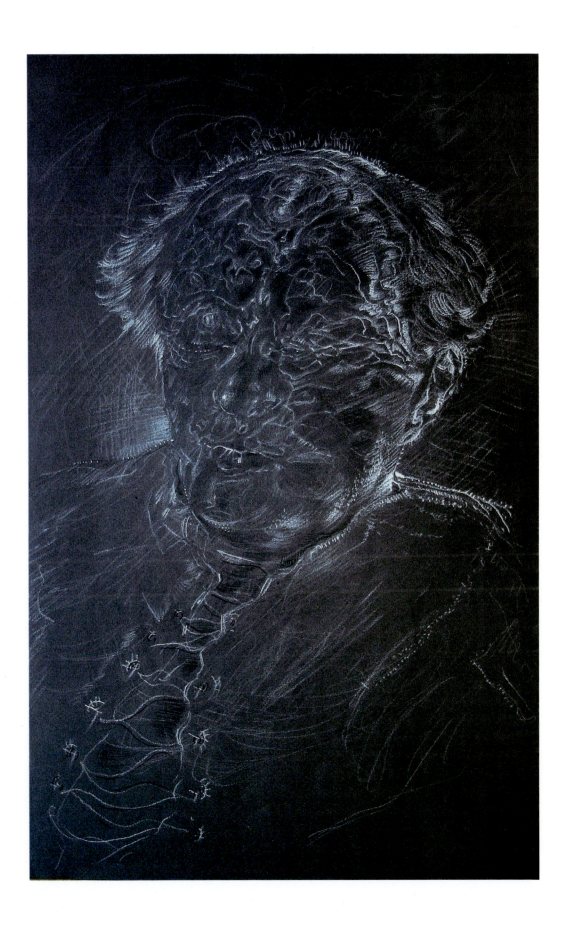

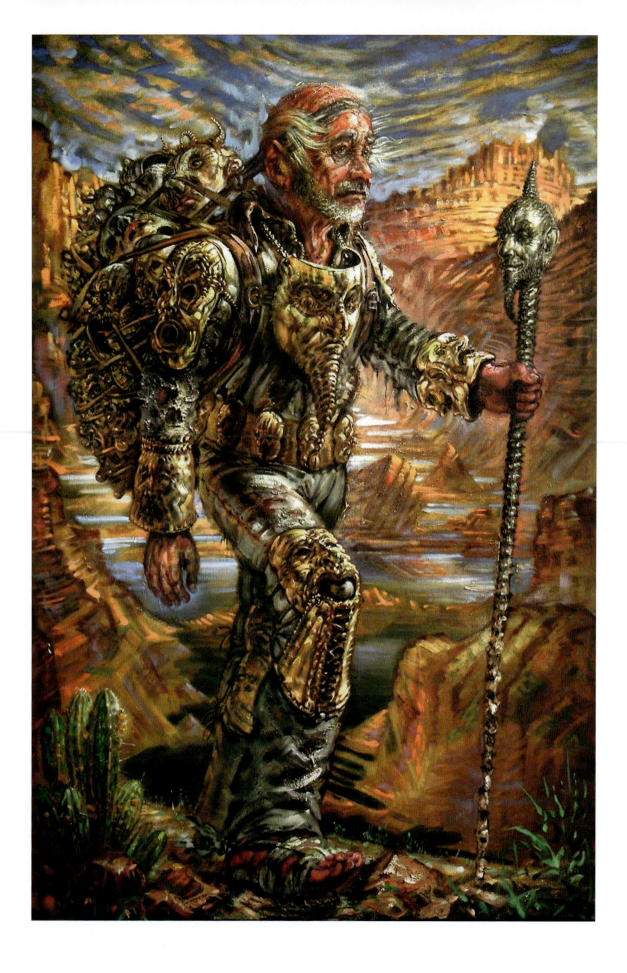

He carries a representative bundle of all the ruses and disguises that he has worked through and conquered – the faces and masks that shield us from our own and others' reality. He can offer them now as props and aids to other fellow seekers on the road. All the world's a stage and he, as a shaman and wise old puppeteer, has earned the right to drop his mask and see beyond. His exhausted human face is beautiful.

The Mask Seller
2009, oil on canvas, 28x40"

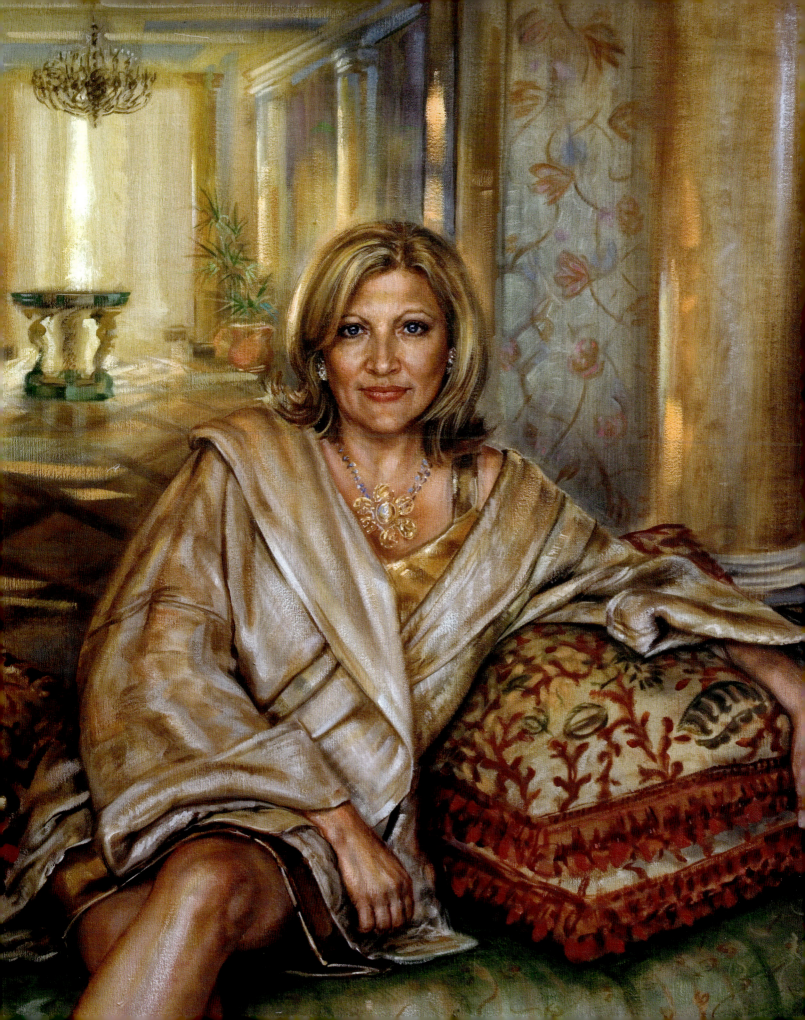

Chapter 11

On Commission

Throughout my time in New York, commissioned portraiture sustained me. It was also artistically challenging in that it took me to places and posed technical challenges that I never would have encountered otherwise. I believe that all artists should be stretched and pushed beyond their comfort zone by commissioned work. Let's not forget that a majority of the great creative works of history were made to order.

This fact is especially true of the portrait painter. Historically, his role began as an adjunct to the court, where his job was to record likenesses – often a potential bride for a lusty king – and to enshrine and heighten the importance of his noble sitters for posterity. That he would often confuse them with deities is how he ensured his longevity; but we should note that the greats such as Velázquez, Holbein and Van Dyck were never great flatterers, preferring to show the truth, warts and all. That they were retained at court is a fitting tribute: great art always finds a way.

In the twentieth century, this beautiful world of hanging silks, deep shadows and pale, exquisite faces was obliterated by the social and economic impact of two wars. We would never see its like again.

But great enclaves of wealth and culture have persisted; and one of these, in my time, has been the Floridian oasis of Palm Beach.

In 2006 I had a portrait show there with Wally Findlay Galleries. This opened up a second front for me beyond New York. The Florida milieu necessitated a softer, more classical approach and I found myself embracing the challenge of pastel and conté drawing with its delicate and diaphanous quality. There were portraits of children to do, and couples and young ladies, all off which meant that I had to dispense with my hog hairbrushes and use sables and soft washes of colour. My admiration transferred from Freud to Sargent: none could equal the deftness and suppleness of the latter's approach, combined with the sheer elan of his brushwork. Overall, I realised that ugliness and

A majority of the great creative works of history were made to order. Commissioned work challenges the artist and often pushes him beyond his comfort zone.

(left) The artist with Sheela in White

(far left) Painting Anne Robinson

character are relatively easy to capture, but beauty and innocence are exceptionally difficult, because one false move breaks the spell.

The society portrait is for me an invitation to light, air and blessed frivolity. It's a welcome escape and has given me the sustenance to continue on my deeper path. Had I not from time-to-time been able to load my palette with bright colours and paint a dress or a child's face, I would have run dry.

I have made these portraits all over the world, from Palm Beach to Monte Carlo, Paris, New York, London and Los Angeles. Here is a selection.

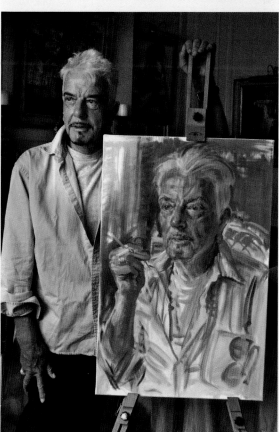

Nicky Haslam with his portrait in progress

Duncan McLaren
1996, oil on canvas, 20x24"

My most committed collector, who commissioned the St George pictures and Theseus and the Minotaur.

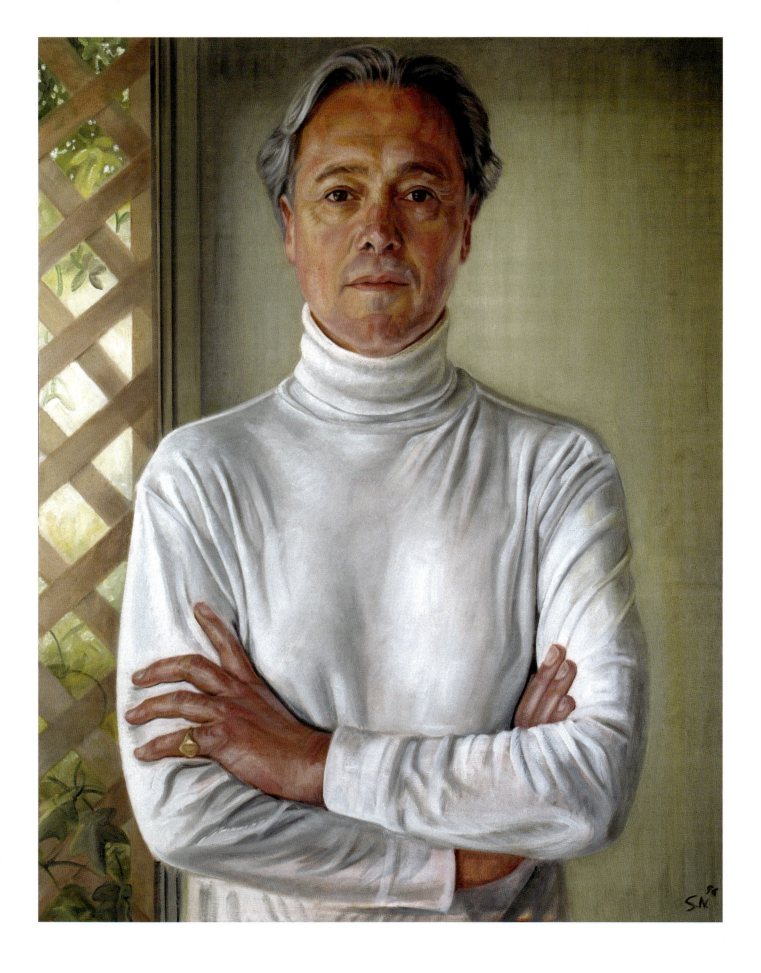

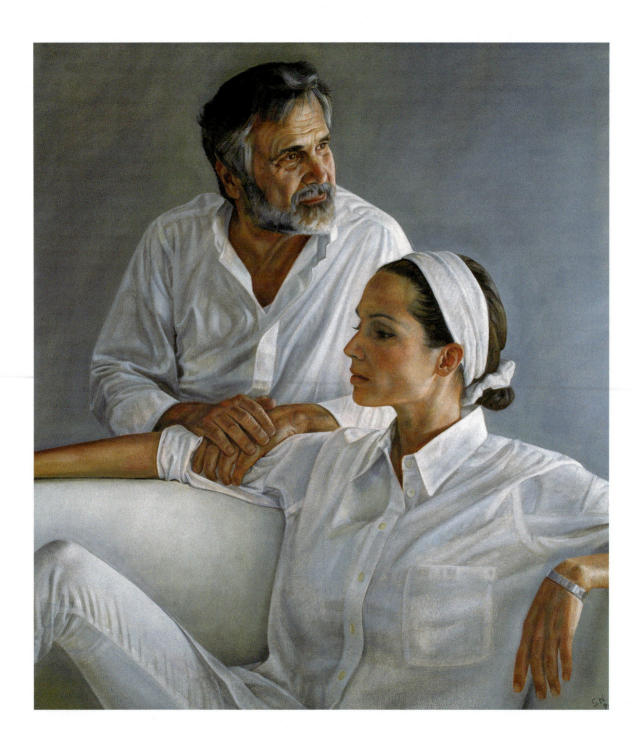

Don and Ilona Margolis
1995, oil on canvas, 36x36"

I was obsessed with white at the time and wanted to explore its seemingly endless tonal range, from warm to cool.

Max Bryer
1998, oil on canvas, 30x60"

Impressed by the use of negative space in Henri Cartier-Bresson's photographs, I use the cliffside and blue sky above the subject to emphasise his authentic and optimistic nature.

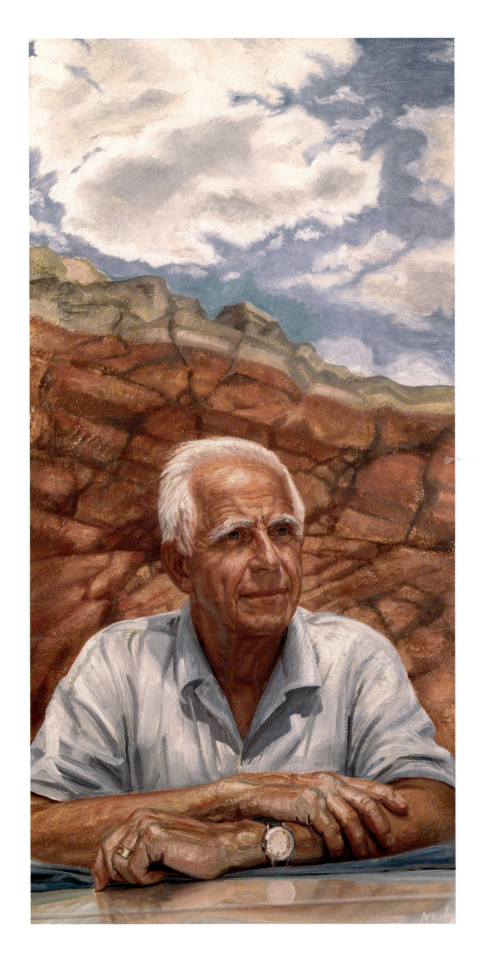

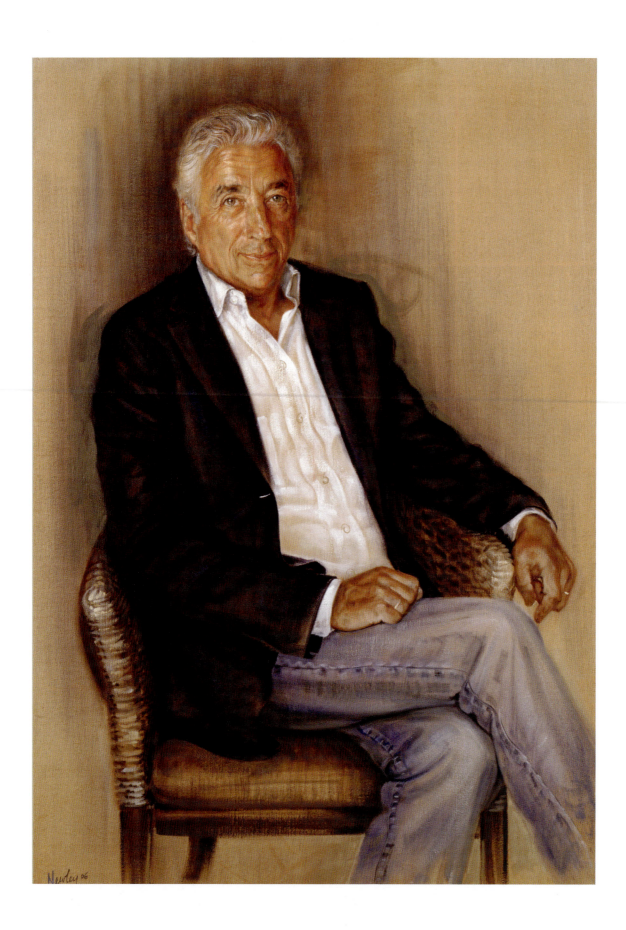

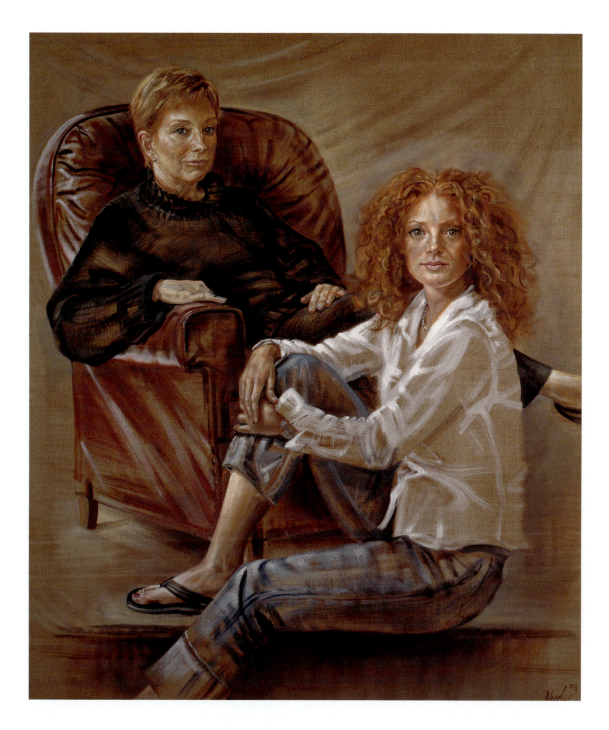

(opposite)
David Morris
2006, oil on linen, 26x36"

The classic London jeweller at his ease in Monte Carlo.

(above)
Anne Robinson and Emma Wilson
2003, oil on canvas, 36x42"

The television presenter-journalist and her daughter. This has a consciously studio-based air, with raw canvas predominating in the background and showing through the clothes.

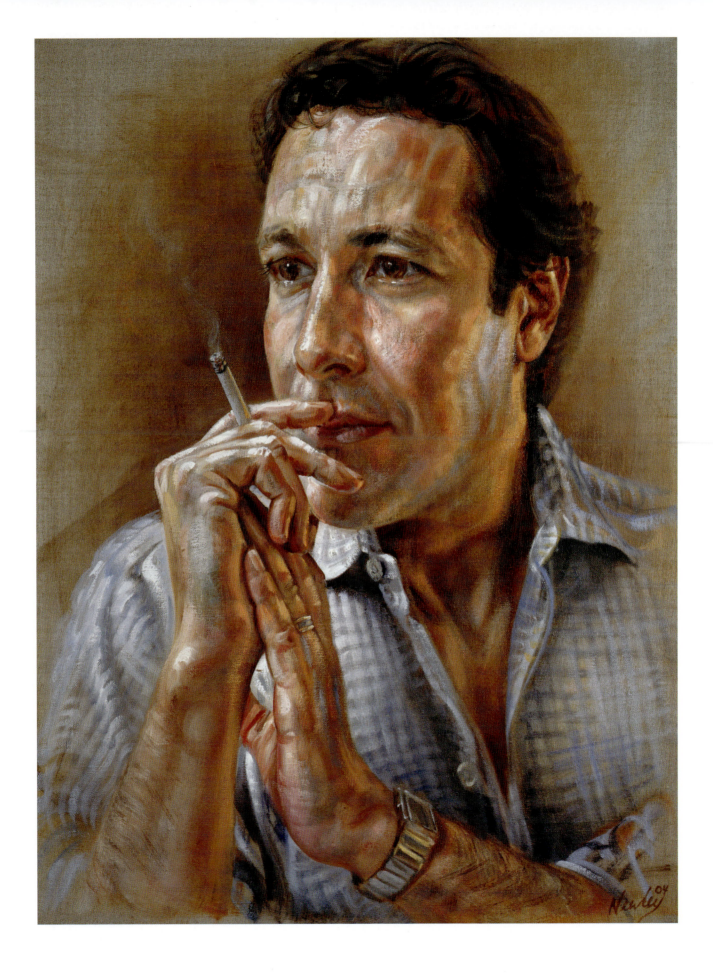

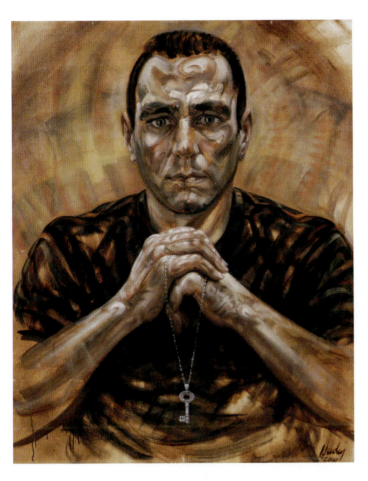 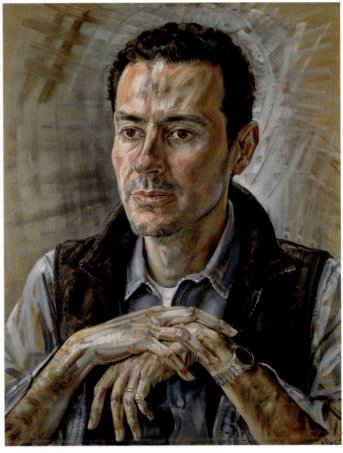

Vinnie Jones
2000, oil on canvas, 32x40"

The jeweller, Theo Fennell, commissioned me to paint this celebrity football player and personality wearing one of his creations: a diamond-encrusted key necklace, hanging from his hands. It was an intense, two-day confrontation, with Vinnie frozen in a challenging stillness.

Gianluca Ciogna
2003, oil on linen, 24x30"

(opposite)
Percy Gibson
2004, oil on linen, 18x24"

ON COMMISSION 241

Ava on Blue
2007, pastel on paper, 14x18"

My eldest daughter, age five. I was experimenting with using tinted paper as a base tone. Here the cool blue is countered and balanced by the warm, rosy tones of pastel.

Ava in a Frilly Hood
2007, white chalk and conté on paper, 14x22"

Louis Tapert Howe
2018, pastel on paper, 16x20"

Overall, I realised that ugliness and character are relatively easy to capture, but beauty and innocence are exceptionally difficult, because one false move breaks the spell.

Herrick
2008, pastel and conté on paper, 20x30"

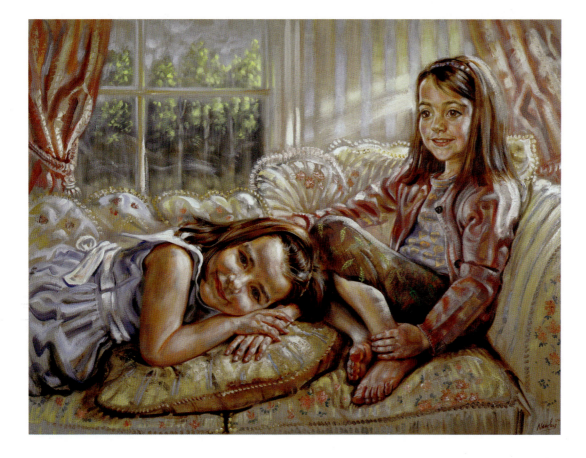

The Gilberg Girls
2004, oil on linen, 30x40"

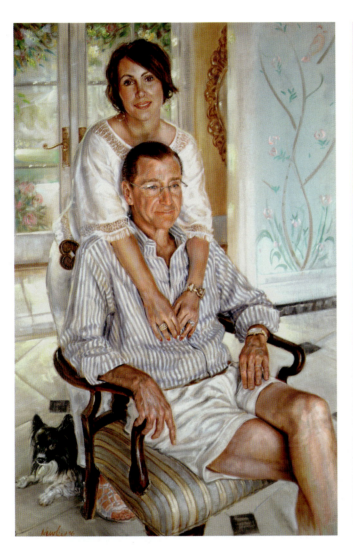

Mr and Mrs Lewis Campbell
2006, oil on linen, 28x46"

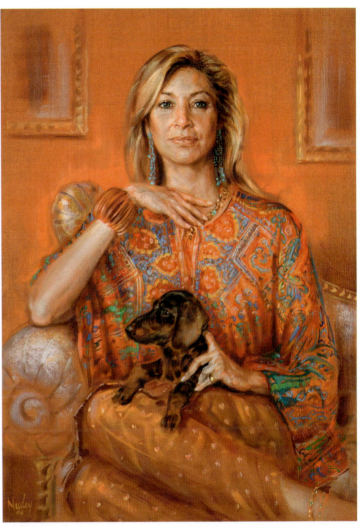

Pauline Pitt
2006, oil on linen, 12x36"

The doyenne of Palm Beach's tastemakers in an exotic mood with her beloved dachshund, Bean. The picture references Matisse's all-red interiors with their patterned cloths and beautiful odalisques.

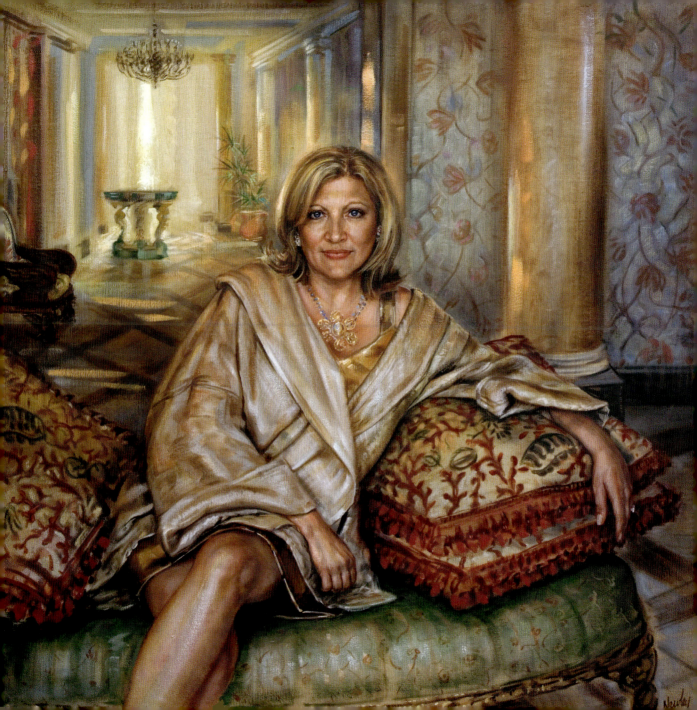

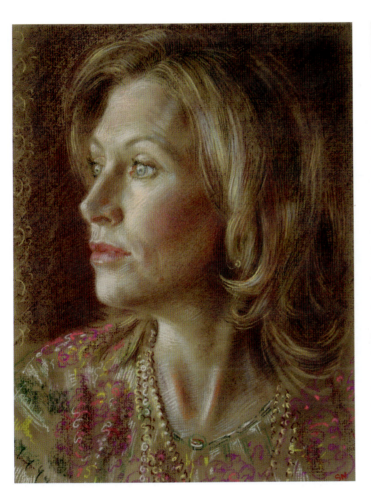

Annette Tapert
2007, pastel and conté on paper, 8.5x11"

A small pastel and conté on paper of the charismatic writer on interior design and fashion in her New York penthouse. It was a crisp autumn day and her gaze soared out dreamily over Central Park.

Nadine Bolander
2009, pastel on paper, 28x36"

Harris Weinstein
2006, oil on linen, 20x26"

(above)
Bill Cheeseman
2006, oil on linen, 26x40"

A businessman whose hometown of Chicago was close to his heart – I depicted him on the roof of his penthouse by Lake Michigan. A decidedly American portrait in its unabashed exuberance and optimism.

(opposite)
Dr Daveed Frazier
2004, oil on linen, 20x26"

A surgeon lives by his hands, and these play a major role in this portrait of the world-renowned expert on spinal injury.

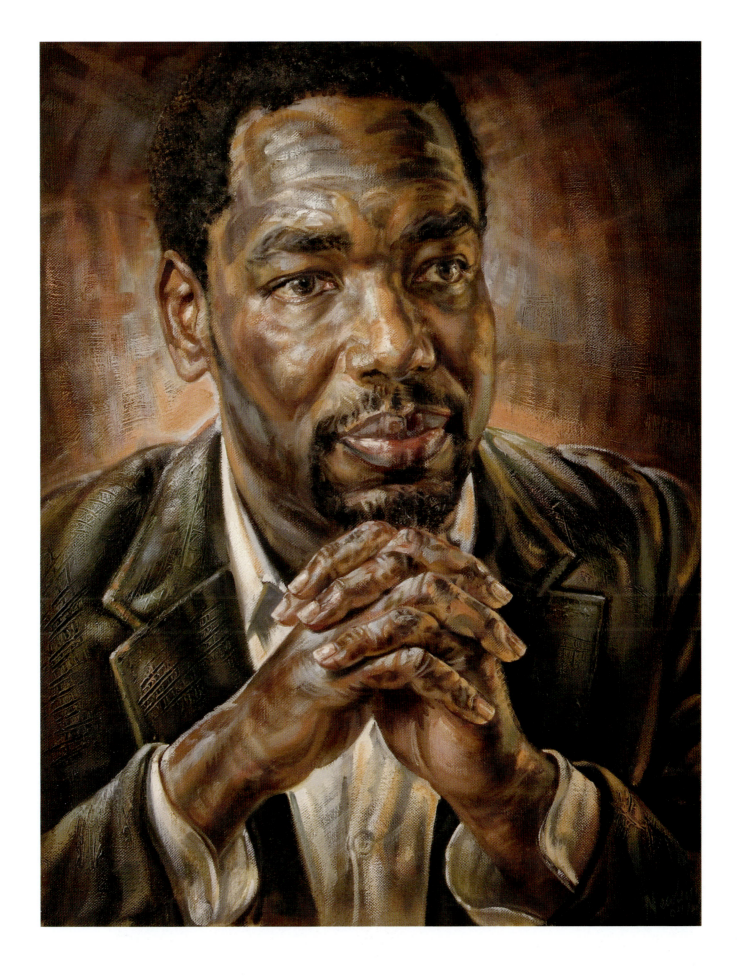

'It captures Ma's spirit so completely – her kindness and glow and grace, and principally her humour. I see it every day and it always makes me smile.'

Emma Thompson

Phyllida Law
2010, pastel on paper, 20x28"

(opposite)
Margie Perenchio
2011, oil on canvas, 24x36"

A fine painter in her own right, captured in mid-inspiration, contemplating her decisive next move.

(above)
Simon Reuben
2006, oil on linen, 24x36"

The British businessman relaxing in his St Tropez garden.

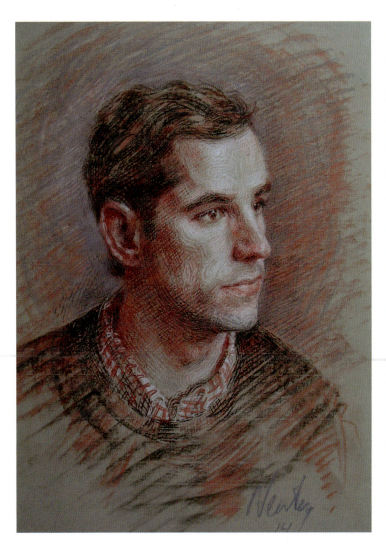

Graham Ober
2014, pastel and conté on paper, 16x20"

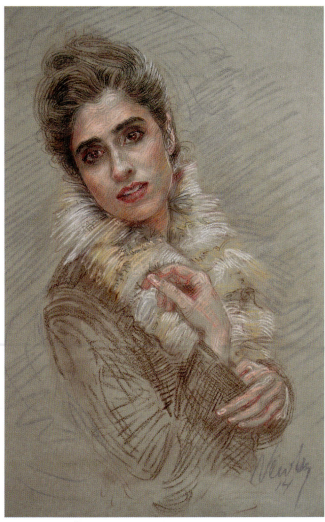

Sheela in a Winter Coat
2014, pastel and conté on paper, 14x20"

(opposite)
Sheela in White
2018, oil on canvas, 34x45"

My beautiful wife, my light and inspiration, in a dress we chose together in India.

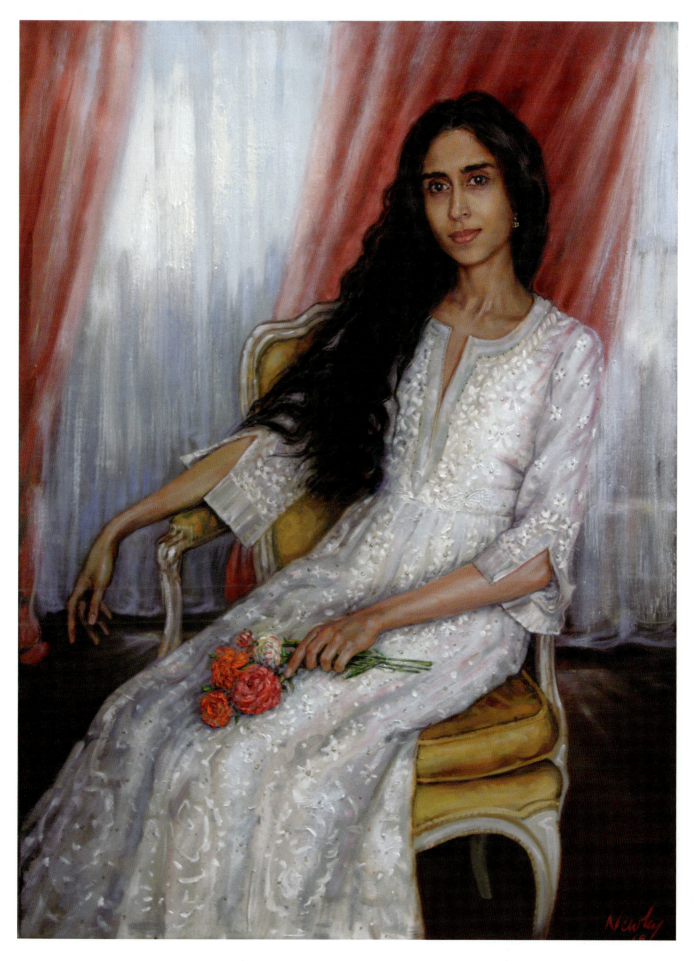

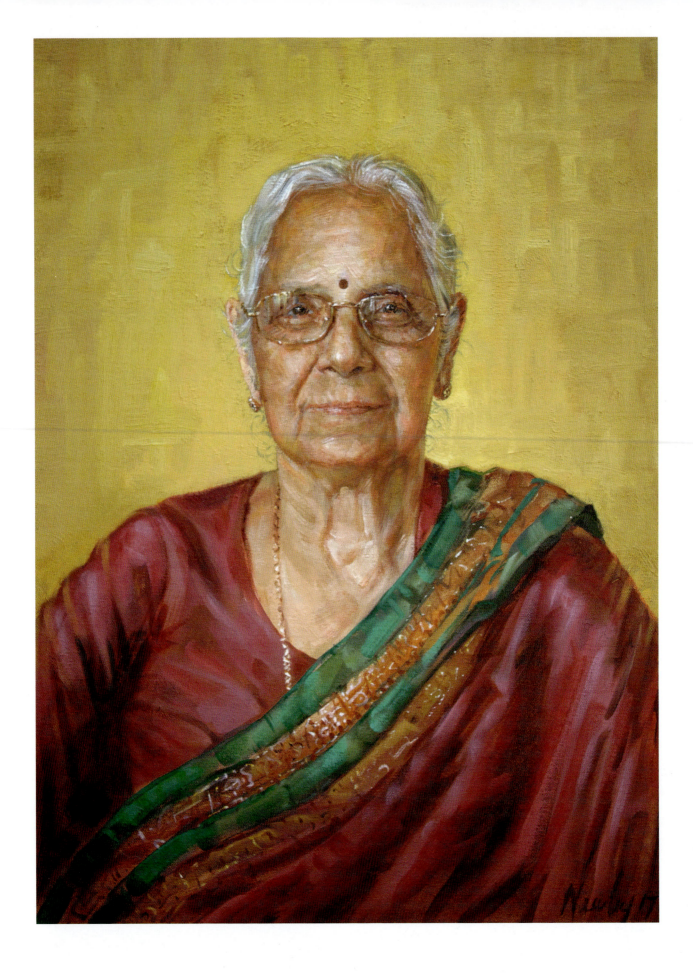

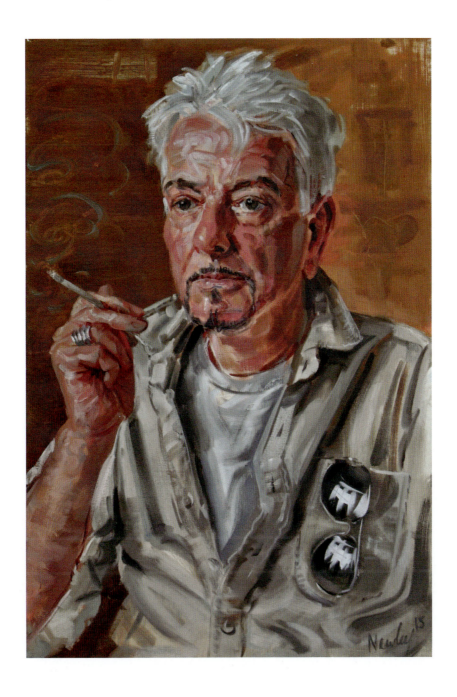

(opposite)
Rukmini Venkatraman
2017, oil on canvas, 18x24"

(above)
Nicky Haslam
2015, oil on canvas, 24x36"

There's no better representative of the overlapping worlds of aristocracy, fashion and art than this irrepressible raconteur, conjurer and arbiter of 'uncommonly' good taste. Our sittings were a hoot.

Sue Campbell
2017, oil on canvas, 16x20"

Basia Briggs
2018, oil on canvas, 26x26"

Alex Hitz
2016, oil on canvas, 18x24"

The celebrated chef, writer and master host, painted at Riccardo's restaurant in London.

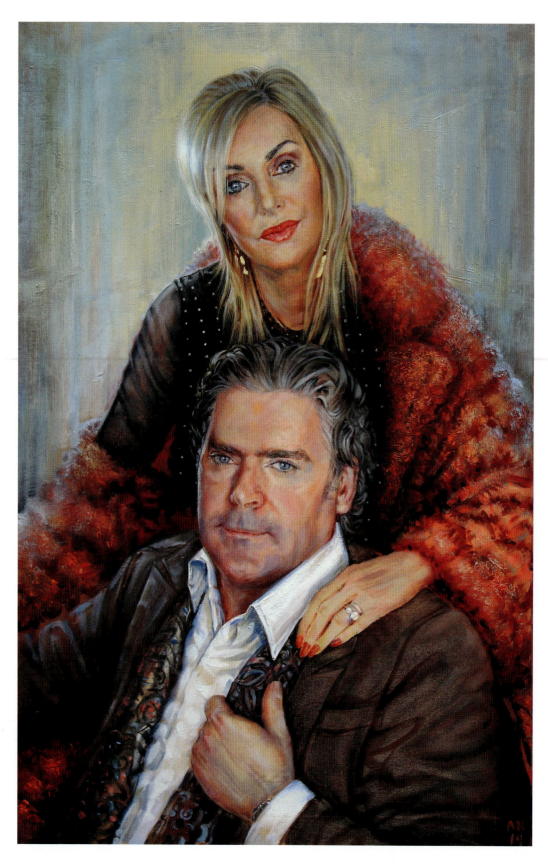

(left)
Dan and Linda Kiely
2019, oil on canvas, 27x37"

The Irish power couple glamming it up in Dolce & Gabbana.

(opposite)
Talbott Maxxey
2020, oil and acrylic on canvas, 43x67"

A swagger portrait with bells on. The subject, a great admirer of Art Nouveau, gave me free rein to push the decorative aspect. I also included her beloved crystals and her love of fine champagne to complete this picture of a bold and beguiling woman who enjoys her life to the max.

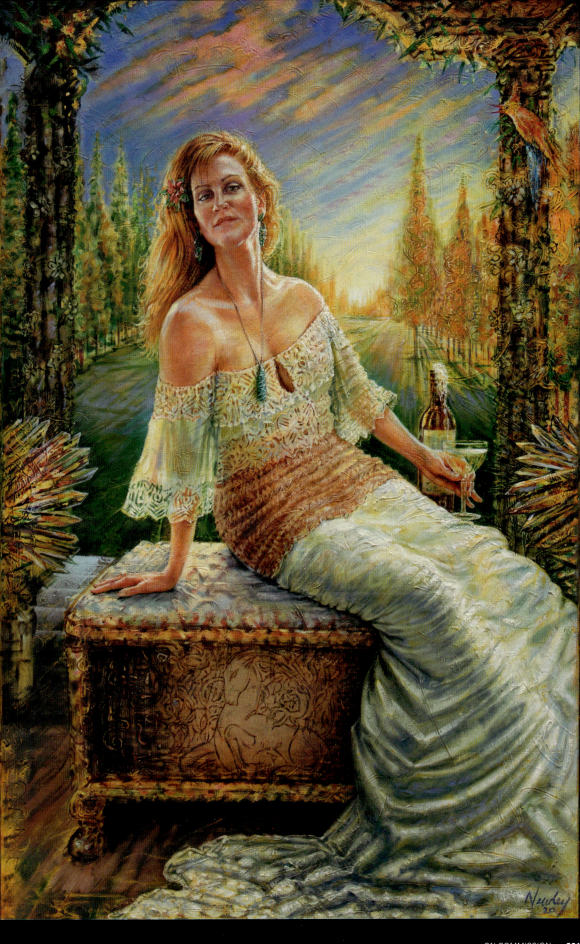

Ballet

As part of my time in Palm Beach, I was invited by Wally Findlay Galleries to visit the Miami City Ballet and make portraits of their principal dancers and their eminent director, Edward Villella – himself considered one of the greatest male ballet dancers of his time.

An American original, Villella was born and bred on the mean streets of Brooklyn from whence he rose to dance with George Balanchine, his most famous moment being the amazing leap at the beginning of Prokofiev's *Spartacus*.

I love depicting dancers; it's an opportunity to show movement in stillness and the exquisite tensions that generate beauty.

Edward Villella
2005, oil on linen, 20x20"

Aged seventy, his face marked by the rigours of art, he is indestructible and still inspired.

Permanent Collection, The National Portrait Gallery at The Smithsonian

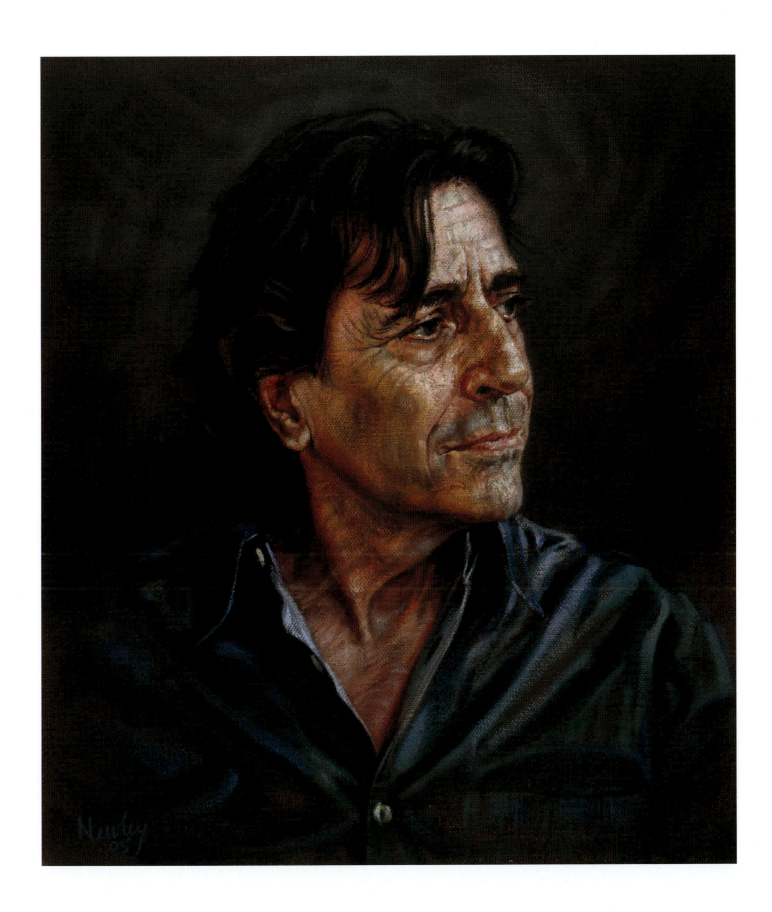

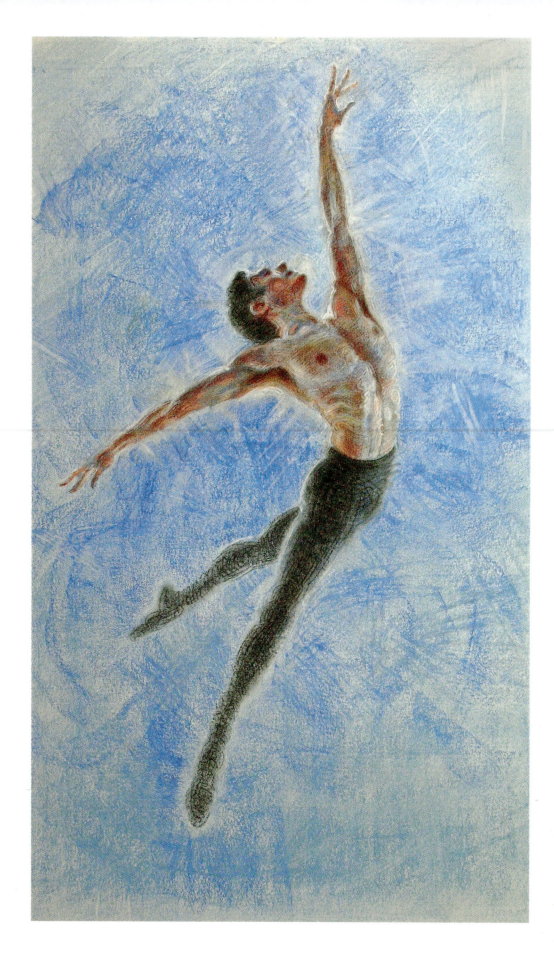

(left)
Sebastian
2015, pastel on paper, 30x48"

(opposite)
Jennifer Kronenberg
2005, pastel on paper, 20x26"

Principal ballerina of the Miami City Ballet, 2006.

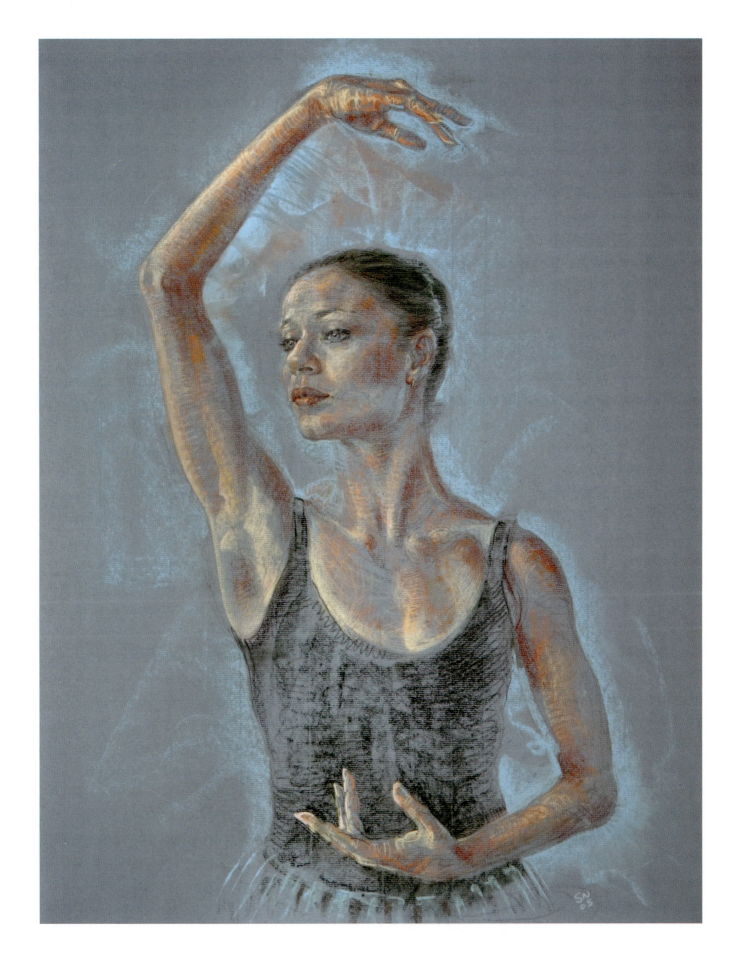

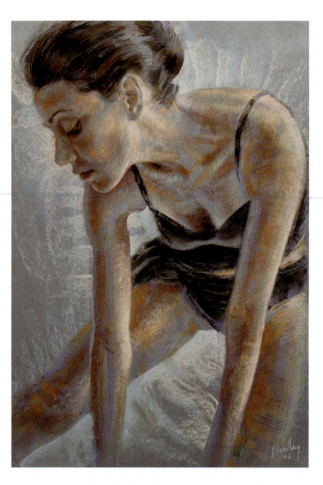

Dancer on Blue
2006, pastel and conté on paper, 16x26"

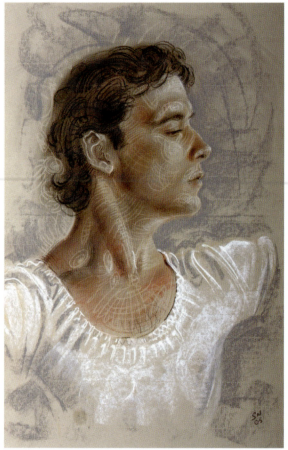

Carlos Guerra
2005, pastel on paper, 12x20"

The descriptive lines in the drawing are tightly choreographed.

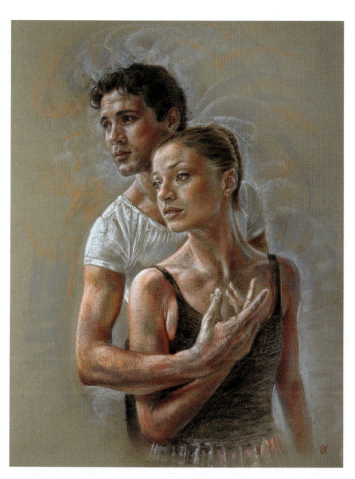

Jennifer and Carlos
2005, pastel and conté on paper,
20x26"

The two principals in a heartfelt pas de deux.

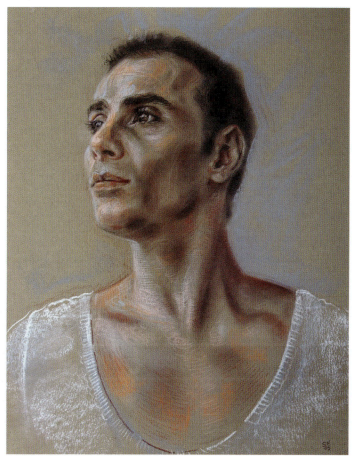

Renato Penteado
2005, pastel and conté on paper,
12x16"

ON COMMISSION **267**

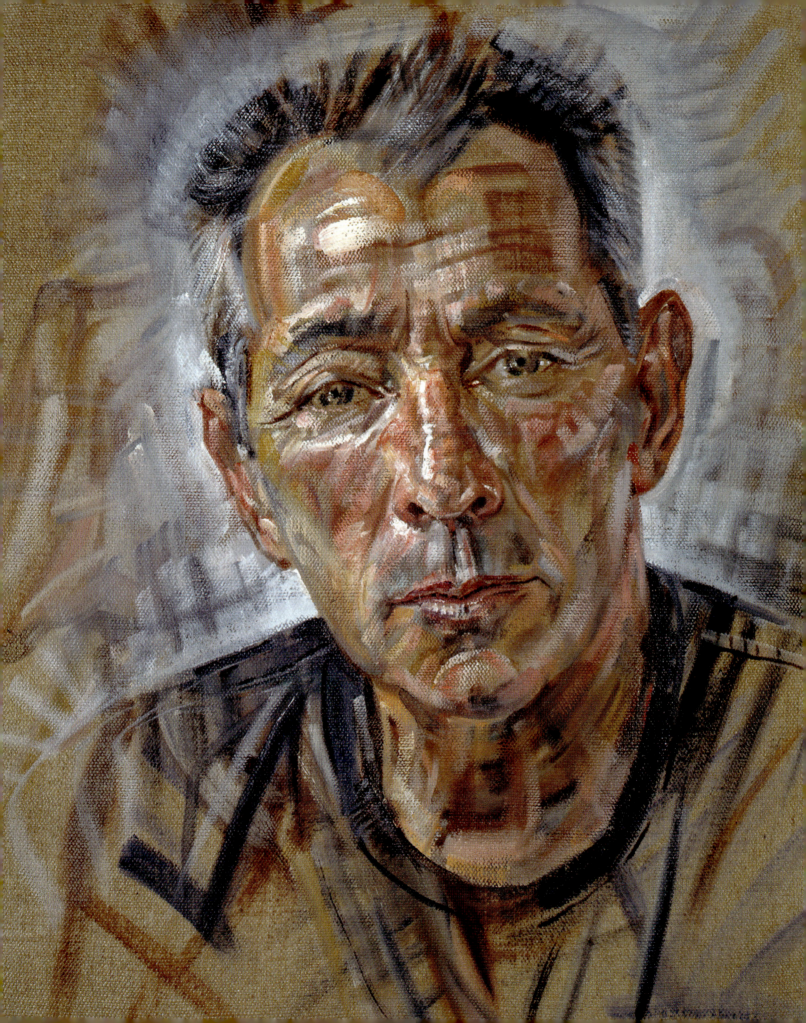

Chapter 12

New York Portraits

n my non-commissioned portraiture the challenge is to be true to my perception of the subject, which means technique is secondary, and I must take risks and put myself on the line.

The film composer, **John Barry (p. 279)**, had worked with my father on the music for *Goldfinger*. We had stories to compare about the Old Man and their shared glory days in '60s Hollywood. He told me that his credo when composing a new score was: 'Make 'em laugh, make 'em cry, and thrill 'em!' I found him elfin and wonderfully sensitive, but with a bracing masculinity – the same mixture of bravado and melting sensitivity that makes his music so distinctive. I painted him in the study of his Long Island home, where five Oscars shared wall space with framed portraits of his heroes: Sibelius, Beethoven and Vaughn Williams. In the painting, his powerful concentration dissolves the world around him, and silence waits for the touch of melody.

The following year I was introduced to another great man of the cinema, **William Goldman (p. 280)**. Our sittings took place in his Library of Congress-style penthouse on the top floor of New York's Carlyle Hotel. We wandered the splendid rooms looking for a place to pose, but eventually settled for Bill hunched over in close-up, looking straight at me. With his hands crossed and seemingly handcuffed, he wears black and a quizzical, haunted expression. This is the writer of paranoid horrors such as *Marathon Man*, but the twinkle in his eye reminds us of the defiant comedy Butch and Sundance muster as they face their final gunfight in his epic Western.

Having made a number of portraits of subjects in film and literature, I was aware that I hadn't yet turned my attention to my own profession. I addressed this with a series of portraits of artists I admired.

Ross Bleckner (p. 284) had a studio not far from me in Chelsea. I had been stunned by his work when I first saw it in Los Angeles some years before – particularly his paintings inspired by the deaths of his friends and contemporary artists from AIDS. His cry of

> These pictures are close to my heart and are portraits of artists, writers and friends I admire, painted as a nourishment for my own journey.

despair and affirmation in paint still stands as one of the most affecting bodies of work to confront that plague. The strategies he employed, from ideas of transience in his blurred skeins of paint to the multiplying fecundity of dangerous cells in his blot paintings, had a deep impact on me. So I was duly awed when I was invited to his studio and allowed to witness the master at work. He was finishing one of his monumental pattern-paintings of birds, and as I watched him deftly handle the varnish and paint to create his blurred effects of movement, the whole canvas came alive with an aviary of falling angels that seemed the very souls of his departed friends.

I made two paintings of him: one large-scale of the artist at work, **Ross at Work (p. 285)**, and a head-and-shoulders, which has an Old Master feeling **(p. 284)**.

The picture was chosen by Faber and Faber for the cover of Berkoff's third volume of plays

Also in the Chelsea District, in his vast studio overlooking the Hudson River Waterfront, lived and worked the dandy, eccentric painter **Hunt Slonem (p. 283)**. To visit Hunt's studio was to be plunged into a fascinating world of curios and maze-like rooms, each with a different colour, theme and subject-matter. His amazing paintings hung everywhere, full of multiplying fauna: birds, monkeys, rabbits, tigers, beasts of every kind, highly coloured and ironically set off in chunky baroque frames. Live birds flitted about the place. Bugs streamed across the floor to devour the omnipresent birdseed that leaked from numerous ornate cages. And amidst all the mayhem Hunt somehow worked, taking phone calls, managing dealers and collectors, his creative focus airtight against the intrusions of commerce.

In my full-length portrait of Hunt, I positioned myself behind his easel to take advantage of the deep perspective of his studio. He stands on tiptoe, yoked to the canvas by an outstretched arm, as if inspiration leads him on, a sleepwalker, into dream after dream. Birds wheel about him like inspirations and his pet parrot perches on his shoulder, daring us to disturb the master at work.

For my next portrait in the series, I travelled back to Los Angeles to see **Ed Ruscha (p. 286)**, who lived and worked in my old neighbourhood in Venice Beach. I again created two pictures of my subject, one up-close – reminiscent of Freud's head of Auerbach – and one full-length, **Ed at Work (p. 287)** – showing the great conceptualist meditating in the middle of his aircraft hangar of a studio. His painting, *IF,* features in the background, suggesting that the whole world of his provocative thought hinges on this vital word.

After our sessions we sat out back in a small garden of rusting car parts and talked. He had the cool and quietly authoritative presence of a Gary Cooper; and with his good looks and hell-raising friendships in the '60s with the likes of Dennis Hopper and Jack Nicholson, he had, he confessed, once been interested in acting. But that was before he painted the masterpiece *Standard Station 1966*, which enshrined his importance as a conjurer of magic and complexity from the American banal.

Another portrait created around this time was my **Head of Lincoln (p. 288)**. The work had been germinating ever since Lincoln seized my imagination as a boy and was brought to fruition by a chance encounter with Leonard

Volk's great portrait bust of the young Lincoln. I was in Beverly Hills at the time, visiting the mansion of an important Hollywood art collector. Billy Wilder had set up the meeting, suggesting I paint the man and his wife, and while I waited for them to appear, I walked around, taking in the collection. There on a stand was the Volk bronze of Lincoln, life-size, bursting with power and emotion. I happened to have my camera with me and quickly photographed the sculpture from every angle. I kept these photos in a file for years, knowing I would someday use them to make a painting.

As with Beethoven, I prepared the canvas with a thickly crusted texture. Once the head was sketched in, I cursively wrote over it the lines of the great Gettysburg Address. As I subsequently worked on the face, I took pains to let these lines show through it: here was a man literally made of his word.

The portrait was later acquired by the Lincoln College Museum in Illinois, the State where Lincoln practised as a lawyer before taking up politics. While I was there to celebrate its acquisition and the bicentennial of Lincoln's birth, Obama came to speak. As I watched our first black president at the podium with the aura of Lincoln very much upon him, I was moved to conceive another portrait.

In **Lincoln/Obama (p. 289)**, I have reversed the angle of the famous last photo taken of

I made two versions of the Goldman portrait, one with a lighter feeling as I feared the first might be too dark. But this is the one that Bill and his wife chose when they visited the studio. You can just glimpse her, and the artist, in the background mirror.

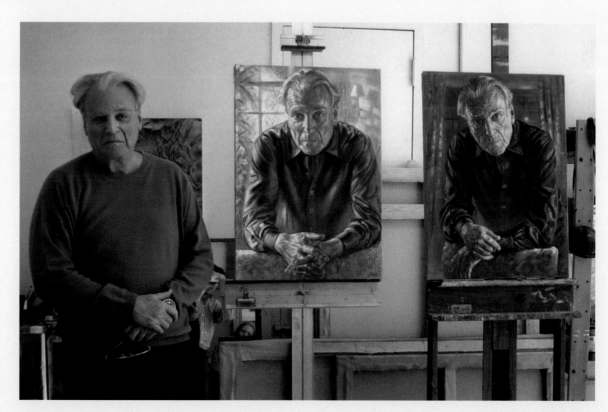

Bill Goldman with his portraits

I happened to have my camera with me and quickly photographed the sculpture from every angle...

Lincoln by Henry F. Warren. I needed this reverse so that Lincoln's face would neatly fit in with the images I had gleaned of Obama on the night. The result is a Mount Rushmore-like double portrait: the great ghost of Lincoln approving the outcome of his steadfast belief.

The portraits I made during this period and the lessons I learned from them culminated with my triptych of the actor and activist **Christopher Reeve (p. 290)**.

Famous as the actor who played Superman, Reeve was a regular presence in the movies of the '80s and '90s until a tragic riding accident left him paralysed from the neck down. Rather than surrender, he became a tireless campaigner for the rights of disabled people and pushed the agenda on stem cell research. I met him in New York in 2003 at a cocktail party he and his wife, Dana, were holding for his foundation. I was immediately impressed by his imposing size and the gentle grandeur of his bearing as he sat enthroned in his wheelchair.

I plucked up courage and asked Dana if he would consider sitting for me. She suggested I send some samples of my work. To my great surprise, he responded days later with a personal email in which he said he would be honoured to sit.

Our session took place at his house in upstate New York on a snow-banked winter's day. The house was off on its own, surrounded by pristine whiteness. I used this sense of frozen isolation in the painting's background; adding a low, wintry sun to dramatise my impression of a man cornered by fate but still defiantly alive.

I was struck by his modesty, resilience and good humour during the whole time that we

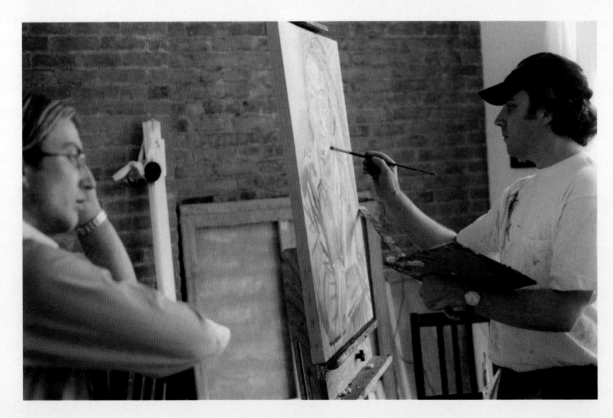

Painting Carlton DeWoody in my Harlem studio, 2002

The Lincoln head installed at the Lincoln College Museum

worked. Despite the pain of a recent infection that had almost killed him, he repeatedly manoeuvred his wheelchair to achieve the angles I was looking for and told wicked stories about Hollywood and his college days with his best friend and roommate, Robin Williams.

He had decided to wear black for the session, and the chunky polo neck that hid his tracheal ventilator, along with his bald head, gave him the appearance of a magus from a sci-fi movie. Indeed, the high-tech wheelchair was literally keeping him alive: hydrating him, feeding him medication and monitoring his breathing. The fire extinguisher in the corner was a reminder that failure of the system could result in death. I included it in the portrait, along with a model sailboat that recalls his passion for the sea – its prow aligned with his ascendant gaze.

The irony was that, trapped in his wheelchair, he had finally achieved the strength to turn kryptonite into gold. Here was a true Man of Steel.

Having completed the full-length portrait, I felt that there was more to say, so I created two more head portraits to augment it. I include the second one here, **Head of Christopher 2 (p. 291)**, which attempts to compress the great life and spiritual beauty of this man into a face ravaged by Fate.

Christopher never got to see the finished paintings, as he died a week before they were completed. The following year, the Smithsonian took the three pictures and permanently installed the full-length in their gallery *The Struggle for Justice*, 'celebrating men and women who have worked tirelessly to achieve civil rights for the marginalised and disenfranchised'.

'I was living and working in Los Angeles and I could not have found a better sanctuary to write in than the Sidewalk Café on Venice Beach. Few places make you feel more welcome than an American diner, particularly in such an exotic and down at heel place as Venice Beach. Alexander, whose work I have long admired, suggested a portrait to me and I felt it would be quite appropriate to be painted there. He has completely captured the environment, the details and the spirit of that café. It hangs happily on my wall and I never tire of looking at it and wishing I was back there.'

Steven Berkoff

Steven Berkoff at the Sidewalk Café
1997, acrylic on canvas, 44x52"

The outsize ketchup bottle in the foreground is my one nod to Pop Art.

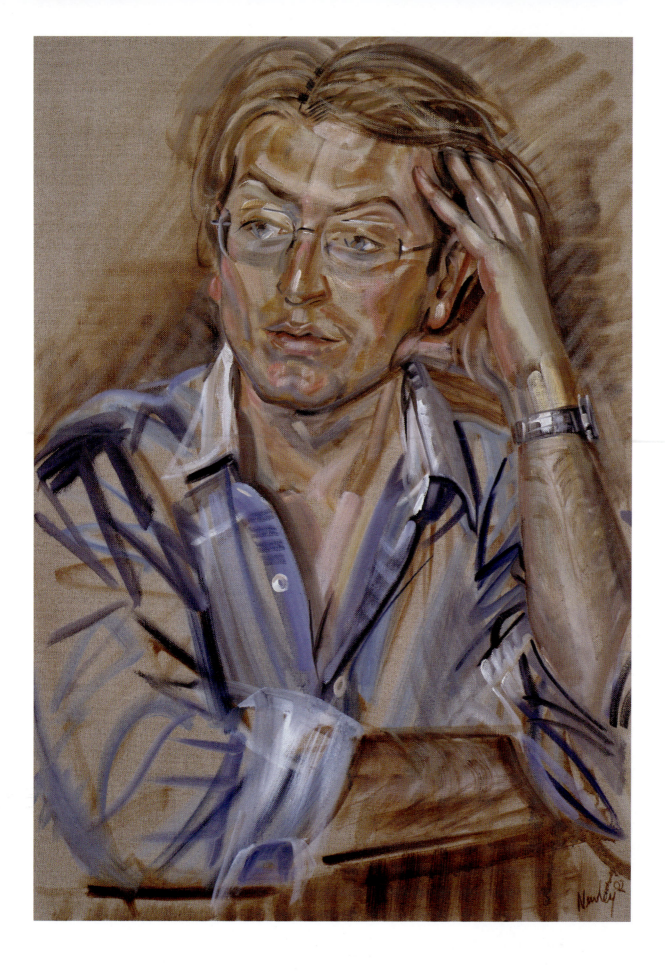

(opposite)
Carlton DeWoody
2002, oil on linen, 24x36"

(right)
Israel Horovitz
2003, oil on linen, 18x24"

The great playwright came to sit for me every morning, promptly after his morning jog, radiating vitality and intellectual energy. I left the picture loose around the edges to let it breathe.

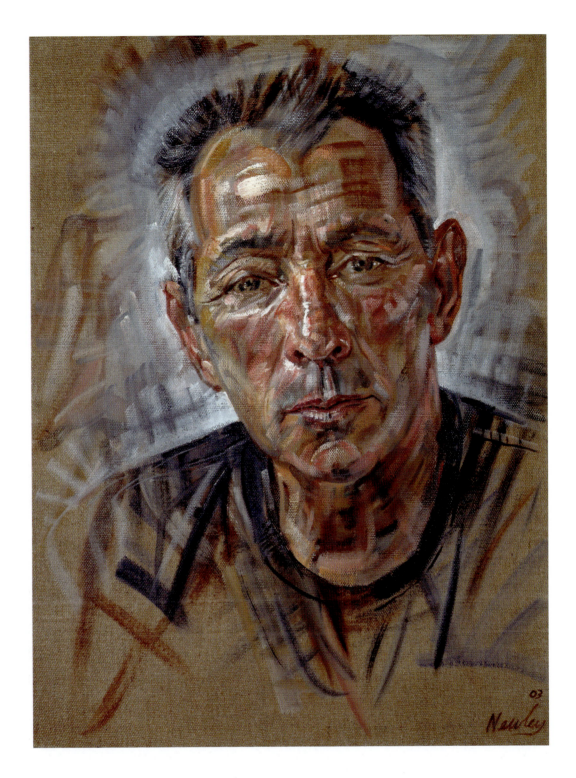

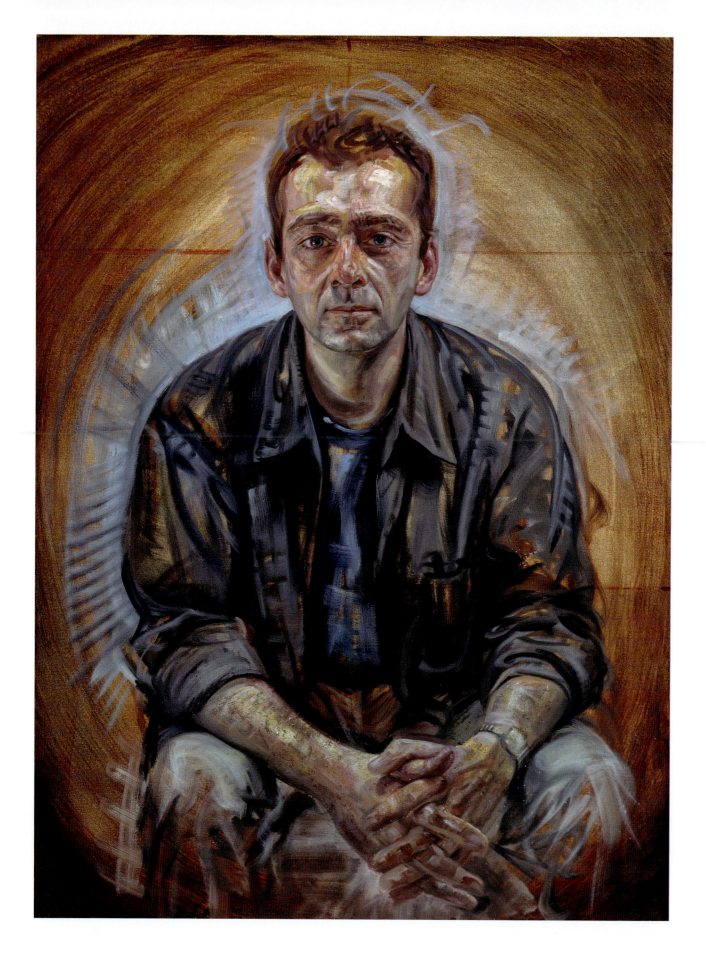

(opposite)
Andrew
1999, oil on canvas, 40x54"

My great friend fixes me with that look of enthusiasm that always seems to say: 'There are great things in you – go do them!' The loose, staccato brushwork conveys his energy and presence.

(right)
John Barry
2002, oil on linen, 26x36"

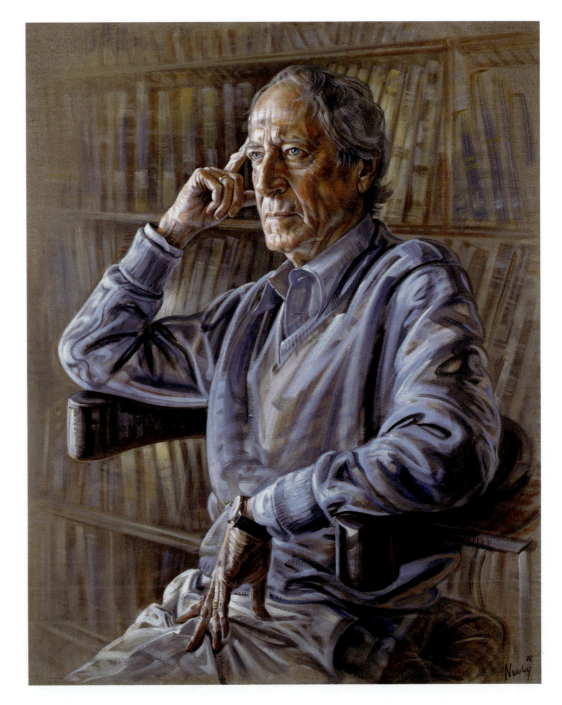

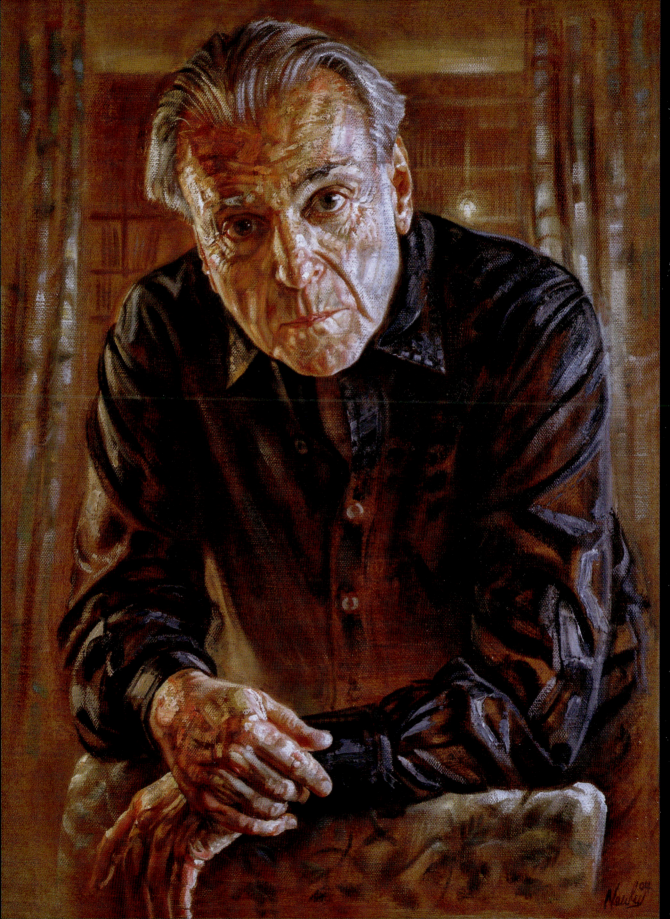

William Goldman
2004, oil on linen, 21x28"

Hunt Slonem
2005, oil on linen, 44x56"

He stands on tiptoe, yoked to the canvas by an outstretched arm, as if inspiration leads him on, a sleepwalker, into dream after dream.

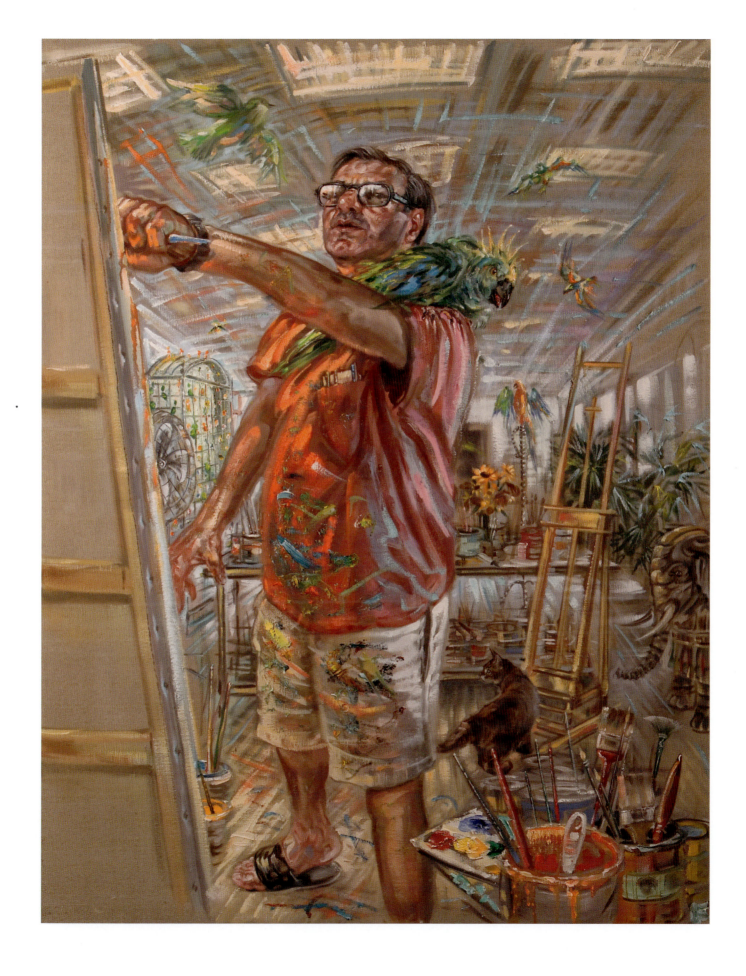

NEW YORK PORTRAITS 283

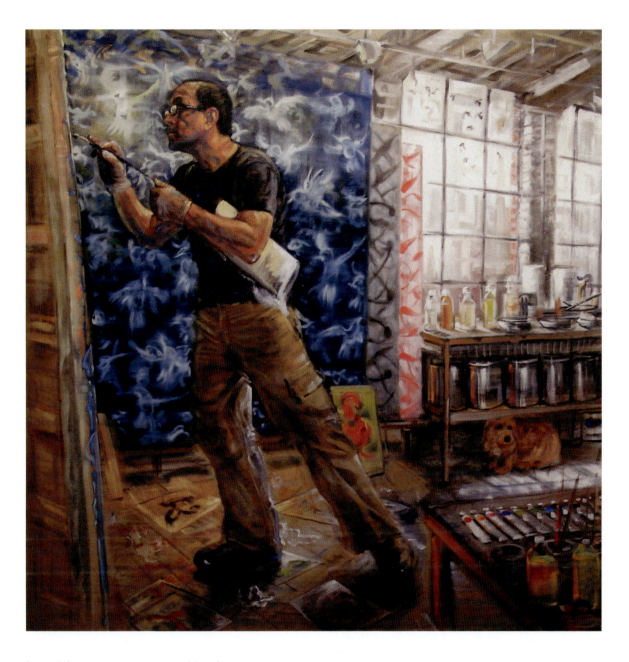

(opposite)
Ross Bleckner
2008, oil on linen, 18x24"

(above)
Ross at Work
2008, oil on canvas, 60x60"

As I watched him deftly handle the varnish and paint to create his blurred effects of movement, the whole canvas came alive with an aviary of falling angels that seemed the very souls of his departed friends.

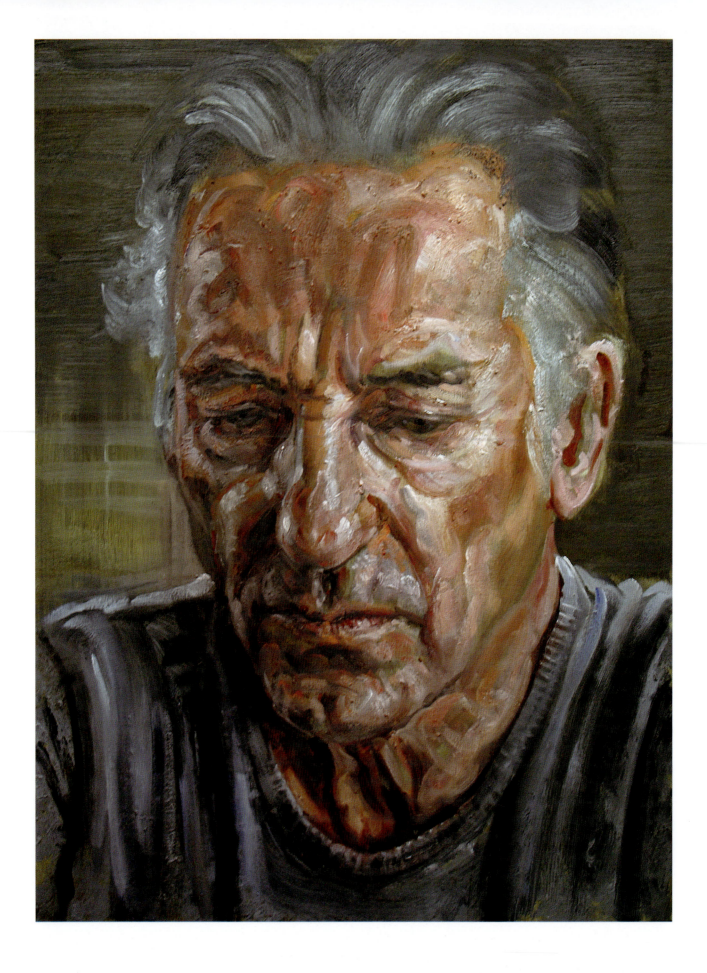

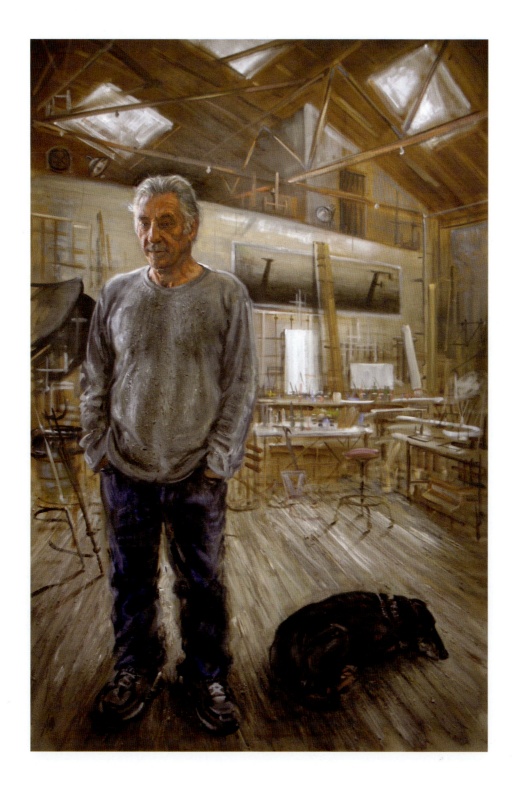

(opposite)
Ed Ruscha
2008, oil on canvas, 30x40"

(above)
Ed at Work
2009, oil on canvas, 60x90"

NEW YORK PORTRAITS

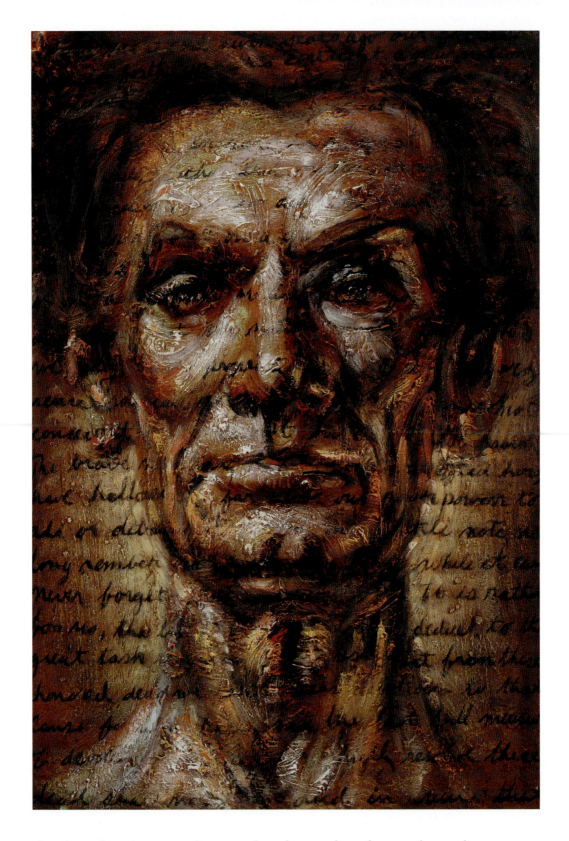

As I subsequently worked on the face, I took pains to let these lines of text show through it: here is a man literally made of his word.

(opposite)
Head of Lincoln
2004, oil and acrylic on canvas, 36x48"

(above)
Lincoln/Obama
2009, pastel and conté on paper, 18x22"

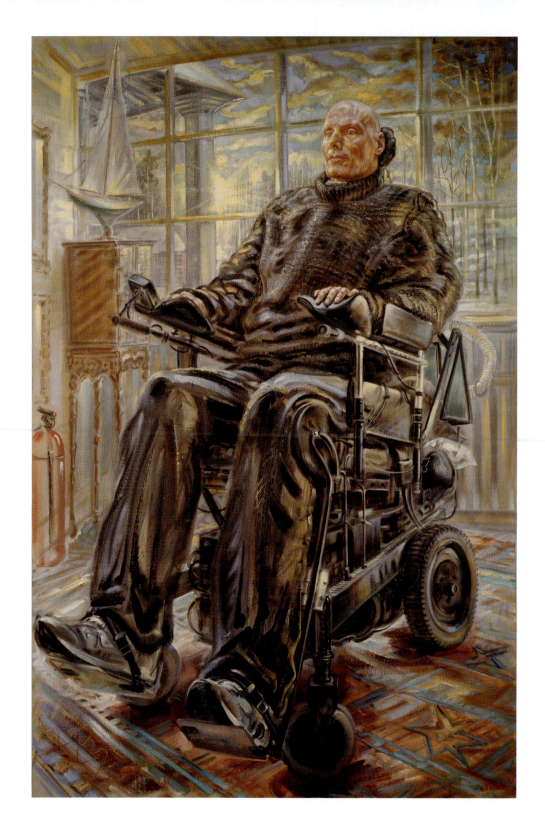

The irony was that, trapped in his wheelchair, he had finally achieved the strength to turn kryptonite into gold.

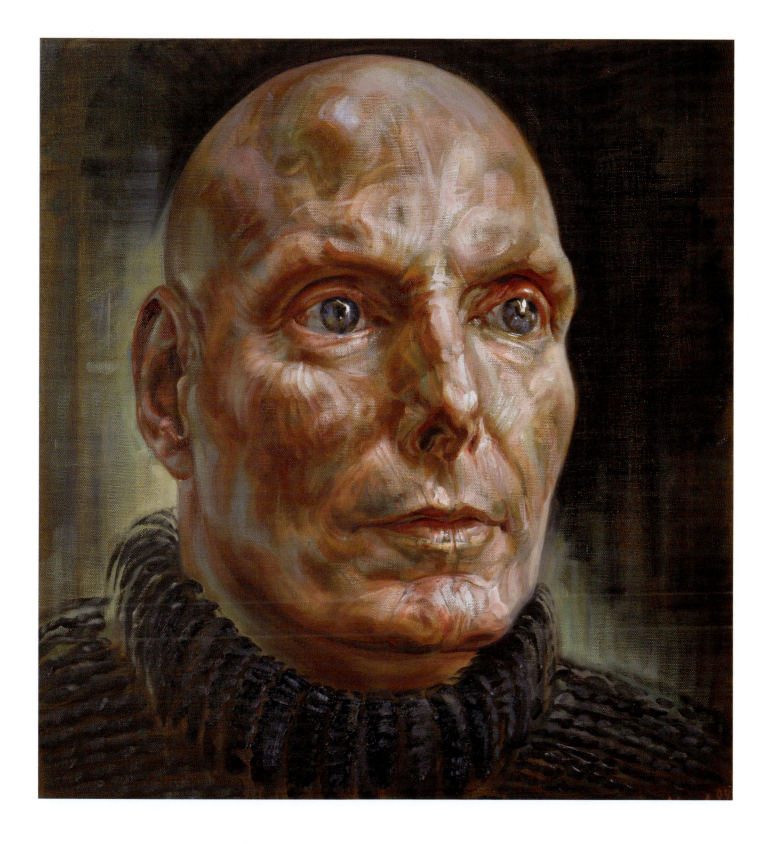

(opposite)
Christopher Reeve
2004, oil on canvas, 44x68"

Permanent collection, The National
Portrait Gallery at The Smithsonian

(above)
Head of Christopher 2
2004, oil on canvas, 20x20"

Permanent collection, The National
Portrait Gallery at The Smithsonian

Blessed curse

In 2008 I had an exhibition in London with the Catto Gallery that featured all the work I had made over the past six years, including the *Cardplayers*, *The Temptation of St Anthony* and a number of autobiographical works. The title I gave it, 'Blessed Curse', summed up my feelings about the nature of the creative gift.

The first of the autobiographical works came about when I was looking through an old box of photographs and found a picture of myself and my family from 1968. What would I say, I wondered, if I could travel back in time and speak to this happily innocent group? How would I spare my parents the divorce that awaited them only a year later? Maybe I could use the canvas as a time machine and paint my way back into the scene. But what would I say when I got there, and how would I position myself within the frame of that picturesque moment, knowing how it would end?

In **Self-Portrait with Happy Family (p. 293)**, the viewer is invited to look across the ancient river-of-time divide and embrace the quietly contemplating witness in the background. The beautiful dream in the foreground is about to fade but perhaps the magic of art can hold it forever.

Having opened this portal into my emotional history, I wanted to do more. I had always been inspired by the feelings and images associated with my very first experience of beauty as a child and set about reliving the moment in **Boy at a Window (p. 295)**. This is based on my actual memory of standing at a window, aged four, and feeling the space inside and outside my body – a majestic space that had no limits. It was a rite of passage both exhilarating and frightening.

Self-Portrait with Myself as a Child (p. 296) was the result of thinking about the classic self-portraiture of the past and wondering how it could be enriched by the discoveries and developments made by psychoanalysis in the past one hundred years. One of these discoveries was the inner child, that crucible of emotions and patterns that stays with a person throughout his or her life and conditions their responses. Becoming aware of it and making peace with it is one of the great challenges of the examined life.

In my painting, the little boy is scared stiff. He's not sure he wants to come to the lip of the stage that is all the world. I gently urge him on and he takes a baby step forward, hanging on to my shorts. He was never taught to trust; but now, with my help, he is learning to.

In **Self-Portrait with Hairy Beast (p. 298)**, the child is reimagined as a recalcitrant monster, which is the truth of the child's shadow. Originally my hand was lost inside the monster's grasp, but this didn't seem to work until I reversed the arrangement and the painting clicked. Caliban is under my spell and jurisdiction, even though he manages a significant sneer at the audience.

Self-Portrait with Happy Family
2008, oil on canvas, 36x44"

NEW YORK PORTRAITS 293

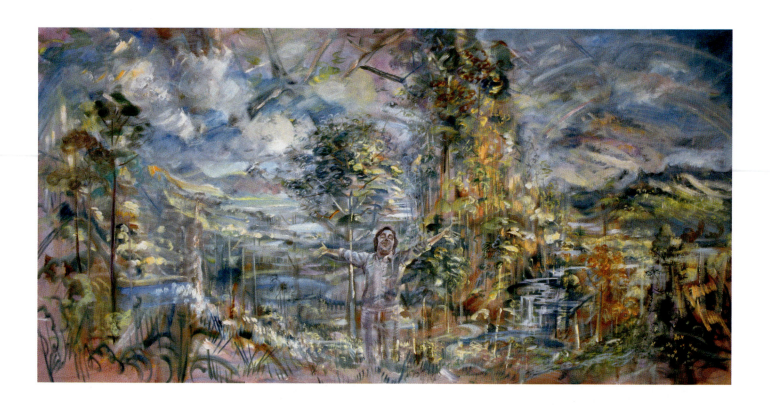

My Father in The Beautiful Land
2005, oil on canvas, 40x90"

I had created this panoramic view for my 'Inner Landscape' series, and then put it aside, unfinished, because I couldn't fathom what was missing. Then I happened to see an old still of my father from a '60s movie and knew it would perfectly adorn the centre.

An explorer could not begin
To discover its origin
For this beautiful land is in
Your heart.
'The Beautiful Land' by Anthony Newley

(opposite)
Boy at a Window
2008, oil on canvas, 36x44"

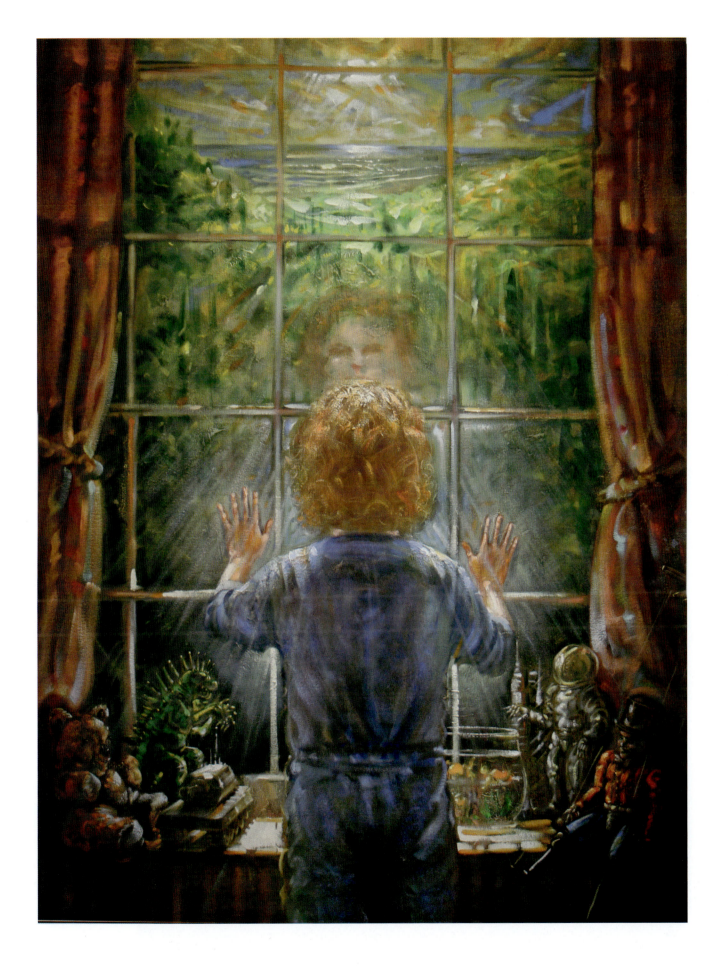

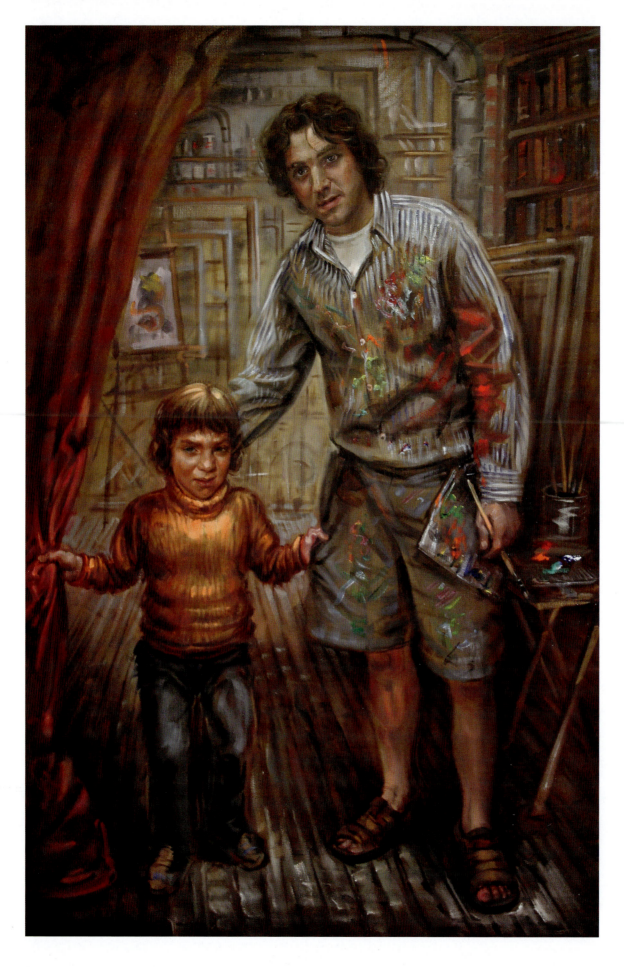

The little boy is scared stiff. He's not sure he wants to come to the lip of the stage that is all the world. I gently urge him on and he takes a baby step forward, hanging on to my shorts. He was never taught to trust; but now, with my help, he is learning to.

Self-Portrait with Myself as a Child
2008, oil on linen, 32x42"

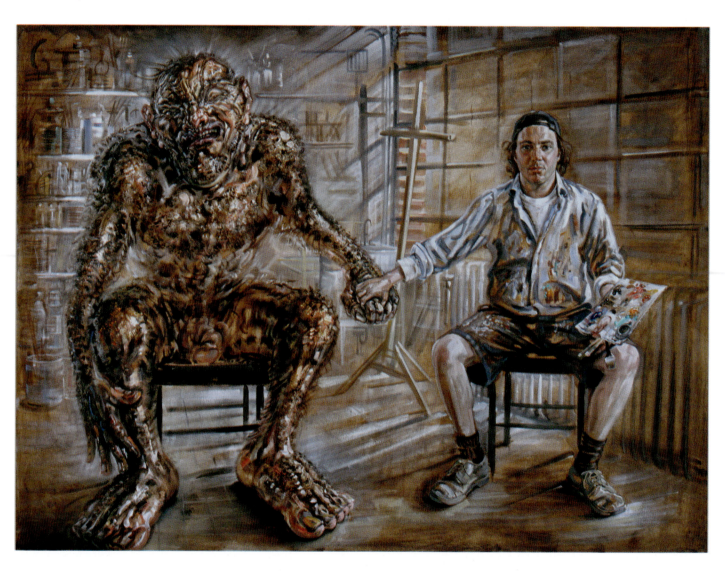

Self-Portrait with Hairy Beast
2004, oil on canvas, 44x60"

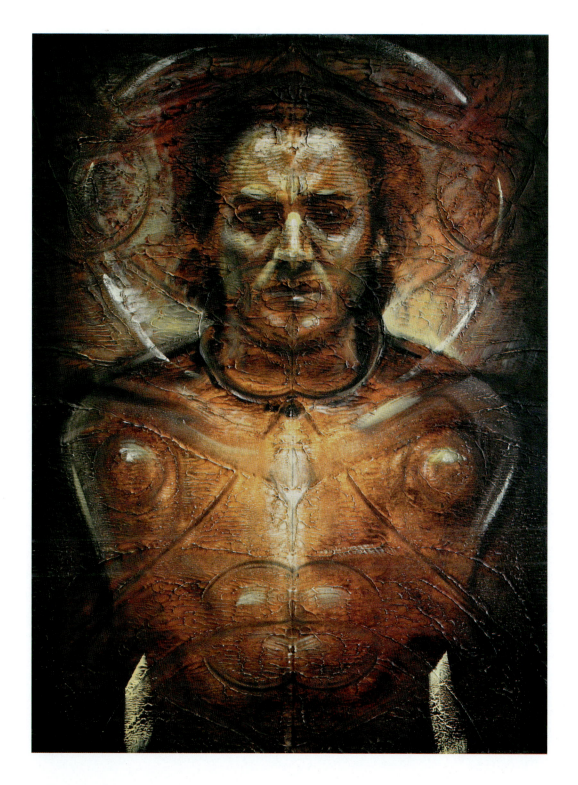

Self-Portrait as Spaceman
2006, oil and acrylic on canvas, 30x40"

The memory of wearing a space helmet as a child evolves into this meditation on the artist's alienation in a world of conformity.

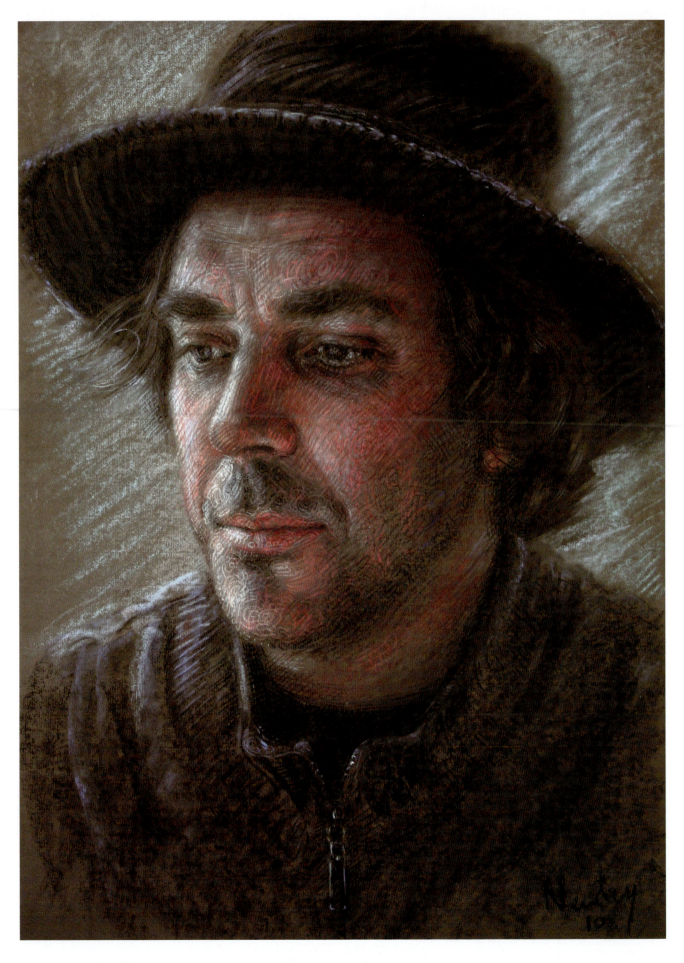

Self-Portrait in a Black Hat
2010, pastel and conté on paper, 18x24"

The elegiac quality in this self-portrait sums up another emotional period of transition in my life. It was near the end of my time in America; and, feeling the inevitable disappointments of midlife, I was ready for a deeper and more nuanced understanding of myself and my place in the world.

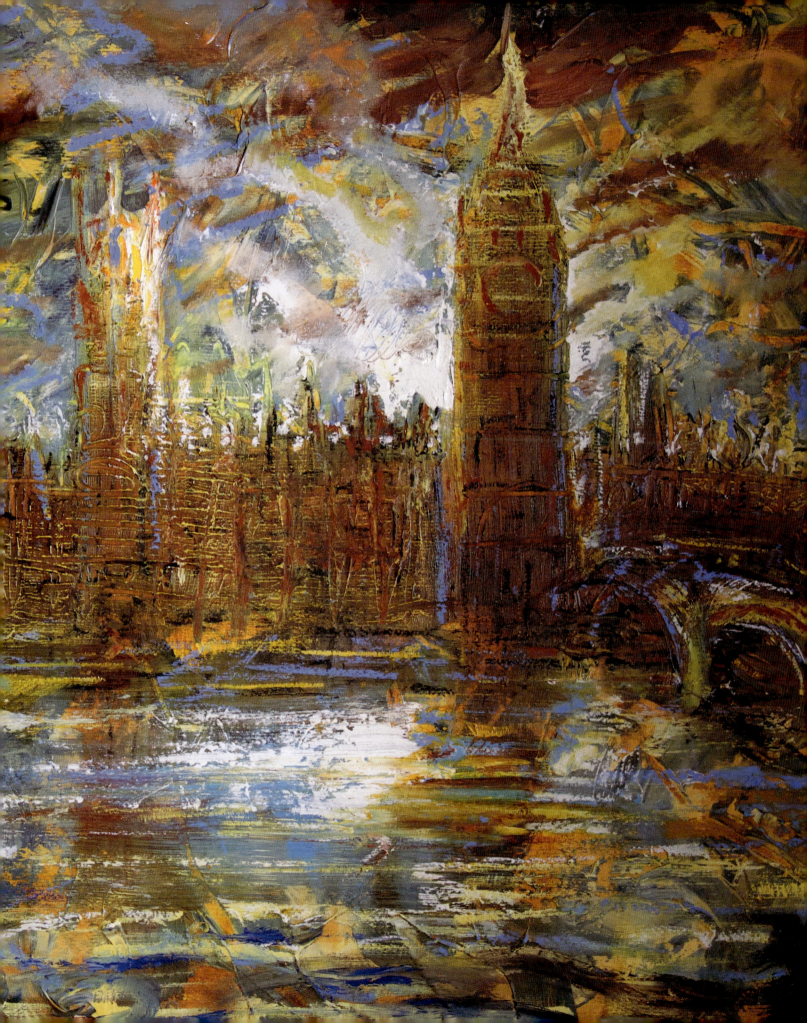

Chapter 13

London

In 2013 I moved back to London. My odyssey in the US had been long and fruitful but it was time to come home.

I felt that the best way to reconnect with London was through portraiture, and in **Lord Jeffrey Arche**r 1 **(p. 306)** I found personified the traits I loved about the city: depth, pugnacity, humour and intelligence.

Sir David Suchet (p. 305) was an absolute treat to paint. I found him to be a fellow traveller and deep thinker on the creative road. I was honoured when my portrait of him was acquired by the Garrick Club to hang, pride of place, in its famous bar.

Eventually I turned my attention to making a portrait of the city itself. As with my pre-9/11 pictures, there was some clairvoyance at work: less than a year away lurked the viral panic that would bring London, and the world, to its knees.

In **London, 2020 (p. 310), the** Shard shoots skyward in a primal scream while the view across the Thames has an unearthly aura of power and menace.

Painting Sir David

'Sitting for a portrait is a timeless experience and my mind always goes back to the National Portrait Gallery where I have enjoyed so many iconic portraits. Being painted by Alexander Newley was joyous and relaxing, and we both found ourselves delving into deep and philosophical conversations. I feel he has caught on to canvas my private persona whilst holding the cane belonging to my alter ego!!'

Sir David Suchet CBE

Sir David Suchet
2017, oil on linen, 20x24"

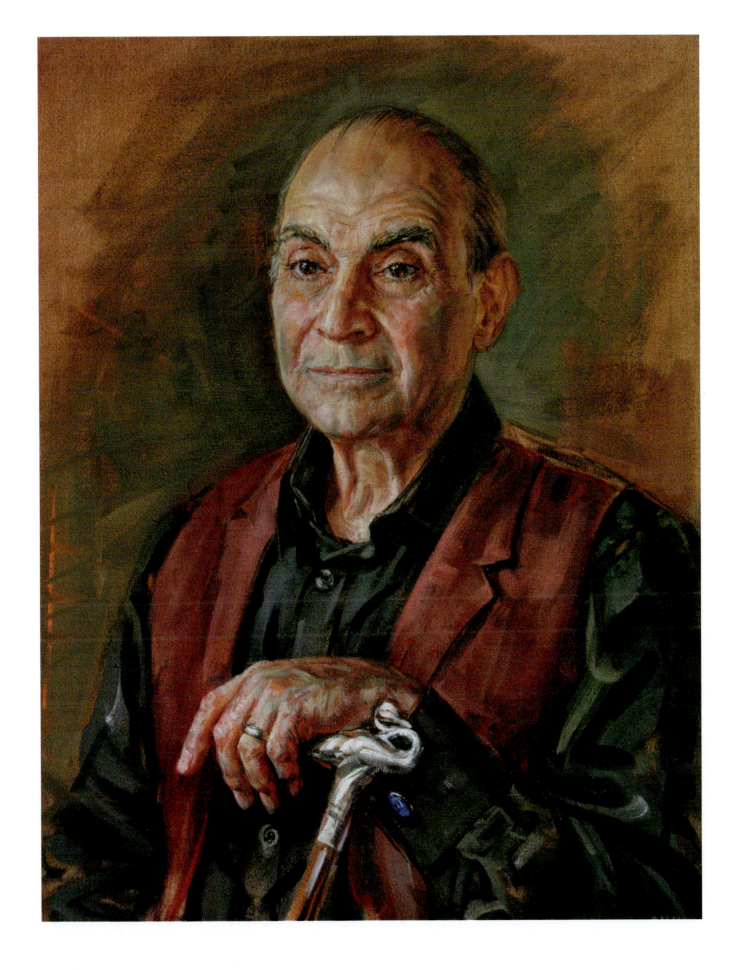

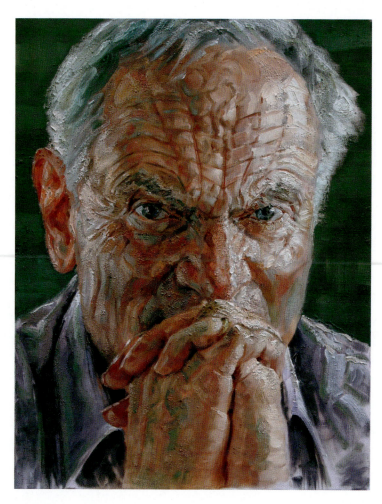

Lord Jeffrey Archer 1
2015, oil on canvas, 30x40"

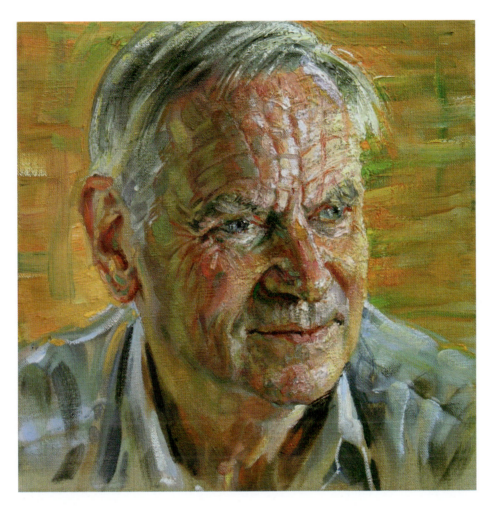

Lord Jeffrey Archer 2
2015, oil on canvas, 18x18"

'This is my wife Mary's favourite picture of me and hangs in her study at our home in Mallorca. Alexander is, without question, one of our great portraitists, and deserves all the recognition and success he's had.'

Lord Jeffrey Archer

'Alexander painted this portrait of me seven years ago, long before I was feeling any sort of call to become ordained as a Priest and Prison Chaplain. Yet his art had a prophetic dimension to it. For he gave my eyes and my hands a futuristic spiritual dimension. My eyes seem to be looking in a visionary way towards some sort of celestial light. My hands are a clasped version of one of my favourite drawings, Albrecht Dürer's *Praying Hands*. As I believe I am finding the true light through prayer this portrait may be a case of my life imitating Alexander's art.'

Jonathan Aitken

(opposite)
Jonathan Aitken
2015, oil on canvas, 12x16"

(overleaf)
London, 2020
2020, oil and oil pastel on canvas, 80x40"

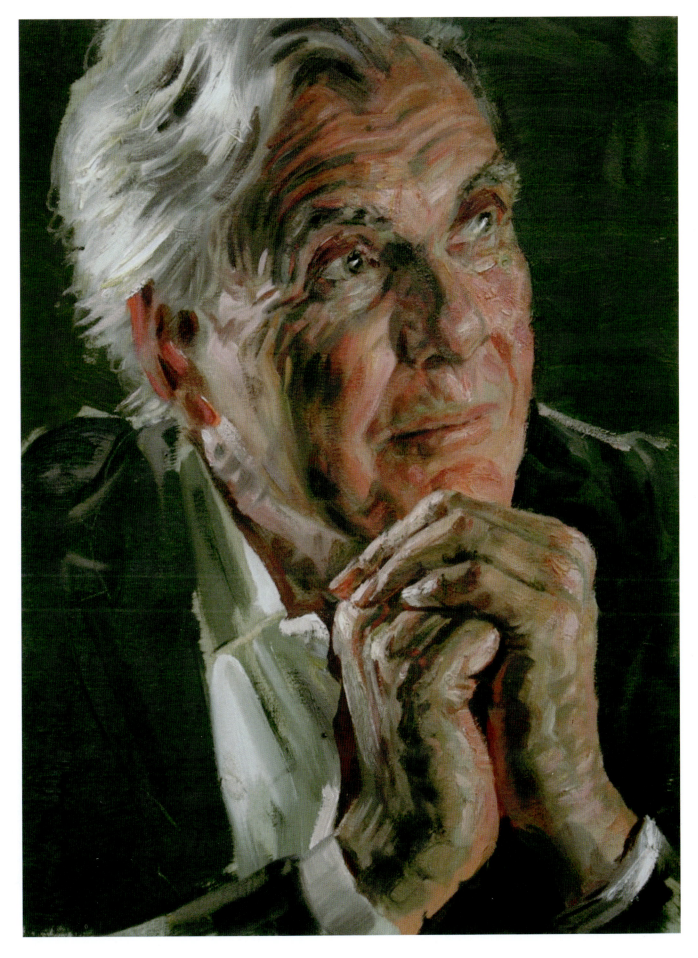

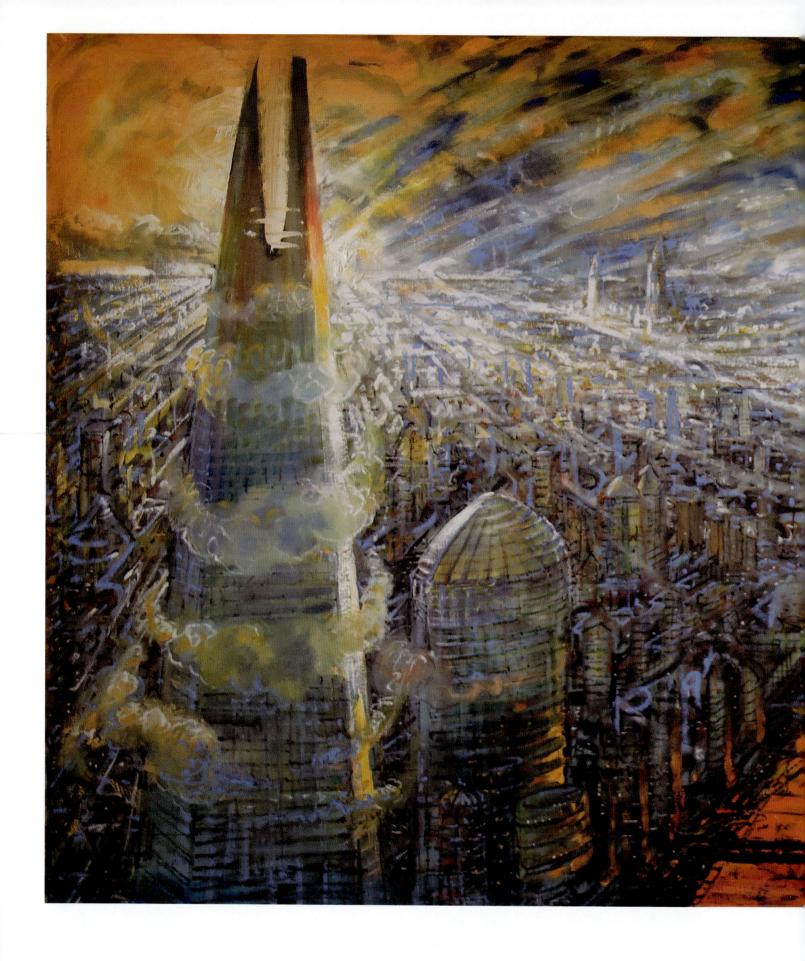

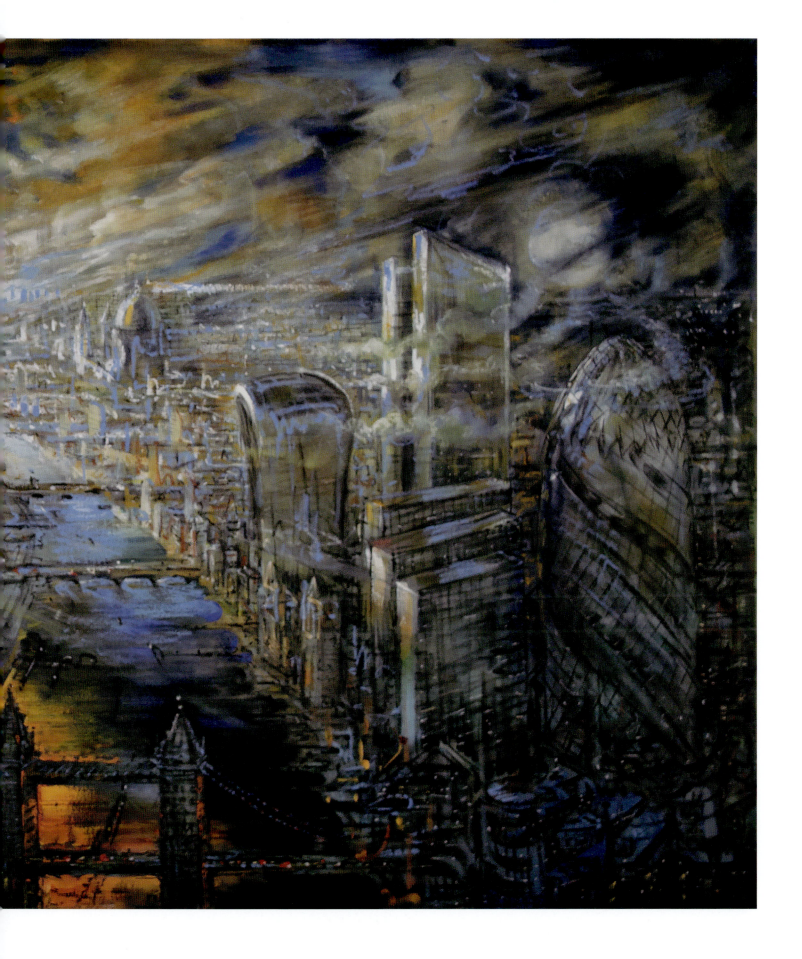

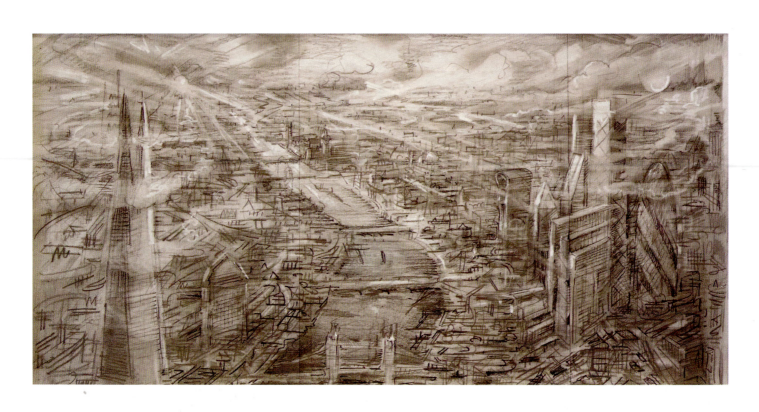

Study for London, 2020
2019, pencil on paper, 29x15"

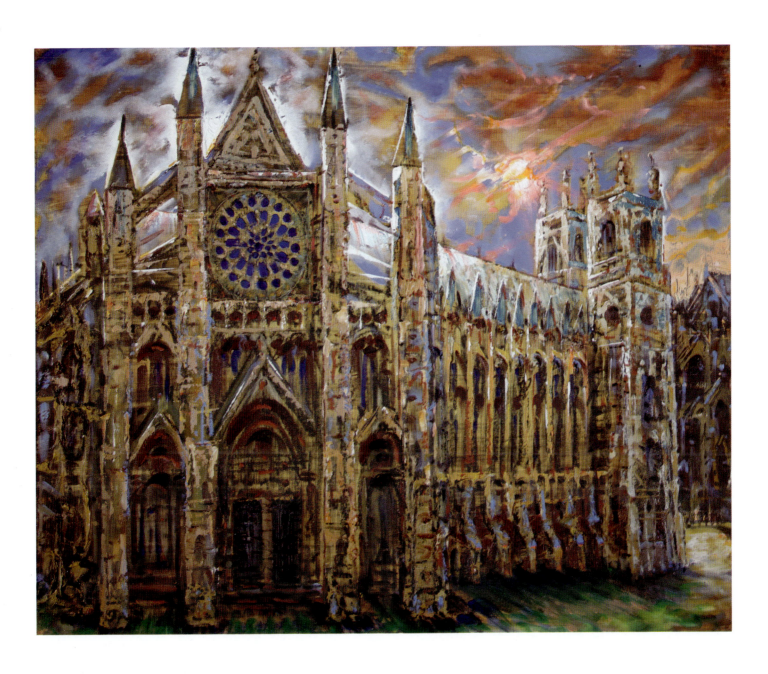

Westminster Abbey
2019, oil and oil pastel on canvas,
43x35"

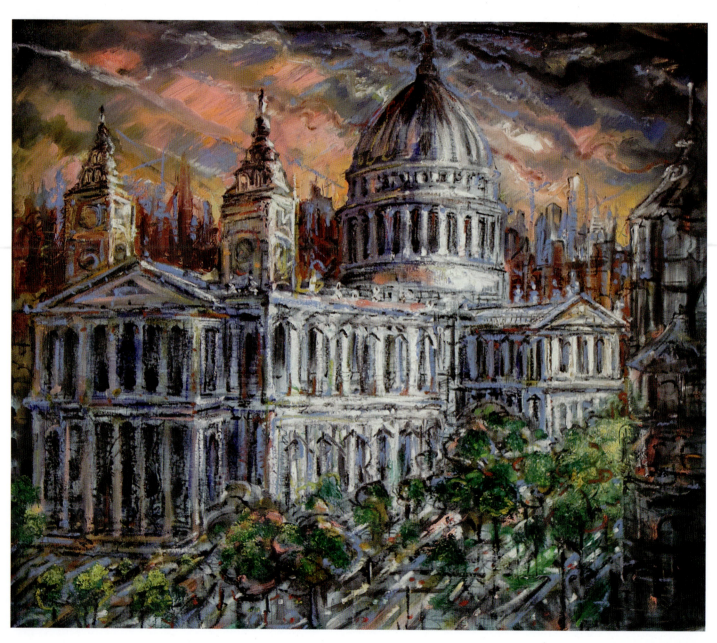

St Pauls 1
2019, oil and oil pastel on canvas, 39x34"

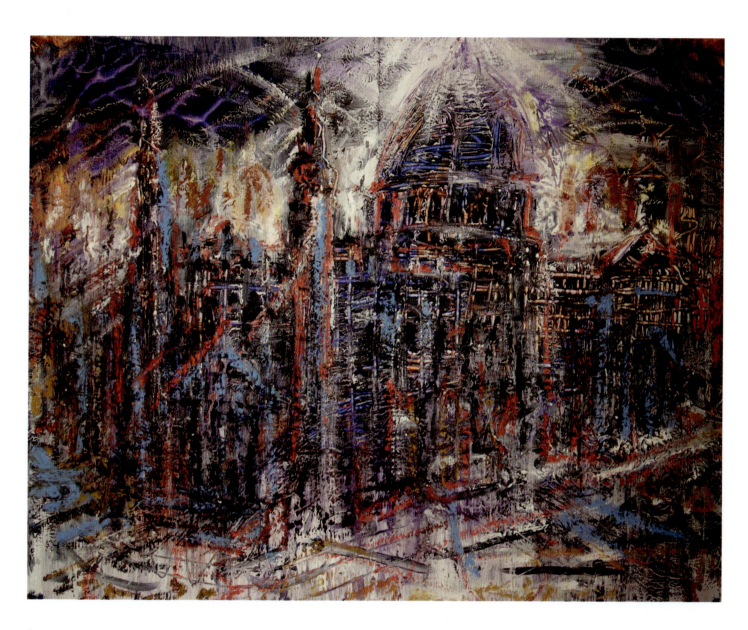

St Pauls 2
2019, oil pastel and acrylic on paper, 21x17"

The great church that survived the Blitz seems to disintegrate in a blast of heavenly light.

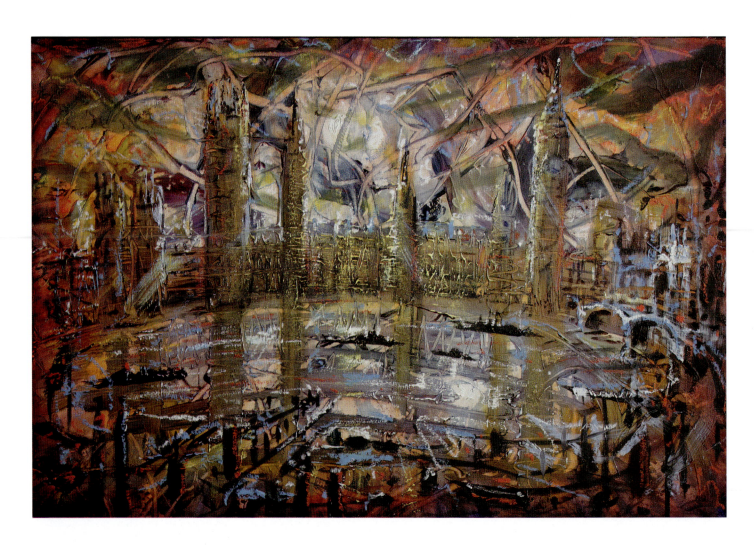

Palace of Westminster, Moonlight

2019, mixed media on canvas, 30x20"

The night sky, crammed with haywire jet trails, forebodes an approaching short circuit in the world's energy.

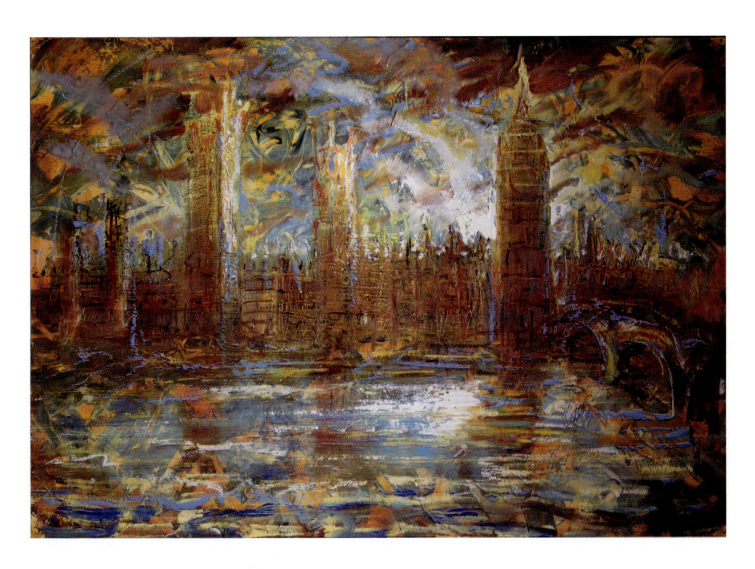

Palace of Westminster
2019, oil and acrylic on canvas, 40x28"

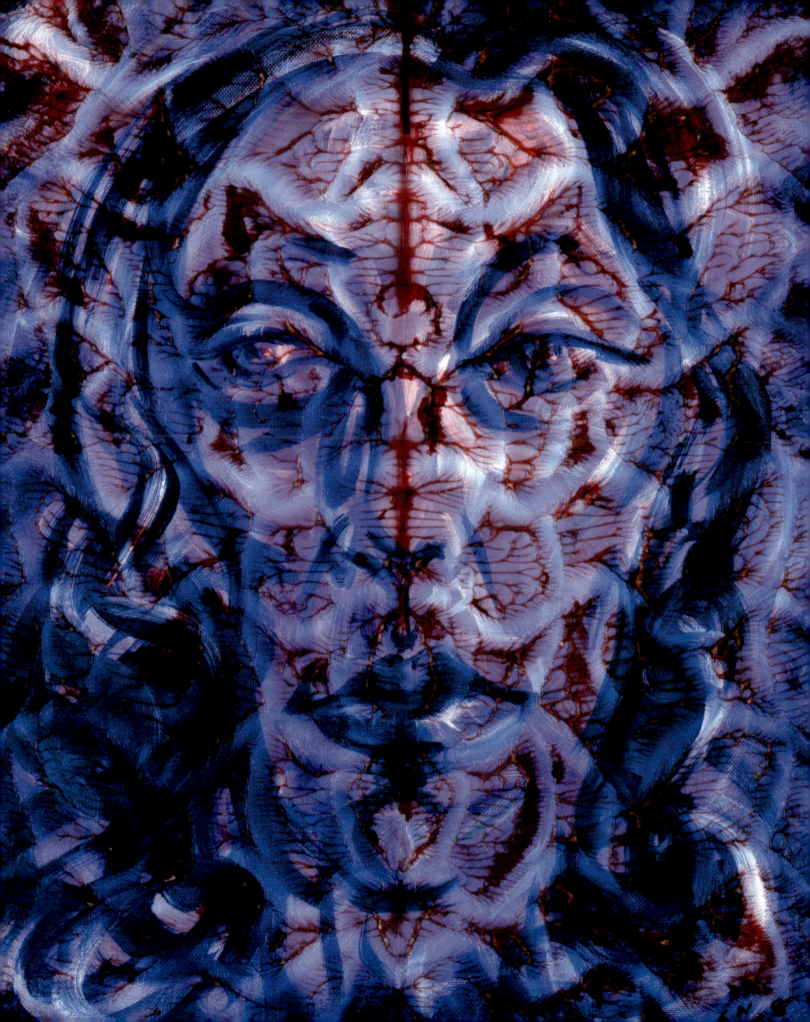

Chapter 14

Witnesses

They appear repeatedly in my work: large head-and-shoulder portraits of presences and beings who both stare out at the viewer and into themselves, as if wondering: What is happening in the world? What is life? What am I? What are we doing here? They are witnesses to the world's disgrace as well as its beauty, and they provoke the viewer to wonder as they do.

I find this quality in my real-life subjects, too. We are all, essentially, witnesses. And our work is our testimony.

To my mind, none of the deep moral conflicts humankind was struggling with in ages past have gone away. Underneath our technological prowess and veneer of modernity, we are still wrestling with the problem of evil.

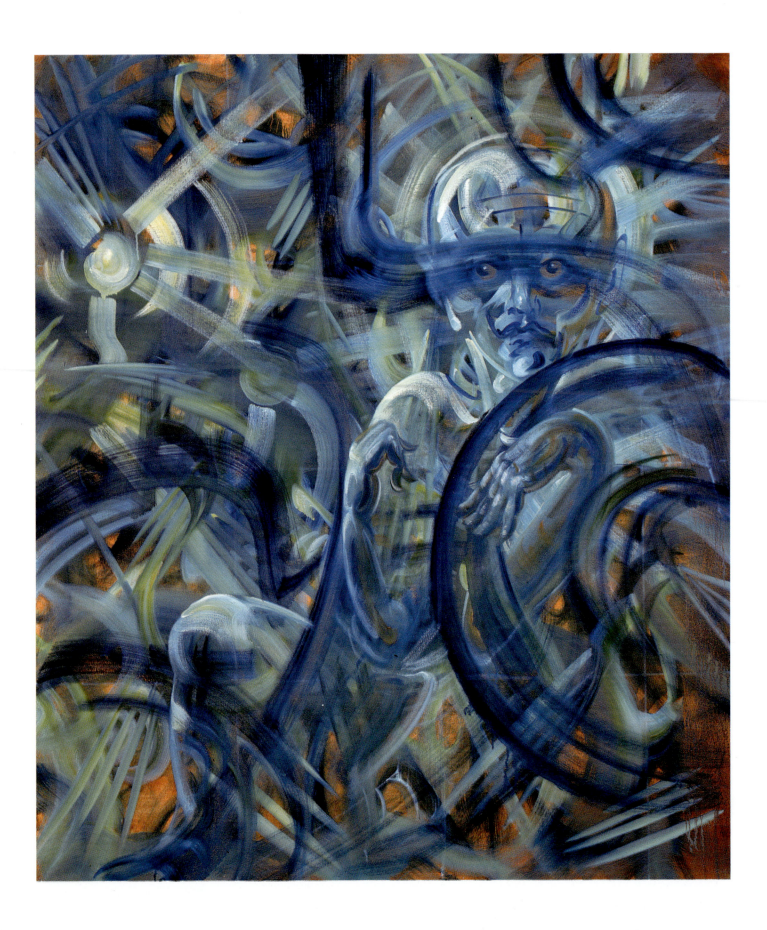

Witness, black etching
1998, black etching paper, 8.5x11"

Pasternak
1998, acrylic on paper, 12x16"

(opposite)
Large Blue Witness
2000, oil on canvas, 50x55"

(above)
My Eyes Saw What My Hands Did
2005, oil on canvas, 11x14"

(opposite)
Fire In The Sky
2005, pastel and conté on paper, 16x20"

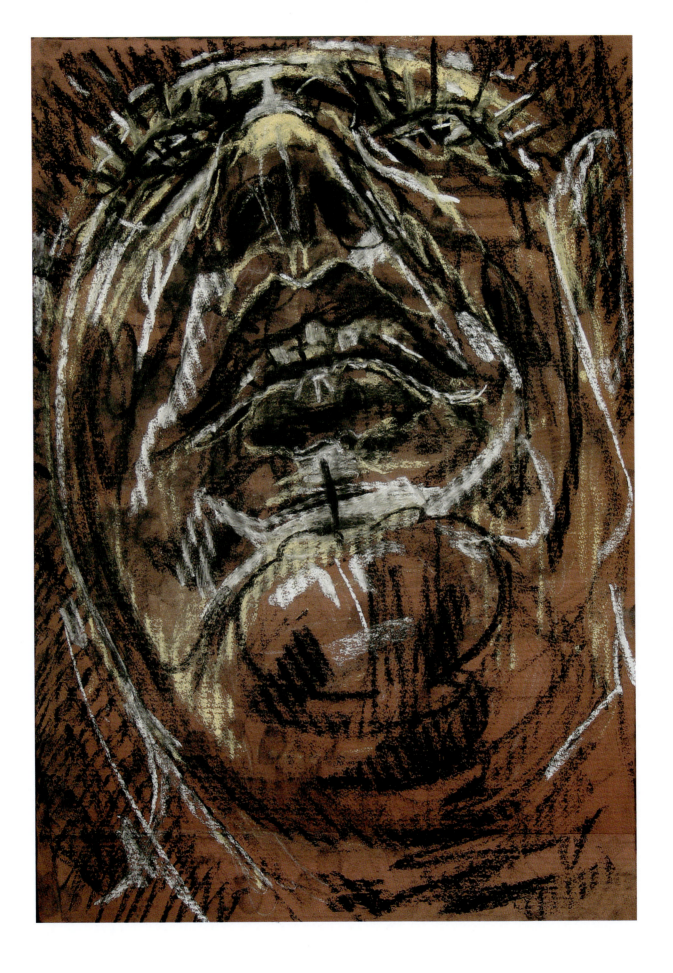

Veiled
1998, acrylic on paper, 16x20"

Red Fractal Witness
1998, pastel on paper, 16x20"

Ghost in the Machine
1998, acrylic on canvas paper, 16x20"

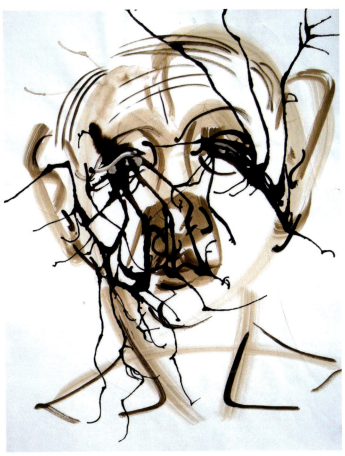

Weeping Woman
1998, acrylic ink on paper, 16x20"

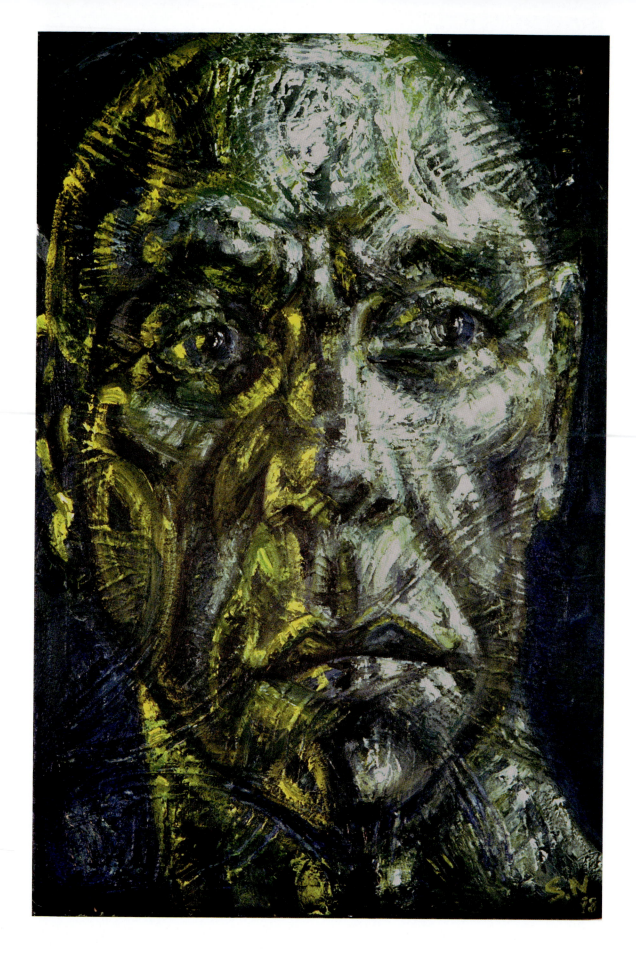

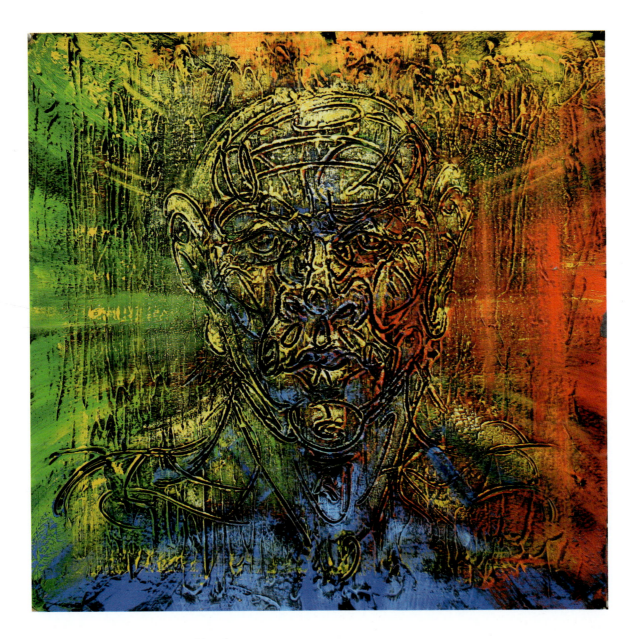

(opposite)
Large Green Witness
1998, oil on canvas, 24x36"

(above)
Four-Colour Man
1998, acrylic and oil on canvas paper, 18x18"

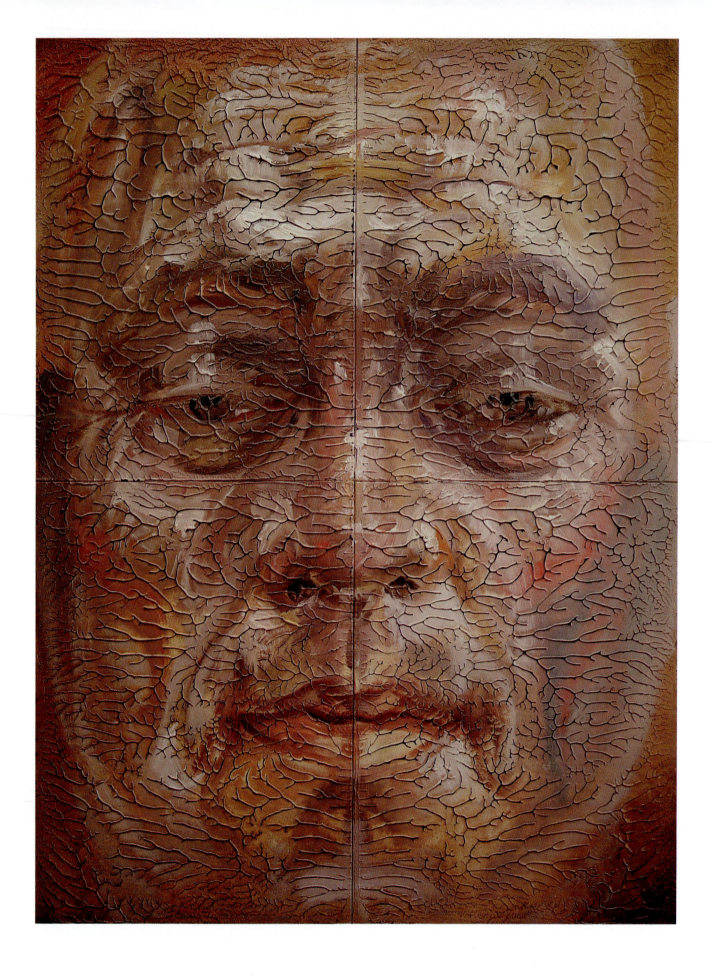

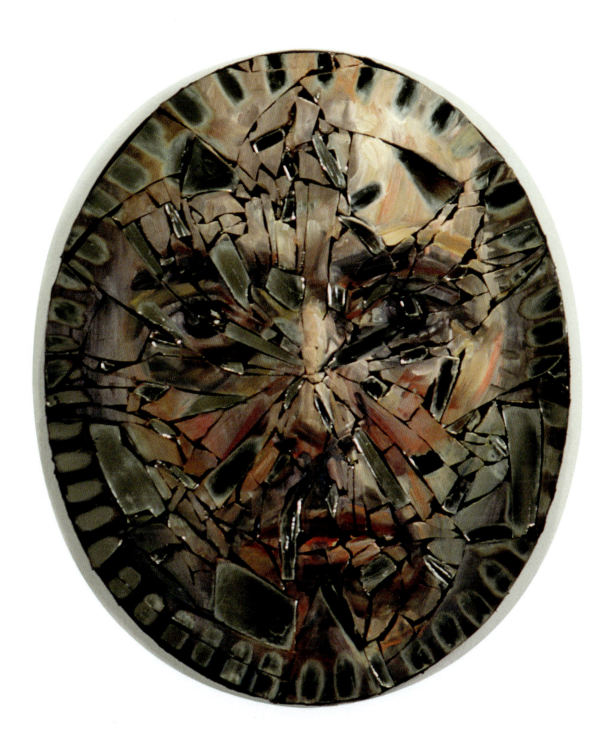

(opposite)
Head of Buddha
1999, oil and acrylic on canvas panels, 20x28"

(above)
Self-Portrait on a Broken Mirror
1998, oil on broken mirror fragments, mounted, 14x20"

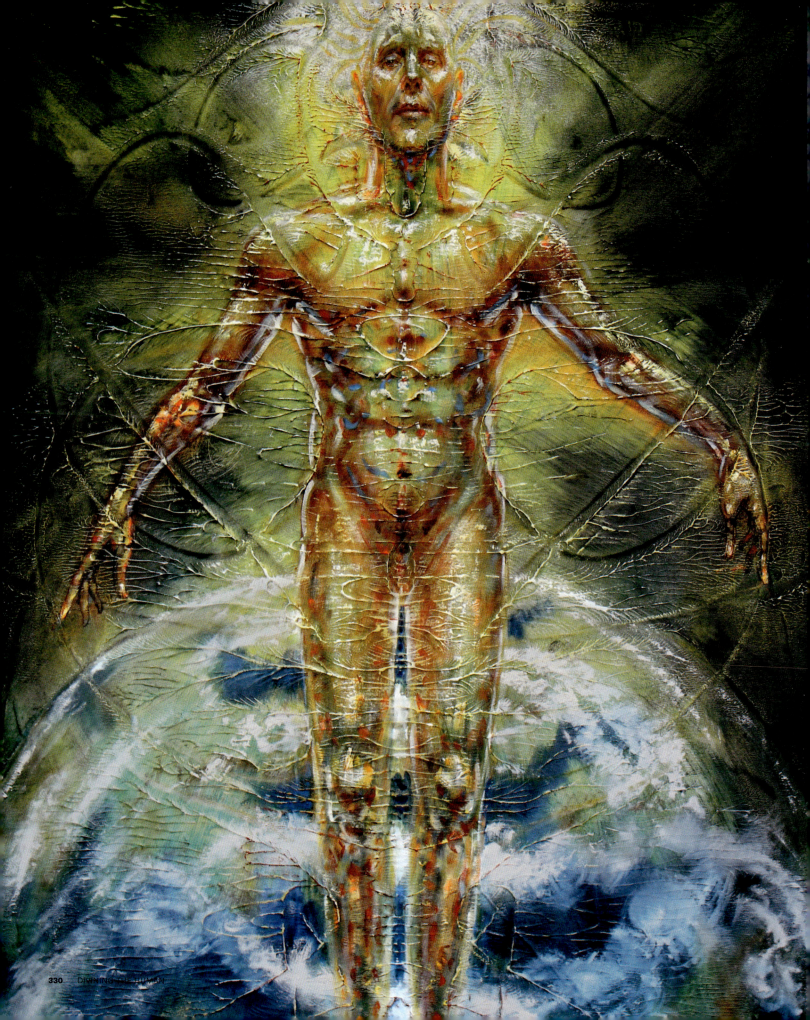

Chapter 15

Ascension

There is art for art's sake, art for self-expression and art for entertainment. The highest calling of art, I believe, is to map the story of our becoming and show a way for the soul to grow towards its perfection.

The central metaphor and parable of this growth in Western culture is Christ. The descent of the soul into form, its crucifixion in a materialistic world and eventual release back to its source in pure energy and love, is the story behind all human striving and woe.

Images of the Crucifixion and Resurrection have surfaced many times in my work. I profess to no mainstream or dogmatic belief, but these images speak to me of a universal desire, and I end my book not on the wings of Icarus – always doomed to deliver us back to the world more damaged than before – but on the only true wings that work: a prayer for ascension, selflessness and love.

First The Tower of Babel, then the Magic Mountain. We climb twice, but the second ascent is real: not the flight of Icarus, but the Ascension proper.

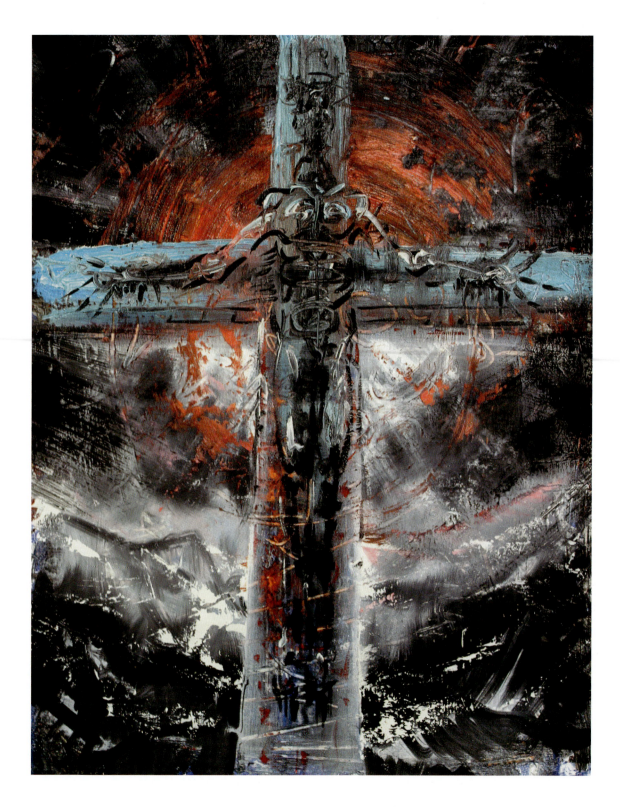

Blue Crucifixion
2018, oil and acrylic on canvas,
16x20"

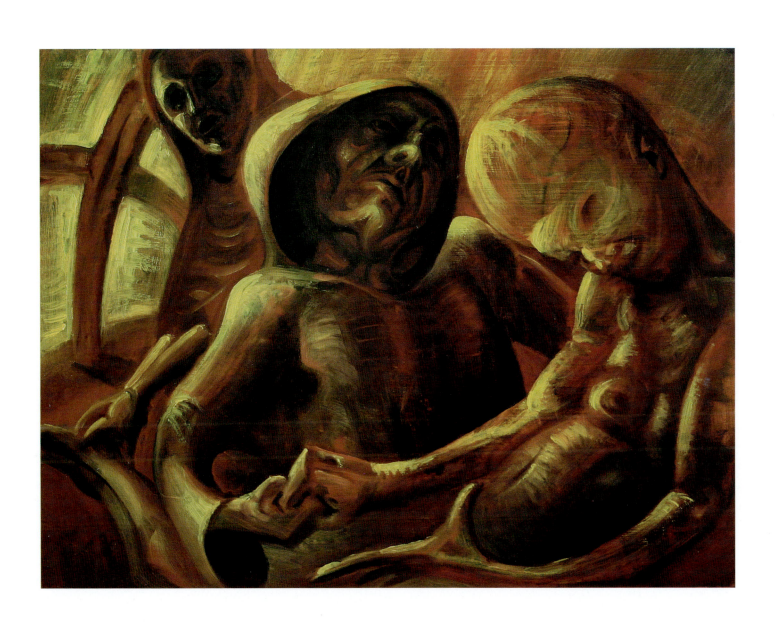

Deposition From The Cross
1988, oil on panel, 16x24"

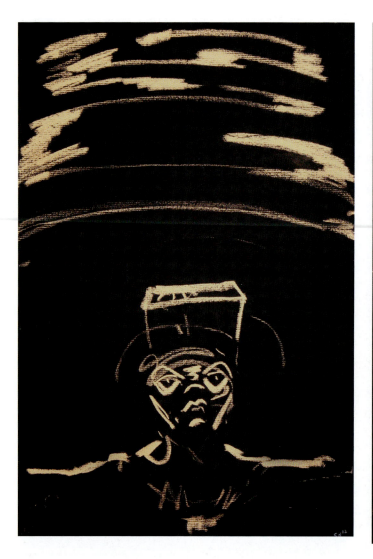
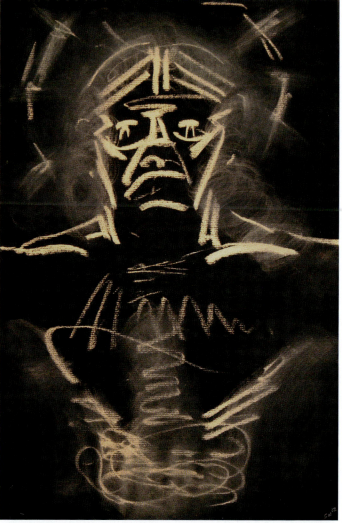

 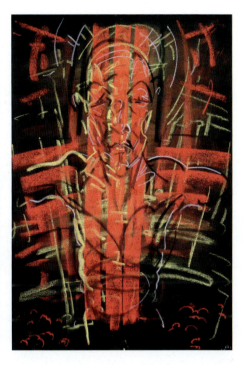

(this spread)
Ascension Sequence
2003, five pastel and conté on paper drawings, 16x20"

(overleaf left)
Salvator Mundi
2018, oil on canvas, 28x44"

(overleaf right)
Talbott Spirit Flower
2021, Oil and Acrylic on canvas, 18x30"

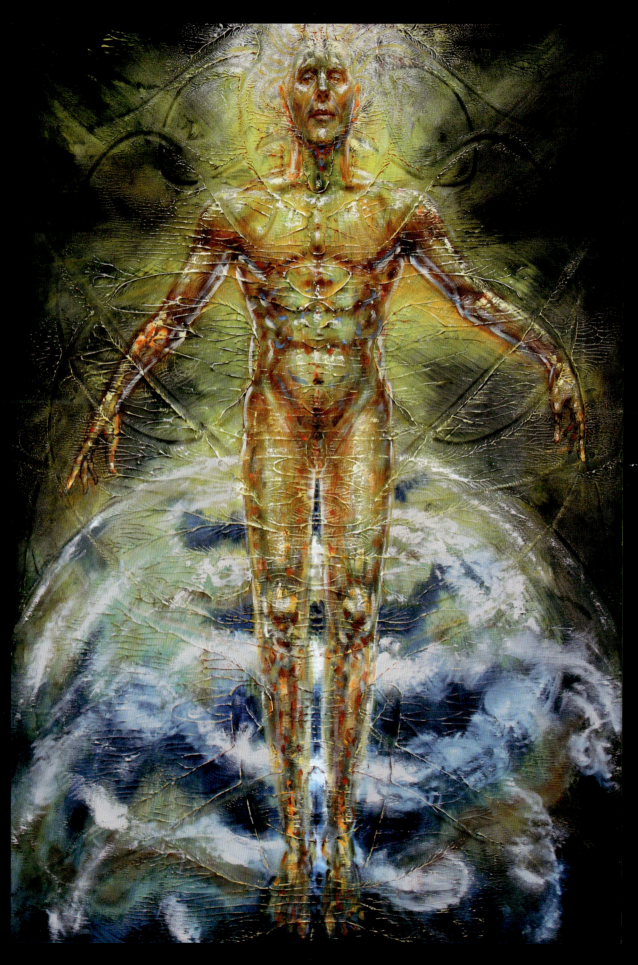

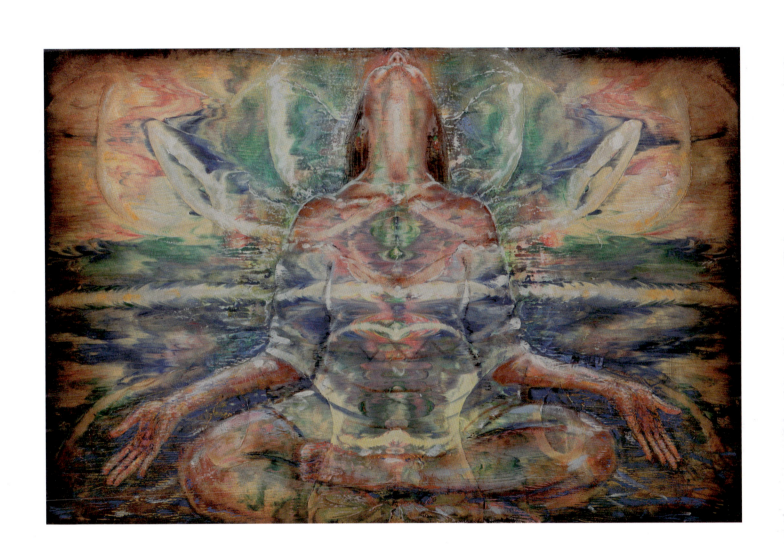

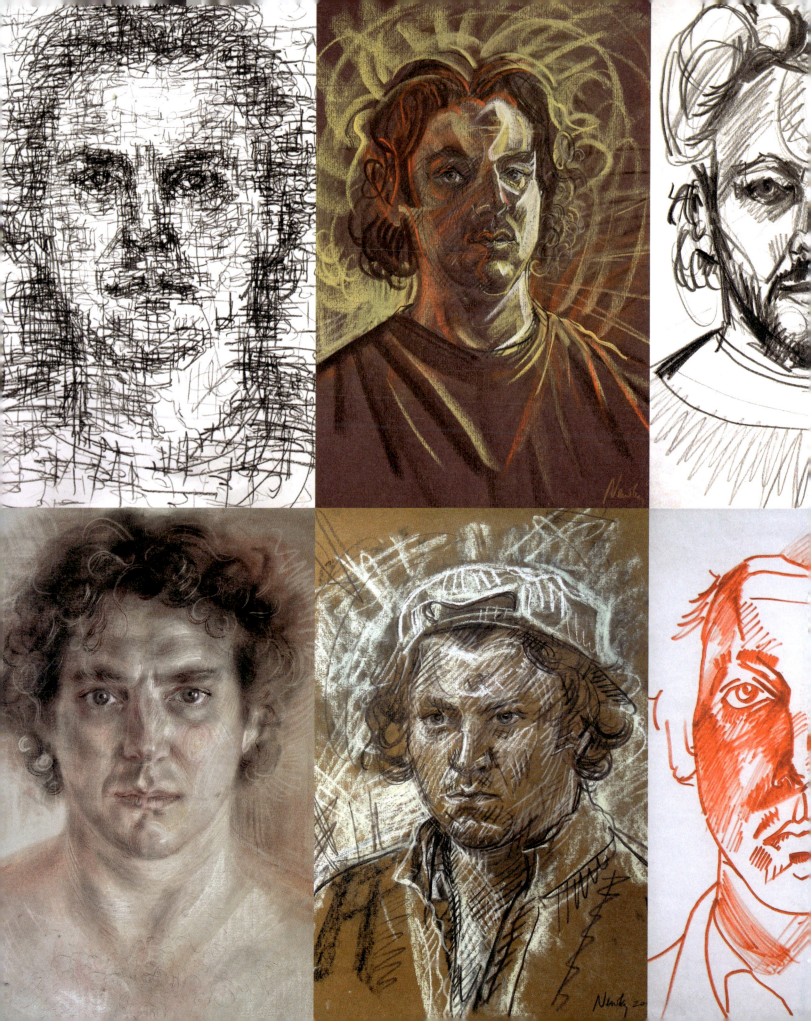